Essays on Art & Language

Essays on Art & Language

Charles Harrison

The MIT Press
Cambridge, Massachusetts
London, England

Library of Congress Cataloging-in-Publication Data

Harrison, Charles, 1942– .
 Essays on Art & Language / Charles Harrison. – 1st MIT Press ed.
 p. cm.
 Originally published as Essays on Art & Language. Oxford, UK : B. Blackwell, 1991.
 Includes bibliographical references and index.
 ISBN 0-262-08300-0 (hc : alk. paper)
 1. Conceptual art – England. 2. Art & Language (Group) 3. Modernism (Art)
4. Art, Modern – 20th century. I. Harrison, Charles, 1942– , Essays on Art &
Language. II. Title.
N6768.5.C63 H37 2001
709′.04′0750942 – dc21

 2001018704

Contents

List of Plates

Plates between pages 174 and 175

Foreword

In theory, recent art should be as available to the writing of history as that of any other period. In practice, coherent and persuasive accounts of its significant episodes have been rare. This state of affairs has not come about because we are 'too close' to the material or because the number of documents is somehow overwhelming. These are familiar and unconvincing excuses: think what any historian of an earlier period would give to have such problems. The primary obstacle has been the fact that much of what was at stake in recent art, in cognitive and intellectual terms, was simply outside the art-historical curriculum.

Charles Harrison's *Essays on Art & Language* is a welcome exception to this rule. The basic line of his work concerns hard questions of ontology and epistemology that became unavoidable for serious artistic practice in the later 1960s. Only by making these philosophical issues his own could he approach an adequate *history* of the events and works of art that figure in his account. His early chapter on the import of the 'conceptual-art' movement of 1967–72 is unparalleled in its acuity, and the opening pages of the book offer one of the most lucid available explanations of post-war modernist culture as a historical phenomenon.

These overviews are, however, only preparatory to a more demanding task, the specific history of the cooperative project known as Art & Language. This presents a greater challenge for two reasons: not only does Harrison want to make Art & Language's work – which is notorious for its 'difficulty' – representative of the central issues facing art in general, he also must include himself as a participant in the history being recounted. The difficult feat that he has brought off is to make the kinds of difficulty present in the work historically and intellectually comprehensible without domesticating the complex, often hastily improvised and *ad hoc* forms of refusal that gave Art & Language its logic and pertinence in the period around 1970. The dimension of indexicality figures throughout the book as fundamental to a revitalized conception of artistic realism. The social history of the group, particularly as it ballooned in numbers on contact with the 'counter-cultural' tide in the New York art world of the 1970s, is recounted with the right measure of detachment and irony. That re-

counting, further, does important intellectual work in demonstrating the hollowness of certain postures of left-wing critical effectiveness that actually left art-making hostage to the marketing/display mechanisms that were ostensibly being opposed. There is humour in the narrative as well, which at the end of the chapter deposits the reader into the much-reduced complement of three major actors (Harrison included) who carried on the Art & Language discussion from 1976 to the present.

From then on the general development of art outside the Art & Language project recedes without being altogether absent, and the reader's attention is placed squarely on the paintings. This is an achievement in itself, in that studies of modern art that claim a traditional priority for 'the object itself' and 'the evidence of the eye' normally offer only cursory and nonexplanatory simulations of rigorous visual attention to art. Harrison demonstrates just how difficult and sustained an enterprise the translation into prose of looking and thinking about demanding works of visual art must be. The reader is made to enter into the process of artists' decision-making, to grasp the logic of production, rather than being treated as a consumer of effects and superficial novelties (the latter being the case in normal writing on contemporary art). The reader comes to see the sequence of paintings produced by Mel Ramsden and Michael Baldwin since the break-up of the expanded group as a practical way forward from the historical and philosophical situation left behind by the first episode of widespread dissent from dogmatic modernism. One of the virtues of that way forward, the reader comes to know, is that it did not assume modernism in general to have been definitively superseded. Another is that is contained some principles of corrigibility; thus Harrison is quick to point out which initiatives were seen in retrospect as misconceived and not worth following up. This is part of letting the reader in on the process of the making, rather than imposing a passive appreciation of successive triumphs or style changes uncritically received. And one sees the paintings all the better for it.

The current situation in art practice is one in which almost no possible artistic decision is free from the burden of historical and theoretical self-consciousness. Even the most sophisticated American criticism, however, still labours under the assumption that criticism can happen over and above what artists actually do with their lives. The Art & Language project has assumed, far more realistically, that making works of art and talking about them can no longer be conceived as separate moments of practice. Hence its continual return to the conversation in the studio. Those involved in Art & Language recognize that both the making and the talking have to meet a commensurate standard of competence. Because Harrison's account makes this requirement clear and makes its realization

immediately interesting, it could not be appearing at a better moment. It sets a standard of rigor, clarity, first-hand knowledge, and sympathy for the practical life of art.

Thomas Crow

Preface and Acknowledgements

This is a book about modern art, though it is not the history of an artistic period. It is also a book about a particular practice, though it is not a monograph. It is concerned with art and language as related concepts, but not with the relations between art and literature. My aim has been to address a range of questions about the history, the theory and the making of modern art – questions about the conditions of its production and the nature of its public, about the current problems and priorities of criticism and about the relations between interpretation and judgement – and to do so in the context of specific examples. The problem-field of such questions is normally contained within professional or disciplinary boundaries: for instance, those which serve to isolate art history from art criticism and both from the practice of art. These essays are written explicitly from the point of view of Art & Language, the artistic practice with which I have been associated since 1970. The questions addressed are principally those for which the works and activities of Art & Language may be mobilized as evidence and illustration. The book itself is a product of that practice. But it is also shaped by those other forms of practice within which texts about art are principally produced: the study and the teaching of art history and the writing of art criticism and theory. My aim in adhering to the form of the essay has been that the book as a whole should be free from regulation by any single principle of consistency – free, that is to say, to disclose the untidiness of its methods and materials.

In the company of Art & Language, I have tried to feel my way towards an understanding of the modern practice of art. In the process I have attempted to look *through* that powerful form of representation of the culture of art which has been identified with Modernism. The ambiguity is deliberate. I mean that I have tried both to see as the competent Modernist is supposed to see and to see past or around the conceptual framework of Modernism. I have also attempted to silence in myself that voice which would speak of artistic culture both as a priceless heritage and as an enduring and unquestionable presence. This latter is not the professional voice of Modernism criticism. It is the persuasive but unreflective manifestation of the bourgeois spirit.

The majority of these essays take as their point of departure some specific work or body of work. Though they are ordered in relation to an approximate chronology, each is designed to be readable as a relatively self-contained discussion. One consequence is that similar observations are occasionally made within different but related contexts of argument, while other matters are altogether disregarded which might have appeared pertinent to a continuous narrative. I hope that the reader will be tolerant of these overlaps and lacunae.

Some of the essays remain marked by the traces of those occasions for which they were originally drafted. 'A Kind of Context' (essay 1) is the barely recognizable product of two commissions. The first, from the Société des Expositions of the Palais des Beaux-Arts, Brussels, was for a catalogue essay to introduce an exhibition of paintings by Art & Language. The second, from the *Cahiers du Musée National d'Art Moderne*, Paris, was for an essay to be included in a special issue on the subject 'Après le Modernisme'. The coincidence of these two commissions helped to establish the character of the essay included here. ' "Seeing" and "Describing": The Artists' Studio' (essay 6) is derived from a lecture given at the Centre Pompidou, Paris, in the series 'Art de voir, art de décrire', while 'On Pictures and Paintings' (essay 10) is based on a public lecture given at the University of Michigan. Though the original texts of both these lectures have been substantially revised, it seemed appropriate to retain their character as deliberations upon the priorities of criticism. 'On the Surface of Painting' (essay 7) is based on a keynote address given to the 'Visions and Revisions' Conference of the Mid-America College Art Association in Minneapolis, the brief for which was that my subject should not be such as to interest Modernists alone.

I do not mean to declare that this book has been patched together either in whole or in part from the materials of articles, lectures and conference papers. Rather, I have had a book of this order in mind for some years, and have used such opportunities as were offered me to advance the project: to try out material in public, and to decide the overall tenor and scope of the book. I make no apology for having responded in this way to invitations originally addressed to me as an art historian. It is a measure of the vitality and interest of any current artistic practice that it serves as a challenge to criticism and as a means continually to animate and to problematize the history of art, while it is a measure of the adequacy of a history of art that it is not simply embarrassed before the complexities of modern practice. I am most grateful to those whose initiatives furnished me with relevant practical incentives and occasions: to Jan Debbaut at the Palais des Beaux-Arts, Brussels, and the Stedelijk van Abbe Museum, Eindhoven; to Yves Michaud formerly of the Centre Pompidou, Paris, and editor of the *Cahiers du Museé National d'Art Moderne*; to Thomas Crow and to David Huntington and Diane Kirkpatrick at the University of Michigan; to Mark Haxthausen at the University of Minnesota; and to Tom Mitchell and James Williams, respectively editor and managing editor

of *Critical Inquiry*, in which journal 'On the Surface of Painting' was published in a previous version.

The two concluding essays, on Art & Language's 'Hostages', are of a different practical character. The first was written largely in the studio, in the presence of the works concerned. My initial aim was simply to describe these paintings to myself and to open them to interpretation. A version of the essay was subsequently published by the Lisson Gallery, London, to accompany an exhibition of 'Hostages'. The second of this pair of essays was written in response to an exhibition (at the Max Hetzler Gallery in Cologne) and in order to secure for the paintings concerned some continuing possibility of critical attention. A version of the latter essay was published by *Artscribe*, and I am grateful to the editors for permission to print the revised version included here. The brief essay *'Unit Cure, Unit Ground'* (essay 9) was written as part of a sales pitch, in response to a suggestion from Michael Baldwin and Mel Ramsden that I should compose a text to be put before a potential purchaser.

The remaining essays represent attempts to organize and to theorize the recent history of art in the light of the practice of Art & Language and of my own absorption in that practice. They are the as-yet untravelled products of the study. Like the other essays, however, they have been exposed in the making to the critical audience of Art & Language itself, in the persons of Michael Baldwin and Mel Ramsden. These two have been the principal companions of my enterprise, and the book is indefensible as a whole if it does not make clear the nature of my debt to them. In all those areas where our occupations have been distinguishable during the period in which these essays were thought about and written, theirs has been the practice which has furnished my own with its most demanding context and its least uncertain purpose.

A first attempt to organize some of the material treated here was made in *A Provisional History of Art & Language*, published in 1982 (by Eric Fabre, Paris), while some relevant theoretical resources were collected in the anthology *Modernism, Criticism, Realism*, published in 1984 (by Harper and row, London and New York). I should like to express my considerable gratitude to Fred Orton, co-author of the former and co-editor of the latter. Substantial revision to several of these essays followed from the critical attention which Paul Wood brought to bear on them and from his contributions to thought about the problems addressed. My wife, Trish Evans, read the text with the interests of other readers in mind, and attempted to impose the requirement that arguments and generalizations be supportable and adequately illustrated. I owe a further debt of gratitude to those students in whose company many of the arguments presented here were tried out and corrected, in particular to students at the Open University's 'Modern Art and Modernism' summer schools from 1983 to 1989, and to the members of a postgraduate seminar on 'Themes and Contrasts in Modern Art' at the University of Michigan in 1988. The assistance of Bonnie

Rubenstein of the Lisson Gallery was invaluable in the task of assembling adequate illustration of the work of Art & Language. Lastly I should like to express my gratitude to Thomas Crow, whose response to my description of this project was such as to render it a practical proposition.

During the period of work on this book I benefited from the support of the Research Committee of the Open University's Faculty of Arts, and from a Research Grant awarded by the Leverhulme Foundation.

Charles Harrison

Preface to
the MIT Press Edition

Essays on Art & Language was originally put together at the close of a historical era: during that two-year moment which saw the fall of the Berlin Wall and the break-up of the Soviet Union, the end of Ronald Reagan's presidency on one side of the Atlantic and of Margaret Thatcher's premiership on the other. Now, ten years after the book's first publication, sections treating of contingent moves and squabbles and speculative passages written about recent work alike appear strangely transformed against the contrasting background of a new orthodoxy. I don't think that this is simply the inevitable effect of distance – or if it is, the distance in question is greater than the mere passage of a decade would normally be expected to create. The intervention of the millennium may have exaggerated the sense of disjunction, but if so only trivially. It may be appropriate, though, to look to the operation of those interests that the accident of the millennium has been used to advance.

For much of the twentieth century, explanations of the dialectical character of Modernism tended to focus on one or another basic occasion of a contrast of values. One model would look to the oppositions of capitalism and socialism: on the one hand the artist in theory assured of freedom and individuality of expression, while in practice tied to the ruling class 'by an umbilical cord of gold' (the phrase is Clement Greenberg's); on the other the artist assured of a public function while threatened by state control over culture. A second model would look to the historical struggle for power within the bourgeoisie: on the one hand the haute bourgeoisie or upper middle-class, its culture and its property inherited, its judgements disinterested, its taste innate; on the other the petit-bourgeoisie or lower-middle class, its status gained through entrepreneurship and trade, its education hard won, its judgements based in financial calculation, its taste always unoriginal. The authentic motivated by inner necessity, the inauthentic doing it for the money. Other contrasts might be considered in relation to these with varying degrees of plausibility and fit: between the aesthetic judgements of the so-called

formalist, and the explanatory apparatus of the social historian of art; between claims for vividness of effect and claims for political effectiveness; between abstraction and realism; between presentness and theatricality.

Modernist writing on art has been subject to considerable criticism on the grounds of its ahistorical character. Yet where it was constructed out of such contrasts as these, an account of the dialectical character of modern art in the West could, if one wished, be readily matched against a broader history of the later nineteenth and twentieth centuries – a history, in other words, that took cognisance of basic tendencies and conflicts and of those differing values that might be connected to these.

Now, however, it has been widely proposed that the spread of liberal capitalism has left no credible theoretical ground for socialism to claim, and that the middle class is at last both homogeneous and (almost) universal. Imagine, then, a world in which the function of the state is to assure the individuality of all, and in which 'doing it for the money' *is* 'doing it out of inner necessity', and vice versa. On what basis might the significance of artistic culture in such a world be related to a larger view of practices and values? Presumably not by reference to a historical *narrative* of conflict and contrast. While the idea of significant difference would necessarily still figure in any process of interpretation, conflict and contrast would be defined not in terms of rival historical perspectives, but on a unified ground of prospective choice – choice of partners, choice of mores, choice of lifestyles, choice of objects of consumption.

Unreal though it may indeed be – not least in its effective denial of the working class – this is the world that seems now to figure in dominant representations of Western culture. In the first year of the new millennium, as if acting in concert, major modern museums on either side of the Atlantic – the Museum of Modern Art in New York, and Tate Britain and the newly opened Tate Modern in London – abandoned chronological sequence as a basis for the presentation of their collections, opting instead for installations that gathered the various artworks of the twentieth century under topical themes. The conjunctions offered under these themes have little to do with the kinds of causal relations studied in traditional art history, or with the kinds of social conflict and dichotomy with which these might be connected. The strongest justification for such acts of comparison as the displays provoke is not that they open history to inquiry, but rather that they add to the fascination of the present and of its population, in the process liberating us from the tiresome linearity of Modernist accounts – perhaps, in imagination, from the substantial difficulties of modernity itself.

It should be said, though, that in those chronological accounts that are now subject to disparagement, the interpretation of art could never simply be a matter of establishing sequence and divergence: significant precedent on the one hand and significant change on the other. The historian was always liable to be faced with hermeneutical convergences –

the apparent clustering of intense examples around a certain formal type or a certain area of concern or both – for which no feasible causal connection, no possible 'influence', could be established. To acknowledge the very possibility of such convergence has always been to confront the limits on ordinary historical explanation. But it does not follow that the orderings of art history are somehow trumped by those of curatorial initiative. On the contrary. The strongest justification for the study of art is that the occurrence of aesthetic oddness and intensity is uniquely revealing – revealing in a way that no other historical evidence can be – of our character and our potential as a species *in* history. To understand the limits on historical explanation as opportunities for novel juxtaposition is surely to miss the point.

I write of aesthetic oddness and intensity here with a familiar sense of unease, conscious of the need for some alternative to the compromised concept of quality in art. There is nothing to lament in the loss of that traditional authority which supported claims for the objectivity of aesthetic judgement, nor in the fact that it now comes easy alike to the earnest academic, to the well-drilled undergraduate and to Rupert Murdoch to expose the interests such claims may be used to serve. Yet if the uncomfortable problem of whether or not works of art are any good is *not* somehow necessary to our experience of them, it is not evident what purpose the concept of art can usefully be serving, unless merely to insulate certain kinds of social act against common-sense criticism. If that is indeed the only real function of the concept, then the field might as well be left clear for the analysts of 'visual culture', so that they can pursue their studies in peace without having to acknowledge any other hierarchies than those already noticed in the social sciences.

In fact, this book was written in a spirit of resistance to that form of withdrawal. It was written, that is to say, out of conviction that the continuity of art depends on the continuity of exceptional and intentional care in the work of art – however unpredictable and improbable the manner in which that care may have to be discharged under given technical and historical circumstances. In talking of aesthetic oddness and intensity, then, I mean to suggest that we may be availed of some conditions of fitness to the objects of our attention, without having to claim that our own preferences are immune to scrutiny and explanation. Experience suggests that some works of art have a greater capacity than others to arbitrate what is and is not a valid description, what is and is not relevant to say about them, what is and is not an appropriate use. It seems reasonable to say of some pretentious but unconvincing work that we cannot accept it at its own implicit valuation. In seeing *how* it has come to be what it is, we see that it is not what it purports to be. By contrast, another work might appear successfully to signal what it is that we need to see in order to think serviceably about it, and to make it serviceable. In this case, in seeing how the work is done, we come to know it as a thing with a certain achieved identity – as we come to see, for instance, that a drip on a Pollock is integral to it technical character,

while a drip on a Mondrian is not. This instructive capacity must presumably be the effect of the work in question somehow establishing principles of integrity or self-description to which we are inclined to assent; in other words, it testifies to the work's achieving or being accorded a significant degree of self-sufficiency or autonomy. Experience also suggests that the measure of a work's capacity in this respect is a reliable index of its possession of other significant properties, such as its power to represent some nontrivial aspect of its historical moment. Though we may not be able to prescribe the manner in which this capacity is acquired, its presence can be felt when we try to articulate our response to a given work and to its effects – so long, that is, as we do not merely look for reflected self-images in the objects of our attention. The strongest motivation for writing about art is precisely that it brings us closer to that which is *other* than ourselves: that which imposes some strong condition of validity on the attempt to represent it.

As I understand it, it is this capacity in the work to arbitrate its own description that the artist deserving of the name tests for in the self-critical procedures of the practice. Potential in this respect is not assured by mere adherence to a tradition and certainly not by the renewal of any exhausted protocols. On the contrary, it may require some ad hoc negotiation among the ruins – the establishment of temporary understandings and provisos to be going on with. Such requirements have been and remain among the practical conditions of the modern, however, and they are open to inquiry and to conjectural explanation. This is to suggest that work subject to these conditions is historically instructive – if only we can read it properly.

This book could be read as a sustained case study in pursuit of that end. In the following pages I have attempted to recount the various self-critical procedures that have been required and pursued within the enterprises of Art & Language. Sometimes in doing so I have relied on extrapolation from the different working stages of a single project; sometimes I have drawn on first-hand observation of the deliberations of my friends; and sometimes I have been able to recall conversations in which I was involved and fully implicated. Though I do not write as an artist, I write both as a participant in the practice of Art & Language and as an advocate for its various productions. I accept that the borderlines between criticism and self-criticism are blurred as a consequence. I would argue, however, that insofar as criticism and self-criticism are distinguishable here, each has the same object in view. Both my participation and my advocacy follow from conviction of the worth of the enterprise. I acknowledge that my engagement sets a limit to any objectivity I might claim on relevant issues. But I would be distrustful of *any* claim to Archimedean distance in the criticism of art.

The exigencies of publication have prevented any major revision of this book. Such changes as I have been able to effect are restricted to the correction of typographical and other simple errors, to the updating of certain of the references in the footnotes, and to the occasional adjustment of a retrospective measure, where lapse of time since first

publication might have rendered the original misleading (as in 'the past twenty-five years'). Under these circumstances it may appear that I have been indifferent to the criticisms launched by some of those who are named in the third and fourth of the following essays, and whose attentions have largely been focussed on these sections of the book. In fact, the objections of former associates are never easily ignored. I would not have agreed to a reissue of the book, however, were I not willing to defend the text as it stands.

The present work has a sequel. *Conceptual Art and Painting: Further Essays on Art & Language* continues from the point at which *Essays on Art & Language* leaves off. My intention, that is to say, is to match Art & Language's projects since the end of the 1980s to a larger narrative of art, to find adequate descriptions for individual works, and to continue that process of connection to a wider history that follows from the task of description. I am most grateful to Roger Conover of MIT Press for providing the opportunity both to revive and to complete this project of publication, to Thomas Crow for agreeing to the revised reprint of his original foreword, and to Michael Baldwin and Mel Ramsden for their continuing criticism and comradeship.

1

A Kind of Context

This opening essay represents an attempt to map some modern but historical conditions of thought about art and to position a kind of practice – the practice of Art & Language – in relation to these conditions. I do not mean to suggest that the practice can simply be seen as the practical product of a set of concerns or even of a set of specifiable problems. Though in a culture such as ours all practical forms of art are subject to the determining effects of the history and theory of art, the name Art & Language also serves to identify a point of production both of history and of theory. This text issues from within the environs of that point of production. It does not follow, however, that it sits secure in relation to those forms of practice it treats as examples. A unity or a reciprocity of theory and practice may be possible *in theory*, but it is not achievable in *thought* and *a fortiori* not in practice. In so far as this essay offers a form of narrative it is one deformed by the dislocations of theory and practice and unbalanced by the asymmetries of intellectual generalization and existential detail.

The history of modern art encompasses the life-spans, normally brief, of many artistic groups. The significance of the moment of formation of a group is normally a matter decided with hindsight, in the light of subsequent critical ratification. Formation of a given group is normally explained as the realization of a set of intentions. In our accustomed view, artistic groups are set up by collections of individuals with a will to change the tendencies of art and art history. Yet hindsight also suggests that, if some group has persisted, it is not to some present quality in aesthetic production that we should look for explanation of that persistence, nor to the expressed intentions of founding members, but rather to the nature of those conditions which imposed a kind of necessity upon its origins and to those same or other conditions which have continued to shape its existence and its activity. The identity of a group may in part be established by positions and actions which are involuntary in the face of those conditions. To consider the continuity of Art & Language over a period of more than twenty years is both to inquire into the autonomy of its practice and to

assess the realism of its response to actual conditions. It is also to confront the complex and often *dis*continuous relationship between Art & Language as a 'group' and Art & Language as a producer of artistic 'works'.

The *methodological* problem flagged in the previous sentence is not addressed in this essay, though it receives some attention in 'The Conditions of Problems'. The present aim is to consider as background conditions of our period those problems concerning the meanings of 'modern art' which may be independent of the will of any individual aspiring to a relevant practice. This procedure is justified by the nature of Art & Language's own continuing existence. Since 1968, when a group first saw itself as having an explicit identity and gave that identity a name, the idea of a modern art has been the one potentially consistent determinant upon the diverse range of interests and activities which can be associated with that name. This is not to say that everything that has been done in the name of Art & Language has been done as an intended contribution to the practice or to the theory or to the history of modern art. The claim I am making is, I think, a stronger one. I am suggesting that the practical, theoretical, psychological and even organizational problems which have preoccupied or beset Art & Language since the time of its formation may be identified with the benefit of hindsight as problems constitutive of modern art. Or, to be more precise, I am suggesting that these problems are capable of being included under the broad field of issues generated when the concept 'modern' and the concept 'art' are related under the cultural and historical conditions of the later twentieth century. Though a substantial literature has developed around the consideration of this relationship, a bibliography of relevant issues would miss the practical point. It has been a condition of the practice of art since the middle of the century that no indisputable index of 'relevant issues' has been available to regulate either the practice or the criticism of art. The index has had to be made and extended in the process of going on, and in face of attempts to prescribe it and to keep it closed. Indeed, the very question of relevance to matters of art and of modernity has often been fruitfully addressed when one thought that one was doing something else.

Modernism in two voices

So far as the arts are concerned, the meanings and values of modernity are now irretrievably associated with those theories and practices of Modernism which have been the subject of considerable dispute since the 1960s. Indeed, the period with which these essays are principally concerned corresponds approximately to the life-span of 'Postmodernism' as a topic of debate in the arts in general. In particular, the developing fashion for the notion of a Postmodern age and a Postmodernist art has encouraged speculation about the grounds upon

which continuity and discontinuity may be traced throughout the art of the modern period. If the Postmodern has a history in the history of art, one might expect that it would commence not just with the point at which the term 'Postmodernism' entered the vocabulary of artistic chat, but with the beginning of the end of Modernism, or at least with the latter's apogee.

It is not simply for reasons of numerical convenience that the year 1950 may be taken to mark the inception of a critical period – the period within which we find ourselves located. Through the miasma of intellectual and curatorial fashion, the moment of the mid-century seems with increasing emphasis to be marked out as a nodal point of significance to the business of interpretation of art. Jackson Pollock is the crucial figure, or, rather, he is the artist whose work seems first and most vividly to testify to that form of change in the relations between art and modernity with which we are still seeking to come to terms and which is still a matter of significant contest (see plate 1). Soon after the 1960s had come to a close, the editor of the most influential of American art magazines wrote of Pollock, 'It is as if his work was the last achievement of whose status every serious artist is convinced.'[1] Three decades later the conclusion appears still valid and still strangely surprising. This is no doubt in part because the institutional apparatus of high culture gathered around Pollock with a vengeance. His work proved crucial to a body of argument and thus, in large measure, to the public possibility of a modern artistic practice. His canonical paintings of 1947–50 stand within that argument as paradigms of aesthetic achievement.[2] Yet, if we consider the apparently resolved quality of these same paintings in terms of the almost paranoid kinds of materials – physical, cultural, psychological – of which they are made, they seem not simply to raise the possibility of a changed

Plate 1 *Jackson Pollock,* One (Number 31, 1950) *(1950). Oil and enamel paint on canvas, 269 × 518 cm. Collection, The Museum of Modern Art, New York. Sidney and Harriet Janis Collection Fund (by exchange). © A.R.S., New York 1990.*

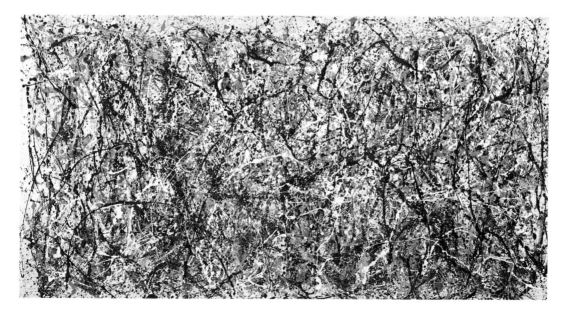

aesthetic but at times even to render absurd the notion of having an aesthetic at all. The questions they admit, that is to say, are of a larger order than those entertained by the institutional apparatus. To say this is not to contradict the status accorded to Pollock, but rather to give it a different inflection.

It was in 1950 that Pollock brought his 'all-over' abstract paintings to a supposedly 'symphonic' conclusion (though his career as a painter was not thereby concluded (see plate 2)).[3] The Cold War years from then until 1956 offer rich material for the art historian and the historian alike. In the words of Ad Reinhardt, 1950 was the year 'when the revolution became an institution, when avant-garde became official art'.[4] In 1950 Pollock, Willem de Kooning and Arshile Gorky were shown at the Venice Biennale; 1956 was the year in which the exhibition 'Modern Art in the United States' – initiated by that most influential of curating and distributing agencies the Museum of Modern Art, New York – completed a triumphal European tour which had opened the year before in Paris.[5] In London the exhibition 'This is Tomorrow' brought the enfeebled legacy of Constructivism together with those artistic fantasies of technical modernization and consumer culture which were the beginnings of Pop Art.[6] 1956 was also the year of the Hungarian uprising and of the Suez debacle, the first year of a 'tomorrow' not easily conceived in a spirit of optimism.

In time this six-year period may come to be seen in the same terms as the nine years between the exhibition of Manet's *Olympia* at the French Salon and the first group exhibition of the Impressionists in 1874. They will be seen, that is to say, as strategically critical ground upon which to test the autonomy of art history and art criticism as means to characterize a culture and to open or to close a period. We may not be able to pronounce the end of Modernism with any greater certainty about the validity of our terminology than we bring to the timing of its commencement. Nor are there any very secure means by which we can distinguish the character of modernism in the production of art from the determining effects of a 'Modernist' theory and history upon our ideas about art. But what we can do is point to moments of instability in the field of reference of the term and seek agreement about the conditions of its use.

Not that this agreement is likely to be easily secured. It has to be said that evidence for the effective exhaustion of Modernist culture during the 1950s and thereafter is largely circumstantial, and that it is open to dispute. There are two different ways to tell the story of art since 1950, or two different voices in which the story has been told. The first is the voice still most often heard. It is not the voice of professional Modernist criticism, but rather the assenting voice of an unreflective and still unrevised Modernist culture. It is the voice which accompanies and facilitates the *distribution* of that culture. Its typical discourse concerns the expressive effects of works of art, which tend to be identified with – or as – the spectator's 'responsive emotion'. In this voice, the individual artist is celebrated for that wilful extension of

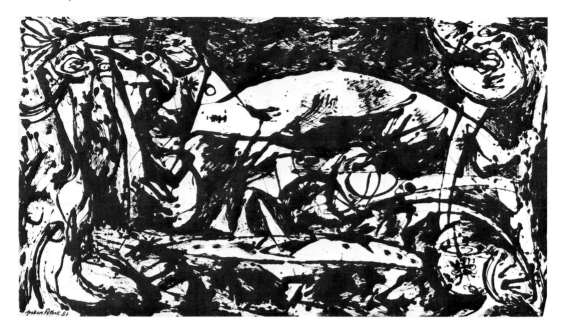

cultural and psychological boundaries which he (or very rarely she) achieves in pursuit of newness of effect. Thus, for example, the work of the American 'First Generation' painters, and particularly of Pollock, is associated with the liberation and purification of art's resources of expression, and with the possibility of a greater spontaneity and immediacy in painting. Subsequent avant-gardes have supposedly continued that process whereby the underlying values and meanings of human individuality are newly embodied in ineffable visual form. The productions of the modern artist, it is assumed, are determined by some special insight into the nature of reality – be it the reality of the natural or of the social or of the psychological world. The work of art is an assertion of the human in the context of the real. Although the values of humanity are seen as 'relatively constant', art of 'quality' is a form of stimulus to spiritual change.[7]

In the second version of the story, the first is taken as given. It is quoted in a spirit of scepticism, not as a true story, but as one typical of a certain culture and rooted in certain interests. The second voice seeks to explain what the first has said, and how it has come to be saying it. It might note, for instance, that 'expression', 'spontaneity' and 'immediacy' are terms characteristically employed within a certain critical rhetoric, and that they implicitly assign a certain value to those forms of art with which they are associated. What if these values were rather the self-perpetuating obsessions of the regarding eye than the immanent properties of the objects under consideration? Modern artistic production is represented in the first voice as a continual challenge to the normal in culture. But could it be that the denizens of a dominant culture generate and sustain an *illusion* of challenge, thereby appearing to demonstrate their capacity for self-criticism

while remaining actually unthreatened and unchanged? In his account of modern art, for example, the enthusiastic authority is wont to speak of each major 'movement' as a 'break with the past'. Yet his relationship with his own past – and with his authority – remains untransformed.[8]

The first voice tends to suppose that the 'creative' is distinct from the 'critical', that artistic practice is governed by intuition and that the production of art is always prior to theory. The value of art is seen to lie in its disinterestedness, its spirituality and its unlikeness to language. From this perspective, theoretical prescription is represented as 'non-artistic' and counter-intuitive. Critical practice devoted to any other ends that those of formal analysis and description is not disinterested or not relevant or neither disinterested nor relevant.

The second voice perceives these distinctions and priorities not as true reflections of the *nature* of art but as forms of organization of the *culture* of art. It takes the prising apart of the 'creative' and the 'critical' as a move to defeat the critical purport of art, and the privileging of practice over theory as a mystification of both. From the perspective of the second voice, critical activity is not possibly disinterested; rather, the claim to disinterestedness is a form of illicit naturalization of actual interests. By the same token, strictures upon relevance are effective closures, applied in order to block those forms of causal inquiry by which the credibility of the first voice might be undermined. Were these closures relaxed and were some actual conditions of production of art to be matched against some actual conditions of production of value and interpretation, forms of inconsistency would be clearly revealed. These in turn would betray the operation of some determining interests, and thus impose upon the first voice that which it most strenuously resists: an attribution to some specific and contingent social section – an identity in class society.[9]

A culture of art

What is at stake in the relations between these two voices is not simply the relationship between what art is and how it is interpreted – though that is a crucial issue for art history and for art criticism. The practice of art itself is determined by the ways in which art is conceived and valued, and there are forms of art which appear to offer more or less support to one account or the other, a greater or lesser compatibility with one or other tone of voice, a tendency towards celebration in fact or towards action and doubt. What is at issue in the argument between the two voices is no less than the moral content of our history. It is an argument about the political nature and destination of culture in the so-called democracies of the Western world, and about the terms in which that culture is best diagnosed and represented. All other arguments about meaning and value in contemporary art are subject to the gravitational pull of this one.

Such arguments are clearly important. They are not to be decided, however, either by a simple choice of alternatives with respect to the meaning of Modernism or by some idealistic reconciliation between them. That they are not reconcilable is a condition of modern cognitive existence – or, at least, of bourgeois ideology, which has been the inescapable context of thought about what we know as 'modern art'. To consider the respective narratives of these two voices, and the relationship between them, is thus to approach what may *now* be the meaning of Modernism, not simply as a culture of art, but as a historical and epistemological condition of artistic practice. (And no contradiction is involved in the suggestion that Modernism is both an epistemologically cast condition and a form of bourgeois ideology.) According to the kind of account which is now available to thought, Modernist painting since Manet's day can be characterized in terms of a dialectical tension: on the one hand the *ideal* of spontaneity and immediacy and freedom of expression and effect; on the other a continual recourse to such technical means of realization as stress the obliqueness and indirectness and conventionalization of all forms of representation – including those forms which are supposedly 'expressive'. Each of our two voices will tend to single out one set of aspects, one kind of content in such art and in its history. Neither tells 'the truth', nor is either alone the authentic voice of Modernism in art. Each voice *represents* Modernism as a form of history and a form of value, yet neither representation is entirely independent of the other, neither altogether 'whole'. If artistic Modernism has now a real life in history and in culture, it is to be reconstructed out of the *relationship* between these two incomplete and fractured accounts. I mean the term 'relationship' here to carry not simply a structural but a fully existential weight. It has not been through the elegant theoretical formulation of the dialectic that plausible forms of Modernist or even Postmodernist art have emerged in recent years. It has been through the desperate and ironic – or disgraceful – living of the dialectical life itself.

The procedures of criticism have been subject to matching conditions. Vitality in the criticism of art has been maintained by those writers who have been able to articulate the dialogical character of Modernism in face of closures performed in the name either of aesthetics or of politics. If there is one writer whose intellectual character presages the agonized conscience of Modernist criticism, it is the communist Walter Benjamin, whom hindsight identifies as a crucial participant in those debates of the 1930s in which the requirements of popularity and realism were considered in relation to the interests of Expressionism or avant-gardism.[10] More unremittingly than any other contributor to the theoria of modern art, Benjamin lived the contradiction between historical materialism and an extreme, almost Nietzschean aestheticism. Though it did not endear him either to the Party or to the dilettante bourgeoisie, he better than any other critic of the period understood the limitations on moral and political purpose in art and in criticism.

For art cannot, for its part, allow itself, in its works, to be appointed a councillor of the conscience and it cannot permit what is represented, rather than the actual representation, to be the object of attention. The truth content of this totality, which is never encountered in the abstracted lesson, least of all the moral lesson, but only in the critical elaboration of the work itself, includes moral warnings only in the most indirect form. Where they obtrude as the main purpose of the investigation ... then this means that the very much more worthwhile struggle to ascertain the place of a work or a form in terms of the history of philosophy has been abandoned in favour of a cheap reflection which is figurative, and therefore less relevant than any moral doctrine, however philistine.[11]

It was also Benjamin who understood that the contradictions of aesthetic autonomy and political tendency were problems of historical realism and conditions of productive activity, not simply the measures of personal 'position' or consistency.[12] In 1938 Gershom Scholem criticized his article 'The Work of Art in the Age of Mechanical Reproduction' on the grounds that the first and second parts were separated by a logical gap. Benjamin replied, 'The philosophical bond between the two parts of my study that you miss will be supplied by the revolution more effectively than by me.'[13]

This was a justifiable dodge under the circumstances, but of course it was not revolution but war that followed. And what followed the Second World War, enabled by the traumas of totalitarianism and by the systematic falsehoods of righteous nationalism, was the political culture of the Cold War – a culture in which the mechanisms of forgetting and misrepresentation were driven by massive political and economic forces. The very term 'Cold War' was a misnomer by which a deeper compact was camouflaged. It is one of the great ironies of mid-twentieth-century history that the representation of Stalinism as the true face of communism served the interests of the Soviet and American administrations alike. In this fraudulent drama, each side generated that *mis*representation of the other which was necessary to its representation of itself and to the maintenance of its chosen sphere of influence. It was also in the interests of both regimes that totalitarianism and individual freedom should be represented as the mutually exclusive faces of a single political choice – though totalitarian was not a description which either applied to itself nor was freedom a value which either found in the other.[14] It is no wonder that the voice of Leon Trotsky had to be silenced.

The current image of Modernism in culture is one which has been refracted through this reciprocating system of representation. In the period from the end of the Second World War to the early 1970s Benjamin's logical gap, far from being closed by some historically

given 'philosophical bond', widened into an unbridgeable divide. On the one hand the value of an expressive autonomy was bureaucratized and dogmatized. On the other, a politically or morally oppositional virtue was claimed for practices in which 'oppositional' themes were merely illustrated or oppositional dispositions signified at the level of mere style.

If the interrelatedness of Modernism's two voices has needed to be stressed in this essay, it is because the dialectical character of Modernism was largely obscured during the 1940s and thereafter, and differently stressed on each side of the global ideological dichotomy. One effect if not one explicit aim of the cultural policy of the Cold War was the effective suppression of the second of our two voices in the interests of the first. For at least twenty years after the Second World War, the second representation of art seemed to have little *cultural* power. The first voice was clearly dominant and in dominating made managerial capital of Modernism's earlier utopian virtue. In the Western culture of the Cold War, modernism in art was firmly associated with the affirmation of liberal humanism and with the wilful and triumphant self-expression of individual free spirits. (In the terms of that culture, only 'individual' spirits *could* be 'free'.) Some artists assisted in this ideological enterprise, equipped by the long and misleading association of modern art with 'freedom' of imagination. According to Robert Motherwell, for instance, 'Modern art is related to the problem of the modern individual's freedom. For this reason the history of modern art tends at certain moments to become the history of modern freedom.'[15] On the other side of the cultural divide thus created, the literary, the academic and the political were alike consigned to a world without aesthetic life. (I do not mean to disparage the role of imagination in the production of art – or of anything else. On the contrary. The point is that to associate imagination either with an idealized 'freedom' or with an idealized 'aesthetic life' is to conceive of imagination as unpractical, which it is not.) Under these conditions the second voice, if it was heard, was identified with the discourse of criticism or of politics or of sociology, not the discourse of art. Subjection to the content of such discourses was seen as leading inevitably to a compromising tendentiousness or literariness in the practice of art and to a consequent loss of autonomy and of aesthetic virtue. By contrast, an authentic Modernist art was characterized in terms of its absolute untendentiousness – its necessarily apolitical character. It was claimed for Modernist art not only that it was innocent of didactic or literary content, but that its virtue was conditional upon independence of language itself.

The form of this twofold hypothesis deserves closer examination, since the *conflation* of the two claims in question was both historically specific and culturally instrumental. The first part of the hypothesis may appear to be relatively 'neutral', in so far as it offers a preferential thesis about works of art in general. It is a defensible if questionable premise, that is to say, that art *ought* to be innocent of didactic and

literary content, in the sense that works of art may be deemed inauthentic when their 'contents' simply correspond to such verbal forms as sentences or proverbs. Even if the premise is accepted, however, it does not follow that art is not in some way language-*like*; nor does it follow that art is not dependent on some language or other in ways other than those which may be reduced to simple correspondence. What the conflation reveals is that in those aspects of Modernist theory which were marked by the 'necessities' of the Cold War, a belief about what art ought to be like in order to be truly expressive was so promulgated as to camouflage the ways in which art is or may be matched against other kinds of signifying stuff. It could be said that the actual if not the intended effect was to obscure the political character of Modernism itself.

The idea that politics is the business of the other side is one which we tend to encounter in history at moments of stabilization, moments when a status quo is being entrenched as a state of nature. The period of establishment of the Cold War was such a moment. But it should be noted that the cultural order which the Cold War entrenched had already been hardening into an orthodoxy in the 1930s or earlier. This is made clear enough by such work as Benjamin's and by other expressions of a pre-war *opposition* to that cultural order – an opposition in which the 'pure forms' of Modernist art history were critically reinterpreted as historically contingent utterances.[16] Certainly, the association of Modernist art with apolitical virtue was not the invention of the Cold War ideologues of the West, but was rather available to be mobilized in their interests. The association has a history at least as long as Modernism itself. It seems to have gained impetus during the mid-to-late nineteenth century from the tendency of the dominant hereditary bourgeoisie to naturalize and to spiritualize its own specialized tastes and interests in face of the rise of the petit bourgeoisie, with its supposedly 'mechanical' and 'commercial' interests. A century later that constituency of business liberals which came to control American foreign policy during the Second World War found that a national Modernist art could be mobilized in their interests to export the image of a disinterested and democratic culture.[17] It would be a serious mistake, however, to conceive or to explain this mobilization as the simple consequence of a historical conspiracy. As I have implied, it was a partial form of development or extrapolation of the character of Modernism itself.

We live now with the epistemological residue of this process of ideological disbursement: that beguiling sense of coherence and consistency with which Modernist art was retrospectively invested. The means by which this coherence was achieved was also, for example, the means by which the intractable art of Pollock was rendered misleadingly secure. A telling parenthesis marks that migration from pre-war Trotskyite internationalism to post-war anti-communist nationalism and aestheticism which led Clement Greenberg, like many other intellectuals of his generation, subtly to recast the history of Modernist

culture: 'Someday it will have to be told how "anti-Stalinism", which started out more or less as "Trotskyism", turned into art for art's sake, and thereby cleared the way, heroically, for what was to come.'[18] 'What was to come' was an art which masked the material conditions of its production behind the seeming immaculateness and instantaneousness of its surface. As suggested earlier, the critically coherent aspect of American Modernism achieved its climactic moment around 1950 in the work of the American artists of the 'First Generation', and notably in the paintings of Jackson Pollock (and in the sculptures of David Smith). During the next two decades this work was represented within American Modernist criticism as exemplifying a reductive and expressive tendency, which was in turn seen as practically continued and exploited during the late 1950s and the 1960s in the painting of Morris Louis, Kenneth Noland and other artists associated with what Greenberg called 'Post-Painterly Abstraction' (see plates 3 and 4).[19] The writers principally responsible were Greenberg himself and Michael Fried, who took Greenberg's formulation of Modernism as the starting-point for his own analyses.[20] In their work, an adequate form of 'Modernist' criticism seemed successfully to represent a mainstream – if restricted – form of Modernist art, and to represent it in terms of the consistency of a reductive and anti-tendentious development. The *locus classicus* for this process of retrospective theorization was Greenberg's essay 'Modernist Painting', the writing of which coincided with the emergence of a fully 'stylistic' Post-Painterly Abstraction. In a discipline generally known for the weakness of its conjectures, this essay offered a series of strong if by no means indefeasible hypotheses. If the task was retrospectively to organize the history of stylistic change in modern art, then no resource of critical theory available at the time seemed to do it better. But the price paid for the transition noted in Greenberg's parenthesis was that amnesia was imposed with respect to that uneasy preoccupation with the interests of historical materialism, that strain of uncertainty and scepticism, which had been carried through the second of Modernism's two critical voices as it worked to reformulate the utterances of the first.

What we are considering is not in fact the complete annihilation of an alternative critical tradition, but rather a complex process of cultural domination. The moment of forgetting was perhaps not as long as we have tended to think. Nor was the amnesia ever complete. In recent years much historical work has been done to connect the cultural exportation of Abstract Expressionism with the aims of American foreign and domestic policy during the later 1950s.[21] As a corollary of this work it has become easier to understand the ways in which the actual conditions of political, intellectual and moral production of American 'First Generation' art were misrepresented – sanitized – in the processes of its distribution (which is by no means the same as saying that sanitization was the motive or even the effect of all supportive criticism and exhibition of the work in question). In turn, it has become the easier to interpret the Second-Generation

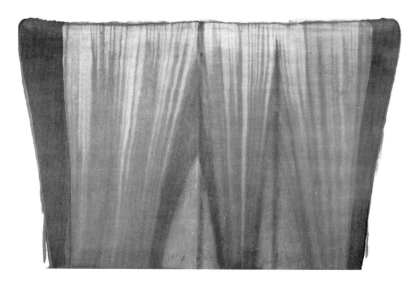

abstract art of the 1960s as work which depended less upon a critical
reduction of Abstract Expressionism than upon a form of induced
blindness to its more inchoate and abrasive aspects (which is by no
means to say that this is the only account of such art which can be

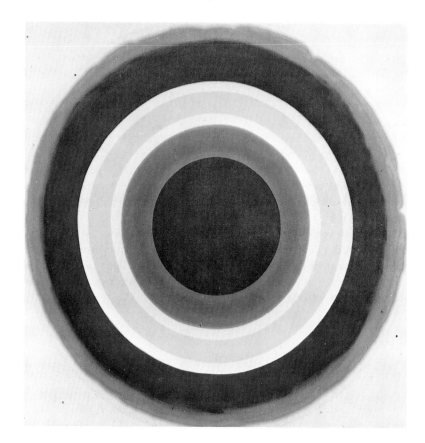

validly sustained). And finally this aspect-blindness can be understood as a means whereby belief in art's independence from language was effectively protected, for blindness to the inchoate and the abrasive is blindness to just those areas where language has to be admitted.

Already by the mid-1960s the mechanisms of cultural entrenchment of business capital were becoming increasingly hard to conceal, particularly as the post-war generations rediscovered grounds of dissent. Opposition to American conduct of the Vietnam War was one factor which served in the later 1960s to focus such dissent and to encourage scepticism. Another was the academic recapitulation and continuation of those pre-war debates about avant-gardism, popularity and realism to which Benjamin had been a contributor. The more it became possible to see the *culture* of Modernist art as implicated in a political and economic system which represented and disbursed it, the more the interests invested in that culture were laid open to view and its morality to question. Coincidentally – or as a consequence – a certain loss of moral strenuousness seemed to be perceptible in those forms of art which were most clearly implicated in the dogmatization of expression, creativity and effect in post-war Modernist criticism (for instance, the abstract paintings of Noland, Olitski (see plate 5), Frankenthaler and others, and subsequently the kinds of abstract and constructed sculpture identified with Anthony Caro and the 'New Generation' in England (see plate 6)). On the one hand the conceptual weighting given to the expressive effects of 'surface' no longer seemed to sustain credible evaluative judgements;[22] on the other, those forms of critical obliqueness which had been the forgotten aspects of Modernist practice now seemed again the necessary conditions of development in modern art.[23] The marginalized second voice of criticism was not overnight restored to first-order status within the world of art, but it became gradually if unevenly possible to conceive a breaking-down of those hierarchies which had served to prise apart the expressive and the aesthetic from the critical and the tendentious, creation from action, and 'art' from 'language'. It became possible to understand what had become the mainstream discourse of Modernism as a voice which *made* the work it treated. To engage in a critique of Modernism as a culture of art was thus to propose a form of work emancipated from the constituting power of Modernism as a discourse. It was under these conditions and in the light of this understanding that a practice such as Art & Language was to represent could feasibly emerge as an *artistic* practice.

Critical resources

The process of recuperation referred to above was gradual, uneven and unsystematic. Furthermore, it was lived through without benefit of those kinds of retrospect on the Modernist critical tradition which were articulated in the 1970s and became the commonplaces of the

Plate 5 *Jules Olitski, Green Rose (1967). Acrylic on canvas, 215 × 170 cm. Reproduced by kind permission of the Knoedler Gallery, London.*

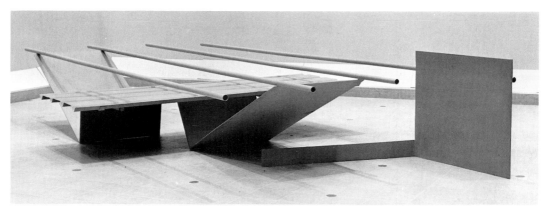

1980s. Certainly, in the 1960s cosmopolitan Modernism still meant American art and American criticism. Even at the end of that decade the painting, sculpture and criticism of post-war America were continuing to furnish the dominant forms of modern art and modern art theory. Nor should this dominance be seen simply as the secondary consequence of a political and economic ascendancy. It was also a function of the actual power and coherence of American art and of its attendant criticism *vis-à-vis* the long tradition of European modern art. Those aspiring artists in Britain and on the Continent who failed to acknowledge this power and coherence condemned themselves to a kind of carping provincialism. For those others in the 1960s who attempted to achieve a working purchase on the *culture* of Modernism, however, the coherent account which could be constructed around the Greenbergian canon was complicated or postively contradicted by some other American work. Robert Rauschenberg, Jasper Johns (see plate 7), John Cage, Ad Reinhardt and Frank Stella were among those active in the 1950s and early 1960s who explored and exposed figural languages of discontinuity, paradox and anomaly, who tended to treat expression and spontaneity not as existential modes but as conventions, and whose practices appeared generally either to contradict the reductive logic of Greenbergian theory or to push that logic to a point of seeming finality – or farce. So far as the practice of art was concerned, it was by no means clear at the time which were the effective alternatives to a dominant and coherent tradition and which merely extensions – or even whether the distinction made sense. For example, were Stella's black paintings of 1958–60 simply the latest forms of Modernist reduction or did they put a period to the currency of such notions and propose a quite new way of thinking about the relationship between painting and objecthood (see plate 8)?[24] Much recent work seemed to question traditional notions concerning the kind of experience an experience of art was supposed to be. Donald Judd and Robert Morris, for instance, seemed purposively to abstain from any claim to spontaneity or expressiveness in their 'three-dimensional work' or to metaphysical significance in the encounter with it (see plates 9 and 10). This work seemed also to stand

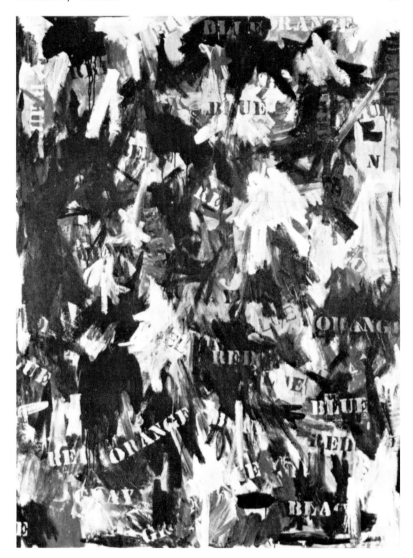

Plate 7 *Jasper Johns, Jubilee (1959). Oil on canvas with collage, 152.5 × 112 cm. Private collection. © DACS, London, 1990.*

aside from the specialized categories of painting and sculpture into which 'high art' must be divided according to the version of Modernist theory propounded by Greenberg and elaborated by Fried. Was mainstream Modernism providing the materials for its own subversion, or was it merely undergoing favourable mutation? Had the modern tradition branched, or was it in process of being overthrown and replaced? If the latter, by what could Modernism be replaced in a modern culture?

For English artists seeking a foothold in modern practice in the mid-1960s, the acquisition of an adequate grasp of Modernism as a complex and cosmopolitan culture entailed seeing through some of those weaker models of modernity which came more readily to hand. At home, for instance, where a post-war 'modernization' of the economy

Plate 8 *Frank Stella,*
Morro Castle (1958).
Enamel paint on
canvas, 215 × 274 ×
7.5 cm. Reproduced by
kind permission of
Kunstmuseum, Basle. ©
A.R.S., New York,
1990.

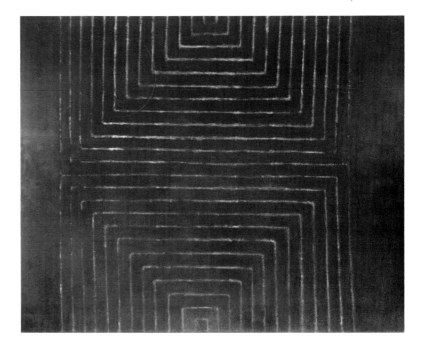

was proceeding along American lines, those artists associated with the
origins of Pop Art in the later 1950s (notably Richard Hamilton and
Eduardo Paolozzi, both exhibitors in 'This is Tomorrow') aimed to
extend and to focus art's sociological penetration and to revise the
interests of high art by reference to the imagery of popular culture.
Their measure of modernity was taken from the world of distribution.
As they saw it, art's critical function was to engage with the represen-
tational aspect already accorded to persons, commodities, utilities and
desires within some overall system of publicity. They tended, however,
to identify the iconography of the modern with the lustre of their own
enthusiasms. The result was neither a significant challenge to the

Plate 9 *Donald Judd,*
Untitled *(1965).*
Stainless steel and
amber plexiglass, 4
units, overall 86.4 ×
206.5 × 86.4 cm.
Saatchi Collection,
London. © *DACS,*
London, 1990.

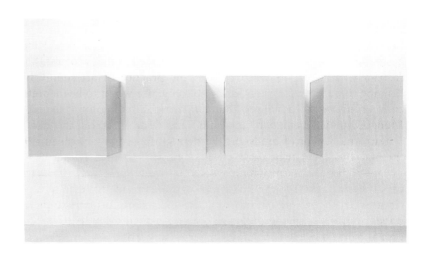

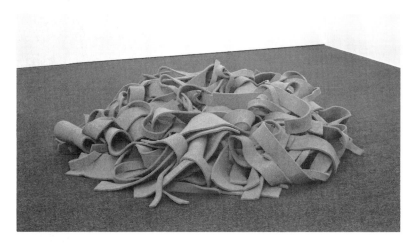

Plate 10 *Robert
Morris*, Untitled
*(1967–8,
reconstruction 1970).
254 pieces of felt, 1.7
and 2.5 cm thick,
overall dimensions
variable. National
Gallery of Canada,
Ottawa. © DACS,
London, 1990.*

canonical nature of Modernist high art nor a significant alteration of
its technical characteristics, but rather the affirmation of a prevailing
ideology and the addition to the Modernist repertoire of an arch and
secondary genre.

An alternative measure of modernity was assumed by those con-
cerned with the rapprochement of art and technology. In their view,
the task was to appropriate the technologies of electromagnetic and
cybernetic systems and to deploy these either to aesthetic or to 'criti-
cal' ends. Such work tended to suffer from a trivial equation of
'modernity' with scientific and mechanical development. It tended also
to be co-opted by the very representational technologies it set out to
exploit.[25] Through negative example, both British Pop Art (as well as
some American Pop Art) and 'technological art' (as well as Cybernetic
Art and Kinetic Art and Op Art) seemed to demonstrate that the
considerations of critical moment in the later 1950s and 1960s were
those which concerned the conditions of 'depth' in art – conditions
which were opaque to analysis of imagery and technical character-
istics. It did not follow, however, that technical conservatism offered
any kind of solution, nor were there any good grounds for retrospec-
tively revaluing the forms of 'Realist' art which were marginalized in
the dominant account of Modernism. It might be true that formal and
aesthetic considerations had been over-privileged in that account. But
realism was not to be discovered in the practice of art simply by
denying those considerations any autonomy, nor was it to be theoreti-
cally grounded by assuming that the marginalized second voice of
Modernism could simply be turned up until it drowned out the first.

With the benefit of hindsight the determining artistic problems of
the mid-1960s might be outlined as follows. There was no means to
overcome provincialism without recovery of the dialectical character
of Modernism. To achieve this was both to learn and to learn how to
circumvent the identifications and valuations of Modernism pres-
cribed informally in the dominant culture and more cogently in the
criticism of Greenberg and Fried. To do this was to work self-con-

sciously within a tissue of misrepresentations. It seemed important to come to terms with the elaborated theory and practice of 'reductive' Modernism, since this was still dominant. It was also important to try out whatever was supposed to count significantly against this theory and practice; to discover, that is to say, what forms of resistance were available to inhibit the entrenchment of a self-satisfied and wilful form of practice within just those limits which the mechanisms of dominance imposed. It seemed for a while that the Minimalism of Don Judd, Robert Morris and Sol LeWitt offered a form of opposition to the constitutive power of the Modernist account, yet in place of that account they offered a narrative of 'objects' as a form of apostasy. '... at the time it seemed important *not* to fall for objecthood but rather in a sense to face up to "nothing"' (Ramsden).[26] For those unwilling to identify with a merely stylistic principle of continuity or a merely technical form of modernity, going on seemed to entail a search for critical and conceptual materials to go on with. There was no knowing for sure where these materials were or were not to be found, though the more palpably bureaucratized versions of Modernist discourse (for instance, those which circulated in the corridors of art schools) furnished forms of *via negativa*. The maintenance of such standardized accounts of art and art history had required that various omissions and generalizations be made. The resulting gaps and bulges appeared during the 1960s as symptoms of a developing crisis. For those who perceived them, these discontinuities in the surface of Modernist culture indicated the possibility, at least, of a different theoretical and practical world.

The point is not that this possibility was pursued in explicit opposition to the criticism of Clement Greenberg and Michael Fried, or to the painting of Kenneth Noland and the sculpture of Anthony Caro, or even to some 'ideology of art' within which those four names might be conjoined with others. Rather, the claim that Modernism in art was to be identified in terms of such practices as theirs was itself representative of a form of authoritative intellectual closure. Under this authority anomalous aspects of a possible history of modern art – divergent practices, discrepant concepts of the aesthetic – were rendered marginal. And it was within these supposed margins that the materials were to be found for a different understanding of modern art. An intuition of the interesting strangenesses of Malevich's work (see plate 11) or Mondrian's or even Reinhardt's, an awareness that the work of Johns and Rauschenberg and Cage formed a significantly different axis from that of the abstract artists of the 1960s, even a curiosity as to the legacy of Dadaism, Surrealism and Fluxus, these were not so much the directives to an alternative tradition as the modes by which it was learned that tradition itself had been subject to a Modernist reduction.

The artists who were to form Art & Language were among those who had an intuition of what a modern and non-provincial practice might be like, and who desired something of the kind. Yet to ask in the

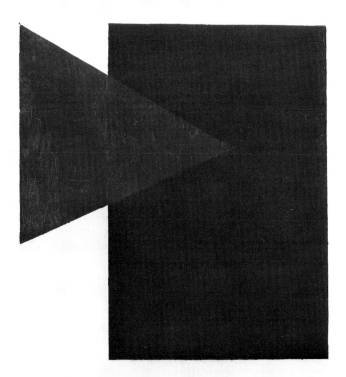

Plate 11 *Kasimir Malevich*, Suprematism (with Blue Triangle and Black Rectangle) *(1915). Oil on canvas, 66.5 × 57 cm. Stedelijk Museum, Amsterdam.*

normal places what might be the price of achieving such a practice was to discover that one's resources were in the wrong form of currency: that the prevailing medium of exchange was 'pigges bones'. Though the supposedly magical significance of the objects in question was belied by the fraudulence of their provenance, this fraudulence was itself a function of the magic-authenticating system. As Benjamin said *à propos* the work of Brecht, the task was to get rid of the magic.[27]

The form of practice which Art & Language was to represent was one which developed unevenly and tentatively from such intuitions and promptings, with an eye to the implications of what was supposed to be the mainstream art of Modernism, and impelled by a growing conviction that one of the functions of such art and of its attendant ratification was to hide the art world which sustained it. The emergence of this practice within the cultural space of high art was a move to be in this 'hidden' but sustaining world, to overcome marginalization, to relax the intellectual closures applied around 'art' and 'history' and 'the aesthetic', and thus to question that authority which constituted culture in its own image.

Plate 12 *Michael Baldwin,* Untitled Painting *(1965). Four mirrors mounted on canvas, each 30 × 61 cm. Private collection.*

Plate 13 *Terry Atkinson and Michael Baldwin,* Acid Box *(1966). Lead paint and sulphuric acid on wood, 100 × 100 × 15 cm. Private collection.*

Terry Atkinson (b. 1939), David Bainbridge (b. 1941), Michael Baldwin (b. 1945) and Harold Hurrell (b. 1940) formed Art & Language as a partnership in England in 1968, though they had been variously associated in joint projects for two years previously. The name *Art–Language* was registered at the same time as the intended name of a journal.[28] After publication of the first issue of this journal in May 1969, Joseph Kosuth (b. 1945) was invited to act as American editor. Ian Burn (b. 1939) and Mel Ramsden (b. 1944) were invited to merge their Society for Theoretical Art and Analyses[29] with Art & Language Press, the designated publisher of the journal, and in fact merged their separate collaboration with Art & Language in 1971. In the years 1965–8 several of these artists, in search of some alternative artistic currency, were independently trying out various avant-garde strategies. Though the legacy of Pop Art and the interests of art-and-technology both featured in the early work of some of them,[30] the more significant gambits involved forms of art which seemed designed either to test or to resist the normal habits and assumptions of mainstream Modernist production and connoisseurship, based as these were seen to be in protocols which mystified both production and interpretation. These early works included paintings in unvaried monochrome, 'paintings' made of mirrors, paintings composed of words and numbers, 'sculptures' painted with acid, 'forms' detectable only by electromagnetic means, 'objects' in hypothetical form, and so on (see plates 12–16). Various grounds of anomaly were sketched out in a spirit of proto-Postmodernist eclecticism and irony. Attendant upon these enterprises there developed a habit of discussion and speculative theorization. Out of necessity rather than conscious avant-gardism, small groups of individuals on both sides of the Atlantic came to adopt as a primary artistic practice the pursuit of the critical implications of modern art's own more quixotic propositions. If mainstream Modernist art had become to some extent the prisoner of its own attendant discourse, then the determining effects of that discourse would have to be made explicit in practice. 'It had seemed

necessary, finally, that the "talk" went up on the wall.'[31] (See plates 17–21)

Such conclusions were not the results of any conscious decision to 'do theory' instead of 'making art', nor of an avant-garde *jeu d'esprit* in which 'conversation' was proposed as 'art work'. These artists may perhaps have aimed to annex or to confront the cultural power of the writer. It was more significant, however, that deciding what kind of work to do had become practically inseparable from learning about the conditions – both logical and ideological – under which that work was to be done. The practice of art was strategically recast as a form of critical inquiry; and 'surface', in Modernist culture the locus of expression and sensation, was let alone for a while to pursue its secret life.

Epilogue: Modernism and the Postmodern

I suggested earlier that, if the Postmodern has a history in the history of art, it must commence at least with the apogee of Modernism around 1950. It would not be inconsistent with this suggestion to say that the conditions outlined at the close of the previous section were the conditions under which the development of Postmodernist forms of art became a feasible prospect in the 1960s. However, that statement could be rephrased thus: in the 1960s the critical strain in Modernist culture was gradually revived and reanimated; those with short historical sight have seen the ensuing developments in art as categorically distinct from that celebratory culture which is all they know as Modernism; they have therefore dubbed these developments,

Plate 14 *Terry Atkinson and Michael Baldwin*, Temperature show *(1966), Documentation No. 3. Infra-red photograph of ground affected by soil heaters.*

Plate 15 *Ian Burn
and Mel Ramsden,*
Soft-Tape *(1966),
printed text from
installation. Collection
Bruno Bischofberger,
Zürich.*

'SOFT–TAPE'
Presentation of the work uses a tape-recorder. The sound
emitted by the recorder is kept throughout at a monotonous
and uniform level which is (as near as possible) at the 'zero-
point' between understanding the spoken words and inde-
cipherable noise. This is a means of stabilizing and holding
directions at a point of 'uncertainty'–which sets up the
possibility of conflicting directions.
 Listening along a relaxed and 'normal' sound level, it will
appear that the recorded sound is a soft and even blur. This is
intentional and any kind of variance (i.e. from the *meaning* of
the words to the *effect* of the recorded sound) will be due to
(i) the physical position of the spectator, or (ii) the amount of
attention he is prepared to give. For this reason, other than
the recorder mechanism, the display space is kept accessible
and approach to the mechanism and its environs free.
 Instead of merely reproducing a standard symmetrical con-
tent, a framework of tension and possibility is set up between
the spectator as receiver and the recorder as transmitter of the
information. This is in order that the desired spatial 'pattern'
be achieved.
 The interpretation therefore is a matter for the spectator's
own decisions and the kind of choices he makes in this respect
will determine his understanding of the piece.
 ANY determining decisions a spectator makes while con-
fronting the mechanism are to be considered a part of the in-
tent of the piece.

mistakenly, as 'Postmodernist'. What is a form of mistake for some is
the grounds of opportunity for others. The currency of Postmodern-
ism has enabled forms of merely artistic avant-gardism to be dignified
by association with a considerable resource of criticism and theory – a
resource which was not primarily developed by reference to the realm
of art, and which is generally conscripted to that realm at the cost of
its trivialization.

 If it transpired that the celebratory rhetoric or the idealist strain of
Modernism were effectively being continued in the world of art under
the guise of a 'writerly' 'Postmodernism', then the second and more
sceptical formulation would receive some support. We should not then
be deceived into thinking on the one hand that some 'non-Kantian' art
world had been accomplished, and on the other that philosophy as
writing was something new *in writing*. Rather, we should recall that
the rhapsodic strain of 'critical' writing had existed 'within' Modern-
ism almost from the start. The aestheticization of the philosophical
'voice' does not of itself entail a transformation of the aesthetic. Art-
loving philosophers would do well to remember this. Indeed, from the
point of view of the world of art, it seems that the voice of the
aesthetically disposed philosophic has been droning on for years.

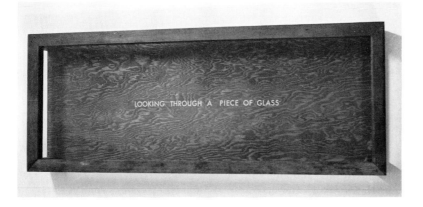

Plate 16 *Ian Burn,* Looking through a Piece of Glass *(1967). Glass and wood, 35 × 82 × 16 cm. Collection Bruno Bischofberger, Zürich.*

There is no natural ontology of art against which to test the appropriateness of the words we employ. The usefulness of some given terminology must be decided on some other basis. It needs to be recognized that the *idea* of a 'Postmodern condition' has been available in the context of art to glamorize and intellectually to dignify a retreat into merely factitious complexity and reflexiveness. It may be that the same idea has served in the meanwhile to distract attention from those problems which have been the unavoidable conditions of assiduousness in modern art – and which may be so still. This view gains some support from the militant triviality which characterizes much – though by no means all – of what is allowed to pass as Postmodernist art.

Plate 17 *Terry Atkinson and Michael Baldwin,* Title Equals Text No. 15 *(1967). Photostat, dimensions variable. Private collection.*

The description of syntax is obviously to be given within a syntactical descriptive range of discourse . . . Some of these ranges are essentially objectual (though not art objectual), the precise structure of which may be hinted at. Part of this description is syntactical and part of it semantical (in the sense of extensional semantics). The non analysed constants of the object theory are said to denote or designate certain objects. And these are in well knit domains. Within this context, there is no concern with 'art objects' sui generis, but only with designation denotation and similar notions. One thing is that within this not very generous context, as formulated for suitable object oriented theoretical languages, a notion of analyticity may be developed. And on the basis of this notion, it will be possible to introduce by definition a specific sort of 'art object' – and this without strengthening the underlying logic or semantical background. The objectual theories and ranges of discourse are thought to be the most suitable for the purposes of intuitionally underwritten discourse. They could be well sorted out as similar to the classical systems of first order. The underlying logic is thought to contain identity as well as the customary connectives. If something more complex is needed it can in some instances be shown that it is merely a special case of the former – or a development of it. Also, many of the art theoretical underlying languages (which are in the relation of metalanguage with the objectual ones) are also available for construction in terms of first order.

In an analysis of the type of entity or theoretical entity under consideration, it may be stipulated that in the context of a theory of art, the art object in question is not a named entity – or at least not named in the context of an object context as such (one which in some way corresponds to the traditional conception of the theory of art) – 'The art object so and so', then is not constructed as a name, neither might it be a description. The table in the corner should not be confused with that art object table in the corner. But it may be that one can't be very clear about that sort of contention until there is somewhat more clarity about existential propositions – i.e. whether they do assert the existence of an object of a certain sort. In either case, an ontology seems presupposed. Even if the ontology of objects are not to take persisters as priority, and take, e.g. events as basic, this would still perhaps not make too much of a hole in the contention above: the point is that the events of which a certain object may be said to be composed should not be confused with the conception of 'art object' here.

Certainly, the art boom of the later 1980s made a *distributional* facility a virtual requirement for current art. Buoyed aloft on the tide of a rapacious and undiscriminating market, countless forms of instant significance found their immediate niche in magazines, galleries, collections and even museums. There is a sense in which such forms of production, like the rationales which accompany them, are aggressive towards certain patrician aspects of the culture of Modernism. They are disrespectful, for instance, towards the concept of an authoritative canon, towards that notion of gravity which would affirm an exhausted humanism, towards the priority accorded to the authentically sensitive observer, and towards the historicism which is smuggled in under the Modernist understanding of historical continuity.

But this is an easy form of opposition – and of affirmation. There is little here that is not already a part of the dialectics of Modernism itself; nothing, that is to say, which has not already been said by those struggling through the century to speak in the second of Modernism's two voices. Indeed it might be said that what Postmodernist forms of art actually do – *in so far as they are distinguishable from Modernist forms* – is take those 'practices of negation'[32] by which the complex anxieties and uncertainties of modern culture have been rendered into Modernist art, and make from them the materials of an unreflective

Loop

An induction-loop would be installed in the gallery and receivers freely available. The effective field of this loop would be curtailed well short of the extremities of the gallery. Thus a visitor equipped with receiver, wandering through, could expect to find very many positions where no signal is received, and many where one is received. This signal would be without variety, the receiver being capable of only two states, quiescent and active, depending on the visitor's location within or out of the loop.

A visitor, suitably equipped with receiver and locomotor inclination would find that in moving into the gallery, after several steps with nothing issuing from the instrument, a point is reached when a signal is received. He would find that further progress in any direction (other than reverse) brought about no further change in the receivers state and a signal of constant pitch and intensity is heard. After several further steps this signal would abruptly cease. After some minutes the visitor might be prepared to assign a 'form' to an area of the gallery and a patient and methodical visitor might endeavour to offer some 'dimensions' of this area.

The loop itself, consisting of a fine wire would either be fixed to the ceiling or located under a carpet, provided it went wall-to-wall, either way one would try to conceal it.

Plate 19 *David Bainbridge,* Loop *(1968), text for lithographic print.*

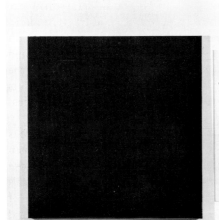

The content of this painting is invisible; the character and dimension of the content are to be kept permanently secret, known only to the artist.

Plate 20 *Mel Ramsden,* Secret Painting *(1967–8). Acrylic on canvas, 12 × 122 cm, with photostat, 91 × 122 cm. Collection Bruno Bischofberger, Zürich*

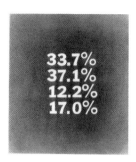

Plate 21 *Mel Ramsden*, 100% *Abstract (1968). Liquitex on canvas, 45 × 40.5 cm. Private collection, Switzerland.*

and self-satisfied celebration. If this is a sustainable view, what we are contemplating is not so much a culture of reaction as a culture of *revenge*. Little is gained in considering the usefulness of a change in terminology, we are reminded, if we do not ask 'useful to whom?' This question will seem the more urgent if we subscribe to the conclusion suggested by the emergence of Modernist culture itself during the nineteenth century: that dominant tendencies in art reflect the interest which dominant constituencies have in exercising and demonstrating those distinct forms of cognitive competence by which they mean to be identified.[33]

The destiny of ironists who cannot be touched by their own irony is to become the butt of the irony of others. The substantive implication here is that no change of terminology will be of *historical* relevance – it will not pick out any concrete change – if it does not also serve to mark a shift in the relations of power within class society, though it may still function as something like the proper name of an episode adequately described in other words. So who is being revenged upon whom? Behind that distracting screen of fears and fantasies which the ruling class constructed out of the forecasts of Marx, can it be that a revolution of a different order has actually been achieved? Has the foreground of art (as of political debate) finally been claimed by that constituency of power-crazed petit-bourgeois lumpens to which Modernists of both voices have for more than a century now directed their scorn? Given the current aspect of our political economy, might not such a process be precisely what we should expect? From where this text was written, within the theatre of what was called (though it never was) Thatcher's Britain, it seems a distinctly credible scenario. So where now are the critical areas for an assiduous aesthetic practice?

There is no answer to that question which is not an attempt to prescribe the direction of art. The question itself, though, has been an animating concern of Modernist art and, I believe, is still its most challenging legacy. Lately this challenge has become unfashionable. The requirement of assiduousness is supposed to have given way to a different kind of concern. In place of the strange opacity of the aesthetic, attention has fixed on the 'transparency that opens onto a dizzying fall into a bottomless system of reduplication'.[34] In this free fall through intertextual space, the 'Postmodernist' critic views the history of Modernism, with a kind of insouciant contempt, as but yet another passing surface. Is this now our cognitive style, our new manner of modernity? Or are we witnessing just one more attempt to idealize away the problem of Modernism and realism (or of realism under the conditions of Modernism)? If the latter, it is as well that the conditions of the problem should be reiterated. Let other voices rephrase them.

It is not as though a victorious Party would reverse its position toward my present writings in the least, but it would make it possible for me to write differently I

am determined to stand by my case under all circumstances, but this case is not the same under every circumstance; it is, rather, a corresponding one. It is not given to me to respond to false circumstances correctly, i.e. with the 'correct' thing If someone produced 'counter-revolutionary' writings, as you quite correctly characterize mine from the Party's point of view, should he also expressly place them at the disposal of the counter-revolution? Should he not, rather, denature them, like ethyl alcohol, and make them definitely and reliably unusable for the counter-revolution at the risk that no-one will be able to use them? (Walter Benjamin, 1931)[35]

The aesthetic and artistic problems first elaborated in the 1960s are the conceptual foundations of what some have called a post-modern aesthetic. The paintings of Art & Language allegorize, displace and ironize these conditions in terms of their own practice. The foundation of the irony is, however, the *modern*. The texts and tools of Conceptual Art appear with other reflections of their production as Analytical Cubist forms and themes appear in post-Cubist work of Braque and Picasso. But these appearances – emplacements – are also displacements. The language is allegorical and ironical as much as referential. What are themselves challenges to the established system of signs are decoded and then re-encoded. This suggests both a continuity of practice and, at the same time, the radical difficulty that such a possibility entails. Art & Language's practice has been a dialogue with the conditions of failure and refusal in respect of the signifying languages of art. Failure to signify is a derogation which bounds a distinctive aspect of their work. The suggestion is that art must continue at the edge of this failure. What is hard is finding where the edge is – or was. (Art & Language, April 1986)[36]

A corrective note

I said earlier that the dialectical character of Modernism was largely obscured during the 1940s, but that the marginalized 'second voice' of Modernism was substantially restored during the 1960s, and that this restoration was a condition of the emergence of Art & Language. (Of course I do not mean to suggest that it was the only condition, nor, as some of the following essays should demonstrate, are these the only terms in which the moment of that emergence might be considered.) I wish to block one possible misreading of this series of assertions. I

mean to refer to a dialectical character or aspect in the culture of Modernist art. I am not much concerned with the battle between opposing tendencies in the academic discipline of art history. The relationship between art and art history is certainly more transitive than many artists and critics have allowed. I do not believe, however, that the practical and intellectual ground claimed by Conceptual Art in the face of Modernist Abstractionism in the later 1960s coincides very precisely with the methodological territory claimed during the 1970s and 1980s by social historians of art in face of the art history of Modernist connoisseurship. There have been some significant momentary alliances where critical interests have converged, but the larger projects on which Conceptual Artists and social historians might have been united were ruled out macroscopically by the turn of historical events and microscopically by the divergences of careers and interests. Indeed, it seems that the post-1968 world of art history has tended to divide along lines which repeat the antitheses of the 1930s and 1940s far more clearly than they mirror the contemporary strangenesses of artistic practice. On the one hand a reactionary reassertion of essential and abiding values (where the real meanings of essential and abiding are camouflaged in the pretence of disinterestedness); on the other, a manichean equation of virtue with 'correctness' of tendency (where the real meaning of correctness is camouflaged in the critique of authority).

2

Conceptual Art and the Suppression of the Beholder

'Conceptual Art' is now a part of the vocabulary of the history of art. It is the subject of retrospective and revisionary accounts and of various interpretations of its significance for subsequent developments. It is also the object of a form of nostalgia. The 'Postmodern condition' has given us 'Neo-Conceptualism', a 'Conceptual Art' without threat or awkwardness. The label remains stuck to enterprises of different orders, and a measure of confusion persists. The aim of this essay is to explore the grounds of confusion and to develop a view of the critical project of some self-styled Conceptual Art so as to narrow and to focus the field of reference of the label.

In a chronological account the moment of Conceptual Art can be located between the years 1967 and 1972. Relevant antecedent activities were pursued by some artists before 1967, while others continued long after 1972 to uphold principles of consistency to their own formative work, but it was only during that five-year period that a critically significant Conceptual Art movement could be said to have been in existence as such. If the moment of Conceptual Art is considered by some to have been extended into the later 1970s by various species of second-generation work, this is due less to the critical interest of such work than it is to the lack of other strong or even *soi-disant* candidates for avant-garde status.

Principally because it coincided and at points overlapped with a broad and international 'anti-formal' tendency, it has always been less easy to circumscribe the Conceptual Art movement than it is to date it. This broad tendency formed out of a number of local developments in European countries and in America during the years 1965–7. Various component developments were made the subject of modest exhibitions during the years 1965–8, but the broad tendency was first publicly surveyed as such in two large exhibitions staged in the spring of 1969,

'Op Losse Schroeven' in Amsterdam and 'When Attitudes Become Form' in Berne.[1] These established a pattern for the involvement of artists in the proposal and often the installation of their own works. Between 1969 and 1972 other such surveys were to follow in London, Krefeld, Lucerne, New York, Seattle, Vancouver, Tokyo and other cities, culminating in the 1972 'Documenta' at Kassel in Germany, which took the form of a massive and cosmopolitan avant-garde Salon. During this period 'Conceptual Art' was one term among many used in art-world gossip and journalism either to refer to the broad tendency as a whole or to single out more or less coherent factions within it.

It is in the nature of Conceptual Art that attempts to distinguish relevant enterprises on conventional stylistic grounds are doomed to failure or to insignificance. The tendency to blandness in graphic presentation, for instance, is a feature of much Conceptual Art, and a significantly strategic feature of the work of such artists as Joseph Kosuth and On Kawara, but it is also a feature of some concrete poetry, of some enterprises claiming the status of 'sculpture', and of much else. A more appropriate approach is to consider the various forms of critical, intellectual and imaginative activity which the various candidate forms of avant-garde practice enable or direct; in other words, to consider what kind of disposition they presuppose on the part of what kind of spectator. It could be said that a measure of this kind, far from being specific to the nature of Conceptual Art, is the one most fruitfully employed in assaying the character of any substantial art-historical development. Changes in art are generally insignificant unless they involve some form of cognitive change, and unless they impose or presuppose some modification of those processes of triangulation by means of which a spectator, a work of art, and a world of possible practices and referents are located relative to each other. In the search for grounds on which to isolate a Conceptual Art tendency from both previous and concurrent developments, the significant indicator will be some characteristic form of difference in the disposition or activity predicated of the spectator and in the forms of matching or reference by means of which the work of art is distinguished.

It is by now one of the conventional images of the age that the wider avant-garde of the late 1960s was engaged on the supersession of Modernism as a source of regulative paradigms for the production and interpretation of art. Whether or not Modernism was in any strong sense superseded may nevertheless be regarded, in the spirit of the preceding essay, as an open question, and one which may have to attend upon an adequate analysis of the various component forms of Modernist theory which were both advanced and assailed during the 1960s. For instance, despite the recent fashion for tracing back the moment of inception of the 'Postmodern', it could be said that what was at stake in the art of the later 1960s was not the supersession of Modernism as a form of interest or value in art, but rather its recovery

as a critical form of practice from the grip of a 'Modernist' *protocol* which had become manipulative, bureaucratic and univocal.

At the time it did indeed seem that what united the various local tendencies of the later 1960s – what made it feasible to see them as converging into an inchoate international movement – was a kind of relaxation of those ontological limits which were associated with the dominant critical regime. There was talk of a 'Dematerialization of Art', of a 'Post-Object Art', and so on.[2] It can also be said that the supposed 'critique' of the art object on which the various artists were engaged – a critique realized in exotic forms of proposal and denial, in accumulations and removals, in interventions and journeys and category mistakes (a few instructive and many dull) – was not addressed to all art objects in general but specifically to the high-art object as construed in the Modernist theory of the 1950s and early 1960s. In due course I mean to suggest that Conceptual Art can be distinguished by the different focus of its critique of Modernism and of its typical object. First, however, we need a clearer sense of how that object was conceived in the standard Modernist theory of the 1960s, of how the spectator's disposition was characterized in relation to it, and of how both object and spectator's disposition were revised in the 'Minimalist' or 'Literalist' version of Modernist theory and practice which developed during the mid-1960s.

Abstraction and Abstractionism

The high-art object of standard Modernist theory was either a painting or a sculpture, each being conceived under a special kind of description: a painting as something contained within its perimeter, not just its physical surface framed, but its signifying character contained within the bounds of what could relevantly be said about the properties of that surface; a sculpture as something contained within the ambient space of the stationary spectator's gaze, its meaning restricted to whatever that gaze could pick out and animate with a responsive emotion. As objects of a supposedly dispassionate contemplation these had been secured against the chaos and contingency of the everyday – against all occasions of conflict and self-interest and doubt. They were so secured in part because of the tendency observed in Modernist theory towards specialization and towards the entrenchment of each form of art within its own area of competence.[3] Outside or 'between' painting and sculpture lay the likelihood of aesthetic impairment and the virtual certainty of marginalization from the Modernist canon.[4]

The 'attuned' spectator was availed of a form of security in face of such works as fell under the operative descriptions of painting and sculpture – notably the 'colour-field' paintings and the abstract-and-constructed sculptures of the 1960s. A descriptive vocabulary appeared to be given in their presence, and so, to a large extent, did a set of valuations. Or at least a kind of learnable method was available

in the criticism which accompanied them – a set of models of how one got from the description to the valuation. And that progress from description to valuation was made in a world in which certain things could be assumed to be true – a world in which the specious ontology of the work of art, the conditions and psychological models of spectatorship and the principles of valuation were held together and in unity in the sensitive and civilized mind.

As suggested, one important assumption made in this world was that works of art are self-contained things and properly regarded as such; that the 'wall-sized painting', for instance, is still to be criticized in terms of its 'internal' relations and properties and of the effects of these upon the spectator, and not in terms of its relationship to its surroundings and of the implications of that relationship, nor in terms of its place within a certain environmental or social system (see plate 22). What mattered about the wall-sized painting was not that it presupposed a certain architecture and must therefore in some sense necessarily be implicated in what that architecture itself entailed, but rather that it entirely absorbed the visual field of the properly positioned and solitary spectator.[5] In the eyes of a Clement Greenberg or a Michael Fried, the aesthetic autonomy and thus the quality of a given work was seen as impaired to the extent that it required acknowledgement of 'environmental' or 'social' considerations.

According to Greenberg abstractness as such had still not proved to be necessary to 'self-criticism' in pictorial art; the point was rather that the associations of represented things tended to 'abate the uniqueness of pictorial art'.[6] Fried wrote of 'the gradual withdrawal of painting from the task of representing reality – or of reality from the power of painting to represent it – in favour of an increasing preoccupation with problems intrinsic to painting itself'.[7] In fact the criticism of both was predicated upon the verdict that the authentic (or 'best') high art of the time was abstract. It is thus appropriate to designate as 'Abstractionist' that highly developed version of 'mainstream' Modernist theory which was current during the 1960s and for which these two writers were largely responsible. It is also appropriate to interpret their notion of 'self-containment' in contemporary art as

Plate 22 *Kenneth Noland,* Coarse Shadow *(1967). Acrylic on canvas, 228.6 × 701 cm. The Metropolitan Museum of Art, New York.* © *DACS, London, 1990.*

implying a high degree of abstractness in both painting and sculpture.[8]

A second and closely related assumption was that works of art are things made primarily to be looked at – or 'beheld', to use a term given special currency by Michael Fried.[9] If that seems a truism, we should note that not all possibly canonical works of modern art are necessarily seen as fulfilling the description. The ready-mades of Marcel Duchamp, for instance, were used in the later 1960s and have been used since as examples of a form of art which – whatever its merits or its inadequacies – was *not* addressed to the beholder (see plate 23). The argument that the ready-mades were never meant to be paintings or sculptures and are therefore beside the point simply begs the question of how and why the technical categories of painting and sculpture have been restricted and privileged. We might also note that Duchamp's work informed (or distracted) Jasper Johns' painted work of the early 1960s and that an *opposition* to the idea of works of art as things made exclusively or even primarily to be beheld was already prepared by that time. The interest of Duchamp's work is limited by its incipient dandyism. It does serve to remind us, though, that a potential for stupefaction endemic to Modernist culture is associated with overestimation of the 'retinal shudder'.[10] Fried's advancement of the idea – or metaphor – of an art 'accessible to eyesight alone'[11] was intended both as a strengthening of the case for Modernist art's autonomy *vis-à-vis* 'the concerns of the society in which it precariously flourishes,'[12] and as a means to raise the threshold at which a painting was considered truly non-figurative or 'abstract'. A clear mutual implication was established between the degree of abstraction in a work of art and the strength of the case for its autonomy. We can say, in fact, that Abstractionism proposed a special interpretation of autonomy.

A further point to note is that the notion of works of art as things to be beheld, which might be thought to have been largely pertinent to painting, was applied with particular urgency to the criticism of sculpture during the 1960s. The case made for a particular interpretation of sculpture was crucial to the development of Abstractionist theory at the time. The theoretical bond which connected abstract painting and sculpture under the dominant culture regime of the decade was effective in so far as, and for as long as, sculpture could be envisaged as an art which aimed 'to render substance entirely optical, and form . . . as an integral part of ambient space'; so long, that is to say, as sculpture fulfilled the prescriptions for 'self-sufficiency' as a *visual* art which Clement Greenberg had set out in 1958. The occasion was his revision for publication in *Art and Culture* of 'The New Sculpture', an essay originally published in *Partisan Review* in June 1949.[13] In the later version Greenberg strengthened his concept of the 'new sculpture' as an art of *optical* effects. The date of this revision is of some significance as regards the conscription of British abstract sculpture to the American Abstractionist canon during the 1960s, especially given the timing of Caro's decisive visit to America in 1959 and the acknowledged role played by Greenberg in Caro's shift from figurative and

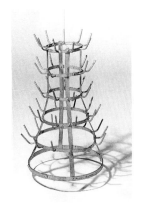

Plate 23 *Marcel Duchamp,* Bottle Rack *(1914, replica 1964). Readymade bottle rack. Musée National d'Art Moderne, Centre Georges Pompidou, Paris, © ADAGP, Paris and DACS, London, 1990.*

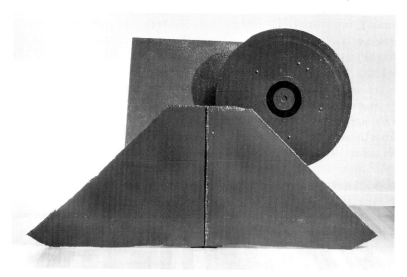

modelled to abstract and constructed sculpture in 1959–60 (see plate
24). As expressed in the revised essay, Greenberg's view was that
'sculpture – that long eclipsed art – stands to gain by the modernist
"reduction" as painting does not', and that it would acquire status as
'the representative visual art of modernism', so long as it provided
'the greatest possible amount of visibility with the least possible
expenditure of tactile surface'.

It could be said that the idea of a specially 'optical' form of art
makes a kind of sense with respect to specific types of painting –
notably the large abstract canvases stained with acrylic dyes which
Morris Louis and Kenneth Noland produced in the late 1950s and
early 1960s (see plates 3 and 4) – though, in so far as optical vividness
is *thematized* as an end or concern of such paintings, one would have
to say, strictly speaking, that they are not 'purely optical'.[14] The idea
of an 'optical' sculpture seems decidedly perverse, however; or, rather,
it is hard to see what grounds there could be for advancing it if not to
conscript (some putative) sculpture into a unified and cosmopolitan
world of psychologically regulated 'seeing', or 'beholding'. In fact
after 1966 Fried was to abandon the Greenbergian notion of 'opti-
cality' on the grounds of its incipient essentialism.[15] Instead he
favoured the concept of 'radical abstraction', which quality he saw as
demonstrated in Caro's work by its 'syntax' and by its 'radical unlike-
ness to nature'.[16] In deciding the dispositions appropriate to the
beholder, however, the concept of radical abstraction functioned
regulatively, in much the same way as the concept of opticality. In the
terms of that largely American critical discourse which attended upon
the English constructed sculpture of the mid-1960s, as upon con-
temporary American abstract painting, to inquire into the material or
cultural conditions of production of such work or to scrutinize it for
references to the non-aesthetic world was to demonstrate that one was
disqualified from 'seeing' it. The assertoric character of the Abstrac-

tionist genre of criticism was such as to contain the reader within the terms of its argument. You either attended to the optical qualities and the syntax of the works at issue, or you were disqualified from discussing them. The implication was that those who failed to fulfil the protocols had failed to achieve *the* reading of the art in question. In the world which this criticism proposed, the practical inquiry becomes a psychological – and in the end social and political – impossibility.

For those not entirely subject to the behaviourally coercive effects of this critical regime, certain situational questions followed upon the assumption that works of art are things to be beheld. How was a beholder qualified as such? Or, what form of public did the canonical abstract art of the early 1960s require or presuppose? Under what conditions did beholding take place? Or, what forms of exhibition and distribution were required or appropriate? To what end did beholding lead? Or, what form of social or other function did this art fulfil? In considering how these questions might be answered with respect to the abstract painting and sculpture of the 1960s we begin to get a sense of the very special kind of relationship which is here signified by 'beholding'. It was not simply to be achieved by anyone under any conditions, nor was it mere looking or regarding or being-aware-of that was being proposed. Under its prevailing critical representation, this art – like the annunciating angel in a Quattrocento painting – made itself visible in its intensional aspect only to those who were properly receptive and attuned and only in certain kinds of sanctified space[17]. And if we asked to what the experience of beholding was supposed to lead, the boldest answer was that it led to nothing. It was an experience in and for itself. Of course, this claim is or was open to paraphrase or redescription. It could be said that what this 'experience' actually testified to was a diminution of the intensional aspect of the work of art to a mere aspect of the onlooker's behaviour, or 'feeling', and that this 'feeling' was itself a kind of formality or closure within the Abstractionist discourse, functioning much like the notion of 'seeing the light' in the discourse of a religious believer.

The rationale which Abstractionist criticism advanced for itself was that its typical procedures were learned in front of the art to which they are applied, and that they were no more than the means to organize involuntary intuitions of which these works were the causes.[18] It could be said, however, that the intention to facilitate the special and concentrated experience of beholding was what led in the first place to the conceiving of 'painting' and 'sculpture' in such specialized terms, and that the practical characteristics of the works themselves were therefore the outcome rather than the cause of the critical protocols. It is certainly the case that the relationship between practical characteristics and critical theory was a close one in that world which saw the coincident production of Morris Louis's later 'Veils' (see plate 3) and early 'Unfurleds', Kenneth Noland's 'Targets' (see plate 4), Caro's first abstract sculptures (see plate 24), and Clement Greenberg's 'Modernist Painting'. Four years later Michael Fried's

Three American Painters both corrected and extended the scope of Greenberg's essay while further circumscribing and detailing the interests of painterly practice. 'Criticism that shares the basic premises of modernist painting', he wrote, 'finds itself compelled to play a role in its development closely akin to, and potentially only somewhat less important than, that of new paintings themselves.'[19]

In the mid-1960s the canonical work of art as represented in Abstractionist theory was something which was 'syntactically' compact but not formally monolithic (more 'ornament' than 'monument'); which stimulated the discrimination of formal relations within a hermetic system, rather than provoking a search for figurative or metaphorical connections to the world at large; which was to be held in the mind as an achieved phenomenal configuration, rather than scrutinized for the means and mechanisms of its fabrication; and which was suitably experienced in some context removed from the contingencies of the social, rather than confronted under conditions which established some sense of dialogue with those contingencies. The type is vividly introduced by Kenneth Noland's 'Target' paintings of the late 1950s and early 1960s, intended as these seem to have been to yield the maximum 'optical effect'; that is to say, to combine instantaneousness, coherence and internal difference in a form offering the minimum temptation to associative response or to practical inquiry (see plate 4).

The fascination of these paintings is twofold. On the one hand they seem to be consummate rhetorical demonstrations of what painting would be like if Abstractionist theory were true, and if such things as paintings could be just self-critical and highly tuned 'vehicles and expressions of feeling'[20] and not social acts of some kind. In this sense they are paradigmatic of the distinctive kind of virtue which Fried claimed for Modernist painting: painting made, as he saw it, of a 'dialectic' which 'has taken on more and more of the denseness, structure and complexity of moral experience – that is of life itself, but life lived as few are inclined to live it; in a state of continuous intellectual and moral alertness'.[21] On the other hand these paintings may be seen as symptomatic rather than morally paradigmatic. They may be viewed, that is to say, as practical evidence of the regulative power of such concepts as 'optical effect' and 'instantaneousness', of the kinds of restriction on inquiry which a 'minimum temptation to associative response' may actually betoken, and of the kinds of cultural politics which tend to be involved in the picturing of art as the ideal site of moral existence. It has to be said that in face of the paintings themselves – and of others like them – this twofold aspect or aporesis is no more easy to hold in the mind than it is coincidentally to entertain the respective dispositions of beholder and of culturally disabused observer. In saying this, I mean to recognize an actual complexity in the works concerned. It is not surprising, however, that critical responses have tended to uphold one form of reading at the expense of the other.

Minimalism and the post-Minimal

The position of the Abstractionists was not left unchallenged during
the mid-1960s. The notion that the aesthetic value associated with
'high art' was to be found only *within* the arts of painting and sculp-
ture was singled out for particular attack. For those artists who came
to be known – misleadingly, but by now conventionally – as Minimal-
ists this was a principle which had to be seen to be overthrown if they
were to succeed in their own campaign for status as the representative
Modernist avant-garde. In 1965 Donald Judd announced that 'half or
more of the best new work in the last few years has been neither
painting nor sculpture'. Advancing a case for what he called 'the new
three-dimensional work', he wrote,

> Painting and sculpture have become set forms. A fair
> amount of their meaning isn't credible. . . . Because the
> nature of three dimensions isn't set, given beforehand,
> something credible can be made, almost anything. Of
> course something can be done within a given form, such
> as painting, but with some narrowness and less strength
> and variation. Since sculpture isn't so general a form, it
> can probably be only what it is now – which means that
> if it changes a great deal it will be something else; so it is
> finished.[22]

Though it has become retrospectively identified with his own bland
and geometric reliefs and boxes of the period (see plate 9), Judd
originally illustrated his concept of the 'new three-dimensional work'
by reference to a wide and heterogeneous selection of artists, including
the French 'New Realist' Arman, the English painter Richard Smith,
West Coast artists such as Kenneth Price and Edward Kienholz, Pop
Artist Claes Oldenburg, and a number of others not easily assimilated
to any tendency or movement. In Judd's view, 'The new work
obviously resembles sculpture more than it does painting, but it is
nearer to painting.'[23] No common property connected his various
examples so much as their evident unsuitability for inclusion in the
Greenbergian canon. In none of the works referred to could one
plausibly have remarked the priority of optical effects, and as many
figurative as abstract works were included in the survey. Furthermore,
the antecedence of the 'new work' was established not according to
the mainstream account of Modernism and of its trajectory – an
account largely decided in Greenberg's writing – but by reference to
just those practices and interests of the 1950s which that account had
tended to marginalize: the work of Rauschenberg and more import-
antly of Johns, the fascination with Duchamp and with Dada which
was given distinctive expression in the writings of John Cage, the
engagement with mass-cultural forms, with notions of performance
and of environment, and so forth. Judd specifically cited Duchamp's

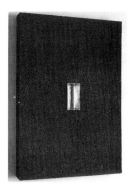

Plate 25 *Donald Judd*, Untitled *(1961). Asphaltum and gesso on composition board, mounted on wood, with aluminium-pan inset, 122.2 × 91.8 × 10.2 cm. The Museum of Modern Art, New York. Gift of Barbara Rose. © DACS, London, 1990.*

bottle-drying rack (see plate 23) as 'close' to some of the new work and identified 'Johns' few cast objects and a few of Rauschenberg's works, such as the goat with the tire [*Monogram*, 1959]', as 'beginnings'. For all the bland formality of his works of 1965, it is possible to view Judd's own passage from paintings to objects as a form of further attenuation and alienation of that 'homeless representation' which Greenberg had seen as virtually exhausted in Johns' paintings of the later 1950s.[24] It is also possible to see Judd's early wooden boxes and reliefs as forms in which Johns' cultural references are subject to a kind of critical denaturing. Judd's wall-hung works of 1961–3 (see plate 25) bear a relationship to Johns's plaque-like flags and targets not unlike the relationship of 'reduction' which is supposed to connect Noland to Pollock.

Judd distinguished the 'new work' from sculpture 'made part by part, by addition, composed' in which 'the main parts remain fairly discrete'.[25] He was later to focus the critical implications of this distinction with a dismissive reference to the 'Cubist fragmentation' which he saw as basic to Caro's work.[26] The practice for which he was claiming status as the representative modern art of the present was supposed to have departed from painting, but to have superseded it. This practice was also framed in explicit contrast to the Abstractionist concept of sculpture and in implicit refusal of that form of discrimination of complex relations and subtle differences which typified the beholder's pursuit.

> In the three-dimensional work the whole thing is made according to complex purposes, and these are not scattered but asserted by one form. It isn't necessary for a work to have a lot of things to look at, to compare, to analyze one by one, to contemplate. The thing as a whole, its quality as a whole, is what is interesting.[27]

If the methodological example of his art criticism was a reliable guide, the intention of Judd's own 'specific objects' was that nothing relevant should be sayable about them which was not a description of their physical characteristics and means of fabrication. His works were forms of plastic realization of J. L. Austin's objection to aesthetics as a philosophical discipline.[28] They stood as forms of mute critique not of Abstract Expressionist painting itself, but of those exciting metaphysical pretensions which characterized art-critical and art-historical interpretation in the wake of Abstract Expressionism. They also appeared to declare a resolute impatience not simply with the entire European aesthetic tradition but with those notions of the privacy of aesthetic experience which that tradition was supposed to enshrine. They seemed not so much aggressive towards the beholder's expectations as indifferent in the face of them.

Robert Morris was the other principal artist–writer associated with the early promulgation of Minimalist theory, and the roots and inter-

ests of his practice also lay in those areas marginalized by the Abstractionist view of art history: in the work of Johns, in neo-Dadaism, in performance and in those various 'environmental' considerations ruled out of court in Abstractionist aesthetics (see plate 26). Where Judd had directed critical attention at Abstractionist sculpture, Morris was concerned to free concepts of sculpture from that determination by theories of Modernist painting to which they were subject in Abstractionist writing. '. . . it should be stated', he pronounced in 1966,

> that the concerns of sculpture have been for some time not only distinct but hostile to those of painting. The clearer the nature of the values of sculpture becomes the stronger the opposition appears. Certainly the continuing realization of its nature has had nothing to do with any dialectical evolution which painting has enunciated for itself. The primary problematic concerns with which advanced painting has been occupied for about half a century have been structural. The structural element has been gradually revealed to be located within the nature of the literal qualities of the support. It has been a long dialogue with a limit. Sculpture, on the other hand, never having been involved with illusionism could not possibly have based the efforts of fifty years upon the rather pious, if contradictory, act of giving up this illusionism and approaching the object. . . . Clearer distinctions between sculpture's essentially tactile nature and the optical sensibilities involved in painting need to be made.[29]

Plate 26 *Robert Morris,* Corner Piece *(1965). Plywood painted grey, 198 × 274 cm. Count Panza di Biumo, Milan. © DACS, London, 1990.*

As Fried was later to observe, such theorizations did not so much oppose the Greenbergian 'logic of reduction' as interpret it with a breathtaking literalism.[30] Morris subsequently pronounced the virtual demise of painting, consigning it to the realms of the antique on the grounds of 'the divisiveness of experience which marks on a flat surface elicit'.[31]

Though some of Morris's works of 1965–6 bore a close superficial resemblance to some of Judd's, they were more evidently theatrical and didactic. Where Judd was interested in the idea of 'wholeness' as a property of art objects, Morris was interested in the work of art as evidence of a form of behaviour and in the experience of the spectator as the art object might affect it. His 'three-dimensional work' suggested an identification of the next move in art with those bits of psychology and phenomenology which had impressed him. He was concerned with the relations between perceiving and conceiving, with the persistence in the mind of certain 'gestalts' and with the recovery of fabricating-processes in the staged encounter with forms and materials.

The theoretical accompaniment to Post-Painterly Abstraction and to Caro's sculpture of the 1960s made much of 'newness' in visual experience and of the irrelevance of situational considerations to the matter of aesthetic judgement. The Minimal Art of the mid-1960s dealt in standard and repeatable units, industrial finishes and regular measurements and, at least in that tendency within Minimalism which Morris represented, with the situational and even sociological contexts of art. The annexing of the world of objects by artists who had been painters, as Judd had been, or performance artists, as Morris was, should not be seen as betokening a conversion to the potential of sculpture. Rather it was a means to break through the discipline-specific discourse of Modernism in its Abstractionist form, to relax the aesthetic strictures applied within that discourse, and to force a confrontation with the world of other encounters, other commodities, other things which were manufactured, designed and thought about. 'Some of the new work', Morris wrote, 'has expanded the terms of sculpture by a more emphatic focusing on the very conditions under which certain kinds of objects are seen. The object is carefully placed in these new conditions to be but one of the terms. The sensuous object, resplendent with compressed internal relations has had to be rejected.'[32] The necessity which Morris asserted was a form of self-serving rationalization. The 'new conditions' were those conceived in a gallery-led sense of epoch – philosophically primitive but commercially astute. The import was clear enough, however. The object which was being rejected was the beholder's object as framed in the Abstractionist theory of the preceding few years. The sociological space of art was no longer to be identified with the beholder's propitious domain. Nor, in the public presentation of Minimalism, was any facility to be provided for that kind of detached self-sufficiency in experience by which the beholder was characterized.

It was just this deficiency which led Michael Fried to dismiss Minimal Art as 'theater' and to condemn Minimal artists for their 'literalism' – a term which took its meaning precisely by contrast with the value he attached to 'abstraction'. Fried developed his thesis in a lengthy article entitled 'Art and Objecthood', published in the American journal *Artforum* in Summer 1967 in a special issue on American sculpture. The issue also included Morris's 'Notes on Sculpture, Part 3' and Sol LeWitt's 'Paragraphs on Conceptual Art'. The publication of 'Art and Objecthood' marked a kind of watershed.[33] Certainly, it served to alert English readers of *Artforum* to the strength of a defensive reaction – and thus, perhaps, to the possible critical implications and extensions of Minimal Art *vis-à-vis* the more orthodox art of American abstract painting and British abstract sculpture, which were conjoined for Fried as the authentic repositories of anti-literalist sensibility and aesthetic grace.[34]

The political conditions of the time were such that these and similar claims for the transcendental value of abstract art were likely to be examined with some scepticism. For an emerging 'post-Minimal' avant-garde the cultural face of a political and economic order was identified with Modernism in its widest sense: not only with the abstract painting and sculpture of the 1960s, but also with the urban, commercial and distributive iconography of Pop Art and its various relatives in England, America and continental Europe, with the angst-ridden art of the post-war figurative tradition, and with more or less everything else with which institutional teaching, criticism and curatorship had established a secure relationship by the mid-1960s. What appeared to Fried as the beleaguered virtue of authentic Modernism was coming to be identified by an increasing number of younger artists with the entrenched authority of an imperialistic culture. Albeit mistakenly, Minimalism was seen as anti-Modernist and thus as opposed to the political culture which Modernism was taken to represent. This was a time when the dream of revolution provoked thoughts of earlier avant-gardes, a time when a certain cachet attached to the dissenting personality. During the later 1960s the pursuit of an art which was neither painting nor sculpture served to rally many who, though they wished to practise as artists, could not be seen to submit to regulative definitions of that practice. It followed that they were unwilling to submit to the authority of those protocols which prescribed the proper activities and competences of the artist in terms of a set of assumptions about the kind of object a work of art was supposed to be and about the kind of experience it was supposed to avail. In a conjunction which was both unhistorical and historicistic, the idea of an art free from formal prescriptions became associated with the pursuit of a political freedom. The years 1967–72 saw the expansion of a broad form of aesthetic egalitarianism and cosmopolitanism to which the 'post-Minimal' tendency was assimilated. Its adherents were united by a commitment to art which was supposedly indistinguishable from opposition to imperialism, war, racism

and repression.[35] This was the broad movement, encompassing such European cognates as the Arte Povera movement in Italy and the circle around Joseph Beuys in Düsseldorf, which was partially surveyed in the exhibitions 'Op Losse Schroeven' and 'When Attitudes Become Form' in 1969.

But, of course, neither sculpture nor painting was exhausted simply because Judd and Morris had respectively pronounced them so in the mid-1960s. What we should rather note is the kind of space these artists were attempting to clear for themselves. With hindsight it can be seen that the points of reference according to which this space was mapped out largely overlapped with those which featured in Abstractionist accounts. Behind the ludicrously epochal character of Morris's claims, as behind the quixotic face of Judd's pronouncements, there lay a concern not to overthrow but to reformulate and to revalue Modernism so as to validate their own enterprises as artistic. The argument was not substantially about the nature of modern culture as a determinant upon the practice of art, but rather about the means practically to interpret the legacy of Abstract Expressionism. As Philip Leider wrote in 1970, 'Both abstraction and literalism look to Pollock for sanction.'[36] What was involved was not an alternative interpretation of art's relation to history in face of the historicism of Abstractionist accounts, but rather a different interpretation of the historicism of Modernism – a different understanding of the intellectual consequences of the 'Modernist dialectic' and a different claim as to the form of the next reduction. Judd's form of 'anti-painting' was not a move outside the conceptual framework of Modernism, but rather an articulate form of Modernist apostasy, while for his part Morris clearly needed Modernism to be current as a plausible conceptual apparatus in order for his own avant-garde position to appear art-historically pertinent.

The case of Frank Stella furnishes the best of illustrations of the complex interrelationship of Abstractionism and Literalism during the mid-1960s, and of the vivid contrasts and pseudo-antitheses by which this relationship was marked. To quote Leider again, 'The way one reads Pollock influences in considerable measure the way one reads Stella, and the way in which one reads Stella and Pollock has a great deal to do, for example, with the kind of art one decides to make; art ignorant of both looks it.'[37] One of the subjects of Fried's *Three American Painters*, Stella was also claimed, the same year, for Judd's 'Specific Objects', on the grounds that his shaped paintings 'involve several important characteristics of three-dimensional work'.[38] Stella's black paintings of 1958–60 take evident cognizance of technical issues raised by Johns' work of the previous five years, yet these and subsequent works appear to engage with just those problems of surface and shape by which the technical agenda of Abstractionist painting was supposedly defined (see plates 8 and 27). Indeed Fried's 1966 essay 'Shape as Form: Frank Stella's New Paintings' was one of the most rigorous elaborations of the Abstractionist analysis of painting.[39]

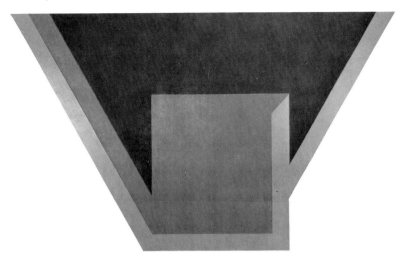

Plate 27 *Frank Stella, Union 1 (1966). Alkyd fluorescent and epoxy paints on canvas 258 × 445 cm. © The Detroit Institute of Arts, Founders Society Purchase, Friends of Modern Art Fund. © A.R.S., New York, 1990.*

On the other hand Greenberg remained consistently indifferent to Stella's work. The 'Literalist' Carl Andre shared a studio with Stella and wrote the catalogue statement for the first exhibition of his work in 1959.[40] Michael Fried was best man at Stella's wedding. 'I was claiming his paintings for a development I believed in', Fried has asserted in retrospect. 'In a sense Carl Andre and I were fighting for his soul, and Andre and I represented very different things . . . the point is that these were issues to fight over, so that if we historicize that moment now we have to see it as a conflictual time, a time when different possibilities were entertained, when the same body of work was seen in different ways. . . .'[41] Though arguments about the nature and implications of Stella's work serve to reveal contrasted positions and commitments, they also demonstrate that certain issues were of moment to Abstractionists and Minimalists alike: issues, for example, concerning the status of painting, the status of sculpture, and the relative virtues of two-dimensionality and objecthood. They further demonstrate that these issues were conceived within a framework of shared assumptions about the dynamic character of Modernism and the authority of American art.

The Minimalist/Literalist intervention in the discourse of Modernism did have two powerful consequences. The first was due largely to the distinctive form of its historicism and of that fixation with artistic succession which the Minimalists also shared with the Abstractionists. According to Fried's *Three American Painters*, the function of the Modernist dialectic was 'to provide a principle by which painting can change, transform and renew itself', while perpetuating 'those of its traditional values that do not pertain directly to representation'.[42] The hidden corollary was that admission of representation compromised the possibility of change and renewal and that the self-criticism of painting therefore entailed a continual evacuation of representational aspects. The form which reduction took in Fried's account was thus *quantitative*: a gradual purging of the material and associative in

favour of the 'optical' and the expressive. In rejecting this view, and in seeking as it were to claim the Modernist succession for their own practices, the Minimalists proposed a *qualitative* change: not a change from deep to relatively shallow pictorial depth, from shape-evoking to pattern-making line, or from target to chevron to stripe, but a shift from painting and sculpture to 'objects', and subsequently from objects to 'post-objects', the 'Works – Concepts – Processes – Situations – Information', for instance, which were sloganized in the subtitle to 'When Attitudes Become Form' in 1969.

This second shift came rapidly in the wake of the first. Except in the individual practice of Don Judd, whose work was to remain quite stylistically consistent, the moment of 'geometrical' Minimalism – of boxes and beams and 'Primary Structures'[43] – lasted no more than two or three years. By 1967, the 'Minimal' artists Morris, Andre, LeWitt and Smithson, though they continued to produce forms of geometrical object and arrangement for display (see plate 28), all appeared at least as much concerned with the systematic or quasi-systematic nature of hypothesized 'works', while a 'second generation' of Process Art, Informal Abstraction and Land Art was beginning to receive exposure in magazines and exhibitions.[44] By then 'Language' was well and truly on the avant-garde agenda – and not only because the Minimalists had made it fashionable for artists to write. 'The better new work takes the relationships out of the work', Morris claimed, 'and makes them a function of space, light, and the viewer's field of vision.'[45] In the post-Minimal world which such exhortations advertised, it seemed that anything could be 'the work' so long as it related to something. The competition for the avant-garde succession degenerated into a search for ever-more-exotic entities, many of which were made present to the spectator only in so far as they were prescribed in forms of words. By 1968 there was already a developing market in proposals, descriptions and nominations.[46] The second and third 'Language' shows held at the Dwan Gallery, New York, in 1968 and 1969 were clearly intended to curate and to promote a tendency which was underwritten by the gallery's investment in more established forms of Minimalism.[47]

The general point being made here is that – in their American forms at least – 'Conceptual Art' and 'Dematerialization' were secondary historicist consequences of the qualitative shift which Minimalism

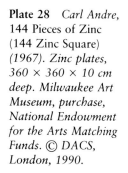

Plate 28 *Carl Andre,* 144 Pieces of Zinc (144 Zinc Square) *(1967). Zinc plates, 360 × 360 × 10 cm deep. Milwaukee Art Museum, purchase, National Endowment for the Arts Matching Funds.* © *DACS, London, 1990.*

represented. In the train theory of art history, they flagged the next thing after Abstract Expressionism, Abstractionism and Minimal Art. For all the apparent extravagance or dramatic meagreness of their physical components, the great majority of the new informal, 'anti-formal' and 'Conceptual' art-works of the later 1960s, where they were not simply extensions of art-student craftiness and individualism, were made in pursuit of the exploitable implications of Minimalism. As I suggested earlier, this 'post-Minimal', anti-formal art was charac-terized by nothing so much as its reaction to negative example. It appeared that that negative example was furnished by the canonical abstract painting and sculpture of the mid-1960s. It might be more appropriate to say, however, that the decisive reaction was to that Abstractionist *representation* of abstract painting and sculpture which asserted its status as the representative art of Modernism.

I don't mean to suggest that Minimalism was the only source of potential precedents for a Conceptual Art. In America both the legacy of 'Happenings' and the continuing development of forms of Pop Art served to erode the paradigmatic status of abstract painting and sculp-ture, while the activities of the Fluxus movement, of Yves Klein and of Piero Manzoni were among the European antecedents which appeared art-historically to legitimate non-Abstractionist forms of avant-gard-ism during the 1960s. Further, given the priority placed in Abstrac-tionist theory upon the primacy of the 'optical', it was inevitable that the 'anti-retinal' position taken up by Duchamp after 1912 would sooner or later ring bells in the minds of those who saw themselves as opposed to Abstractionism, and that his subsequent work would be mined as a source of precedents. The point is, however, that Minimal-ist theory was the most coherent and the most powerful avant-garde discourse of the mid-1960s, and that this was so largely because of its cultural *adjacency* to the discourse of Abstractionism. It was for this reason that, until 1968 at the earliest, other forms of anti-Abstraction-ist practice and critique tended to be subsumed under the authority of Minimalism.

The second consequence of the Minimalist intervention was closely related to the first. It was a feature of works of art in the geometrical phase of Minimalism, and of Judd's work in particular, that they appeared to propose the gallery rather than the studio as the site of generation of art. These objects came, as it were, ready-adjusted – in scale, materials, methods of fabrication and finish – to the institutions in which they were to be displayed. Some were measured and con-structed with specific gallery spaces in mind; others were built *in situ* in order to articulate a given wall or room. (Among the genres issued in by the Minimalist shift was the avant-garde installation, which was 'art' but not painting or sculpture or architecture or theatre.) The almost immediate institutional (as opposed to art-critical) success of Minimal Art had much to do with its suppression of internal relations – and of the type of complex artistic intention which they supposedly expressed and embodied – in favour of forms of relation between the

work and its conditions of display. In the commercial and curatorial climate of New York in the mid-1960s, there were many who were only too happy to adopt some more public, distributable and business-like paradigm of the encounter with art in place of the private and patrician experience of the beholder. To say that Abstractionist theory was dominant in the early 1960s is not to say that it was universally popular, nor is it by any means to say that it coincided at all points with the self-images of those institutions engaged in the curating and distribution of Modernist culture.

If Minimal Art inaugurated a form of administration by artists – in the sense that it included the gallery, its space and time, within its area of operation – the return it offered was to render its own objects and enterprises highly transmissible. This compact – for such it rapidly became – was a distinctly American contribution to the institution-alization of avant-gardism in the 1960s. Given the coincidence of this compact with the train theory of art history, it was a short step to the institutionalization of various forms of 'refusal' of display: the exten-sion of the museum and the gallery into 'alternative' spaces; the empty gallery as a form of exhibition; the catalogue as 'the show'; the closed gallery as 'the show'; the advertisement of the show as 'the show'; and so forth. By such means, sections of the supposedly anti-Modernist avant-garde were able to represent themselves as subverting the system while in truth meshing the more closely with its operations as the curators of themselves. The Minimal shift thus both marked and began a new form of professionalism, not only among artists but also among those critics and dealers and curators who attended in one manner or another upon the distribution of their work. For all the oppositional idealism which occasionally marked their pronounce-ments, the denizens of the post-Minimal art world were professional, knowing and secular. The notion of an art of transcendent values was simply not of interest to them in its Abstractionist version, and they explicitly avoided or derogated those styles and properties by which such art was supposedly distinguished. The forms of art which typified the 'Post-Minimal' developments of Informal Abstraction, Process Art and Land Art or Earth Art were generally not stable, not hermetic, not reliant upon significant and constant relations of difference between parts, not necessarily insulated against aesthetic collapse by the empty white-walled gallery, nor necessarily rendered vulnerable by disloca-tion from it. Their autonomy was assured not by their 'opticality' or their internal syntactical coherence, but by a kind of bureaucratic legitimation: by the *cultural* plausibility and currency of the idea of art as idea. That this plausibility and currency were more frequently asso-ciated with *idea-tokens* – intellectual 'ready-mades' – than with *ideas* was entirely consistent with the values obtaining in the New York art world of the time.[48]

Though Conceptual Art is unthinkable as an artistic movement without those developments in American Modernism which largely sustained it, it could be said that the critical project of Conceptual Art

was primarily a European possibility. The pursuit of this project, that is to say, required emancipation from that historicistic view of the reductive development of art which was a coercive condition of existence in the North American art world during the 1960s.[49]

Conceptual Art and Art & Language

As a broad category Conceptual Art generally designates a cluster of 'post-Minimal' forms of practice in which objects are mapped or proposed or prescribed or nominated, and in which those same or other objects are presented to view, if at all, only as contingent illustrations or demonstrations of some 'idea'. In 1967 Sol LeWitt's relatively speculative 'Paragraphs on Conceptual Art'[50] had offered a name for an artistic disposition compatible with his own practice, a disposition according to which 'art' was rendered consistent with the 'anti-retinal' legacy of Duchamp.[51] Published in the first issue of *Art–Language* two years later, his more gnomic 'Sentences on Conceptual Art' provided a set of protocols for a movement. The tenth 'Sentence' read,

> Ideas alone can be works of art; they are in a chain of development that may eventually find some form. All ideas need not be made physical.

and the fifteenth,

> Since no form is intrinsically superior to another, the artist may use any form, from an expression of words (written or spoken) to physical reality, equally.[52]

It appeared that the Minimal intervention had provoked a kind of explosion of the ontological limits of art. These limits were conceived by different persons in different ways, according to the sociological, historical and cultural determinants upon learning and imagination. What was supposed to follow from the relaxation of limits was consequently subject to a wide range of different interpretations. A distinctly 'Californian' variety of Conceptual Art distilled the ethos of a wistfully agnostic hippiedom, while in New York artist–artisans crossed Dematerialization with the ready-made or with systems theory or with concrete poetry and were transformed into artist–intellectuals or McLuhanite savants or neo-Dada mystics (see plate 29). In Europe in the climate of '68 the critique of the Abstractionist object was identified with the Marxist critique of fetishism, or with the Situationist critique of spectacle. The relaxation of conventional artistic boundaries was taken by some as a promise of coming political liberation from the fetters of capitalism and imperialism.[53] Others – and some of the same – saw themselves as licensed to aggrandize autobiographical materials into megalomaniac proposals. And so on.

Plate 29 *Dan Graham,* Poem-Schema *(1966). Published in* Art-Language *Vol. 1 No. 1.*

POEM SCHEMA	**DAN GRAHAM**
1	adjectives
3	adverbs
1192½ sq. ems	area not occupied by type
337½ sq. ems	area occupied by type
1	columns
0	conjunctions
nil	depression of type into surface of page
0	gerunds
0	infinitives
363	letters of alphabet
27	lines
2	mathematical symbols
38	nouns
52	numbers
0	participles
8½ x 5	page
17½ x 22½	paper sheet
offset cartridge	paper stock
5	prepositions
0	pronouns
10 pt.	size type
Press Roman	typeface
59	words
2	words capitalized
0	words italicized
57	words not capitalized
59	words not italicized

The form of Conceptual Art particularly associated with Art & Language departed from two interconnected perceptions, both of which have helped to form the present account. The first was the perception, already suggested, that the reductivist logic of Modernist theory was a condition both of Abstractionist and of Minimalist practice; that is, that both Abstractionism and Minimalism were forms of a Modernist historicism. The second was that the historicizing critical talk had overpowered the objects of both; that those 'works of art' which this discourse had once constituted as such were already so attenuated within the historicist model that the attempt to conceive them outside discourse had become absurd. For all their apparent anomalousness, the typical avant-garde art-works of the later 1960s offered little resistance to the critical theory which sought to represent them. Under such conditions the extension-by-reduction of the life of

the Modernist object, be it through ever more ingenious forms of trace, or of least presence or of intellectual ready-made, was an enterprise devoid in the last instance of significant critical potential.

The view that art had, as it were, disappeared into the conceptualizations of its discourse was by no means the same as the notion that art had become subject to a further Minimalist reduction or had 'dematerialized'. Many of those to whom the 'Dematerialization' label was stuck appeared from an Art & Language point of view to be fetishists of one complexion or another, engaged with such thoroughly substantial materials as paper, books and gallery walls. Their 'ideas as art objects' appeared as token commodities in the world of post-Minimalist taste – a world whose design parameters had been mapped by Dan Flavin: 'I believe that art is shedding its vaunted mystery for a common sense of keenly realized decoration . . . we are pressing downward towards no art – a mutual sense of psychologically indifferent decoration – a neutral pleasure of seeing known to everyone.'[54] In such a world, black-on-white or white-on-black photostat statements took the place of abstract paintings, with little sense of cultural dislocation.

The idea of ideas as discursive items, *as art*, was a far harder one to sustain in some practical and social space. It required that the hypothesized object be seen not as 'the art', but as the object of an inquiry for which the status of art was more-or-less strategically claimed. The conviction which characterized Art & Language was that it was the inquiry which had to be the work and which therefore had to become 'the work'. Though Minimalism had furnished forms of precedent for the meeting of 'art' with 'language', this concept of practice as necessarily made of discursive materials was not a consequence of Minimalist theory. Rather it was a different response to the conditions which Minimalism itself had addressed, and one which implied a critique of Minimalist historicism. In face of the 'beholder' discourse of Abstractionism the Minimal artists had resorted to forms of refusal of the beholder's supposedly empiricistic interests – as 'reductions' in line with the Modernist dialectic. Judd had aimed to suppress those internal relations which provided the beholder with facilities for comparison, analysis and contemplation. LeWitt claimed that 'Conceptual art is made to engage the mind of the viewer rather than his eye or emotions.'[55] In the world of such assertions, the beholder was not abolished as a determinant upon the production of art. Rather he was re-created in negative image as a straw man: the eye as moron,

Something which is very near in place and time, but not yet known to me

1969

Plate 30 *Robert Barry*, Something which is very near in place and time, but not yet known to me *(1969).* © *DACS, London, 1990.*

One standard dye marker thrown into the sea

divorced from mind (mind being conceived along the lines of an
idealized Marcel Duchamp). It transpired, of course, that the sup-
posedly disappointed beholder of Minimal and Conceptual Art, far
from being overthrown, was no less – and no more – than amanuensis
to the full-blooded beholder of Modernist art. The latter's eye – sen-
sitively attuned though it might be to the 'optical' characteristics of
Louis's abstract works, or Noland's, or Caro's – was no thoughtless
camera, but was typically the organ of a mind quite capable of assimi-
lating Judd's work and LeWitt's, and even Robert Barry's (see plate
30) or Lawrence Weiner's (see plate 31), to an extended Modernist
canon.

The position taken by Art & Language in the later 1960s has been
represented as the extreme form of a contemporary avant-gardism, as
if it were a kind of 'furthest-out' version of Conceptual Art and there-
fore a bid for the ultimate Modernist reduction. According to one
(representative) American commentator, for instance, the Art &
Language of the Conceptual moment took 'the extreme position that
there would be no use of material beyond print on paper'.[56] In fact
Conceptual Art worthy of the name was only provisionally and
trivially an art without 'art objects'. More significantly it was an art
which was not to be *beheld*, which was not visible – or even conceiv-
able – in any mode which the 'adequately sensitive, adequately
informed, spectator'[57] was competent to regulate. The initial task was
not to invent a form of high art without objects – logically speaking,
an absurd-enough idea – but rather to evade in practice those predi-
cates which the beholder was wont to attach to the objects of his
attention.[58] In pursuit of this aim Conceptual Art was on common
ground with some aspects of the broad anti-formal tendency of the
later 1960s, but its practice was sharpened by a more sophisticated
understanding of what was entailed.

In Minimal Art what had been forestalled was not 'objecthood'
itself, but rather that form of relationship between 'objecthood' and
'visuality' or 'opticality' which was seen as characteristic of Abstrac-
tionist painting and sculpture. This relationship was the typical subject
of the beholder's discourse. For the beholder it was necessary that the
work of art be emphatically a form of object – that the painting have a
surface and the sculpture a mass – so that he might notice the 'visual'
transcendence of its objecthood as a significant achievement. For it
was this supposed achievement of transcendence which was the very
occasion of those pleasures by which the beholder lived. In the dis-
crimination of those effects by which transcendence was managed, he
found the reflection of his spiritual capacities and his *raison d'être*. It

was not the objecthood of Minimal Art that had attracted the con-
demnation of Michael Fried. It was the fact that this objecthood was
not transcended, so that the works remained 'literal' and thus
unamenable to being properly beheld.[59]

What was offered in many forms of Conceptual Art, however, was a
return to transcendence in another guise. In the world of Weiner's
Statements, for example, the beholder as audience or as 'receiver'
became the intended creator of that imaginary and picturesque form in
which the material 'proposal' was both realized and transcended.[60]
The more critically acute forms of Conceptual Art were those which
took up and extended the more resistant aspects of Minimalism, or
which were coincident with Minimalism in so far as they shared some
of the same sources and addressed some of the same problems. The
tendency within Art & Language was to view Minimalism with an eye
to its critical implications but with scepticism about the typical forms
of its extension. In the art of the avant-garde ready-made and in
installation art, for instance, it seemed that the Minimalist abandon-
ment of internal complexity was taken as justification for an overall
absence of complication and depth. Within Art & Language the
Minimalist downgrading of relations within the work was seen, as
suggested earlier, as the means by which the Minimal object
established a relation of compatibility with the representing institution
– a type of institution for which the modern American museum was
the token. The Conceptual Art of Art & Language was work which
was either done with no installation in mind, or which was to be
realized in social and discursive life outside the conditions of its instal-
lation. It presupposed not a form of responsive emotion but a form of
responsive activity. It achieved its intended form of distribution, if it
did, not through being beheld or otherwise institutionalized, but
through being criticized, elaborated, extended or otherwise worked
on.

In the normal work of Minimal or Conceptual Art it was the sup-
posed end product of the artist's activity that claimed primary atten-
tion, however ontologically avant-garde that product might be,
however strategically framed through a linguistic 'form of presen-
tation' which was not to be confused with the 'artistic content'. (This
strategic separation of 'art' from 'form of presentation' was the styl-
istic hallmark of a particular Conceptual Art stable, the members of
which were Robert Barry, Douglas Huebler, Joseph Kosuth (see plate
18) and Lawrence Weiner. Assembled by the avant-garde dealer Seth
Seigelaub in New York in 1968–9, the stable was subsequently adop-
ted by the powerful Leo Castelli Gallery.[61]) From the point of view of
the spectator of such work, perceptions of the artist's processes and
conditions of production were speculations bounded by the actual or
hypothetical identity of an intentionally aesthetic object. As such they
were subject to the forms of mystification of those processes which
were endemic to Modernist culture.

In the representative activity of Art & Language, on the other hand,

it was intended that primary attention should be accorded to the discursive processes of production. It was assumed that these were the 'work' on view. Any products which might be identified were materials which happened to have been generated in these processes – as contingent consequences or as remainders. They were seen as *ad hoc* and as intrinsically corrigible and as such not mystificatory. Of course, the risk that was taken in proceeding on this basis was that aesthetic ratification would not be forthcoming, there being nothing deemed suitable to contemplate.

The point was not that theorizations of art or discussions about art

Plate 32 *Terry Atkinson and Michael Baldwin, key to 22 Predicates: The French Army (1967). Letterpress book, edition of 50.*

KEY:

FA — French Army
CMM — Collection of Men and Machines
GR — Group of Regiments
Assertions. Explicata.

The context of identity statements in which 'collection of men and machines' appears as a covering concept is a relativistic one.
Identity is not simply built into that concept. The 'sense' of identity is contrasted with the constitutive one.
The FA is regarded as the same CMM as the GR and the GR is the same CMM as (e.g.) 'a new order' FA (e.g. Morphologically a member of another class of objects): by transitivity the FA is the same CMM as the 'New Shape/Order one'.
It's all in support of the constitutive sense that the FA is the same CMM as the GR. The inference is that the FA is predicatively a CMM. The identity statement subverts the covering concept. It's a strong condition of identity that the FA and the CMM have the same life history (both the FA and the CMM are decimated) and in which case CMM fails as a covering concept. If the CMM isn't decimated (no identity), the predicate fails. The 'constitutive' concept stays. And its durability doesn't come from a distorted construction of 'Collection'.
The concept of collection or manifold is one for which there can be no empty or null collection. The manifold FA; a domain, a regiment; it's all one whether the elements are specified as the battalions, the companies or single soldiers.
(This doesn't work for classes).
The elements are intended to define and exhaust the 'whole'.
If the CMM is to be regarded as no more and no less tolerant of damage and replacement of parts as FA, then the right persistence-conditions and configuration of CMM can be ensured only by grafting on the concept FA, and this is to 'decognize' thing-matter equations.
The rest is not equivocation. 'Concrete' and 'steel' are not, in this framework, the sortals with classificatory purport (and in the terminological context, the sense does not emanate from them). And the same for all the constituents which may be specified at different dates for the FA.

(or whatever) were being presented by Art & Language as ever-more-exotic forms of Conceptual Art object – as kinds of conversational 'ready-made' perhaps.[62] It was rather that, in face of the possibility or necessity of abandoning for the time being the object as conceived in Modernist theory, the task which ensued was to puzzle at the consequences and implications. There seemed no other defensible course of action which was not simply a form of pseudo-avant-garde opportunism. The notorious 'rigour' of Art & Language was simply a form of vigilance *vis-à-vis* the temptations and distractions of 'least objects' and similar devices. If those distinctive competences which were associated with the making of painting and sculpture had been deprived, at least in thought, of their status as determinants upon the concept of high art, and if this reflected some form of critical exhaustion of the dominant culture at a deep level, then the possibility of some form of artistic practice capable of sustaining complexity and depth was not to be realized through painting-substitutes or sculpture-substitutes, any more than by encroachments upon theatre or photography or film. For the time being it seemed to be required that practice be made of the representing and misrepresenting discourse itself, and of its own fissures and discontinuities; that it be made of these real materials, and of such theoretical materials as might be employed in their analysis, and not cobbled together from those radical fictions which were but the remaining attenuations of the Modernist object in avant-garde disguise.

Like other adherents of the Conceptual Art movement, contributing members of Art & Language did hypothesize various forms of

Plate 33 *Terry Atkinson and Michael Baldwin,* Map to not indicate . . . *(1967). Letterpress print, 50 × 62 cm, edition of 50.*

'theoretical object' – objects which were not built or which could not be built. But from the start of the collaboration between Terry Atkinson and Michael Baldwin, in 1966, such theoretical objects were explicitly accorded an essayistic aspect (see plates 32–4). From 1968 onwards, once Art & Language had a quasi-formal existence as a partnership, actual or hypothesized 'art-works' were treated neither as sops to the beholder's imaginative faculties nor as the furniture for post-Minimal installations, but as the defeasible materials of a continuing conversation. It was that conversation itself, and the critical and self-critical apparatus that it generated, which became the means to identify and to locate both an artistic practice and a propitious constituency. This conversation was largely conducted *ad hoc*. What follows is not an attempted representation of its actual tenor, but rather a form of imposition upon it, with the benefit of hindsight, of an organizing explanation.

If the historicistic tendency of Modernism was to be opposed, the actual power and authority of the beholder discourse would have to be acknowledged and confronted – and in the end overthrown. The object of Art & Language work was to challenge the competences of the 'adequately sensitive, adequately informed, spectator' and to do so on the ground of an artistic practice which extended into the territory of language and literature (see plates 35 and 36). There was no other way to engage directly with the world of the beholder – and thus to breach the Modernistic division of labour between producers and explainers – for the discourse of the beholder is a literary discourse. It constructs retrospective historical accounts, forms of interpretation and systems of evaluation, and it constructs them as kinds of allegories which develop in a time and a space adjacent to practice but separated from it. The mechanisms which animate these allegories, and which give them their systematicness and their autonomy, are those forms of power and interest which define and sustain the beholder's non-aesthetic existence. The forms of reference to the aesthetic which are the apparent functions of the allegories serve and express these powers and interests even as they mask and misrepresent them. The

Plate 34 *Terry Atkinson and Michael Baldwin,* Title Equals Text No. 22 *(1967), artwork for photostat. Card, 10.7 × 22.1 cm. Courtesy of Lisson Gallery, London.*

" Other maps are such shapes, with their islands and capes! But we've got our brave captain to thank"
(So the crew would protest) "that he's bought us the best - A perfect and absolute blank!"
A state of affairs like that is said by Anscombe to obtain in old-fashioned philosophical textbooks - when the laws of contradiction and excluded middle are laid down as the foundation of the truth.
Wittgenstein uses a similar but double analogy; he says that the proposition in the positive sense is like the space in which a body can be placed. In the negative sense it is like a solid body which prevents any body from being placed in the space it occupies.
Since proposition 'p' divides the whole space, then the positive proposition 'p' or 'not p' leaves the whole space empty: "Both the island indicated by 'p' and the rest of the space; and its negative 'not (p or not p)'blocks the whole space.
The all white globe, 'might be said to represent the whole world - or rather to be a representation of the whole world'.
It is because of the shape of the whole that the two shapes - 'p' together with 'not p' combine to make the shape of the whole. And this throws light on what Wittgenstein means when he says that the logical propositions describe or rather represent the framework of the 'world'.

Plate 35 *Mel Ramsden*, 100% Abstract *(1968). Acrylic on canvas, 44 × 68 cm. Private collection, Belgium.*

COPPER BRONZE POWDER	12%
ACRYLIC RESIN	7%
AROMATIC HYDROCARBONS	81%

'adequately sensitive, adequately informed, spectator' historicizes, interprets and judges in the aesthetic realm, and does so securely so long as he is allowed to be disinterested; so long, that is to say, as the material (and other) grounds of that adequacy are not laid open to inquiry.

Another way to express the intuition that art had 'disappeared' into discourse is to say that during the later 1960s the actual power and authority of the Modernist allegory seemed such as to prescribe and to fix the autonomy of art. This could be interpreted as a sign that Modernist culture had become dogmatic and decadent, for autonomy must always and ever be a *relative* matter in the practice of art, or it must be so long as the prospects of critical function, of realism and of significant change are maintained. Moreover, this relativity has constantly to be reviewed and its ground struggled for in face of that world of shifting conditions which is lived history. To allow the autonomy of art to be fixed would be to accept prescription of the practice of art. In face of the regulative effects of the beholder's discourse, Art & Language's attempt to carry artistic practice into the territory of language was a form of insurgency. (In an Art & Language publication of 1973, the authors looked back quixotically to an 'epistemological inquisition launched by us on the art-world' in the years 1968–9.)[63] The intention was not to deny all possibility of autonomy in art, but rather to prise open those forms of closure which had come to demarcate the aesthetic from the circumstantial, and which did so by constructing each as the negative of the other. The means to this end was to bombard the Modernist practice of art with the materials of its own contingency, to reflect back – as the materials of art – both the entrenched terms and conceptualizations of the beholder's discourse, and representations of the actual powers and interests which those terms concealed. The substantial aim was not simply to displace paintings and sculptures with texts or 'proceedings', but rather to occupy

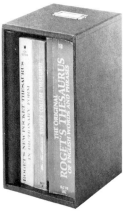

Plate 36 *Mel Ramsden*, Elements of an Incomplete Map *(1968). Four annotated books in slipcase, 20 × 16 × 15 cm. Collection Bruno Bischofberger, Zürich.*

the space of beholding with questions and paraphrases, to supplant 'experience' with a reading, and in that reading to reflect back the very tendencies and mechanisms by means of which experience is dignified as artistic.

The project entailed was twofold. The first requirement was to engage with the current forms and contexts of modern practice, but in doing so to render whatever form of 'beholdable' object might be produced both highly provisional and thoroughly recalcitrant *vis-à-vis* the expectations and the discourse of the beholder. The practice of art cannot be conducted without reference to the practice of art, but the point was to evade co-option to a historicistic development by ironizing the nature of this reference. In some of the early art of those who were to compose Art & Language, 'artistically' bland objects and surfaces were accompanied by or were made the bearers of texts which reflected back models of explanation and exegesis, with the intention not so much of frustrating the beholder's activity as of displacing it with intellectual speculation or pre-empting it with irony. 'Titles' became texts in themselves, while texts which resisted the application of either literary or artistic predicates were put in place of paintings (see plates 37 and 38). The suppression of unreflected content rendered this work simply unavailable for co-option to the beholder's discourse. Instead, through the appropriation of vocabularies and technical terms, hypothetical works were strategically addressed to inquisitive but non-artistic constituencies – to the world of *Wireless World*, of logical systems, or of engineering practice (see plates 39 and 40). These were not the mere expressions of an avant-garde recalcitrance and exoticism so much as forms of flailing about – products of the search for practical and intellectual tools which had not already become compromised and rendered euphemistic in Modernist use. The search for tools was mutually implicated in the search for a

Plate 37 *Mel Ramsden,* Guaranteed Painting *(1967–8). Liquitex on canvas with photostat, two parts each 92 × 92 cm. Collection Bruno Bischofberger, Zürich.*

Multiple meaning (polysemie) and ambiguity function as aesthetic constants. The study of 'multiple meaning' which is an aspect of structuralist research in literature, suggests many other parallels in other disciplines. The problem of multiple is of particular interest because, more than any other factor, it seems to offer the chance of establishing a distinction between linguistic structure (pure and simple) and poetic structure (language). It could be said that the common aim of the introduction of multiple meanings is to ensure that meaning itself is not dissipated. The phenomenon of multiple is kept within bounds.

The notion of semantic vagueness.

Challenged the notion of emotive and cognitive value (Richards). The problem of single meaning, which plays a considerable part when it is a matter of evaluating a contemporary document, becomes in fact 'decisive' in evaluating an ancient text.

Terms of reference.

Multiple meaning. The admittance of two or more distinct structures (that is to say of a linguistic structure proper), the language or the idiom in which the meaning is expressed.

Norberg Schulz . . . 'particular structures have a certain limited possibility for meaning: receiving contents'.

Barthes has tried to apply linguistic schemata to the visual disciplines. In Barthes' account (Rhetorique de l'image), an illustrated advertisement based on a colour picture of a food product, comprises three types of message, an encoded iconographic message and a second iconographic message (not encoded) the linguistic message being denotative and the other two connotative as are, in general, those in which the figurative element is dominant. Today Barthes affirms 'on the level of mass communication it is evident that the linguistic message is 'present' (sic) in all images in the form of title, caption or as film dialogue'.

Plate 38 *Terry Atkinson and Michael Baldwin,* Title Equals Text No. 12 *(1967). Photostat, dimensions variable. Courtesy of Lisson Gallery, London.*

kind of public – or for a model of relationship to some conceivable audience, which is what the concept of 'public' tends to stand for in the logic of artistic anxiety. If the (culturally) relative inadequacies of the 'adequately sensitive, adequately informed, spectator' could be demonstrated, and if he could thus be dislodged from his position as regulator of artistic competence, then a different range of competences might be brought to bear in art and on art.

The second requirement of the Art & Language project was to render the Modernist allegory open to inquiry and to explanation. There were two principal means to this end. The first was to mount a critique of its descriptive apparatus; to demonstrate that its typical forms of representation of the objects of art were open to logical and other forms of correction, and that its typical forms of representation of the experience of art (for instance, those which singled out a range of purely 'visual' or 'optical' properties and effects) were based on defeasible models both of 'object' and of 'mind' (see plate 41). The principal (though by no means exclusive) resources available for this purpose were those of logical and linguistic analysis, as practised within the Anglo-American tradition of analytic philosophy. Consequent upon this procedure, what was required was an explanation of the means and mechanisms of generation of the allegorical system; an account of why it functioned in the way that it did. To work for such an account was to engage in a form of social-historical inquiry, and here the most efficient conceptual and theoretical resources were those of historical materialism. By such means an account of the logical fallacies and inconsistencies entrenched in the critical discourse of Modernism was connected to an account of the interests served by systematic misrepresentation of aesthetic practices. 'Not Marx or

```
THE CYBERNETIC ART WORK THAT NOBODY BROKE

TYPE ALL PARTS
1.1 TYPE "YOU HAVE RED"
1.2 TYPE "YOU HAVE GREEN"
1.3 TYPE "YOU HAVE BLUE"
1.4 TYPE "YOU HAVE YELLOW"
1.5 TYPE "YOU HAVE NOTHING, OBEY INSTRUCTIONS!"

3.05 PRINT#
3.06 TYPE # FOR PP=1:1:3
3.1  PRINT "TYPE EITHER 1 OR 0 IN BOTH A AND B."
3.2  DEMAND A
3.3  DEMAND B
3.4  DO STEP 1.1 IF A=0 AND B=0
3.5  DO STEP 1.2 IF A=0 AND B=1
3.6  DO STEP 1.3 IF A=1 AND B=0
3.7  DO STEP 1.4 IF A=1 AND B=1
3.8  DO STEP 1.5 IF A>1 OR A<0 OR B>1 OR B<0
3.9  DO STEP 3.05

DO PART 3
TYPE EITHER 1 OR 0 IN BOTH A AND B.          A=1
          B=1
YOU HAVE YELLOW

TYPE EITHER 1 OR 0 IN BOTH A AND B.          A=8
          B=3
YOU HAVE NOTHING, OBEY INSTRUCTIONS!

TYPE EITHER 1 OR 0 IN BOTH A AND B.          A=1
          B=0
YOU HAVE BLUE

TYPE EITHER 1 OR 0 IN BOTH A AND B.          A=1
          B=1
YOU HAVE YELLOW

TYPE EITHER 1 OR 0 IN BOTH A AND B.          A=0
          B=0
YOU HAVE RED

TYPE EITHER 1 OR 0 IN BOTH A AND B.          A=R
ERROR AT STEP     3.2
          R              IS UNDEFINED.
```

Wittgenstein, but Marx and Wittgenstein' was an Art & Language
slogan of the late 1960s. If these were the characteristic intellectual
materials of the time, their conjunction was by no means a normal
feature of the culture.

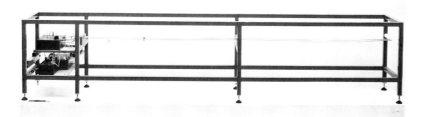

Plate 40 *David Bainbridge, electronic installation for* Lecher System *(1969–70). Oscillator, torch bulb, lecher lines. Galerie de Paris, Paris.*

The fruits of the Art & Language project in the years 1968–72 were inchoate, obscure and occasionally paranoid. Insight alternated with irony, embarrassment and bathos – often in the same particle. No coherent or consistent aesthetic system could be wheeled on to demarcate between various forms of production: for instance, between such forms of display as machines, prints, diagrams and posters, and such forms of text as essays, 'proceedings', transcripts and jottings. Strategies were adopted and defeated. For conducting a discursive practice as a practice of art, or as a model of an artistic practice, and for doing so without presupposing any aesthetic hierarchy, there was a price to be paid in terms of a kind of material rootlessness. Various besetting forms of administration seemed necessary to organize 'work' as 'production', or to transform 'research' into 'art'. (Some discussion of relevant problems will be found in the two following essays.[64])

Of course, it was generally said that the results were not 'visual' and (and thus) not art (plate 42). It was also said by some that Art & Language work was actively hostile to 'art'. And of course these were valid criticisms on their own terms. But the assumption that they were *sufficient* criticisms betrayed an inability to conceive the conceptual conditions of failure or defeat of the prevailing accounts of art and of the aesthetic. This in turn entailed an inability or unwillingness to comprehend the intentional aspect of Art & Language's form of Conceptual Art, for the 'artistic' representation of those very conditions of failure and defeat was the *effect* for which it was striving. In this 'terror' lay its claim to a form of realism. Further, it was implicit in the work of Art & Language that this very inability and unwillingness were symptomatic – if they were not at some level contributory causes – of the loss of critical power in late-Modernist culture; a culture in which the functions of the imagination had been bureaucratized in the name of the 'sensitive', in which the realm of the cognitive had been restricted in the name of the 'visual', in which the tendencies of the critical had been suppressed in the name of the 'creative', and in which the role of the participant had been marginalized in the name of the 'beholder'.

In the later 1960s and early 1970s, the task of recovery of a projective modernism in practice and in history, wherever that task was better than arbitrarily addressed, appeared to be associated with restoration of the notion of art as a form of critical activity. So far as

The initial assertion is that a wall between 26 and 25 Sunnybank is an art object. Now the possible outcomes of what's going on include the building of a wall between those two houses; such a wall is an art object.

This raises the possibly jejune question whether any vestige of the formal properties of identity is to be salvaged. And this question is asked not necessarily from the point of view of 'essentialism'. The point that it looks as if one is individuating something as an art object, but what he appears to individuate it as may in some sense determine what's singled out, but any connection with a principle of individuation is, to say the least, tenuous. And even the postulation of surrogate contemporary objects of future ones doesn't hold singling-out on the rails for long. It looks as if it will have to be shown how the singling out is done if an essentialistic view is to be supported. It's worthwhile making at least a glossy survey of these problems (and others) so as to propound the efficacy of developing a theory of the esthetic domain. And this also to show that such a theory is not inevitably committed to revisionary metaphysics or circumlocuted by the novel. And if identity has no place in the domain of art objects then there is every reason to show that it has none.

Now, the possible outcomes of what's going-on don't include the starting to exist of an individual individuated as 'the wall between 26 and 25 Sunnybank.' Those outcomes do include the possibility that there shall be an individual built, etc. and that it will be singled

Art & Language was concerned, the ideal of an activity pursued in common was not to be realized in terms of the merely 'internal' relations of some democratically constituted group, any more than the suppression of the beholder was undertaken as a mere avant-garde necessity.

> Collaboration . . . was not a kind of working-together-ism. It was a matter of destroying the silence of behold-ing with talk and with puzzles, and of forcing any and every piece of artistic 'work' out of its need for incor-rigibility and into the form of an essay.[65]

Ash, W. *Marxism and Moral Concepts*. New York: Monthly Review Press, 1964. xvii, 204 pp. $3.50—Although Ash (an American living in England) does put the Marxist position in language familiar to the English reader, both Marxism and moral concepts are not treated in depth. Marxism (which according to Ash asks to be judged on results in socialist countries) is primarily a theory which holds values are based in a direct way on economic relations. Recent advances in Marx scholarship or discussions with the Marxist movement are ignored as the attack is focused on the capitalist order. — K. A. M.

Bahm, A. J. *The World's Living Religions: A Searching Comparison of the Faiths of East and West*. New York: Dell Publishing Co., 1964. 384 pp. Paper, $.75—After an introduction about the nature of religion and primitive religion, the author discusses the Indian religions: Hinduism, Jainism, Buddhism, and Vedantism and Yoga. How Vedantism and Yoga could be considered as a religion different from Hinduism is not clear. In the second part the author studies the religions of China and Japan, Taoism, Confucianism, Buddhism, and Shintoism are represented. As the representative religions of Western civilization he has chosen Judaism, Christianity, Islam, and Humanism. The norm the author has adopted to distinguish between the Eastern and Western religions is questionable. The concluding chapter discusses syncretic tendencies and the pursuit of comparative studies that might eventually help to form a World Religion. — J. K.

Bohm, D. *The Special Theory of Relativity*. New York: W. A. Benjamin, 1965. xiv, 236 pp. N. P.—This is not a textbook in mathematical physics—excepting for one chapter one need not possess much more than geometry and elementary algebra—rather it is a philosophically reflective examination of the cardinal features of special relativity theory. Throughout the book Bohm is not merely doing physics, but thinking about doing physics as well. This metatheoretical reflexion appears in chapters concerning pre-Einsteinian notions of relativity, attempts to save the aether theories, the "ambiguity" of space-time measurements in the new cosmology, "common sense" notions of space and time, and the falsification of scientific theories. There is a long appendix dealing with physics and perception—the relation between scientific objects and perceptual processes. One will, however, by working through the text learn plenty of physics in a rigorous and concise fashion. The author wisely does not attempt to cover the mathematically far more difficult and philosophically more profound General Theory of Einstein. In the area chosen, Bohm has written clearly and felicitously; this should serve a model for others who like to take their physics with a dollop of philosophy. — P. J. M.

As regulator of the 'primordial conventions' of art, the beholder obscured the prospect of a new constituency. His displacement was a necessary condition of the pursuit of that prospect: the pursuit, that is to say, of the idea of a public which was intellectually and not just culturally franchised. It was a dream of this public that sustained the critical enterprise of Conceptual Art, and it was to this wide and still largely imaginary community of participants that Art & Language addressed its *Documenta Index* of 1972, the work which put a period to the moment of Conceptual Art in the minds of those engaged in its production.

Plate 42 *Michael Baldwin*, Abstract Art No. 2 *and* No. 3 *(1968). Photostats, dimensions variable. Private collections, Florence.*

Postscript

Though the moment of Conceptual Art is not simply to be explained in terms which would invoke the social and political world of '68, there are coincidences at some level, and no account of Conceptual Art would be adequate which failed to take account of those political hopes and implications for which the intended suppression of the beholder is a kind of metaphor. All art idealizes a public in some form. It would be true to say that the public envisaged for or presupposed by the Conceptual Art of Art & Language was one which only a social transformation could conceivably bring to the foreground of culture (though this is not to deny that public a continuing and significant presence both in imagination and in the actual margins of social life). To that extent the movement recapitulated the critical utopianism of those earlier phases of Modernism which had been marginalized in orthodox art history and art criticism by the cultural protocols of the Cold War. Under this regime the destabilizing practices of the Dadaists, the Constructivists and the Surrealists had been allowed to feature as art-historical curiosities in the margins of a 'high art' tradition, but not as the moments of generation of an agenda of problems and practical strategies.

It would also be true to say that the degeneration of Conceptual Art as a form of cultural project largely coincided with the degeneration of the movements of '68 and with the gradual reimposition of Cold War culture in a more sophisticated form. For all but the most resolute adherents to both the political and the artistic programmes, history offered a choice of destinations during the later 1970s: either Bohemia – but a ghostly Bohemia, a Bohemia which was now not a social but a psychological location; or Academia, where the necessary opacities of the political and artistic text could be rendered transparent and anaesthetic and unpractical.

And what of painting and sculpture and 'objects'? It may be that the Minimalists' notion of 'three-dimensional work' sketched out a form of potential which was unrealized to the extent that subsequent work either degenerated into the status of mere 'installation' or 'performance' or claimed for itself and was accorded the privilege of 'sculpture'. Certainly much American work of the 1970s took environmental or ephemeral form, while the lure of sculpture as a form of aesthetic privilege played a large part in the development of British art during the late 1960s and the 1970s.[66] For all the talk of change and liberation which accompanied the anti-formal movement of the later 1960s, new forms of 'three-dimensional work' either fulfilled the forecasts of Fried's 'Art and Objecthood' in theatricalizing the environment, or adjusted themselves under the beholder's eye to take their place in the tradition of 'sculpture'. Meanwhile the tradition of painting stagnated, awaiting its rebirth in the journalism of the 1980s. In the painting of the 1970s the prevailing Western modes were cunning mutations of Pop Art and attenuations of Post-Painterly Abstraction into a fussy Post-Post-Painterliness.

Times change. If the moment of the later 1960s was a form of failed cultural revolution, there could be no doubt about the success of the counter-revolutionary culture which was the culture of the 1980s. Its progress did not restore the beholder to his previous position of primacy, however. He was, after all, a figure in whose expensive conscience the traditional virtues of liberalism were enshrined, and in the supposedly Postmodern culture of hysteria and replication the ideal spectator presupposed was one untainted by such soggy attributes. It may now be time, in fact, for the beholder to be reanimated. He was at least a worthy adversary. Perhaps we should set him loose again as an imaginary representative of value in the experience of art, as one whose patrician faculties and interests might now again be mobilized to relatively emancipatory and critically effective ends. What we need, though, is not a gentlemanly but a mad beholder – a beholder run amok. At the end of the wide swathe which such a one might cut between the tedious zealots of Art for the People and the repulsive puppets of Business Art, art of some critical depth and power awaits the paranoid eye.

3

Indexes and Other Figures

The index as art-work

In 1972, Art & Language was invited to participate in 'Documenta 5' at Kassel in West Germany, and was allocated a single square room in the Museum Friedericianum.[1] This was the occasion for the first of a series of 'Indexes' by which the production of Art & Language was organized into public displays during the early 1970s (see plate 43). The adoption of the index as the means to map and to represent relations within a conversational world was in part a consequence of the enlargement of Art & Language itself. An 'editorial board' of ten was listed on the masthead of *Art–Language*, vol. 2, no. 2, published in the summer of 1972. This was composed of the four founding partners, Atkinson, Bainbridge, Baldwin and Hurrell (though Bainbridge had effectively disassociated himself from Art & Language by the end of the previous year), Kosuth, Burn and Ramsden from New York, together with Philip Pilkington and David Rushton, former editors of *Analytical Art*, and myself. Pilkington and Rushton had been drawn into Art & Language projects during 1971 and were to merge their student journal with its effective parent in 1972.[2] My own relationship with Art & Language had been formalized into the position of 'general editor' in the spring of 1971.

Through the forum of *Art–Language* and through less formal means of exchange, a habit of correspondence and conversation developed rapidly if unevenly between the members of this extended group and their various interested affiliates. By the spring of 1972 a substantial corpus of written material had accumulated, addressed to a range of issues which was not easily circumscribed, but which seemed in need of some form of identification, if only so that the identity of the association itself might be reviewed by those who saw themselves as composing it. In the life of Art & Language during the 1970s, this sense of the need for a negotiable identity took various forms, including the promotion of an imaginary 'Art & Language Institute' to

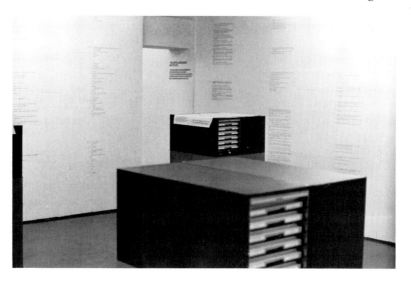

which authorship of the *Documenta Index* was briefly and strategi-
cally attributed;[3] the formation in England of a limited company
which never traded; and, some years later, the constitution in America
of an 'Art & Language Foundation Inc.', which attracted grants and
published *The Fox.* With hindsight, however, it may be said that the
effective identity of an enlarged Art & Language was discovered in the
indexing-project itself, not as a kind of bureaucracy, but as an open set
of ways and means of learning – not as a kind of artistic style with
which all contributors equally could identify their names, but as a
possibility of going-on working which was unevenly distributed and
always contingent.[4]

The commitment signalled by the *Index* was that the purposive
activity of Art & Language would be identified with the analysis of its
own idiom, its language or languages, on the evidence provided by the
accumulation of written material. What was thus proposed was not a
further historicist form of reduction in the materials of art – such as
was made by those Conceptualists who offered their own conversa-
tions, their own thoughts and even the supposed contents of their
unconscious minds as avant-garde 'least objects'.[5] The implication of
Art & Language's position was rather that, if a tendency existed such
as had been observed in Modernist theory, and if self-consciousness
and recursiveness as regards style and representation were distinguish-
ing aspects of modern art, then the consequence to be drawn was that
the analysis of linguistic idiom would have to be faced not as a volun-
tary form of avant-gardism but as a condition of modernity.

Though the world the 'Indexes' addressed was not coincident with
the contemporary world of art, the art world furnished the occasions
of their exhibition. At Kassel, the visitor to the completed installation
was confronted by eight metal filing-cabinets placed on four grey-
painted stands which raised them to a height convenient for reading in
a standing position. Each cabinet contained six drawers. Within the

drawers, typed and printed texts were fixed page by page to the hinged leaves of the filing system, so that they could be read *in situ* in their entirety (see plate 44). An initial theoretical presumption was made which allowed a given essay or paragraph-like unit to be a discrete readable text. On this basis the component writings were ordered according to an alphabetical and numerical sequence, some being subdivided into discrete fragments and their subdivisions treated as separate items.

Plate 44 *Art & Language,* Index 01 *(1972),* view of file drawer with text.

Around the cabinets, the four walls of the room were papered with a form of index, photographically enlarged from an original typescript so as to cover the entire surface available. The index listed the texts according to their alphabetical and numerical designations. Under each of some 87 separate citations the other texts were variously listed according to one or other of three possible relations to the text cited. These relations were symbolized as '+', signifying a relationship of compatibility between a given pair of texts; '−', signifying a relationship of incompatibility; and 'T', signifying that the relevant documents did not share the same logical/ethical space and were therefore not to be compared in advance of some notional transformation. An 'Alternate Map' for the *Index* was printed and issued as a poster during the exhibition (see plate 45). This was expressed in the form of a matrix, with a selection of the texts listed along the top and left-hand sides, and the relations between them symbolized at the points of intersection of horizontal and vertical axes. The matrix mapped a reading from one citation, which was transitive and reflexive with respect to eighty-six others.[6]

The names listed at the entrance to the Documenta installation were those of the *Art–Language* 'editorial board' as concurrently composed. The adoption of a principle of collective responsibility was not simply a matter of strategy in the face of public exposure. It had been an informal assumption of Art & Language interchanges from the start that the materials of discourse were open to being differentiated on more powerful grounds than those of authorship. In the design of the *Index* this informal assumption was elevated to the status of an organizing principle. It should be emphasized that acceptance of collective responsibility neither requires nor implies an egalitarian distribution of tasks. In the 'work' of Art & Language, individuals have stared at the wall, had ideas, conducted discussions and written texts. Other or the same individuals have talked to curators, organized hardware, read texts, cut and pasted pieces of paper, and so forth. In individual projects, those doing the discussing (etc.) have generally taken the lead up to the point at which decisions and actions were required which involved organizing hardware, talking to curators, and so on. Different individuals have had clear roles established by character, competence and tradition, and they have tended to act in accordance with these roles in contributions to joint projects. Sometimes people have acted out of character. The final form of an Art & Language work has not always been something which all

Plate 45 *Art & Language,* Alternate Map for Documenta *(1972),* detail of poster. *Lithograph on newsprint, overall 72.5 × 50.6 cm.*

ALTERNATE MAP FOR DOCUMENTA
(BASED ON CITATION A)

KEY TO MAP

— AT THE ORIGIN OF A VERTICAL/HORIZONTAL AXIS INDICATES A COMPATIBILITY BETWEEN THE RELEVANT DOCUMENTS CITED IN THE LEFT-HAND COLUMN AND ON THE TOP ROW OF THE MATRIX.

— INDICATES AN INCOMPATIBILITY.

T INDICATES THAT THE RELEVANT DOCUMENTS DO NOT SHARE THE SAME LOGICAL/ETHICAL SPACE.

involved could see as an achievement. The convention of collective responsibility has meant that some results have had to be lived down, others lived up to. In the specific case of the *Documenta Index,* the indexing-system itself was the initiative of Michael Baldwin. Philip Pilkington and David Rushton did some work on the logic and implications of indexing in general (and published a substantial bibliography on the theme of 'Models and Indexes' in *Art–Language,* vol. 2, no. 3, in September 1973). Others variously read texts, pasted paper and talked to curators.

Though there had been forms of 'Art & Language' participation in mixed shows since 1968 (if one counts 'Atkinson–Baldwin' collaborations as contributions by 'Art & Language') or since 1970 (if one does not), the exhibition of the *Documenta Index* was the first occasion on

which the work of Art & Language was presented as *necessarily* the work of a group of people. This is not to say that those involved achieved an ideal and unpractical form of sharing, nor on the other hand that some agreed to work *for* others. Rather, the production of the *Index* was the outcome of a process in which different people learned different things.

From the point of view of the notional spectator, the exhibition of the *Index* was also the first occasion on which Art & Language achieved a form of coincidence between attention to the materials of presentation and attention to the form of the work, such that neither was in the end left as a remainder of the other. This coincidence was achieved in part by conceiving of the spectator as a reader and potential interlocutor – and thus as the type of an engaged and intellectually versatile public quite distinct both from that constituency of detached and self-sufficient beholders which was predicated in mainstream Modernist art and theory, and from that constituency of professional and knowing curators which had identified itself with Minimalism.

The *Index* was as bland (or as slick) as it could be made in its form of presentation. To do more than merely 'look' at the cabinets and the printed wallpapering was to engage with the nature of the intellectual materials indexed and with the kinds of decisions which had been taken by Art & Language about the relations which obtained between them. The physical and logical formalities of the *Index* opened onto a world of contingencies. This effect followed from the solution of those problems which attended upon the project from the outset. These were of two kinds: those largely practical problems which were produced by the need to conceive and to realize an appropriate display; and those social, organizational, intellectual and psychological problems and conflicts which were generated by and among those individuals who now identified themselves in part or in whole with Art & Language.

The requirements upon the display were not of themselves unusual, given the conditions of large modern art exhibitions at the time: it would have to be plausibly modern according to some adequately sophisticated concept of artistic modernity; it would have to be formally self-contained, while adequately representative of the complexity of Art & Language's practice; and, since the quinquennial 'Documenta' was the most prestigious of international avant-garde salons, and since Art & Language was no freer than any other exhibitor from the urge to upstage, it would have to be striking, though not necessarily (or, rather, necessarily *not*) in the sense of 'visually' or optically vivid – the pursuit of such vividness being irreconcilable with that tendency to utter blandness which Conceptual Art had proposed as the ironic destiny of the Modernist reduction. The principal design decision was that the appearance of the indexing-system should be made compatible with the appearance of other indexing-systems – and not *prima facie* with the appearance of other works of art. If this suggests that the *Index* was redolent rather of the

office or the library than the art gallery or the museum, it should be borne in mind that metaphorical assimilation of the one form of location to the other was by 1972 an established stylistic tactic of avant-garde art. It was a cultural condition of Minimal Art, and of those forms of Conceptual Art which were closely connected to Minimalism, that powerfully suggestive forms of the iconography of modernity were generated by the furniture of multinational business and by the technology of information storage and retrieval systems. These were symbolic of that non-aesthetic world with which any modern art with pretensions to realism was required to engage at some level, and in face of which – whatever the pretended voluntarism of artists in the sphere of design – it was required to establish its autonomy. (Of course, it does not follow that all forms of display which refer to this form of the iconography of modernity can be reduced to the same stylistic or intentional category.)[7]

The problems internal to the Art & Language 'community' were no more unusual in themselves; rather, what was unusual was the attempt by a number of individuals to conceive of an artistic practice as one somehow held in common. It was clear that this conception was not to be realized simply by issuing the various productions of several people together under one group name, nor by associating several names with the initiative of a sole artistic author. What was required was a single complex form with sufficient organizing power both to dramatize the social nature of thinking and to render marginal or irrelevant the more mystifying conventions of the individuality of thinking. This would necessarily involve opposition to certain stereotypes of artistic personality and creativity, though not necessarily to other forms of idiosyncrasy or other forms of competence. The organizational and psychological problems which beset Art & Language in early 1972 were those which had to be circumvented if such a conception was to prevail. Social and intellectual problems had somehow to be subordinated to the project or be rendered capable of representation within it. Work on the *Index* was in this sense necessarily communal. In fulfilment of the task of indexing, individual interest in reading has to be adjusted to the template of a matrix.

Besides serving to focus a kind of productive activity specific to Art & Language and to its problems, the type of display paraphernalia involved in the *Index* resolved a set of problems which had bedevilled Conceptual Art from the start. Engagement with the notion of high art, and of modern high art in particular, had required that the forms of Conceptual Art be insinuated into the kinds of cultural, distributive and economic spaces occupied by other current types of Modernist avant-gardism. Given the increasing size and status of the typical exhibition catalogue, an invitation to exhibit could often be exploited as an opportunity to publish an essay. But to allow a book of essays to *stand in* for actual exhibition would be to surrender the critical power of anomaly and to submit to a form of avant-garde ghettoization. There remained the problem that the essayistic or research-like

character of Conceptual Art – and *a fortiori* of the work of Art &
Language – could normally be represented in the gallery context only
in token form. The pieces of paper on the gallery wall were in general
no more than the residues of that work, yet the tendency of the
cultured audience, still largely stuck with one ontological paradigm of
art and with one appropriate set of responses, was to scrutinize these
pieces of paper as objects of art – as 'significant', or more plausibly as
'signifying', forms – and to go no further. To quote an analogy well-
rehearsed in the conversational world of Art & Language itself, 'Set-
ting up displays is beginning to get like pointing your finger for a dog –
the dog looks at your finger.'[8] The problem was how to render the
'work' viewable in its intensional aspect, or, to pose the other face of
the problem, how to give readable items an appropriate standing in
contexts where 'viewing' was the form of activity normally presup-
posed. To exhibit notes and scribbles might be to preserve some sense
of productive informality, but it would also be to invite the viewer to
make a fetish of the authorial 'hand' – and thus to mistake the nature
of the enterprise. On the other hand, cleaned-up printed texts in place
of paintings tended either to invite wholly irrelevant associations with
concrete poetry or to declare themselves self-importantly as forms of
objectified knowledge. The resulting problems tended to bedevil con-
tributions to mixed exhibitions. Certain anxious curators of these,
faced both with the necessity of including an Art & Language con-
tribution and with their own confusions in face of the work, resorted
to framing copies of *Art–Language* and mounting them on gallery
walls – thereby at one and the same time confirming their own
stereotypes of avant-gardism and rationalizing their sense that the
journal was 'unreadable'. (Art & Language was represented thus in a
large avant-garde survey mounted in 1970 by the Museum of Modern
Art, New York. It is a nice testimony to the heuristic priorities of the
art world that an exhibition structured by such curatorial initiatives
should have been given the title 'Information'.)

Such confusions, though not tolerable, were understandable.
Similar treatment was after all appropriate enough to Conceptual
Art's various versions of the ready-made. But the form of avant-
gardism which Art & Language envisaged was not actually consistent
with the artistic 'extremism' of presenting books or essays or diagrams
to be beheld as if they were paintings. Rather, what Art & Language
proposed was that the type of disposition supposedly definitive of
aesthetic experience – a type for which the appreciative viewing of
paintings furnished the principal token – should be displaced in the
culture by another, which Conceptual Art was designed to enable and
to encourage, and which entailed a willingness to conceive of 'viewing'
and 'reading' as requiring the same kinds of cognitive capacity. In the
wider world of critical thought this may not have been an entirely
original proposal.[9] That it went against the grain of contemporary
artistic culture, however, was made clear by the surprise and hostility
with which it was generally greeted wherever there were intellectual

and professional boundaries to be protected (which is to say, almost everywhere). For example, in colleges of art where students showed an interest in the ideas of Art & Language, those with administrative responsibilities for the teaching of Fine Art tended to react nervously and even repressively to the notion that a commitment to artistic work might be fulfilled by reading and writing. At Lanchester Polytechnic in Coventry, where several members of Art & Language were teaching, the Chief Officer of the National Council for Diplomas in Art and Design was called upon in 1971 to furnish a ruling that only 'tangible, visual art objects' would be considered acceptable for submission for final assessment.[10] By such means it was presumably hoped to resolve at a stroke both the aesthetic and the ontological status of pieces of paper with writing on them. Essays would be deemed acceptable supplements to 'studio work', so long as the latter was forthcoming. Otherwise they would have to be mounted on the wall, assessed for their 'visual' qualities, and presumably found wanting. ('Art Theory' is now generally deemed acceptable as an *option* in the study of Fine Art, but the 'Art Theory' component for which Art & Language was responsible at Coventry between 1969 and 1971 was dismantled by exercise of administrative power and by the dismissal of most of those individuals who had taught it.)

The problem of what to do with the pieces of paper had been addressed explicitly in some Art & Language work of 1971.[11] The 'Indexes' suggested a practical solution to this problem, and one which served also to ensure against confusion with the Conceptual Art ready-made. They provided forms of graphic display which could be suitably tailored to the conditions of gallery exhibition, which were readable under those conditions in a way compatible with their intensional aspect, and which directed forms of attention towards other readable materials – whether or not these were features of the display. The *Index* was not feasibly viewed as a demonstration of graphic design, nor as a mere avant-garde 'object of thought'. Nor could it be seen as a simple repository of text from which stable interpretations could be continuously elaborated. Rather, it was a device with the power to place a vast range of *absent* text within its own margins, and thus to transform, even to threaten, the status of its contents. 'One of the things I recall being interested in', wrote Michael Baldwin, 'was the way it might have killed the "edges" of artworks; viz. you could be doing the work and not know you were doing it – or could you?'[12] As a work which was bounded neither by the identity of an individual author nor by its singularity as 'concept', the *Index* gave practical expression to a didactic intent: that the art of Art & Language should be seen to be made *of* ideas and not *by* personalities.

As implied earlier, although the pursuit of Art & Language projects was as often vexed as one might expect by organizational problems and by conflicts of personality, a form of control was already provided by shared commitment to production and publication of the journal *Art–Language* and to the generation and circulation of other texts and

theoretical materials. The *Index* served to represent this commitment in the form of an accumulation of written material, for which *Art–Language* furnished the core. The texts included in the filing-cabinets were the collected contents of the journal and of its virtual offspring *Analytical Art*, together with other published and unpublished writings by those variously associated with Art & Language. Though the status of 'texts' as 'art-works' had been much discussed in avant-garde circles since 1967, and though the production of Art & Language had been both central to the issue and at times explicitly addressed to it,[13] no distinction was made in the *Index* between writings presented as 'art-works' and writings presented as 'essays'. In a sense, the form of the *Index* seemed to leave the issue for dead. The expressed concerns and critiques and theorizings of some five years – coincidentally the five years of 'Conceptual Art' – were now treated as working-materials and their contingent aspects located in the margins of a new system.[14] With each component text read in relation to every other, and with each of the resulting relations expressed in terms of one of the three specified alternatives, a relatively 'abstract' form was drawn across a complex network of ideas, beliefs, assertions and speculations – and, incidentally, across whatever personal forms of social, intellectual or psychological investment the authorship of a given text might betoken or conceal.

Superficially it might seem that the mapping of the *Index* laid the grounds for a kind of orthodoxy. Those texts which were listed as compatible with a majority of others might be seen as relatively orthodox, those incompatible with a majority as unorthodox, and those incomparable with a majority as eccentric. But within the *Documenta Index* no one citation was privileged over any other, nor was any principle of transitivity applied. Decisions about the relations between each text and each other were made *ad hoc* on the basis of reading. The aim of the *Index* was to produce a system in which a diagrammatic representation of these decisions was faced as a model of the sorts of connectedness there might be between various texts. The work was an attempt to map a form of conversational world, and to find a representation, however schematic, of a place where meanings could be made. It was not intended that evaluative decisions should be taken about the implications or 'meaning' of any individual text *per se*, or about the kind of ideological space the *Index* might be seen to define. Once the assemblage of materials was complete within relatively informal limits, each component was in principle accorded the same status as any other. The task of reading was to fulfil commitment to a problem-making system, and the system was not such as to allow exclusion or inclusion to be decided by preference. It was designed not to discover what was 'in' or 'out' for Art & Language, but rather as a means to learn what Art & Language was into or out of.

In fact, though the initial curiosity of those working on the *Index* might have been drawn to the findings of compatibility or

incompatibility *vis-à-vis* one text or another, and thus to the geography of internal agreement and disagreement, interest in the prospect of continuing work tended to centre rather upon those problems of translation across logical and ethical boundaries which were flagged by the relation of 'transformation'. The orthodoxies of our conceptual apparatus are reflected in those normal principles according to which we group linguistic and other items into commensurables and exclude others as incommensurable. The fragments (a) 'I like' and (b) 'tomatoes' are compatible in a way that the fragments (c) 'Give me a' and (d) 'potatoes' are not. In this case the matter is decided by adherence or non-adherence to grammatical rules, irrespective of anyone's taste in vegetables. The fragment (e) 'X loathes the sculpture of Anthony Caro' is potentially compatible with the fragment (f) 'X loves the painting of Fra Angelico', but not with the fragment (g) 'X loves the sculpture of Anthony Caro'. The principles of consistency which apply here are rational rather than grammatical. But what of the three fragments (h) 'The painting of Kenneth Noland is extremely beautiful', (i) 'The criticism of Clement Greenberg is admirable' and (j) 'Football is a matter of life and death'? A common-sense decision would be that (h) and (i) are compatible, and that – at least within that world in which their compatibility is accorded some significance – (j) has the status of a noise off, an outburst from another world which just happens to be overheard. Yet, if we were to transform the context of conversation such that (h) was forced into adjacency with (j) – if we assumed the possibility of their co-occurrence within the *same* conversational space – a different *decorum* of 'conversation' would have to be envisaged, and no doubt a different kind of outcome. The concatenation of incommensurables is generally a prescription for meaninglessness or hiatus. But it is also an occasionally fruitful stage in the critique of ideology, not least where the boundaries transgressed are those which protect principles of rationality, ethical systems and cultural protocols.

Analogues for the indexing-project are to be found along that borderline between the study of artificial intelligence and the theorization of mind and memory which has enlarged into a distinct field of research since the 1970s. In typical work in this field, forms of knowledge are represented in terms of such devices as 'semantic nets' and 'frames' – which are kinds of index. The aim of theoretical systems hypothesized in this field is not that they should be subject to criteria of logical orthodoxy, but that they should adequately model the open operations of human remembering and learning.[15] The analogy with such systems also serves to distinguish between different forms of Conceptual Art: on the one hand, for instance, the art of the intellectual ready-made, in which ideas were treated as immutable objects and the art world as a kind of system in which these objects were to be installed; on the other hand, works which required as a condition of engaging adequately with them that not only they themselves, but also the structures within which they were located, should

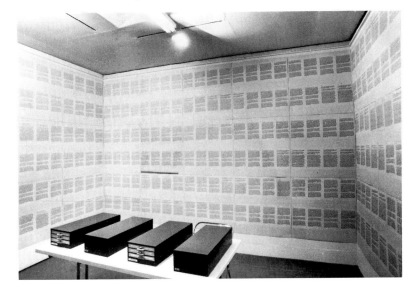

Plate 46 *Art &
Language*, Index 02
(1972), *installation at
Lisson Gallery,
London. Four file
cabinets, texts and
photostats, dimensions
variable. Collection
Annick and Anton
Herbert, Ghent.*

be seen as problematic, so that the mutual relations between 'work'
and 'structure' might be rendered dynamic and transformable.

While what became designated as *Index 01* was still on show at
'Documenta', *Index 02* was produced for exhibition in 'The New Art'
at the Hayward Gallery, London (see plates 46 and 47). Where in the
former version decisions about the connectedness of texts had been
taken informally, the latter was subject to a principle of consistency.
Those supposedly rational desiderata of transitivity and symmetry
which had been explicitly excluded in the design of the *Documenta
Index* were applied in this second version to produce an alternative
picture of a kind of 'identity'. The requirement of symmetry was that,
if text A was compatible with B, then B was assumed compatible with
A. (*Index 01* presupposed an *order* of reading; *Index 02* did not.) The
requirement of transitivity was that, if texts A and B were judged
compatible and if text C was judged incompatible with A, then text C
was assumed also to be incompatible with B, and so on – this irrespec-
tive of the supposed intentions or dispositions of individual authors.

The completion of this formal system established still further dis-
tance from the specific contents and occasions of the original texts in
the drawers. One requirement on the resulting representation,
however, was that the form of display should not camouflage its
explicit reflexiveness as a form of immaculate *culture* – that the
relatively rigorous form of the installation should not endow the tex-
tual fragments themselves with a spurious logic or objectivity. In the
conventions of semiotics, an indexical sign is one which is tied to its
referent through some process of cause and effect, as smoke is a sign of
fire, or a footprint a sign of someone's passage. It could be said that
the demand of explicitness made of the *Index* was a *strong* require-
ment of indexicality: that what it signified should be determined by
what had happened, been written, been said and so forth, irrespective

Plate 47 *Art &
Language*, Index 02
1972, *detail of wall
display. Photostat.*

of any lack of elegance in the material involved.[16]

The display was not feasibly considered either as the manifestation of some problem-solving achievement or as a form of felicitous collective 'expression' in any psychological sense.

> A lot of us are more likely to be nearly omniscient than just one: this may be a quasi-assertion [or] logical formulation of the axiom, 'You can't fool all of the people all of the time', not of the axiom, 'Two (or more) heads are better than one.'
>
> There is, in the institute, no concern with 'expression' – the idea of the pursuit of a psychologistic relation – even with the public. The problems of the 'life-world' are more or less ad hoc.[17]

The invitation was to observe meanings being generated, not to aestheticize their significance. A 'meaning' within the context of the *Index* was not a fixed and Archimedean point from which the world might be considered; rather it was a point on a lattice, or a moment in a network of relations. It was in thus abstracting the form of a contingent conversational world that the *Index* both addressed the practical problems of Art & Language production and presupposed a certain kind of public for that production (however indifferent Art & Language may have been to the psychological aspects of its relations with that public).

Of course, this imagined public was not simply to be conjured into being on such occasions as 'Documenta', nor were its representatives likely visitors to the Hayward Gallery in the early 1970s. The very improbability that the *Index* would be competently read in such locations was not simply a measure of its ontological anomalousness as art. It was a consequence of those wider disjunctions which condition expectation and evaluation in the broad field of the arts: disjunctions between 'thought' and 'imagination', between 'reading' and 'experiencing', and between 'language' and 'pictures', that were and still are characteristic and structural features of the culture as a whole. To envisage a public emancipated from this structure of conventional antitheses – and to presuppose such an audience in the design of work for exhibition – was only in a trivial and circumstantial sense to adopt an avant-garde position. More significantly, it was to insist on the contingency of the disjunctions and on the possibility and desirability of their being overcome.

In the world of modern art, however, the structure of antitheses is accorded a particular value. The predictable response of the normally conditioned spectator of the *Index* was still to mistake the strategy of display for the intentional character of the work. The conditions of frustration of a rehearsed rhetoric of consumption were taken for the signs of an aggressive orthodoxy. The critic of the London *Sunday Times* no doubt spoke for the perceptions of many in labelling the

Documenta Index 'a Stalinist reading-room'.[18] In fact, the conception of learning as a form of search and interaction within an open system, which is what the *Index* represents, is maintained in direct opposition to forms of orthodoxy and dogma. But certainly, if the *Index* implied identification with some kind of 'place', it was a place more like a kind of reading-room than it was like the artist's studio as normally conceived – conceived, that is to say, as a crucible of invention. In the history of modern art there have been various calls to extend the reach of artistic activity beyond the confines of the studio. In the Modern Movement of the 1930s the artist was proposed as the type of the ideal planner. In the utopian artistic culture of the later 1960s and early 1970s (and in the careers of such figures as Joseph Beuys), the individual creative activity of the artist was often proposed as the ideal model of all productive activity. Such notions tend to depart from an *aesthetic* conviction of the meaninglessness of other lives. The aspiration of the *Index*, as an enterprise addressed to some notional public, was rather to assume the possibility of a place of work, to identify the place of work with a model of the social, and to represent that model as a form of art. Of course, this is not to say that any form of activity which was a form of work could somehow be represented in the terms of the *Index*. But it is to claim that other forms of work than the 'artistic' could be admitted into its intellectual and organizational margins, alongside other forms of text, without its autonomy having to be either compromised or defensively reasserted. In this sense – and in so far as the movement of Conceptual Art can be identified with the Benjaminite aspiration to admit and encourage spectators into the position of collaborators[19] – the *Index* was the summary work of Conceptual Art.

A logical implosion

What followed from the making and exhibition of the 'Indexes' of 1972 was referred to within Art & Language as a 'logical implosion'. There are two ways in which this process might be explained. It could be said that the pursuit of the indexing-project led to an increasing concentration upon the generation of meaning within a kind of community – a community defined in terms of what its members learned from one another. It is certainly true that Art & Language became much preoccupied with the analysis of its own idiosyncrasies and its own idiolect. In the early years of Conceptual Art, critical tools and materials of paradox had been furnished for Art & Language by the tradition of analytic philosophy. The resulting work was widely seen as sterile. It was indeed sterile. The confused discourses of art had been isolated from the world of art and subjected to forms of logical scrutiny and ironic paraphrase. Now, however, the implications of the indexing-project led rather towards pragmatic and situational considerations. The appropriate intellectual tools were found in that

family of methods and inquiries which includes linguistics and modal logic, and the semantics and pragmatics of natural languages, while the materials processed were the terms and contents of Art & Language's own conversations and arguments. The realities and absurdities of art and of artistic life, of 'Being' and socialization – both within Art & Language and between Art & Language and the world – were subjected to those paradoxes imposed upon them by the formal completion of various indexing-systems. Most Conceptual Art was *primitive* art, in the sense that it was 'made' of words and 'ideas' which were the unattainable stylistic and intellectual property of the art world's betters. The tendency of Art & Language was to treat the concept of intellectual property with a prodigal irresponsibility, while refusing the notion that artistic practice might be offered as an alibi for intellectual inadequacy. The territory of linguistics and the philosophy of language was viewed as a terrain of *empirical* investigation. There were abortive attempts to produce a 'Thesaurus' and a 'Lexicon'. The aim of such projects was not, as was widely assumed by commentators, to 'do philosophy' as 'art' – as if philosophical problems and protocols were forms of intellectual ready-made for which avant-garde status could be claimed by those with credentials as artists. Nor was it a matter of reading one's way out of trouble. Rather the reverse. Art & Language was obliged to generate theory where there seemed to be none: to conceive a representational practice in a world which appeared composed entirely of misrepresentations; to proceed so that there might be materials to proceed with. The relation between 'technical' and social or existential concerns was suggested in an introductory note to *Index 02*: 'Indexing problems . . . are coincident with the difficulties encountered in mapping the space in which our conversation takes place.'[20]

At one 'extreme' of an index are its atomical components – forms of idiomatic expression: sentences, phrases and words used in certain ways and in certain contexts, bearing a certain meaning and serving a certain use. At the other, macroscopic 'extreme' of the index is that ideological world within which it is itself located, and through which the idiomatic expressions are absorbed into an ever-expanding fringe of other discourses. The second form of possible explanation of the 'logical implosion' following the *Documenta Index* is one which would draw attention to the wider conditions under which the need for theoretical materials was experienced. Such an explanation would connect the apparent exhaustion of Modernist culture and the various forms of reduction by which it was characterized to the broader conditions of productive life at a time of gathering reaction. The political culture of the later 1960s – at least as it was understood by the middle-class liberals of the Western world – was distinguished by its emancipatory claims. In so far as the emancipation envisaged was a form of *cultural* emancipation, these claims were sustained by – or were sustainable in the face of – a long economic boom. The end of the 1960s marked the end of the boom, and in this sense marked the

inception of those conditions of retrenchment by which the emancipatory claims were to be rendered clearly unrealistic. The apparent defeat of the radical student movements, for instance, seemed to leave exposed to sceptical view the very idealism which had sustained them. (In some retrospective analyses this defeat or demoralization has been seen as coincident with failure of the project of Modernism. The coincidence is only significant, however, if student political activity and Modernist culture are both characterized as 'experimental'; that is to say, only if they are viewed, as they are in the fantasies of the political right, as notionally dangerous though actually trivial.)

In the field of industrial relations, however, the period of the early 1970s was a time of gathering militancy in the face of crisis. In Britain alone, the period saw the defeat of a proposed Industrial Relations Bill, the freeing of the Pentonville dockers, and two successful miners' strikes culminating in the overthrow of a Conservative government. The same period saw an increasing politicization of intellectual life as the rhetorical structures of the Cold War were both opened to view and reimposed. Art & Language had not been caught up in the political idealism of the late 1960s, but it was certainly affected by the politicization of intellectual and artistic life which followed defeat of those ideals, and indeed was to have its own contribution to make to the theoretical analysis of political alternatives – and to the drawing of implications for the practice of art. Though the negotiable public space for modern art appeared to be expanded during the early 1970s, claims for the expansion of art's expressive range rang with increasing hollowness. To stand back from the world in which such claims were made and admitted was to notice how deeply rooted they were in a context of commitments and interests – the more deeply, it seemed, the more loudly an aesthetic privilege was claimed, *vis-à-vis* the social, for that which was uttered as art. In any practice aspiring to realism, the determining effects of these commitments and interests would have to be taken into account – and that taking-into-account would have to be a systematic part of the practice itself and of its means of self-scrutiny and self-criticism. The 'logical implosion' was thus also a form of ideological self-examination. Art & Language has retrospectively viewed the 'content' of the 'Indexes' in these terms.

> One of the things we became aware of in '72–3 was that our activity might have to function in terms of massive indexicality; we approached the problems of our own context and (unacknowledged?) interests: the kinds of entailments that might exist in our social system exemplified as conditions in ideological fragments. These ideological fragments were exhibited as determined by massively complex practical (dialectical) pathways and quasi-orderings.[21]

These two forms of explanation of the 'logical implosion' may be

brought together and clarified by means of analogy with a relevant controversy in the philosophy of science. In his book *The Structure of Scientific Revolutions* (1962) Thomas Kuhn challenged Karl Popper's influential account of science as a form of shared 'thought'.[22] Instead, Kuhn proposed a view of science as shared material practice. That is to say, he suggested that the cognitive authority of science was vested not in the intellectual rules and principles which govern scientific inquiry, but rather in the constitution of that scientific community which recognizes, ratifies and validates the results of inquiry. In a Postscript added to the 1970 edition of his book Kuhn further explored the implications of this suggestion.[23] He pointed to the need to study what he called 'the community structure of science' and to 'the need for similar and, above all, for comparative study of corresponding communities in other fields'. He concluded, 'Scientific knowledge, like language, is intrinsically the common property of a group or else nothing at all. To understand it we shall need to know the special characteristics of the groups that create and use it.'

Like Popper, Kuhn was concerned with the nature of change and development in science and in scientific knowledge. But to Popper's view of the gradual and rational formation and correction of hypotheses he opposed a more catastrophist picture: at moments of 'scientific revolution' there is a 'paradigm shift' as one set of conceptual models is replaced by another; this is followed by a period of 'communication breakdown' within the practice of science, before a consensus is established in favour of a new set of paradigms. In his Postscript, Kuhn expanded upon the conditions of such a breakdown:

> What the participants in a communication breakdown can do is recognize each other as members of different language communities and then become translators. Taking the differences between their own intra- and inter-group discourse as itself a subject for study, they can first attempt to discover the terms and locutions that, used unproblematically within each community, are nevertheless foci of trouble for inter-group discussions. . . . Having isolated such areas of difficulty in scientific communication, they can next resort to their shared everyday vocabularies in an effort to discover what the other would see and say when presented with a stimulus to which his own verbal response would be different. . . .[24]

Clearly, the explanation of change and development in art could be conceived in very similar terms. It is not hard to imagine how the concepts of 'paradigm shift' and of 'communication breakdown' might be used in an art-historical account of the later 1960s and early 1970s. The relevance of the analogy is not simply a *post hoc* matter, however. A 'language community' was just what the indexing-project

had shown Art & Language to be. Kuhn's book and his Postscript had been discussed in Art & Language seminars at Lanchester Polytechnic during 1971, as had the published contents of the symposium *Criticism and the Growth of Knowledge*, to which Kuhn and Popper had been contributors.[25] Over the following two years Kuhn's work furnished pertinent ways of describing and theorizing the implications of the indexing-project as they made themselves felt in Art & Language's practice. Above all, Kuhn offered a means of conceiving of the relationship between self-criticism and the development of practice which was grounded in the contingent behaviour of actual agents, and which was thus free from the reductivism and historicism of the Abstractionist account of Modernism. By analogy with Kuhn's view of science as shared material practice, a form of autonomy could be thought up for the practice of art (or of Art & Language) without social and situational considerations having to be ruled irrelevant either to its conduct or to the explanation of its development. Furthermore, reasons could be entertained for doing different kinds of work which were not simply avant-garde positions or stylistic attitudes. It may well be that Kuhn's book also had an organizing function among some students interested in the work of Art & Language. On the one hand it suggested that those put in authority over us are as dispensable as we are. On the other, it offered grounds for confidence in trying things out and trying things on.

The analogy with Kuhn's view of science helps to explain why it was that, after *Index 01* and *02*, the emphasis of the indexing-project shifted away from the exemplification of quasi-logical relations between items of text towards a form of modelling of processes of learning and socialization. Viewed as the symptom of a kind of Kuhnian crisis, the logical implosion entailed a form of sociological contextualization. After the completion of *Index 02* in the summer of 1972, the second type of index developed by Art & Language was one in which the spectator was invited to map the pattern of his or her interest as it determined the process of reading from one item to the next – or, we might say, as it determined the process of learning.

This index was exhibited in three different versions, each of which had three basic components: a body of microfilmed text assembled from Art & Language writings and transcripts, divided into sections with each ascribed a letter in alphabetical sequence; a list of topics numbered from 1 to 16; and a computer print-out listing the kinds of relations which could hold between items under certain topics and assuming the operation of some form of interest (see plates 48 and 49).[26] Thus the reader could start with a piece of text, attempt to read it in the light of the topic ascribed to it, and then proceed to another text, to which another topic was ascribed, and so on. The form of the index formalized a string of decisions as to whether the reader could thus concatenate one text with the next – that is to say, whether he or she could or could not join them together as links in a chain of meaning and thus 'go on' from one to the other. Each string in the

Plate 48 *Art &*
Language, Index 05
(1973), instructions for
reading the index.
Collection Philippe and
Carine Meaille,
Luxembourg.

ART AND LANGUAGE

01 (c)
Select a topic of interest from the
'topic list' (02) and find a place in
the text (on microfilm) that's index-
ed by that topic number. The index
set of each concatenatory unit (ex-
pression) is potentially the topic
set whose several members are
designated '1' - '16'. Each line
of the (microfilmed) index can be
read as listing possible relations
of 'going-on' (e.g., A to B, B to
C, etc.) in discourse. The num-
erals '1'...'16' refer to the items
in the topic list. 'x' is a bound
variable substitutable for a term
designating any relevant pair of
items of the text which instantiate
the relation A to B...etc.

No textual items are named in the
index... it merely lists the kinds
of item (relational individuals) that
can be considered together in relat-
ion to one another.

Select a concatenation expression
that seems promising (as a relat-
ion). You can continue to uncover
figure-ground circumstances with
respect to the grammar (logic) of
concatenation by trying to map the
continuance of a concatenation rel-
ation with respect to your interest
(hence selection) of either a topic
or an item of text. You are cons-
idering the sets which are the life
conditions of your interest(s).

Topic List (02 (c)
1) Idiolect
2) Ideology
3) Ideology revision
4) Interest
5) Technology/Bureaucracy
6) Modalities
7) Pragmatics
8) Situations...Guessing who...
9) Socialization
10) Indexicality
11) Going on grammar
12) AL Teleology
13) Community presuppositions
14) Good faith, bad faith
15) Darwinian descent
16) History/Methodology

index covered sixteen possible consecutive relations between one item
or 'reading' and the next, each of which could be positive or negative
with respect to going-on. Thus, if item A was read under topic 1 and
item B was read under topic 2, A and B could or could not be con-
catenated, and, if item C was read under topic 3, B and C could or
could not be concatenated, and so on up to sixteen possible con-
catenatory relations. The decision as to whether or not it was possible
thus to proceed at any point from one item to the next was seen as
relative to the interest of the spectator/reader. The reader was invited
to search the index for a 'string' of positive/negative concatenation
relations which matched his or her 'reading' of or interest in the
material presented, attempting to follow either a sequence of texts *or*
the development of a set of topics. According to the accompanying
instructions,

You can continue to uncover figure-ground circum-
stances with respect to the grammar (logic) of con-
catenation by trying to map the continuance of a
concatenation relation with respect to your interest in
(hence selection of) either a topic or an item of text. You
are considering the sets which are the life conditions of
your interest(s).[27]

Plate 49 *Art &
Language,* Index 04
*(1973), fragment from
computer print-out.*

To cite these instructions is to raise a final cluster of questions about
the 'Indexes'; or perhaps it is to point towards a single problem area
which may be approached in a range of different forms. Who is this
'you'? To whom were the 'Indexes' in fact addressed? Can their effects
be quantified? What forms of interest did they attract at the time? Was
their intentional character retrievable, and if so by whom? I volunteer
no precise answers to these questions, but rather offer three assertions
from which forms of answer may be extrapolated. The first is that for
those who worked on the indexing-project the interrelations of 'art',
'work', 'thought', 'learning' and 'society' were decisively though
variously illuminated and transformed. The second is that the pursuit
of that project was associated, in some causally significant though not
causally mechanical fashion, with substantial changes in the composi-
tion of the Art & Language 'community', changes which included
considerable if temporary extension of its notional membership. And
the third is that, though the public as imagined within Art & Language
was not a mere extension of some collective self-image, neither was
that public conceived as a form of everyman.

The Conditions of Problems

*How is it possible to be clear, when the problem of the
erotetic (questioning) framework is such as to inhibit the
express formulation of 'our' problems? . . . We are look-
ing for the conditions of problems . . . questions.*
Art & Language, *Proceedings 0012 Child's Play*

Background

CONDITIONS OF WORK

Different forms of art represent different types of relation to the
prevailing social order. This is virtually a truism. How else are we to
attach significance to the differences between different artistic forms if
not by noticing varieties of connectedness to the formalities of human
existence? The evidence of modern history is that, at any given
moment in the advanced society, complex relations will obtain
between, on the one hand, contingent forms of social and political
organization and, on the other, those imagined grounds of autonomy
according to which certain enterprises are singled out as 'artistic'.

The structure of these relations is not static. It may be that, under
conditions in which the social and economic grounds of the practice of
art are clearly prepared or prescribed, technical and aesthetic cate-
gories tend to be seen as constant, aesthetic criteria and criteria of
competence tend to be derived by reference to an unquestioned canon,
and the relativity of the autonomy of art remains an uncontentious
matter. Indeed, it seems that under such conditions this very constancy
is what art tends to 'mean', so that sooner or later in every typical act
of enthusiastic criticism the individual work of art is made the bearer
of eternal, or abiding or unchanging values. But at moments of

Whether there exists, or has existed an *ideological* person (an ideological/problematical person) . . . whether all are . . . or no-one there is no prospect of deciding. There is no proposal that the issue be decided . . . but we must be permitted to sit *here* and consider the (defeasible) conditions of an ideology – how such an 'ideologue' might conduct his dialogue/activity . . . life . . . without in a speculative fashion committing ourselves to the paralogism of inferring an object of contemplation from sets of postulates, much less concluding from our hypothetical thinking that it's *ourselves* as a well-formed set . . . by virtue of the alleged identity of cognition and the prospect of quantifying.

. . . Anyway, what we do is not so personal or anthropological as to say (to) of anyone that he is an ideological (religious?) person . . . neither do we deny (to) of anyone that he is ideological. We establish the possibility that everyone can have ideology . . . confront an index/indices – with the exception of those who simply *can't* be afflicted.

How else can we be suggesting a learning/teaching in respect of the unsaid? . . . The bedlam (pandemonium) of the said must constitute the sets of points of reference of the unsaid.

How is it possible to be clear, when the problem of the erotetic (questioning) framework is such as to inhibit the express formulation of 'our' problems? . . . We are looking for the conditions of problems . . . questions. Why Bxal and all that? We assume that intra-AL space dialogue possibilities are not that simple. . . . Copernicanism versus a black-hole?

There's the problem that 'going-on' (concatenation is a partial formalism of this) is what pervades our experience from the inside. . . . It might also be said to be the only rigorously accessible principle of any culture (learning). How would you map determinism in your life with that thought in mind?

The Bxal (etc.) situation is a friendlier climate than other schemata can be 'Experience' (i.e. that which linguists call 'mere', try to iron-out, etc.) doesn't have to come to terms with the CO_2 atmosphere of other schemata (in use, or putatively use/mention). It (or rather its permitted-operations-specification) is amenable to the absorption and also the capturing of that experience's discontinuity together with requisite formalizing continuity.

Bxal can catch a lot. . . The limit is expressible, not expressed – it can't specify *one* idiolect or language. What it can do is remind one of certain global conditions of any 'communication'. This prima facie involves the revision of ideology, e.g. in no circumstances is discourse (communication) semantically neutral, in fact it's not semantic (cf. para. 2). Academic logic is just the quack proprietory medicine – a reliever of recurring symptoms.

We, in manipulating Bxal, and each other (in the AL asylum), are merely suggesting what it might be like to have any index . . . which is not an object of contemplation. Pace Lukacs, 'the icy finality of criticism in the dialectic is only the margin of (our) index (soul) contents.'

Plate 50 *Art & Language,* Proceedings 0012 Child's Play *(1973–4). Photographic print in two parts, dimensions variable. Private collection, Paris.*

transformation, when the social ground of art is a matter of uncertainty and contest, the canons and the principles of autonomy by which artistic practice is defined as such themselves become matters of controversy, as do the relations of mainstream and margin, of high art and low or popular art, of fine art and applied art, and of art and language. At such moments the notional constancy of technical and aesthetic categories appears retrospectively as a form of conservative illusion, while the unquestioned canon and the uncontested autonomy of art are reidentified as the interested constructions of a dominant order – an order interested, that is to say, in nothing so much as its *own* constant existence.

These 'moments of transformation' are not to be defined in terms of the psychological events and processes of the artist. The critical perceptions which accompany them are perceptions of a world of differentiated practices and powers, and these must at some level be capable of being indexed to forms of social and political organization. In the historical culture of the West, it is from the second decade of the twentieth century that we principally derive our sense of what such moments of transformation are like. Discussion of the relations of artistic and social change tends still to refer to this period for vivid illustration. However, it is not so much that the relations in question are well understood and securely theorized, rather that the *coincidence* of artistic with social change is dramatic and unmistakable during that period which includes the First World War and the Russian Revolution. The *causal* relations of artistic and social change remain matters of confusion or of dogmatic prescription. It is only in flagrantly idealistic views of history that 'revolutions in art' are supposed to precede social changes. On the other hand, we have no particularly strong or interesting theory in the light of which to examine the cultural consequences of *gradual* change.

One thing should be clear: though the fuzzing of media categories tends to accompany various attitudinal forms of avant-gardism, transgression of the culturally entrenched grounds of artistic autonomy is not an *option* for the individual artist in the face of history. It may be that one can do anything and name it as art, but significance will not attach either to the doing or to the naming in the absence of some strong conditions determining both. Our namings are empty, that is to say, unless they are such that the material world offers the possibility for their displacement and ruin. In turn, our commitment to a causal and material existence is empty unless it is such as to be threatened by our namings. 'Representation heedless of its status as practice is as sterile as practice ignorant of its condition as representation' (Paul Wood).[1]

In the absence of some intension for art, the once avant-gardist idea that 'If someone calls it Art it's art' ('Don Judd's Dictum')[2] leaves the world very much as it was. On the other hand, systems of valuation of art's intensional character have recently been associated, from certain forms of social-historical position, with a kind of elitist mystification

of art. Yet without the operation of some axiological principles it is hard to see how the idea of art is to be protected from collapse either into an indifferent vagary or into equivalence with whatever anyone happens to find virtuous at a given moment. Philip Pilkington and David Rushton addressed 'Don Judd's Dictum and its Emptiness', in a written contribution to an Art & Language seminar at Coventry in 1971:

> The intensional object is an object for all its lack of dumb material status. 'Conforming to what axiology?' may be the immediate question to answer. 'Axiology or Value-Theory began as the tailpiece to Ethics, but it arguably ought to end as the tail which wags the dog, which by illuminating the ends of practice alone makes the prescription of norms for practice itself a practicable undertaking' (J. N. Findlay, *Axiological Ethics*). 'Artist' is in some degree a professional distinction which we may hold out for, as opposed to an ostensive definition. The simple nomination of an object as art appears sufficient qualification of that nominating agent as artist, [but] the promiscuous use of this causality on an extensional and intensional level could endanger the historicity and meaningfulness of art. The fact that 'artist' is not axiomatically defined is no reason for its not being ... axiomatically defined.[3]

It does seem that an imaginative concern with the possibility of transformation – or, to give it its negative designation, a sense of alienation – may serve to determine the practice of art on grounds which are not merely psychological but ethical. The person 'detached from the official beliefs of his class'[4] – who need have no other of the qualifications of a political revolutionary – may find him- or herself working outside the terrain of established practices involuntarily, because within that terrain intentional activity – doing, doing with some sense of historicity, *and meaning the doing* – has become impossible for a multiplicity of reasons. The implications of this exile will then have to be faced as incidences of technical problems. That is to say, the impossibility will be discovered and explored empirically, through complex kinds of failure in practice. Forms of iconoclasm and iconophobia will tend to follow as quasi-logical consequences of the intuition of change, and resources will have to be discovered which are not irredeemably associated with an unacceptable *and now unpractical* status quo.

To say this much is to assume that some meaning of the ethical can be strongly associated with some set of norms for the practice of art; or at least that a meaning of the ethical can be realized in the establishment of some such set of norms. Clearly, the relationship between forms of socio-political nonconformism and forms of transgression of artistic technical boundaries is one which works both ways. To occupy

a form of working space and to require a form of individuation and distribution of one's production outside those forms which are automatically sanctioned by the prevailing socio-economic order is to face questions about the principles of autonomy by which products, practices, professions and careers are defined as such; that is to say, it is to face questions about the character of one's activity in the world, and about the grounds upon which criticism of that activity is to proceed.

The period of the late 1960s and early 1970s seems to have been one in which the capacity to face such questions was a condition of non-trivial avant-gardism in the visual arts. According to the view of the mechanisms of change so far sketched out, though these questions may have appeared as matters of definition and demarcation among the tendencies and objects of art itself, and though these tendencies may themselves be accorded a certain autonomy, the specific form the questions took must have been largely decided by the impetus of more substantial historical, sociological and epistemological problems. I do not mean, however, to associate the avant-garde art of the late 1960s and early 1970s with a revolution which never came – with the form of 'revolution', for instance, which was widely propagandized among radical students and others on the cultural left in the heady days of '68. On the contrary, I propose that both the avant-garde art and the avant-garde political agitation may be seen, with the acknowledged benefit of hindsight, as symptomatic and causally related though not equivalent forms of resistance to a revolution-in-being of another kind; that, despite the political militancy of the early 1970s, what was *in the end* ushered in by the 'moment of transformation' which was the historical context of avant-gardism was that form of the 'Postmodern' over which the likes of Mr Reagan and Mrs Thatcher were to preside. I mean further to suggest that this (ideological) form of the Postmodern was not a form of critical succession to the aesthetic culture of Modernism, but rather the means of unaesthetic continuation of Modernism's hegemonic aspect. Lastly I mean to suggest that the historical conditions of that continuation were, for some of us, conditions of the *impossibility* of going-on in any manner which was just artistically continuous.

Behind these suggestions lies a subtext of assertions. Though I hope that these assertions are readable from the foregoing essays, I make them explicit here in recapitulation, the better to establish the grounds of a continuing discussion.

The *first assertion* is that, if Modernism is not to be an entirely arbitrary term, it must designate some qualitative and not just quantitative presence, however radically difficult to locate and to articulate this presence may be in the contingent ideological circumstances of the modern.

The *second assertion* is that the dialectical and dialogical character of Modernism (as sketched in the first of these essays) is

established practically through some real dialectical process – or, more particularly, through some 'Greenbergian' procedures of self-criticism – and through the saturation of technical by moral concerns.

The *third assertion* is that both the qualitative presence of Modernism and its dialectical and dialogical elaboration are distinct from the cultural accretion of support structures, institutions and institutional systems of evaluation within which both are represented.

The *fourth assertion* is that this process of representation by and through the cultural and institutional apparatus involves systematic mystification and occlusion – misrepresentation – of the very virtues of that which is apparently sponsored. This systematic misrepresentation is the hegemonic aspect of Modernism.

The *fifth assertion* is that to perceive the *difference* between the qualitative presence of Modernism and its hegemonic misrepresentation is to find that the cognitive conditions of one's practice are critically and involuntarily transformed. The perception, that is to say, is a perception *in practice*.

The *sixth assertion* is that some – though not all – forms of *soi-disant* Postmodernism are *not* post-transformational practices in this sense, but are rather forms of perpetuation and exploitation of the misrepresenting structures.

In face of an analysis along these lines, and given the circumstances referred to above, talk about the incipiently revolutionary character of art tended to sound crass during the later 1960s and early 1970s. Following the account so far offered, and at a relatively trivial level of assertion, we might say that forms of 'critique of the art object' were widely practised in avant-garde circles in the later 1960s, and that the implications of these critiques were faced by some during the early and mid-1970s. We might restrict the reach of explanation by referring to an agenda of questions established in Minimal Art and pursued in Conceptual Art, or we might go further and associate the 'critique of the art object' with a broader form of dissent; a dissent from those aesthetic presumptions which were the regulating protocols of an institutional Modernist culture – if not of all forms of modernism in art. The point is, however, that such accounts remain unsatisfactory – and uninteresting – as forms of explanation while they still presuppose a world of individual artists choosing between 'positions'. What did it actually mean, we should ask, to perceive the culture of modern art merely or importantly as a hegemonic system of beliefs about modernity and the artistic, and to conceive of that system as defeasible (that is to say, as capable of being logically if not practically overthrown)? What empowered the intuition? What was it like? Like feeling a perturbation, perhaps, in that deep historical fault upon

which the system of misrepresentation had been located in the nineteenth century, and along which it was extensively developed during the twentieth. If so, the form of movement involved would clearly not be one which was subject to the wilful control of individuals, though the sense of it would no doubt affect their subsequent actions.

THE POSITION OF THE WORK

The modern practice of art has had to be pursued in a welter of misrepresentations, in a world in which every supposedly civilizing cultural form appears sooner or later, in a different aspect, as the obverse of a brutal power. In this world the meaning and value of modernism are matters of continual contest. Between the qualitative and the quantitative presences of Modernist culture, between the established categories of fine art and the overlapping categories of popular forms and marginal practices, between assent to the established forms of the aesthetic and dissent from the established forms of the political, a type of artistic half-life has been sustainable which is the mode of being of a continuing 'crisis of modernism'.[5] The history of modern art is sometimes supposed to have been a history of resistance to the prevailing social order. Yet, interpreted as a requirement of resistance, the requirement of modernity has seemed increasingly hard to meet – at least, by reference to those technical and practical categories which have been represented within the dominant critical tradition as the very forms of high Modernism itself: abstract painting and abstract sculpture, to which may perhaps be added 'three-dimensional work' in the Minimalist vein.

It is a hypothesis common to the essays in this book that the authority of Modernist *theory* as a source of regulative paradigms has been in decline since the early 1950s, even though the moment of greatest apparent coherence of that theory with abstract painting and sculpture was not reached until the early 1960s. The problem seems to have been not that the forms of high abstract art were necessarily unspeculative in themselves as that they became at a certain point virtually indissoluble from the discourse which represented them – and which represented them both as privileged and as insulated against unsympathetic speculation. As Modernist theory achieved the hysterical certainty of bureaucracy, the autonomy of painting and sculpture was simply asserted, and asserted with increasing stridency. (I should make clear here that I am not arguing for reconsideration of all those types of figurative art which were derogated in Modernist theory. Though Johns, Rauschenberg, Warhol and Lichtenstein are more interesting artists than they could be allowed to be in Abstractionist accounts, the authority of Modernist criticism is not to be denied by ignoring the most trenchant of its strictures – for example, those which address the technical archness and conservatism of such work as is more appropriately contained within the category of Pop Art,

English Pop Art in particular. Nor is the force of abstract painting significantly undermined, abated or redirected by forms of art which treat the cultural world as a source of ready-made but novel representations, while leaving the substantial problems of artistic representation and expression more or less where they were.) Yet, if writing in the Modernist tradition seemed increasingly to assume the authority of the academy, within the actual practice of art modernism remained a volatile critical value, as indeed did abstraction in face of the differently grounded work of Judd, Stella, Andre, LeWitt, Smithson, Serra and others. It was a lesson of the 1960s that neither the value 'modernism' nor the value 'abstraction' was restricted by any logical necessity to a specific typology of objects, whatever might be the status of some abstract painting and sculpture as contingent forms of (a possibly contingent) 'high art'. Except as resources of negative example, the restricting prescriptions of Modernism as a theory of high art seemed at the time to have become more-or-less irrelevant – or only negatively relevant – to the problems of how to conceive modern artistic objects.

It did not follow, however, that painting or sculpture was 'dead'. In its Greenbergian form, the theory of Modernism is a theory of high art, and of high art's distinctness as a means to the preservation of value. The theory offers a strong defence of professional specialization and a strong case for the constancy of aesthetic categories. It has generally, therefore, been seen as concerned with the 'meanings of the dominating'.[6] For those concerned with the ethical character of modern art, however, it has been nothing if not a vexed question since at least the early 1960s whether the forms of high art are irredeemably bound to the values of a dominant order, or whether they are actually or potentially available, as forms of resistance, dissent and negation, to express the 'meanings of the dominated' – or both. One form of response to this question is simply to refuse it any merit as an issue, and to accord an absolute democratic virtue to forms of popular art. Another is strategically to ignore the distinction between 'high' and 'popular' altogether, in furtherance of the hope that 'forms of representation' can be envisaged, and presumably practised, which are not hierarchically distinguished. Conceptual Art – or at least the form of Conceptual Art associated with Art & Language until 1972 – was never proposed as a possibly popular counter to the forms of high art, nor did it rest on the assumption that the abolition of all hierarchies was possible in practice or in criticism. Nor was the Conceptual Art of Art & Language envisaged as a fulfilment of the forecasts of Walter Benjamin concerning 'The Work of Art in the Age of Mechanical Reproduction';[7] that is, as the typology of a set of artistic tokens which, by virtue of their indefinite repeatability, would serve to dispel the aura attaching to the authentic original. Rather it aspired to engage on equal terms with a certain *culture* of high art, which was seen as very much 'alive'. It was a strategic function of this engagement that painting and sculpture were regarded as

provisionally unavailable practices, but it did not follow that they were seen as terminated traditions.

Certainly, no significant freedom from artistic protocol or precedent followed from decline in the authority of Modernist theory, nor did the attendant dethroning of abstract painting and abstract sculpture as paradigms of modernism mean that just any object of a new or a revived enthusiasm would serve as the practical exemplar for a modern art. Either practice is grounded in some material particulars, in some language-like conditions and in some 'intrinsic human capacities'[8] such as those which determine language itself, or it is arbitrary. What followed was rather a demand that the terrain of artistic practice and the ontology of the artistic object be somehow re-established on other than morphological grounds. It was an incidental consequence of this demand that the distinction between abstract and figurative art became simply insignificant in practice – or irrelevant in the last instance to the prospects of meaning and content. (Meanwhile normal art history and art criticism, having failed adequately to theorize this distinction when it was a matter of urgent practical contest, were left to struggle with a distracting legacy of redundant problems. The earnest enthusiasts of 'Realism' fared no better, committed as they were to discovering an oppositional virtue in the figurative.)

It was a further consequence of decline in the authority of Modernist theory – or a further consequence of whatever process that decline itself betokened – that disturbing salients appeared in those lines of demarcation between the aesthetic and the political to which Modernist theory, if not Modernist practice, had accorded the virtual status of conventions. From the later 1960s onwards, the writings of avant-garde artists, critics and curators were marked by just those kinds of agonizing about the nature of art's function and its audience which the bolder versions of Modernist theory had tended to deal with in summary fashion by according an absolute priority to the aesthetic.[9] By the early 1970s territorial negotiations within the international avant-garde typically took the form of arguments about 'art and politics', and about the political virtue or venality of artistic practices. Questions of demarcation between political and artistic acts came to seem inseparable from questions about the security and significance of media categories – and vice versa.[10] At worst this circumstance led to such confusions as that opposition to the dominant forms of abstract painting and sculpture was not simply a means to achieve independence from Modernism as theory, nor a mere over-determined avant-garde strategy, but a transcendently virtuous position in itself. At best it generated the demand in respect of the artist's own production that he or she face in some possibly public form the ethical implications which followed from ontological claims. To confront the problem of the axiological character of artistic practice was not to look away from the implications of political change. Rather it was to look *for* those implications within one's own practical and dialogical world.

THE ARTIST AS AUTHOR

One further issue deserves mention among those problems which may be historicized by reference to the art of the late 1960s and the 1970s. It has so far been suggested in these essays that a sceptical avant-garde emerging in the mid-to-late 1960s questioned both the conventional means of categorization and individuation of the objects of art, and the conventionally established relations between the objects of art and the complexions and dispositions of spectators. It should be noted that the status of the (modern) artist as individual author had coincidentally become a highly propitious or over-determined subject for examination and critique. The very formation of Art & Language in 1968 could be seen as symptomatic of dissent from prevailing stereotypes of artistic personality and of the individual artistic career, while the *Documenta Index* of 1972 is open to interpretation as a form of artistic device by means of which conversation (or the generation of meaning) is represented and examined in abstraction from actual conversationalists (or authors).

The suppression of authorship in such works as the *Documenta Index* was entailed by the intended suppression of the beholder – and of those aesthetic categories and predispositions for which the beholder stood as guarantor. Assumptions about the artist as author are related to assumptions about the object-character of the work of art – and about the nature of its transcendence of that character – through conventions which are both epistemologically and sociologically powerful and contingent. A conventional concept of the individual artist as author serves to determine the expectations of viewers as readers, while conventionalization of the relations between viewer and artist in turn serves to fix and to stabilize the technical categories of art. To open to question those conventions according to which the work of art is categorized and individuated was thus inevitably also to question assumptions about the individual artist and about his or her position as author of the work.

The 'death of the author' was widely canvassed during the late 1960s and the 1970s, principally in film theory and in literary theory originating in France. More sensibly we could say that the concept of the author was historicized at this time and its ideological functions investigated.[11] A previous critique of the concept of the author is associated with the work of Walter Benjamin during the 1930s. His thesis was that the conventional concept of the author as creator serves to pull the identities of author and producer apart. Where the status of author as producer is not adequately established and acknowledged, he argued, the reader is allowed simply to occupy the role of consumer. The aim of the author-as-producer should be to transform consumers into producers, readers or spectators into collaborators.[12] The later critique of the author departed from a concern to elevate the status of reading, and to advance the critical and imaginative role of the reader in the constitution of the literary (or artistic)

'text'. What Benjamin had in mind as collaboration is perhaps not entirely satisfied by the notion of a 'text' as something somehow co-produced by author and reader (or artist and spectator, *mutatis mutandis*). The different teleological character of his analysis was driven by a sense of ideology as capable of dispersion in pursuit of a view of some 'basic' conditions, and in the interests of a more basic practice. The later critique of the author was associated with the long trek out of Stalinized Marxism, and thus with a different climate of theory. It departed from a view of ideology as pervasive, of the equal materiality of all contingent points of engagement, and of all practices as bearing a 'politics'. The earlier and later positions are by no means easily reconciled, but they may be allowed to converge as forms of critique of cultural hagiography and individualism.

In literary criticism it is by now a well-rehearsed lesson that interest in the author of a text may stand in the way of reading. In the words of Michel Foucault, 'The author is . . . the ideological figure by which one marks the manner in which we fear the proliferation of meaning.'[13] That interest in the author of a painting or sculpture may stand in the way of viewing is a lesson formally acknowledged though not widely observed in the criticism of art. Resistance to acceptance of the thesis can generally be traced to persons and institutions with an interest in the findings of connoisseurship. In the world of the connoisseur the value of a work is equated with its authenticity, and its authenticity is equated not with the possibility of its sustaining some strong reading, but with the possibility of its revealing the physical trace of a specific authorial hand. (This 'orthographic' authenticity is distinct from the concept of existential authenticity invested in the idealization of the artist as creator. The tendency of the culture, however, has been to assume the value of the latter as a kind of reward for establishment of the proof of the former.) This possibility of revelation of the authorial hand is seen as grounding an ontological distinction between the literary work, which supposedly exists as an artistic form independently of any specific autograph version, and the work of 'visual art', which supposedly does not. This ontological distinction is itself connected to and sustained by the habitual and favoured forms of operation of specialized parts of an economic system: on the one hand auction houses, museums and galleries, dealers in art and collectors of art; on the other, publishers, libraries, book-sellers, book-buyers. The individualism often represented as endemic to Modernism is not a necessary function in the production of (modern) art. Rather it is a value necessary to that economic system to which Modernist theory accommodates itself.

I do not mean to suggest that the business of interpretation of art can or should remain indifferent to the matter of how artists lead their lives. Nor do I mean to suggest that orthographic considerations are always (or often) irrelevant or trivial in respect of works of visual art. But it is one thing to assert, uncontroversially, that the signifying character of an authorial hand or style is a factor generally and

adventitiously serving to distinguish works of art from works of literature. It is quite another thing to assert that signification of an individual authorial personality is a necessary condition of works of visual art. It would be still another to use a distinction between art and literature established on these grounds to entrench the practice of visual art within a restricted ontological (and economic) world of clearly marked surfaces and clearly manipulated objects. To the question 'Why can this printed text not be seen as a form of (visual) art?' there may be some robust forms of modern response. But 'Because it does not exhibit the marks of the originating artist's hand' is not one of them. Nor is 'Because works of visual art are by definition intended to be viewed and viewing is not like reading.'

The impersonality ascribed to the work of the Minimalists was effectively aggressive to those conventions of artistic authorship which were associated with valuation of the originating hand. Stylistic indifference and blandness were qualities cultivated in much 'post-Minimal' art of the later 1960s, a category which includes various 'early works' by artists subsequently involved with Art & Language. In various forms of Conceptual Art, for which Lawrence Weiner's 1968 *Statements* may be taken as representative (see plate 31),[14] it was implicitly proposed that it was not the status of autographic versions nor the means of subsequent publication and distribution that served to distinguish between works of visual and works of literary art. Rather it was a matter of whether the ideas involved were ideas about art or ideas about literature. A printed specification for a work of art was an actual or potential work of art, not an actual or potential work of literary fiction or poem. The 'ontological inquisition' upon works of art as objects was thus contained within boundaries which were, in fact, quasi-professional. At the time, interest in the protection of such lines of demarcation tended to take precedence over interest in questions of the form 'Are the ideas about art ideas which are cognitively and not just sociologically significant?' and others of the form 'Is the potential work of art a work of art in any quantitatively significant sense?' For a while it was almost exclusively within the pages of *Art–Language* that the two types of questions were connected.

A further resource of attitudes critical of the notion of authorship was derived from the Duchampian ready-made and its various descendants and extrapolations. One notorious example was Robert Rauschenberg's contribution to an exhibition of portraits of the dealer Iris Clert, held in Paris in 1961. His 'work' took the form of a telegram: 'This is a Portrait of Iris Clert if I say so.' In fact, the idea that a work of art achieves its identity as such through the stipulating power of the individual artist is a weak form of critique of the fetishization of the artist as author. The example serves to alert us to the fact that suppression of the artist as author was all too often during the 1960s and 1970s treated not as a matter of ethical necessity but as a form of avant-garde opportunity. In the Duchampian tradition, the artist as author died only to be resurrected as a dandy. Worse

was to come. In the more degenerate continuations of Conceptual Art, the death of the artist as author was the birth of the artist as self-curator – proprietor and protector of an always-consistent, always-unmistakable logo. In this last incarnation an interesting transformation may be observed. The artist now aspires to reverse the roles of connoisseur and author, treasuring that artificial authenticity as author which is extracted from the creative consumer. From the elaborated reading solicited by the 'post-Conceptual' object the imaginative spectator duly extrapolates a palpitating artist.

SOME METHODOLOGICAL UPSHOTS

The foregoing considerations form a kind of background to discussion of the activities of Art & Language during the 1970s. Any putatively art-historical account of those activities must negotiate two interconnected methodological problems. The first is how the production of Art & Language is to be singled out and characterized. That this problem is posed by the corpus of Art & Language activity is, I believe, an indication of how that activity is of interest. This is to say that an account of Art & Language in the locale of art history or art criticism must first confront the contingency and historicity of the demarcations it practises – notably those demarcations which are made in order to identify some materials rather than others as artistic. It will not do simply to adopt some currently instrumental ontology of 'art' as a touchstone for the activities of the 1970s, since to do so would be to impose amnesia concerning just those kinds of problem to which these activities were addressed and in face of which they were pursued. Notable among these problems were those which had been given figural form in Art & Language's 'Indexes', and which followed from identifying the intensional character of art not with a range of objects and craft practices but rather with some shared or sharable modalities – conditions of necessity and conditions of possibility – within a continuing conversation. The second and consequent methodological problem, therefore, is how – or whether – the identity of Art & Language is to be established in terms of actual interlocutors or agents. The problem of the author, that is to say, follows from and is implicated in the problems of individuation of 'the work'.

These were both problems which were acknowledged and addressed within Art & Language itself during the 1970s. Indeed, my own account of these problems is largely the product of that conversation. But I should make clear that in speaking of problems addressed I do not mean to picture a communal agenda adopted by individuals with an overview of history. Rather, the activities, projects and conflicts of Art & Language in the years from 1972 to 1976 can be interpreted with the benefit of hindsight as forms of illustration of the scenario sketched out above; that is to say, as incidences of the problems themselves – and, sometimes, of the consequences of falling foul of them. It is my contention that these problems were historically given

and significant. Further, I mean to suggest that, in so far as the 'art' of
Art & Language involved engagement with historically given condi-
tions, its practice was realistic, however distant the resulting forms
may have appeared to be from those to which normal art history is
used to accord the accolades of Realism. The form of realism I have in
mind is more fatalistic than programmatic. In the first dozen or so
years of its existence, Art & Language could be viewed as a form of
continuing experiment. The project was to maintain an artistic prac-
tice unprotected – or *as if it were unprotected* – by those related
though not coincident closures which are normally performed in the
name of the aesthetic and of the creative individual. Supposing that
such a practice were possible, what would it be like? It would, for
example, be fully exposed to the contingencies of non-aesthetic forms
of production and to the psychological and other business of social life
– which are the materials of some kind of history. If the experiment
had a 'conclusion', it was not that there was some new position to be
claimed for art. It was rather that practice was a matter of being cast
adrift upon the polity, and of nevertheless seeking to navigate and to
act.

In attributing a form of realism to the practice of Art & Language I
do not mean to claim that all or any of the relevant actions took place
at the centre of the cultural stage. The force of the determinations of
history may be revealed in the problems of political organization and
in the agonizings of high-cultural debate. It may also, sometimes,
be vividly demonstrated through the correspondence in parish
magazines. During the years in question, it was not always easy to tell
which was which.

Foreground

PROCEEDINGS: LOCAL HISTORY

Ten names were publicly associated with Art & Language's
Documenta Index in June 1972. In February 1976 fifteen individuals
gathered in New York to discuss their relations to the name Art &
Language (among other concerns), and, had a similar conversation
been mooted in England at the same time, almost as many potential
participants could have been assembled. This is to say that the putative
'membership' of Art & Language in early 1976 numbered between
twenty-five and thirty persons (with an approximate two-to-one ratio
of men to women). This was as large as the membership was to
become, and the subsequent reduction was rapid and considerable. By
1980, when an exhibition of Art & Language work was staged at the
Stedelijk van Abbe Museum in Eindhoven, the relevant complement
was reduced to three. The artists then (and since) responsible for work
shown in the name of Art & Language were Michael Baldwin, the
only persisting founder member, and Mel Ramsden, the only survivor

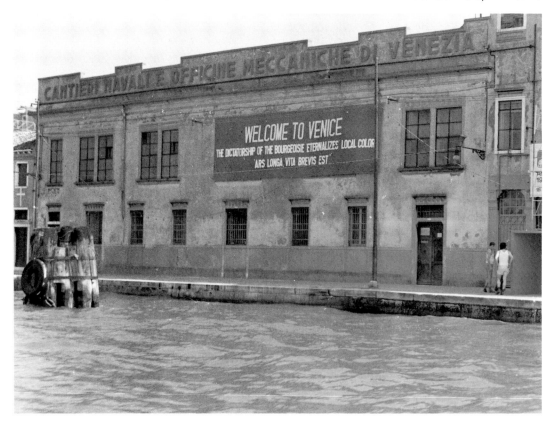

Plate 51 *Art &
Language, installation
of* Banner for the
Venice Biennale
(1976). *('Welcome to
Venice/The
Dictatorship of the
Bourgeoisie eternalizes
Local Colour/"Ars
longa, Vita brevis
est"'.)*

of the community based in New York, accompanied by the present
author in a role which the formula 'editor of *Art–Language*' may be
used to dignify.

Between 1972 and 1980 Art & Language continued to publish the
journal *Art–Language* at irregular intervals, while in New York the
'Art & Language Foundation Inc.' published three issues of a separate
journal, *The Fox*, between April 1975 and the spring of the following
year. Apart from contributions to these and other journals, various
essays and 'proceedings' were published in other magazines and in
catalogues. A long-playing record of songs by Art & Language was
issued in 1976 under the title *Corrected Slogans*.[15] Other work produ-
ced by Art & Language for distribution or exhibition during this
period included types of agit-prop posters, a banner for the Venice
Biennale (see plate 51), a billboard for a shopping centre, photostat
displays employing texts and graphics, video tapes, poems, postcards,
pamphlets, cartoons, flags and paintings. Over the same eight-year
period, exhibitions of Art & Language work were held in New York,
London, Oxford, Newcastle, Leeds, Paris, Nice, Rome, Milan, Turin,
Florence, Naples, Zürich, Cologne, Brussels, Ghent, Antwerp, Zagreb,
Warsaw, Melbourne, Sydney and Auckland.

Lists of this kind are customary in the documentation of artistic

careers. They are components of the apparatus of promotion. But neither a comprehensive citation of publications and exhibitions nor an exhaustive list of 'contributors' would serve adequately to characterize Art & Language activity during the period in question or to map the actual distribution of initiatives, competences and tasks. Clearly there is some connection to be made between the evident diversity of the activity and the expansion of the personnel involved. But the diversification was not a simple consequence of more hands and more competences being made available. In fact both the expansion and the diversification might be considered as consequent upon the conditions sketched out in the preceding sections of this essay. That is to say, they might be seen as the results of an engineered coincidence between strategic transgression of the fixed curatorial categories of Modernist culture and strategic suppression of the individual artist as author. This is not to assert, however, that 'more hands' did not sometimes (often) mean more people getting in the way.

In view of what has already been said, it would be absurd to narrate the activities of Art & Language during the 1970s as moments in an artistic career, or retrospectively to sort out the various forms of production into established aesthetic categories. Such enterprises tend anyway to be sabotaged by the volatility of the materials available: disparate memories and traces, the marks of events which might or might not be moments in the narrative of an artistic career. The *artistic* status of any or all of this production must remain an open question. Until 1972, however, it had still been possible to consider the strategic forms of Conceptual Art as consistent with an extreme type of Minimalism; to conceive of them as exotic objects presented under a kind of aesthetic cold shower. After 1972 even these uningratiating forms of display tended to be dissolved in the terrain of analysis and investigation they had served – often naïvely – to stake out. For a while the problems of aesthetic individuation simply disappeared or were suppressed in a game of theoretical match and mismatch. Exhibitions were necessary for the maintenance of a public presence and for the economic survival of those attempting to live as 'artists'. But, following the example of the 'Indexes', material which was used for exhibition or which took other published form was now for the most part extracted or synthesized from a much wider body of theoretical and conversational material exchanged between individuals and groups of individuals. As much as anything, that exchange itself – its necessary discontinuities and unevennesses – was what characterized the practice of Art & Language during the period in question.

The socio-psychological conditions of this practice were voiced in a representative transcript of 1974: 'Consistency, exhaustiveness and simplicity have been called the canons of empirical enquiry . . . must I be in a madhouse then, since I have none of these?'[16] This was work done in the absence of overarching theory – or work done in the ruins of the arch. Intellectual materials were used where they were found. The prevailing requirement was not that one idea should be capable of

being fitted to another within some negotiable rationality, but that it should be possible to go on.

> I think one of my personal beliefs at this time ... was that theories, even small passing ones, *do not fit with themselves*. This was the source of the fascination of such ideas as going-on. ... It was also a source of the congeries of thoughts such as that communality was both irrelevant *and* necessary. (Baldwin)[17]

Within the bedlam of Art & Language conversation, the possibility that intellectual materials could be shared was a condition of the possibility of going-on; that is to say that having someone to talk to was the minimum condition of being able to proceed. Art has been made of less.

There was much discussion of the nature of the Art & Language community – of what was meant by 'community'. Two normal senses of the term can be distinguished. According to the first, the basis of community is mutual agreement upon a set of principles, which may be used to organize and to regulate production. According to the second, the basis of community is that those concerned take each other's production on trust (which is not to say that they see that production as insulated against criticism). Art & Language was no more immune than any other comparable organization to the tendency to confuse these two models, and to the problems attendant upon that confusion. What can be said with the benefit of hindsight, however, is that attempts to identify organizing principles always failed or were sabotaged, while the possibility of continuing activity in the end always required that intellectual production be taken at least initially on trust.

Work offered for exhibition tended to reflect the nature of the conversation and was for the most part regarded as wilfully obscure. It is true that a kind of militant 'refusal to signify'[18] was a predominant feature of Art & Language's public face, and that this refusal to signify was accompanied by a refusal to clarify. It is also true that both forms of refusal met internal resistance from those who worried not only about the 'effectiveness' of the resulting materials but also about the meaning and value of collective responsibility in the face of a less-than-collective grasp of issues and arguments. The relations between 'internal' and 'external' audiences were by no means clear-cut. These relations were themselves the subject of considerable discussion, as were the relations between forms of Art & Language idiolect and the constituents of other discourses. Texts on these and other questions grew through processes of elaboration, annotation or correction. Some took the form of tape-recorded discussions. Some of the discussion was fertile and interesting. Some of it was self-regarding and dull. Various accumulations of texts were used in England as raw material for forms of index. For example, a display designated at the time as

Li Proceedings 1972/73 invited viewers/readers to consider a sequence of text in the context of a list of topics or interests.[19] The resulting reading was to be matched against a form of microfilmed index. This gave strings of permuted concatentations and non-concatenations, patterns of the possibility or impossibility of going-on ('reading'). The following items were specified in the topic list for one index of this form: 'Idiolect', 'Ideology', 'Ideology revision', 'Interest', 'Technology/bureaucracy', 'Modalities', 'Pragmatics', 'Situations ... guessing who ...', 'Socialization', 'Indexicality', 'Going-on grammar', 'AL teleology', 'Community presuppositions', 'Good faith/bad faith', 'Darwinian descent', 'History/methodology'. When *Li Proceedings* was installed at the Lisson Gallery, London, in September 1973, the names listed under Art & Language were Terry Atkinson, Michael Baldwin, Ian Burn, Charles Harrison, Graham Howard, Harold Hurrell, Lynn Lemaster, Philip Pilkington, Mel Ramsden and David Rushton.

A separate accumulation of material resulted from a New York-based project known as *The Annotations*, begun at the end of 1972. The project involved the circulation and annotation of texts and was intended to organize the shared or sharable work of those then associated with Art & Language in New York. In practice it also established a basis upon which that association could be extended. A selection from the resulting material was published in 1973 as an index in booklet form under the title *Blurting in A & L*.[20] This listed 408 separate indices, from 'Alternatives' and 'Ambiguity' to 'Work (Introduction of)' and 'Work (Pragmatics of)'. Those listed as involved in the publication were Ian Burn, Michael Corris, Preston Heller, Andrew Menard, Mel Ramsden and Terry Smith. Joseph Kosuth had also been involved in *The Annotations*, though he played no part in the production of the booklet.

It may be noted that, while Burn and Ramsden were listed in the context of the index installed in London, though both were then based in New York, no contribution from England was made or at least acknowledged in respect of *The Annotations*. This observation serves to highlight a difference between priorities and ways of proceeding. The tendency in 'English' work was for priority to be accorded in the last instance to the organizing potential of formal and logical systems, and for the materials and persons thus organized to be treated as relatively incidental. 'Contribution' was decided – sometimes disingenuously, more often strategically – as a kind of formality. There was a tendency for Art & Language to be given whatever form of public face was thought to be didactically effective. The tendency in New York was for priority to be accorded to the composition of a working community and to the nature of its concerns. The problems of formalization of the results were at times experienced as kinds of social crisis variously affecting all contributors.

It could be said that these differences in ways of going-on serve to distinguish between ironic and literal forms of organization – or

between the ironic and the literal in notions of community. At times these differences were explained or symbolized in terms of the different conditions respectively determining those living at various sites in rural and industrial England and those living in what was supposed to be the metropolitan centre of international Modernism. In fact the different complexions of work on either side of the Atlantic were attributable rather to the different psychological dispositions and educational experience of those taking the relevant initiatives. Certainly, however, the tendency of Art & Language concerns was to be inflected by the force of these differences. Both as a consequence of the dual location of Art & Language's practice and as a result of the intellectual upshots of reading, it became only too clear on both sides of the Atlantic that the intensional aspects of both writing and reading were relative to differences in circumstance.

The 'transatlantic' differences were given explicit formal treatment in *Index 002 Bxal*, first exhibited at the John Weber Gallery, New York, in December 1973 (see plate 52).[21] The assumptions underlying this work were that reading and interpretation take place within a world of modalities (conditions of necessity and contingency, possibility and impossibility), that modalities may or may not be shared between groups of readers or between individual readers, and that the resulting compatibilities or divergencies may at least in theory be examined down to the finest levels of grammatical detail: for instance, in the ways in which 'meaning' develops, in the actual process of reading, as a form of possibility or interest carried over or transformed from one word of a sentence to the next. The display was designed so that the process of reading, thus understood, could be represented 'abstractly'. A wall-sized printed text was sent from England, spaced out so that a range of possible relations of 'going-on' or 'concatenatory expressions' could be pencilled in beneath the lacunae. These were to be chosen from a formalized set of types of expressions (or possible relations of concatenation between individual lexical items) which were specified on printed forms accompanying the main text. The range of possible decisions was of the order of 4^{16}.

The printed materials were accompanied by a letter of instruction to Art & Language, New York:

Plate 52 *Art & Language, wall display for* Index 002 Bxal *(1973). Letterpress on paper with pencil, 144 × 625 cm. Stedelijk van Abbe Museum, Eindhoven.*

Basically you are presented with a list of concatenatory expressions, related to concatenatory entries (pairs from text) provided by Art & Language, England. Your problems start here. There are six semi-discrete operational boundaries. These could be thought of as 'comparison' modalities. (Each potential (text) pair member has a number.) The modalities, or points of reference, of most significance are those indexed to the right of the concatenation selection.

Your operations can be listed as follows: Consider/compare the TAMB selection [i.e. Terry Atkinson/Michael Baldwin – a means to symbolize an 'English' reading] against the IBMR concatenation selection for the same entry (pair) [i.e. Ian Burn/Mel Ramsden, symbolizing a 'New York' reading] – and fill in the form accordingly. There is a complication in each case: you have to apply (systematically) a rule of congruence – this is where the modalities {i}, {a} come in. (We will have selected (a) concatenation expressions, and (b) some modalities (if you like, points of reference of these modalities).) In relation to your operations, the rule of congruence states that for every concatenation there is always one modality shared by TAMB and IBMR, and that there is always one that's not shared. . . .[22]

The relations mapped in *Index 002 Bxal* were not simple relations as between the two members of a pair, though they were somehow dependent upon the separate identities of members of pairs. Rather these relations were forms of resonance back and forth between large numbers of real or imaginary pairs – people – and their indices. Ninety-two exemplary indices were specified on a form of poster, as tags for such forms of disposition, interest, preoccupation or commitment as might condition reading (see plate 53). In form varying between the conventional, the portentous and the absurd, they ranged from 'Language is ever so interesting' to 'Ideology sloganized', via 'Hope', 'Depression', 'America! America!', 'Dead parrot', 'Corruption' and 'Modern history'. The function represented by the 'B' in 'Bxal' was intended to convey the idea that no utterance (no 'Blurt') is made in a framework of considered rationality; rather, since speakers and hearers exist and act in a surrounding world of other utterances, echoes and whispers, utterance is part-conversational, part-manipulative.

The strategy was that this work of mapping should be done during the month of the exhibition and that *Index 002* should be complete by the end of that period; i.e. that the work involved should be 'the work' on display. Two specific and contrasting audience responses were recorded in *Art–Language* in September 1974: 'This derives from Bar-

Plate 53 *Art &
Language, instructions
for* Index 002 Bxal
*(1973). Printed card,
84 × 51 cms.*

Art&Language

(P)
1. Languages are ever so interesting.
2. Dead language
3. I wish we had a dictionary.
4. I wish they had a dictionary.
5. It's only syntax...
6. Semantics.
7. Synonymy is ever so important.
8. 'Significance' ... oh my word!
9. Paralysis
10. A history of language
11. Language of the 'group'
12. History of the 'group'
13. Epistemological conservatism
14. Paradox
15. Contradiction ... for whom?
16. 'Contextual logics' sounds funny.
17. Assertion
18. Locate ... formalities of culture
19. Explicate – structure
20. Mesomerism ... hybridify
21. Learn...
22. Education ... finger wagging
23. Condition (me/us)
24. ...Associates... ...association
25. Objects, figure and ground
26. Have an idea ... a range of ...
27. Prospect of ideology
28. Hope
29. Morality
30. Teleologically (incidentally(?))
31. Teleologically
32. Good faith ... inculcate
33. Bad faith ... execrate
34. Hermeneutic ... consider
35. Christology
36. Depression
37. This belongs to something as portentous as the Geisteswissenschaft
38. History of B-ing xal
39. Guilt
40. Group ... transmit penance
41. Possessive individuation
42. America vs. England
43. England vs. America
44. Selfishness in the group
45. Relations to the group historically
46. Ethical subjectivity
47. Map internally
48. Map from a specific context ... externally
49. ... The good ... imperatives
50. Ideology as 'formal' culture
51. Culture relativity
52. History ... consciousness
53. Concatenate ... input from history
54. America! America!
55. God save the Queen
56. Guess if it seems to be english
57. Learn ... (no drill)
58. Condition (them)
59. Against ideology ... Inspector Descartes
60. Outside ideology ... Inspector Descartes
61. Against thought ... Inspector Descartes
62. Outside thought ... Inspector Descartes
63. Dead parrot
64. Principle of existential indulgence (qualify?)
65. Fear
66. Xenophobia ... scandal
67. Guess (in the limit)
68. Drill ... learning as scandal
69. Skeptical...
70. Ironical...
71. Cynical...
72. Funny...
73. Reinforce ... anaphor
74. Subjective...
75. Striving (me/us)
76. Negative...
77. Positive...
78. Absurd...
79. Decide...
80. God (talk)
81. Self (talk)
82. Resignation (sigh!)
83. Corruption
84. Homo religiosus
85. Chile
86. Modern history
87. Christian...
88. Comic...
89. Individualism is ever so impressive.
90. Conscience requires...
91. Idiolect
92. Ideology sloganized

(g)
1. Grammar
2. Concatenation
3. Everyone's aspirations
4. Discourse
5. Ideology
6. Principle of existential tolerance
7. Historical input to group
8. Historical relativity
9. Linguistic relativity
10. Ethical relativity
11. Education
12. Indulgence
13. Immanence
14. Hypocrisy
15. Subjectivism
16. Disassembly

There are two basic macro-operations, 1 and 2. They are distinct with respect to the indices of time, place and group performing them. The results of operation 1 are indicated in section A of the form AB, those of operation 2 in section B.

A. $A_1 1 - D_1 16$, B. $B_1 1 - D_2 16$.

Accept (e.g.) that:
xal 'shut' y 'your mouth' Cal 'going-on'

Any set (?)
$(xal, (y, Cal))$: Bxal By Cal (s) is a going-on al relation of type (i)
$(xal, (y, Cal))$: Bxal By n Cal (s) is ... etc. type (ii). (Think of 'n' as indicating 'failure' ... negation moderation.)
$(xal, (y, Cal))$: n Bxal By Cal type (iii)
$(xal, (y, Cal))$: Bxal n By Cal type (iv)
$(xal, (y, Cal))$: Bxal n By n Cal type (v)
$(xal, (y, Cal))$: n Bxal n By Cal type (vi)
$(xal, (y, Cal))$: n Bxal By n Cal type (vii)
$(xal, (y, Cal))$: n Bxal n By n Cal type (viii)

The simple types are too strong (and they're silly in application most of the time). Don't worry about why at the moment, but a fairly exhaustive characterization of ... going-on relations can be obtained from constellations of the simple types: from the four schemata(e) one can obtain 4^2 'basic types'.

1–6 are sets which represent satisfiable formulae. 7–16 are molecular (and) complex expressions capable of weakening 1–6 when concatenated therewith.

The application of a whole (four element) concatenation expression ('line') involves a structural (concatenatory) hybrid of degree 1.

$A_1 H1 - D_1 H6$, $A_2 H1 - D_2 H6$:

An additional concatenatory relation (hybrid of degree 2) is introduced. It is indicated by 'H' in the concatenatory expression. The structural hybridity here reflects a tactic 'reversability' (i.e. the teleological 'drag' of the second-place member) of a given pair – there being postulated a degree of tactical contingency ('accidit-ness') in the first-place member.

Col. g. A topic/modality is tied to each set (concatenatory expression) throughout.

Cola. (1), (a). There are two further sets of topic/modalities in operation: they are selected in relation to concatenation expressions. Part 1 operations only disclose one of these ((1)) to part 2 operators (but not necessarily vice versa). Part 2 operators make-up a set of their own to be selected for the (a) column.

Section B. There are six 'selection' functions, $H - Hr^0$ (generating hybrids of type 3). For H, (H^0): comparisons between possible concatenatory expression selections are made in relation to the same concatenatory entry (pair) as appears in part 1. The comparison may result in a difference of concatenatory expression selections between the part 1 operation and H, (H^0) in respect of the same entry.

For h, (h^0): comparisons between possible concatenatory entry (pairs) are made in relation to the same concatenatory expression selection(s) as appears in part 1. The comparisons may result in a difference of concatenatory entry (pairs) between the part 1 operation and h, (h^0) in respect of the same entry.

For Hr, (Hr^0): concatenatory entry (pairs) and concatenatory expression selections distinct from those appearing as a result of part 1 operations are considered in relation to the modalities attached to relevant part 1 selections.

A rule of congruence is applied in all part 2 operations in relation to selections from the modality sets (1), (a): there are six operations in part 2:

H If (l_1) / (l_2) and (a_1) (a_2)
H If (l_1) (l_2) and (a_1) / (a_2)
h If (l_1) / (l_2) and (a_1) (a_2)
h^0 If (l_1) (l_2) and (a_1) / (a_2)
Hr If (l_1) / (l_2) and (a_1) (a_2)
Hr^0 If (l_1) (l_2) and (a_1) / (a_2)

I, II, V, IV, X, Y, H, An example of a synopsis of results is provided in these spaces. These (example) results are also filled-in in relevant columns on the forms. A similar order is used for each operation) on the wall display.

Hillel's notions of indexicality, doesn't it?' and 'What the fuck is this elitist nonsense?'[23] The project remains notorious for its complexity even among those who worked hardest on it. The specified operations led to no single solution, as a crossword puzzle might do. Rather they posed sets of problems in a framework of indices and modalities. And, though it was axiomatic to the index that to read is to face implications, no one form of understanding was prescribed. Rather, the possibility of understanding as a recountable form of enlightenment was systematically ruled out in the design of the work. The refusal of this concept of understanding has been a persistent feature of Art & Language work.

The index was designed by Baldwin and Pilkington following a visit to New York and was intended to make the most of the transatlantic divide, while pursuing the logical and dialogical implications of the indexing-project as a whole. It was suggested at the time that the work offered an alternative form for dealing with the accumulated material of the 'Annotations'. As such it invites a comparison with the publication *Blurting in A & L*, which serves to reinforce the foregoing account of different priorities in England and New York. While the booklet preserves a sense of the idiosyncratic concerns and dialogical character of a specific community, *Index 002* systematically reduces social content to logical and quasi-logical form.

The work on *Index 002 Bxal* was accompanied by a series of formal and logical workings-out, collected under the title 'Handbook(s) to Going-on' (see plate 54). The publication of the 'Handbook(s)' as *Art–Language*, vol. 2, no. 4, in June 1974 marked a high point – or perhaps a low point – in the complication and difficulty of Art & Language work.

> 'Going on' was an early glimpse of what is now called anti-theory . . . going on (concatenation 'syntagmatism') does not impute any other meaningfulness to a fragment except its capacity to push the conversation on. This will presumably occur in accordance with a vast array of passing theories. This I think was a prediction . . . (though I wouldn't claim it as such) in an oblique (allegorical) form, that to know a language or to know some bits of language is to know a way round the world, however small that world is. It is to say that there is no signifying stuff or there need be no signifying stuff – there is only the temporary staving off of degeneration into (or transcendence into) irony and bathos. . . . 'Going on' is an implicit recognition of the manipulative, causal character of culture and discourse. (Baldwin)[24]

These remarks may be connected back to that notion of 'fatalistic realism' which was sketched out in the previous section.

Plate 54 *Page from*
Art-Language *vol. 2
no. 4 ('Handbook(s)
to Going-on') (June
1974).*

These are very imperfectly formed postulates – and the
order/ontology isn't at all clear. It will be possible to con-
sider it by 'working' the tableaux to some extent. Anyway,
this may do as faintly mnemonic.

Think of the 'I's' as 'index + Bx selection + surface' in a
sense, and leave some of the rules to sort it out. 'Bxs' =
'Bxal, etc. selection', etc.

For any Ca, Cb:

$$\text{Bxs}^{\{Ia\}}\{c\} \neq \text{Bxs}^{Ib}\{c\} \;\; \therefore \qquad \text{N.B. ' c ' denotes the whole lot of concatenatory candidates.}$$

$$\text{Bxs}\left\{[cal]\right\} \neq \text{Bxs}\left\{[cb1]\right\}$$

$$\text{Bxs}^{\{Ia\}}\left\{[cal]\right\} = \text{Bxs}^{\{Ia\}}\left\{[ca2]\right\}$$

$$\text{SBjs}^{\{Ia\}}\{c\} = \text{Bjs}^{\{Ib\}}\{c\} \qquad \text{This is 'the whole set'.}$$

$$\text{Bjs}\left\{[ca1]\right\} = \text{Bjs}\left\{[cb1]\right\} \qquad \text{This may be too strong –}$$

$$\text{Bjs}\left\{[ca1]\right\} \neq \text{Bjs}\left\{[ca2]\right\} \qquad \begin{array}{l}\text{or 'rigorous' – expres-}\\ \text{sing a relation where}\\ \text{none exists.}\end{array}$$

$$\text{Bjs}\left\{[ca1]\right\} \neq \text{Bxs}\left\{[c\,{}^{M}2*]\right\}$$

$$\text{Bjs}\left\{[c\,{}^{M}1*]\right\} = \text{Bjs}\left\{[c\,{}^{M}2*]\right\} \qquad \text{and}$$

$$\text{Bxs}\left\{[c\,{}^{M}1]\right\} \neq \text{Bxs}\left\{[c\,{}^{M}2]\right\} \qquad \text{etc.}$$

$$\text{Also, T} \equiv \left\{[mc\,{}^{M}1 + \ldots]\right\}^{\{Ia\}} \longrightarrow \left\{[c\,{}^{T}1]\right\}.$$

$$\left\{[mc\,{}^{M}2_1 + \ldots]\right\}^{\{Ia\}} \longrightarrow \left\{[c\,{}^{T}2]\right\}.$$

$$\text{Bxs}\left\{[c\,{}^{T}1]\right\} \neq \text{Bxs}\left\{[c\,{}^{T}2]\right\} \qquad \text{etc. ('=' Bjs)}$$

$$\text{and TM} \equiv \left\{[mc\,{}^{M}1 + \ldots]\right\}^{\{Ia\}} \longrightarrow \left\{[c\,{}^{TM}1]\right\}.$$

$$\left\{[mc\,{}^{M}2_1 + \ldots]\right\}^{\{Ib\}} \longrightarrow \left\{[c\,{}^{TM}2]\right\}.$$

$$\text{Bxs}\left\{[c\,{}^{TM}1]\right\} = \text{Bxs}\left\{[c\,{}^{TM}2]\right\}$$

PLACE OF WORK AS POSSIBLE WORLD

The matter of the 'unshared modalities' apart – and their effects were
substantial – the problem of the identity of the work undertaken on
both sides of the Atlantic can be summed up by a question raised often
and in various forms in conversation between 1972 and 1976: how
was a domain of Art & Language discourse to be distinguished from
the world of all other utterances; or, rather, where were the margins of

the Art & Language domain and what were they like? If it transpired
that there were no 'real' edges, should some be imposed, lest the
putatively artistic work of Art & Language dissolve into the nuances
of the world? Would such dissolution be a problem, or was it rather a
conclusion to be desired? What was the function of an 'Art &
Language' identity?

Inevitably the question of the identity of Art & Language work was
directed to the forms of its production; that is to say, to inquiry into
the language of Art & Language. This was not simply a matter of
attending to the words – though, as mentioned earlier, an attempt was
made in England to produce a form of 'Lexicon' in the wake of the
first indexes. Nor was it a matter of studying some notional Art &
Language 'community' as an anthropologist might study a group of
Trobriand Islanders – as if the limits of that community's language
could be used to define the limits of its world. Rather, the contents of
Art & Language's discourse were considered (with a touch of desper-
ate idealism perhaps) as continually transformable indices of learning.
They were also considered as the points of reference for processes of
socialization. The model of individualism offered in Modernist
theories of art was predicated upon a negative image of community.
The image of the solitary artist as wilful creator is extruded from a
fantasy in which collective enterprise entails a levelling-down to the
lowest common denominator. The critique of individualism, on the
other hand, departs from a positive image of community. The various
forms of Art & Language index were all in different ways addressed to
the relationship between socialization and learning.

> What we've been concerned with is a method of index-
> ing in which we can sort out some of the modalities
> associated with what we learn from one another.[25]

If the tendency of the 'Indexes' of 1972 was to *identify* socialization
with learning, the tendency of subsequent forms of index was to
identify learning, in turn, with idiomatic exchange.

The question of the autonomy of Art & Language discourse was
thus connected to another which was as widely and as urgently con-
sidered: how was an 'Art & Language community' to be recognized?
Who counted as a member of a conversation? Or, what constituted
membership of Art & Language? Such answers as these questions
received were neither definitive nor regulative.

> Art & Language is a shifting set of indices, learning
> modalities, etc. which are discoverable as (transcen-
> dental, perhaps) indices of the experience of most
> people.[26]

> We're not a well-formed set. We don't even know who
> 'we' are. It depends on who makes out the list – among

other things. We can't ever do more than understand parts.[27]

What can be said, though, is that in the early 1970s, at a time when established models of the individual artistic career had come to seem conservative or otherwise unattractive, when recent (and largely utopian) hopes for a widespread revision of learning had been subject to a form of large-scale political disappointment, and when normal avant-gardism had nevertheless found a comfortable home, Art & Language attracted a small number of individuals who might otherwise have been rendered morally homeless by their inquisitiveness and their scepticism.

> Talking to each other has to do with the relationships it's possible for you to set up between people . . . and to do with being frustrated by present concepts of exchanges between people. This is important because what's contingent on such relationships is the way 'knowledge' is produced – and especially the way learning takes place; part of what we are trying to do here is break up the regimentation of structures which makes some people 'experts', some 'learners'. . . .[28]

> We don't know just what learning means, but we do know that at some point it must entail a sense of the need to transform the circumstances in which learning takes place.[29]

And with hindsight:

> Perhaps the situation was not so much the enlargement of authorship but the attempt to locate and determine a *place* of production distinct from the distributive place of lonely artists servicing eager galleries. (Ramsden)[30]

The models of community which the early 'Indexes' provided were relatively 'abstract'. They were based not upon an assumption of shared interests, but upon the possibility of assent to a set of methods and proceedings, and of commitment to whatever 'readings' these might generate. The readings themselves were productive of sharable problems and interests. These in turn encouraged further reading of a research-like character, in the semantics and pragmatics of natural languages, in epistemology and in the philosophy of science, and in due course, as problems of collective work became implicated in what are perhaps best called problems of organization, in social and political theory.

To read from professional interest can be to read one's way out of trouble, or to read in order to stay clear of trouble. The reading that

counted within Art & Language was amateurish and impertinent. It
was not a discipline-bound reading.[31] Whatever intellectual tools were
thus acquired were brought to bear self-critically but also opport-
unistically upon Art & Language's immediate environment and upon
its own production. The reading itself was contagious rather than
collective, however. There was no comfortable Art & Language read-
ing-circle. Indeed, during the years 1974–6 methodological instru-
ments and instruments of analysis were occasionally to be turned by
one faction or individual upon another – with the aim of doing
damage.

In the wake of the first 'Indexes' the problems of the division of
labour between artists and viewers or writers and readers were
reoriented for Art & Language by the 'logical implosion' discussed in
the previous essay. The individual artist was submerged in more art-
ists, who were also viewers, the author in other authors, who were
also readers, while customary practical distinctions between artist and
author and between viewer and reader tended to lose their regulative
force. It was a busy time. While the culturally sublime became virtu-
ally indistinguishable from the culturally bathetic, the contingencies of
working life and social existence seemed to be stuffed with content
and marked out with significant differences. This sensation was con-
nected to or was consequent upon the derogation of the aesthetic – or
upon the intuition that whatever the notion of the aesthetic had con-
ventionally served to enclose might somehow have spilled out into a
large and previously irredeemable world.

The last of Art & Language's 'Indexes' was made for exhibition at
'Projekt '74' in Cologne.[32] In those forms of production which were
proposed as exhibitable forms of art from mid-1974 until the end of
1976, graphic or linguistic inscriptions ('writings') were composed of
'readings', and interpretative texts ('readings') were composed of
'writings'. The character of the results may be sampled in two
representative sets of works, one from England and one from New
York. The first set were forms of display employing paired photostats,
given the collective and ironic title *Dialectical Materialism* (see plate
55). On the first panel of a typical work from the series, a number of
indices signifying points of depth is mapped onto a configuration
taken from a sample of Constructivist graphics. Certain areas of the
same configuration are designated as 'surface' and are marked out as
such by reiterations of the abbreviation 'Surf'. The second panel dis-
plays a printed text. This addresses the nature of Art & Language
work and dialogue, questions of ideology, learning and language. The
separate sections of text are variously marked with those indices
which appear on the graphic panel alongside.

The suggestion made in this work is that there is a possible 'reading'
of the dialogical text which is a kind of picture; i.e. which amounts to
a mapping of its surface and depth upon one synchronic surface. The
work will also sustain the corollary that there is a form of possible
'viewing' of the graphic image which quantifies its formal ingredients

Plate 55 *Art &*
Language, Dialectical
Materialism: Ernie
Wise *(1975). Two*
photostats, dimensions
variable. Private
collection, France.

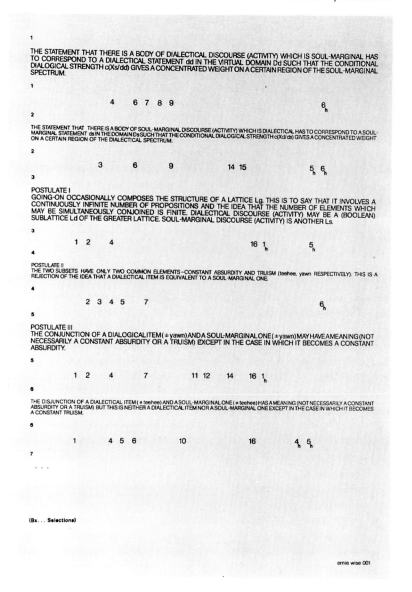

Plate 55 *Art &*
Language, Dialectical
Materialism: Ernie
Wise *(1975). Two*
photostats, dimensions
variable. Private
collection, France.

by reference to a linguistic text. It could be said that the maintenance
of vividness and paradox in demonstrations of this hypothesis and this
corollary has been and remains a distinguishing characteristic of Art
& Language work. The use of Constructivist graphics as a resource of
motifs in the *Dialectical Materialism* series serves to suggest some
precedents in a previous and actual 'moment of transformation' – and
to invoke some political associations and entailments with which to
haunt those who idealize the 'transformation' of the present. (Works
in this series were shown in 1975 at the Museum of Modern Art in
Oxford, and at the Galleria Schema, Florence.)

The second set of works is composed of silkscreened and hand-

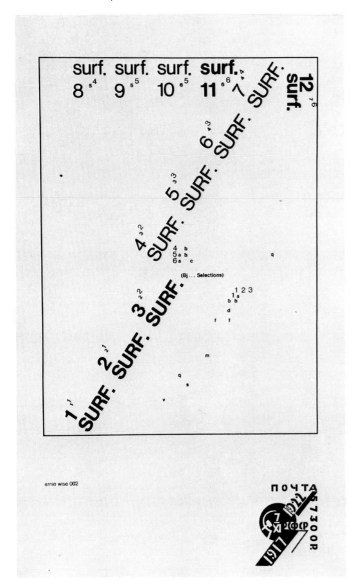

lettered posters (see plate 56). At the bottom left of each, a man's head
and outstretched arm are shown with the kind of graphic simplifica-
tion used in inexpensive publicity and propaganda. The man is singing
one of a number of slogans, which issues from his mouth and is
lettered across the posters: 'O-O-O . . . THE LANGUAGE OF THE WORK-
ING CLASS IS UNIVERSAL; ITS LYRICISM LIGHTENS THE HEART'. The
slogans self-consciously express a naïve optimism of the kind then
associated with Chinese propaganda posters. They are taken from
songs written and recorded by Art & Language. The 'Singing Men'
were intended as wallpapered 'atmosphere' to accompany a videotape
of these songs, *Nine Gross and Conspicuous Errors*, produced by Art

Plate 56 *Art &
Language,* Singing
Man *(1975). Silkscreen
and liquitex on
newsprint, 76 × 61
cm. Private collection,
Paris.*

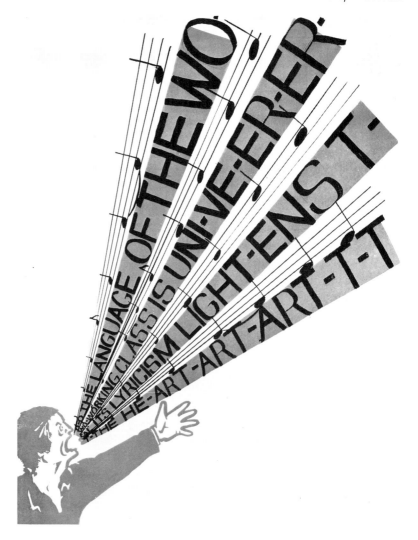

& Language and The Red Crayola in 1975. Posters and video were
used in an exhibition of 'Music–Language' at the Galerie Eric Fabre,
Paris, in 1976 (see plate 57).

In these works, as in the *Dialectical Materialism* displays, the ironic
assimilation of the rhetorical and graphical characteristics of publicity
and propaganda was self-consciously reminiscent of some earlier pre-
cedents: Constructivist graphics again, and also the publications and
strategies of the Surrealists. In the orthodox art history of the time and
in the distributive culture of Modernism, both Constructivism and
Surrealism were treated as largely irrelevant episodes. Or, rather, both
were treated *simply* as episodes, from which certain durable and
canonically acceptable works of art might nevertheless be extruded in
order to be admitted into Modernist critical and technical categories.[33]
Thus for a surprisingly long time the image of Constructivism in the
West remained consonant with the topicalizations of Alfred H. Barr

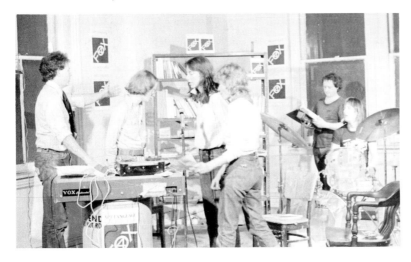

Plate 57 *Recording of songs by Music-Language (Art & Language and The Red Crayola) (1976), still from the film* Borba u New Yorku *by Zoran Popovic.*

Jr's 'Cubism and Abstract Art', with the contents of *Circle* and with the theory and practice of Naum Gabo.[34] Thus the significance of Miró's anarchic and hallucinatory paintings of the early 1920s is that they serve to establish a technical bridge between the spatial characteristics of Synthetic Cubism and the spatial characteristics of Pollock's all-over abstractions.[35] For Art & Language, forms of antecedence were to be discovered in the frayed edges of the Constructivist and Surrealist movements: in those very forms of practical and theoretical inquisitiveness, agitation, extremism and absurdity which had had to be ignored in order that the more propitious products of those movements could be assimilated to the culture of capital.

No single body existed to organize or to approve forms of Art & Language production such as the *Dialectical Materialism* series and the singing men. Though there were those of us who occasionally behaved like officials, there was no Art & Language bureau. In the early 1970s the groups on each side of the Atlantic worked with some independence of each other, and occasionally in open conflict, but for the most part in agreement that the intellectual labyrinth of Art & Language was a common resource. Besides *Index 002 Bxal*, various other 'transatlantic' activities were undertaken in the course of the long indexing-project of 1972–4, and some exhibitions then and later were the results of co-operation between the respective centres. For the most part, however, from 1971, when Burn and Ramsden merged their separate collaboration with the English group, until 1976, when the New York 'community' was disbanded, material was issued by distinct and changing groupings of individuals. Some projects were developed by two or three people working in relative isolation. For example, most of the theoretical work issuing from England between 1973 and 1976 originated in the conversation between Baldwin and Philip Pilkington. This work was both theoretically complex and highly idiomatic. Though it was not produced as an artistic form of philosophy, it was done in a way in which some philosophy has been

done – particularly in recent years. Work issuing from New York tended to involve less logical and more sociological detail, though it was not done as a form of sociology.

As regards the publication of Art & Language work for exhibition, initiative tended to reside *de facto* with those who had the power to make that work count in the art world (who were not necessarily always those whose contributions to Art & Language projects were intellectually substantive). During the period in question that power was largely vested in those who were curatorially, journalistically or economically identified with the first phase of the Conceptual Art movement in the later 1960s: Atkinson, Baldwin, Kosuth, Burn and Ramsden. (Neither Bainbridge nor Hurrell ever attempted any penetration of the market, or even seriously undertook the production of marketable 'works'.) During the 1970s the art-world presence and economic survival of the members of this 'first generation' was largely secured by the waning market strength of Conceptual Art and by demand for its relics. For those centrally or vestigially identified as members of a second (or third) generation (including, in England, Pilkington, Rushton, Lynn Lemaster, Graham Howard and Paul Wood: and, in New York, Menard, Heller and Corris) it was impossible to survive economically on the basis of that membership. This was not simply because they had neither historical avant-garde credibility nor 'early works' to trade. It was also, and more significantly, because a negotiable image of an artistic career was virtually irretrievable from that Art & Language conversation to which they had become contributors. That is to say, it was irretrievable from that point in the conversation of the early 1970s at which their own contributions counted – or irretrievable, at least, in any sense to which the economic interests of the art world in the mid- and late 1970s could be reconciled. It followed that there was no possibility of economic survival for them as kinds of artists doing 'Art & Language work', even had they wanted survival on this basis, which it was not clear that many of them did. Certainly they were mostly at a greater distance from the prevailing artistic stereotypes than the members of the 'first generation'. The latter had encountered the stereotypes as a function of their induction into the practice of art. Some members of the second generation had been induced into or encouraged in a disabused *view* of the practice of art by those members of the first who acted as teachers.[36]

The association of Art & Language with processes of teaching and learning serves to register an important and corrective emphasis. The practical world of the early 1970s was not entirely defined for Art & Language by the world of avant-garde art. The effective suppression of the Art Theory course at Lanchester Polytechnic in 1971 had by no means terminated Art & Language's engagement with the world of art education (though it left Baldwin unemployed and virtually blacklisted). All those involved with Art & Language in England maintained some form of regular or intermittent art-educational role

during the early 1970s, Baldwin through continuing contact with those who had formerly been his students in a formal sense, and the rest of us through whatever full-time or part-time posts we could secure and tolerate. In England if not in New York, the art school complemented the art world as a site of hegemonic mystification and dissident struggle. It followed that the work of teaching was a practical aspect of the larger Art & Language project, and that the conditions of teaching and of studentship were among the problems by which that project was defined at the time. 'Putative Art Practice in Britain is focussed on the Art Schools . . .' was both the title and the commencement of an essay by Art & Language published in 1975.

> The question is raised what sort of dialogue, organization, etc. could enable the grown-up artist to learn something (that is, evaluate his own relations . . . practice) in the light of any substantial relationship (interrelationship) with (or in) class dysfunctional activity as socialist student practice. A related question is to what extent can those artists (etc.) who see their situation as problematic do any 'teaching' at all. . . . The questions are readily amplified: to what extent can/must the class character of (art) student practice be regarded as a pointer to the grown-up artist's social-sectional problem of penetrating and participating in the transformations of the class struggle (and in the transformation that is the class struggle); to what extent do the grown-up artist's struggles and difficulties with respect to class activity and a possible intra-space revaluation (i.e. of art practice) present a transformational possibility in the students' context? . . . A feasible response to the questions will have to propose the dialectic (the culturing reciprocity) between artists (who have some grasp of their socio-historical situation) and art students (who may or may not have such a grasp) outside the bureaucratizing range of the institutions.[37]

In 1975 and 1976, in order to symbolize the proposed dialectic and its propitious context, Art & Language produced and circulated a series of anonymous posters inviting support for a mythical organization called 'School' (see plate 58). These served to furnish the organization with a range of appropriate slogans and exhortations. Further posters appeared which Art & Language had not initiated (see plate 59). Various 'School' meetings were subsequently held by students who had had some contacts with Art & Language, and in 1979 an edited selection of critical material from art-student magazines was published as a 'School Book'.[38] For several of those associated with Art & Language as members of second and third generations, it was through such activities as these, and not through some quest for the name and

Plate 58 *Art &*
Language, poster for
'School' (1976).
Letterpress on
newsprint, 63 × 43
cm.

The careless purveyors of high culture are presented with clear alternatives. One of them is finally to be fixed as the harmless class, the dangerous harmless class, the social and historical scum; for the most part, the bribed flunkey (tool) of reactionary intrigue, the worst of all possible allies, absolutely venal and absolutely cunning, a wholly indefinite disintegrated mass thrown here and there, rich and poor, offal, organ-grinders, rag-pickers, mountebanks ... the helpless dregs who turn in circles between suicide and a tedious madness, incapable of the uncritical violence which is their true heritage; a plague zone that can't be cleansed by the plague.

SUPPORT SCHOOL

Or they can realize that they are incapable of 'governing' themselves, struggle to reach, and restore to themselves a social and historical base, recognize that they can seldom find their way around the countryside; recognize that they are a non-working, not-working class - penny capitalists - and ask themselves what that means: become people in process.

profession of an artist, that it seemed most appropriate to continue the commitments and lessons of an 'unaesthetic' practice.

WORLDS APART

Differences in economic opportunity and differences in geographic and cultural location were factors always likely to lead to fragmentation of Art & Language. The journal *Art–Language* provided some point of public identification or common ground during the early 1970s. From the start, though, it had been edited and controlled in England. In recognition of the increasingly transatlantic character of the group, *Art–Language*, vol. 3, no. 1, was composed entirely of transcripts from conversations recorded in New York and was edited

'..... we often meet people from the different social (class)
sections of colleges who want to chew over their self-
fixing pro fessional paradoxes and then go back and get
on with the job. When meetings with colleagues from
other parts of the college break up each goes away
thinking that the discussion somehow missed addressing
reality'

SUPPORT SCHOOL

Those paying lip-service to the nostrums of cultural
bureaucracy are vocationally depoliticized.

Either you accept some responsibility for the **(social)**
conditions of your own productive existence **or**
you just give up.

Plate 59 *School Press,*
poster for 'School'
(1976). Letterpress on
newsprint, 42 × 27 cm.

by Burn, Ramsden and Smith. This edition of the journal was
published in September 1974 with the subtitle 'Draft for an Anti-
Textbook'. That this publication was largely disregarded in England,
however, served only to emphasize the grounds of divergence of inter-
ests. With the publication of *The Fox* in New York the following
April, the quorateness of *Art–Language* itself was finally called into
question (see plate 60).

I accord a prominent place in this essay to *The Fox* and its attendant
scandals. It could be argued that in doing so I privilege a form of
effective and normal art-world 'noise' over more cognitively interest-
ing questions, and that I thus bow to just those priorities which Art &
Language itself was concerned to overthrow. It might seem, that is to

Plate 60 *Cover of*
The Fox *vol. 1 no. 1*
(1975).

say, that I am assenting to or even engaging in a metaphorical form of imperialism in according priority to the factional business of (a fragment of) the art world over the further struggles of art education or the logical details of artistic work. A rebuke of this order might with justice be levelled at the text by a member of Art & Language's second or third generations, who at the time in question might well have felt disengaged from the factional business and remote from the world in which it was conducted. These essays are written from the position of the first generation, however, and are penetrated by the contradictions of its practical and ethical world. It has to be acknowledged both that *The Fox* was an enterprise of Art & Language and that the reassertion of a normal 'imperialism' was one of its intended, if not uncontested, functions. It should also be acknowledged that *The Fox* attracted at the time a degree of public interest which was out of all proportion to previous forms of publication associated with Art & Language, albeit, or rather precisely because, that interest was almost entirely restricted to an American audience.

The rise and fall in the personnel associated with Art & Language is not to be explained simply in terms of cognitive issues and conflicts. Nor, on the other hand, is it simply a consequence of individual motivation and action that none of those directly involved emerges from the narrative with clean hands – least of all the narrator. It seemed during the period in question as if the contested historical substrate heaved to the surface to form a shifting terrain of anxiety and bad faith. The temptation of a retrospective regard is to ignore the accidents and to search out those configurations upon which rational forms can be imposed. In this case, however, the methodological instruments which come readiest to hand are the reverse of those conventionally associated with a scholarly distance. The decent formality of lists and diagrams gives way to the embarrassing detail of *ad hominem*.

The Fox was one among several symptoms of schism and was in the end to become the occasion of an actual rupture. It was Kosuth's initiative, apparently intended to establish a position of pre-eminence not available to him within the Art & Language community or publicly as a member of that commuity.[39] It was also intended to be readable and (thus) effective as it had often been claimed that *Art–Language* was not, and in ways in which it had never been intended that *Art–Language* should be. And it was to be specifically addressed to the conditions and concerns of the New York art world, as *Art–Language* had never been. Both cognitive and non-cognitive interests were vested in the project.[40] The concern with effectiveness and with topicality was not simply a reflection of art-world ambitions, though such ambitions undoubtedly played a major part in the conception of *The Fox* and of its propitious role. Nor was it simply a reaction against the refusal to signify or to clarify which was associated with English contributors to *Art–Language* (and particularly with Baldwin and Pilkington). It was also a consequence of the deriving of

prescriptions from Marxist, Leninist and Maoist theory, according to which practice was not practice unless it had an audience and an end in view. Mao's 'On Practice' was a compulsive source of mnemonics in the world of radical ideas.

> If you want knowledge, you must take part in the practice of changing reality. If you want to know the taste of a pear, you must change the pear by eating it yourself. If you want to know the structure and properties of the atom, you must make physical and chemical experiments to change the state of the atom. If you want to know the theory and methods of revolution, you must take part in revolution.[41]

It should be said that the conflation of art-world ambition with Marxist or Maoist theories of practice was not the invention of the Art & Language community in New York. During the mid-1970s it was a virtually inescapable condition of avant-garde cultural life. Nor was the attempt to identify Art & Language with a form of graspable and effective discourse merely ill-intentioned, though it was based on a misunderstanding. Ramsden, for instance, was committed to the difficult cognitive content of Baldwin's and Pilkington's writings and believed that that content ought to be more widely accessible. The mistake which he and many others made was to see the writing as a form of failed normal language, and thus as potentially corrigible in the interests of improved communication. In fact Baldwin's writing in particular was intentionally resistant to paraphrase and intentionally generative of uncomfortable and unnegotiable objects (which is not to say that it was not idiosyncratic, nor that it was not occasionally careless, nor that none of its obscurities were involuntary). This very resistance was an indispensable aspect of the practical character of Art & Language work as Baldwin envisaged it at the time. It was required, that is to say, in order to render Art & Language material unamenable to co-option by the manipulative and managerial discourses of the culture. In the eyes of many of those who tried to comprehend this material, however, its difficulty appeared as a form of intentional *ineffectiveness*, and thus as the sign of an elitist indifference towards practical goals. Among those who saw Baldwin's work in this light were several people associated with Art & Language in New York.

The proposal for *The Fox* drew support from those in New York who felt that English editorial control over *Art–Language* served to suppress difference, that it was exercised with disregard both for the specificity of their own local problems and concerns and for the interests of potential readers outside Art & Language itself, and that it was thus obstructive to the progress of practice. The members of the editorial board were Sarah Charlesworth, Joseph Kosuth, Michael Corris, Andrew Menard, Preston Heller and Mel Ramsden. Ian Burn was listed as 'Review Consultant' and Paula Ramsden as 'Copy

Editor'. Effectively Kosuth was the publisher and Ramsden the editor. (It was only at Ramsden's insistence, on the grounds that antecedence should be acknowledged and in order to preserve a sense of collective identity, that the name of Art & Language was used for the publishing 'Foundation'.)[42]

Each of the members of the editorial board contributed at least one article to the first issue of *The Fox* and to the announcement of its implicit agenda. Kosuth's 'The Artist as Anthropologist' was clearly intended to map out a quasi-theoretical base for the next phase of his own career. Ramsden's 'On Practice' opened with the assertion that 'the administrators, dealers, critics, pundits etc. who once seemed the neutral servants of art are now, especially in New York, becoming its masters',[43] and concluded, 'The bureaucracy will subsume even the most persistent iconoclasm unless we begin to act on the realization that its real source of control lies in our very concept of our own "private" individual selves.'[44] An essay by Burn titled 'Buying Cultural Dependency: A Note on the Crazed Thinking behind Several Australian Collections' flagged his interest in notions of international-ism, provincialism and 'decentering' – interests shared by his fellow Australian Terry Smith. If there were imperialistic intentions behind the establishment of *The Fox*, there were also individuals involved who were concerned to pursue the critique of imperialism.

Various members of Art & Language in England were invited to contribute to *The Fox* as named individuals, with the reservation that material was supposed to be generally comprehensible – a condition of its being of interest to American readers. Baldwin and Pilkington sent an essay titled 'For Thomas Hobbes' which opened with a jibe at the idea of New York's centrality.

> The editors wanted something written about New York. What a bizarre idea.
>
> One prevailing emotion (is that what it is?) is our inordinate snobbery in relation to the community alleg-edly under scrutiny. 'Why are so many of them so thick?' is perhaps not the sort of question we should be asking. . . .[45]

The essay ended with a series of extracts from a bulletin put out by Chrysler workers in England after a strike in September 1973, offered in this context as 'a radical alternative' to the form of 'aesthetic democracy' associated with expensive Marxism and left-wing art. The intended implication was that, if Art & Language had a party line, it was sceptical and critical and was not possibly a form of volunteering in the interface between art and society. Three other texts from Eng-land were published in the first issue of *The Fox*. Under the title 'Optimistic Handbook' Lynn Lemaster (Lynn Baldwin) contributed a fragment of a lexicon, which derived from the abandoned project of three years earlier. Atkinson contributed an article 'Looking back,

Going on' which was symptomatic of the divergence of his own inter-
ests from those of Art & Language in England. Rushton and Wood
sent an essay – 'Education Bankrupts' – which derived from their own
continuing work on art education.

An editorial invitation was printed on the opening page of the first
issue of *The Fox*:

> It is the purpose of our journal to try to establish some
> kind of community practice. Those who are interested,
> curious, or have something to add (be it pro or con) to
> the editorial thrust . . . the revaluation of ideology . . . of
> this first issue are encouraged, even urged, to contribute
> to following issues.

The magazine was successful in attracting attention and contributions
and received the accolade of endorsement in the pages of *Artforum*,
then still a leading modern art magazine.[46] *Fox 2* was published in
September 1975, with support from the National Endowment for the
Arts and with a greatly extended list of contributors. In an essay under
the title '1975', Kosuth adopted the spurious objectivity of an editorial
voice in order to celebrate schism as if it were a triumph for the
'specificity' – and presumably centrality – of the issues of New York
art-world life.

> The importance of Art & Language remains as an ideo-
> logical (art) collective. I say 'collective' and not com-
> munity, but one could say the collective consists of two
> communities – one in England and the other in New
> York. The recent collapse of the spirit of Art &
> Language as *one* community has come about through
> work by the New York group which concerns itself with
> issues anchored in the specificity of their New York lives
> and the larger community here. *The Fox* is obviously
> one expression of this work. It has forced us into the real
> world, or to put it better, it has shown us that Art &
> Language spans *two* real worlds: and that the gulf
> between the two communities is, indeed, as wide as the
> Atlantic.[47]

This pseudo-analysis was a precise demonstration of what Baldwin
and others in England had been concerned to prevent. In his implicit
identification of the New York art world with the 'real' world, and in
the location of agency in that world, Kosuth re-established the
hegemonic voice of Modernism in his own person as if it were the
voice of an Art & Language finally brought to its senses.

If the 'real world' is the world of some quantifiable cultural effec-
tiveness, *The Fox* did indeed provide members of the Art & Language
community in New York with the means of entry. By virtue of its

appearance of radicalism, the magazine served as a kind of rallying-point for a New York art world in which radical politics had (again) become fashionable. Members of the editorial collective were closely involved in the Artists Meeting for Cultural Change, an organization attracting a broad membership among artists and critics in SoHo, established as a form of revival of the Art Workers Coalition of the late 1960s. Links were also made with a more 'serious' organization, the Anti-Imperialist Cultural Union, in which were to be found some heavy-duty Maoist–Stalinists who were 'real' at least in the sense that they were involved in the organization of labour.[48]

Organizational activities provide a kind of culture of learning. One lesson learnable from such activities, however, is that distinctions can rapidly become blurred between the grounds of principled relationship and the grounds of expedient association, particularly where the opportunities for social and political transformation are more imaginary than actual. Indeed, the blurring of those distinctions was a more-or-less inevitable consequence of the enlargement of Art & Language, a consequence which the extension into other forms of association was bound to aggravate. Under these circumstances the means of individuation of Art & Language work and of an Art & Language membership became matters of confusion, of anxiety or of irrelevance for those in New York. Meanwhile some members of the group in England worked to dissociate themselves from what they saw as an instant and anti-intellectual form of Marxism and watched with concern as the name – or mythology – of Art & Language became confused with a welter of endeavours, some apparently commensurable with an Art & Language identity, others not. There were methodologically fruitful aspects to the notion of specificity of address as it was canvassed in New York. For instance, some critical instruments were evidently sharpened by the strategic use of *ad hominem* and other rhetorical solecisms.[49] But much of what was represented in New York and in the pages of *Fox 2* as specificity of address was seen in England as an admixture of provincialism and chauvinism, while what was represented as an extension of community appeared as a failure of resistance. On the one hand the crudeness and hegemony of American Modernist historicism was being readmitted under the guise of Kosuth's 'issues anchored in the specificity of . . . New York lives'; on the other, the strangenesses and difficulties of critique were being exchanged for a kind of mob-rule instrumentality.

In defence of some of the activities undertaken in New York it can be said that the extension of an Art & Language practice out into the world of the explicitly political was a form of consequence of the indexing-project and of the questions it raised. If the first 'Index' was a device with the power to place a vast range of absent and other text within its own margins, where were the margins of that practice which was determined by the implications of the *Index*? What would be in those margins? By what kinds of activity would they be defined? Into what other forms of practice could Art & Language be drawn by the

implications of its own critique of intensions? The text of some works in the *Dialectical Materialism* series records a tag from Georg Lukács which first entered Art & Language conversation, suitably amended, in 1973: 'We, in manipulating Bxal, and each other (in the AL asylum), are merely suggesting what it might be like to have any index . . . which is not an object of contemplation. Pace Lukacs, "the icy finality of criticism in the dialectic is only the margin of (our) index (soul) contents".'[50] At one level what was at issue was the meaning of criticism itself. At another, 'controversy' reduced to a competition between the self-images of individuals. This is indeed what the 'real world' is like.

Some terms of reference for the transatlantic conflict can be read out of various publications issued in 1975. *Art–Language*, vol. 3, no. 2, hurried out in May 1975, carried various texts critical of *The Fox*, no. 1, together with an essay which took Burn to task for an article published in the April *Artforum*.[51] *Fox 2* included a review of this issue of *Art–Language* by Burn, in which he noted 'the potential, at every stage, for psychologized (rather than socialized) personality coming to dominate community' – a thinly veiled complaint about Baldwin.[52] The further implicit criticism that theoretical complication is anti-practical surfaces as a recurring *Leitmotiv* of New York views on Art & Language UK. Differences in understanding of the nature and possibility of political activity reflected those distinctions between literal and ironic forms of community which were noted earlier. It was the perception of many of those involved in the extension of Art & Language activities in New York that they were engaged in forms of political consciousness-raising and in actual forms of political struggle. The tendency in England was to behave as if the artistic engagement with politics were a kind of allegorical game – though none the less critically determined or serious in being so.[53]

Since the summer of 1971 Ramsden had been the principal go-between serving to maintain connections between the communities in England and New York. It was he and Burn who had undertaken the work of distributing *Art–Language* in North America and he who had prevented moves to conceal the connection between Art & Language and *The Fox*. By the summer of 1975, however, Ramsden had become indifferent about his ties with Art & Language in England, preoccupied with what *The Fox* had become and with attendant organizational activities in New York, and alienated by English responses to both. For Baldwin, whose identification with the name of Art & Language was determining on all others', it was coming to seem as if nothing in the name was to be salvaged from New York. During this same period Mayo Thompson was working in England with Baldwin on some songs for a long-playing record first mooted in 1973 (see plate 61). The tracks for the record, *Corrected Slogans*, were finally recorded by Thompson and by English members of Art & Language in September 1975.[54] Thompson returned to New York later that autumn with a mandate to take over distribution of *Art–Language*.

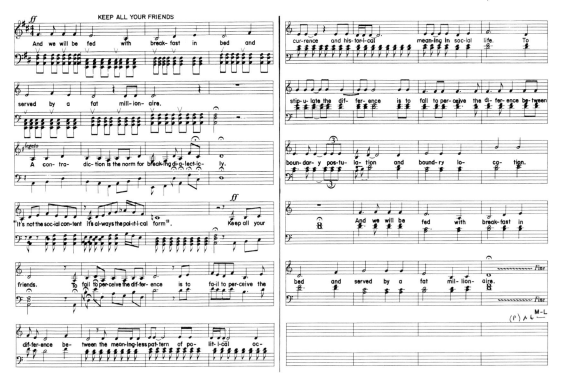

Plate 61 *Art & Language and The Red Crayola, sheet music for 'Keep all your Friends' (1975), from the long-playing record* Corrected Slogans.

This was a measure of the English group's desire to take use of the name of Art & Language away from the group in New York, particularly in face of the progress of *The Fox* as a form of radical bandwagon. (The significance of this decision needs to be put in perspective. *Art–Language* was published only occasionally and in editions normally of 500 and never larger than 1,000. Less than half of the copies printed were sent to North America. At the time, neither control of the distribution of *Art–Language* nor control of the name of Art & Language was likely to interest or to effect more than a handful of people in the world. The first issue of *The Fox* was printed in an edition of 3,000. *Fox 2* and *Fox 3* were printed in editions of 5,000.)

By this time, however, it was becoming clear to some, including Burn and Ramsden, that a working community grouped around *The Fox* was not a feasible proposition:

> For all involved in New York ... the establishment of Art & Language as a sort of political party or mythological clamour prevented serious work *in the end*. It enabled journalism but not real work. How could it if it was AMCC [Artists Meeting for Cultural Change], AICU [Anti-Imperialist Cultural Union], *The Fox* and every other hanger on. This is how the project of suppression of the author after suppression of the work actually ended. It ended with the neat category of

journalism and exposés – a stable second-order dis-
course. (Ramsden)[55]

Burn and Ramsden made clear that they had every intention of retain-
ing their affiliation with Art & Language, that they were concerned to
protect the name from exploitation, and that they were themselves
beset by problems of unscrupulous association.

What followed may be read out of the opening item of *Fox 3*,
published in the spring of 1976 (see plate 62). This was an edited
transcript of the discussions referred to earlier, published as 'The
Lumpenheadache'. The participants were Christine Kozlov, Carole
Condé, Andrew Menard, Alex Hay, Preston Heller, Jill Breakstone,
Sarah Charlesworth, Nigel Lendon, Karl Beveridge, Joseph Kosuth,
Mel Ramsden, Michael Corris, Ian Burn and Mayo Thompson.[56] The
persistence of three principal and connected problems can be read out
from the pages of 'The Lumpenheadache'. The first problem was that
the making of self-identifications with socialism was practically
incompatible with the available grounds of solidarity. 'Community'
had been successfully established as a critically interesting value within
the New York art world, but that value tended to be reduced to a
remainder when careers were at stake and when the wider require-
ments of political solidarity were contemplated. The second problem
was that identification with Art & Language had become an issue
fraught with anxiety, which took different forms for individuals with
different investments and with different career prospects. The third
problem was that the isolation of Kosuth (and contingently of
Charlesworth in so far as she made common cause with him) was a
clear requirement if there was to be any practical address to the first
two. On the one hand the pursuit of socialization through learning
was endangered by the spread of a coercive egalitarianism. On the
other, the individualist basis of Kosuth's actions tended to undermine
attempts to maintain some form of community on the basis of a
critique of individualism.

What can also be read from between the lines of the transcripts is
that some of those involved had already decided how these problems
were to be resolved. At the end of the discussions a vote was taken on
a set of 'provisos or points of unity' designed to establish a form of on-
paper solidarity. Those who accepted them would adopt the desig-
nation 'Provisional Art & Language', suggested to Thompson by Bald-
win in ironic reference to the troubles in Northern Ireland. Those who
did not would remain as 'Art & Language'. Members in England,
alerted in advance, redesignated themselves as 'Provisionals'. The pro-
visos included an agreement not to hold individual exhibitions and to
submit all 'public work' to collective scrutiny and to the 'will of the
general body'. This parody of coercive egalitarianism had been so
designed as to invite its rhetorical opposite – the assertion of artistic
individualism – and thus to ensure Kosuth's dissent. That the 'commit-
ment' of the remaining majority would have no determining effect on

Plate 62 *Poster for*
Fox 3 *(1976). Photo
offset on newsprint, 89
× 59 cm.*

their subsequent activities was of less significance than that Kosuth was now strategically isolated. As the only abstainers, Kosuth and Charlesworth found themselves left as sole members of a rump. Predictably, they refused the offered self-identification.

From the point of view of an Art & Language conceived with the benefit of hindsight, what had disqualified Kosuth was his abiding commitment both to a form of historicism which was *in fine* Modernist in character, and to those conservative notions of authorship which were entailed by Modernist historicism. His style was, as it were, his biological property, not a consequence of contingency and anomaly. The necessity attached to his 'work' was that it must be located as a significant moment in all causal chains. He was concerned to maintain Conceptual Art as a professional category in the face of overwhelming evidence that it was already an ironical one. This ironization was in part the 'work' of Art & Language, and Kosuth could neither embrace nor contain it.

The existence of the 'Art & Language Foundation Inc.' was subsequently solved by convening a special meeting of the directors, at which Kosuth was outvoted and the Foundation wound up. On the proceeds of a grant from the National Endowment for the Arts, the Ramsdens transferred to England early in 1977. By then Burn had already left New York for his native Australia, where various Art & Language activities had taken place over the previous several years.[57] Thompson and Kozlov were to follow the Ramsdens in June.

'Art & Language (provisional)' published one edition of *Art–Language* before the dissolution of the New York community was complete and before the original name was reassumed. Vol. 3, no. 4, was issued in October 1976, with a cover carrying the subsidiary designation '*Fox 4*'. The manner of this designation was such as to signify that the later journal had been effectively subsumed and suppressed. Most of the contents addressed the fashion for semiological art and 'university art' (in connection with which the journal *October* was named as a culprit) (see plate 63). The authors responsible were Baldwin, Pilkington, Ramsden, Thompson and Kathryn Bigelow. (Bigelow had joined Art & Language (p) in New York after 'The Lumpenheadache' and in time to take part in a 'Music–Language' show at the John Weber Gallery in June 1976. After the several migrations she was briefly to act as guardian of remaining Art & Language interests in New York.) The first article embodied a form of editorial statement and a series of brief retrospective deliberations in different fictional voices, each of which claimed a quasi-editorial status. In sum, these were such as to reassert the identification of Art & Language with shared and sharable projects and to reaffirm a notion of community based on idiomatic forms of learning.

> 'Our' work has been, is, and will be done, not *made*. We look not to the 'very advanced' or to the 'very authentic' but to any to whom this makes historic sense or for

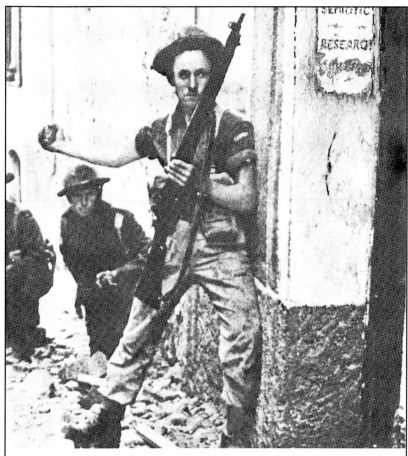

Canadian troops prepare to flush out Semiologists whose ideological resistance was of particular importance in slowing down the drive towards Rome.

Plate 63 *Art & Language (p), illustration for* Art-Language *vol. 3 no. 4 (Fox 4) (1976). Original artwork ink and gouache on photograph, 17.6 × 13.9 cm.*

whom it is an historic problem – i.e. to any who are prepared to go-on with (in?) it. . . .

In great part, the thrust of the meetings that spawned Art & Language (p) or out of which consensus of problems A & L (p) was forged was an 'organic' response (white corpuscle action) to an infection. So, in a sense, it seems that the organism can return to normal . . . or advance to normative forms of operation. . . .

Some advanced artists (advanced self-consumers?) schematize 'their audience' and 'themselves' as 'learners and teachers'. This is not a trivial observation. . . . A year and some of producing *The Fox* taught us what we have to do to 'reach a wide audience': turn ourselves into entrepreneurs. . . . To mediate between learners and what can be learned is to end up a crypto-enterpreneur, a nascent fascist fixer of 'learning'. An entrepreneur is

not determined according to the 'left', 'right', 'anarch-
ist', 'conservative' (etc.) content of his or her themes. An
entrepreneur is in a logically necessary niche of capitalist
exploitation regardless of themes – 'righteous' or
otherwise. Some of our friends and neighbours have
fallen, jumped, stumbled or been pushed into that
niche.[58]

MEANS OF SURVIVAL

Involvement with Art & Language has been an episode of greater or
lesser duration in a considerable number of lives, and an episode not
necessarily inconsistent with a wide range of subsequent activities.
Given the anti-individualist basis of Art & Language's quorate proj-
ects, it is not surprising that the former adherents whose activities have
seemed most evidently discontinuous have been those who wished to
pursue careers as artists under their own names. Atkinson played a
central part in the formation of Art & Language and in its early
establishment as a kind of avant-garde identity. A major proportion of
the earliest work associated with the name was generated in his col-
laboration with Baldwin, but he played a less effective part in Art &
Language projects once that collaboration was absorbed by them – as
it was for the most part by the end of 1971 – and his gradual aliena-
tion was complete by 1974. As for Kosuth, the *Documenta Index* was
the last (and only) substantial exhibited work with which his name can
feasibly be associated, while his contribution to the body of written
material associated with Art & Language can at best be equated with
those few essays which were issued under his own name.

For others who were identified with Art & Language during the
years 1972 to 1976, other necessities in the end became more pressing
or other forms of activity more appropriate. After his return to
Australia late in 1976, Burn established a media-resource centre for
trade union activities. Rushton was engaged in similar work in Eng-
land during the late 1970s and early 1980s. As mentioned earlier,
Hurrell had never sought an economic identity as an artist. He
resigned a full-time teaching-post in 1975, and in 1977, after periods
of unemployment and factory work, he took a job as a tool-maker in
Chipping Norton. In 1978 Thompson reformed his band The Red
Crayola with a number of younger musicians in England and soon
after began working as a producer for Rough Trade. In September
1979, Pilkington accepted a full-time post as administrative research
officer for the Students' Union at Lanchester Polytechnic. Others who
had been more briefly engaged with Art & Language during the period
simply continued with those interests which had always been
predominant. After the winding-up of the Art & Language Founda-
tion in New York some hangers-on were left with nothing to hang on
to.

It is worth entertaining the conjecture that Art & Language projects

have been like sustained programmes of investigation in the natural
sciences, at least in this sense: that the possibility of engagement has
never been a matter entirely subject to the wills of individuals, and that
potential contributions and competences have been usable or not
regardless of individual self-images and other investments. The
analogy presupposes relevance to some form of mind-independent
problem-field as final arbiter of the potential of projects (though *not* as
arbiter of their representational form). This view of Art & Language
projects can be sustained only as far as the analogy will hold. But no
contradiction need be involved in the hypothesis that reduction of the
membership of Art & Language was by the later 1970s an enabling
condition for continuation of that work which followed from the
expansion of membership a few years earlier. Nor would such a hypo-
thesis require either that we privilege the status of 'paintings' (for
example) over 'indexes' (or whatever), or that we see the former as a
necessary continuation of the latter.

If Art & Language's various former contributors and affiliates are
here remembered, it is not in response to some spurious principle of
historical justice and liberalism. Nor are 'subsequent careers' men-
tioned as functions of a methodological device by means of which the
appearance of complication is given to an otherwise partial and
'linear' account. This account remains avowedly partial and Anglo-
centric, and no apologies are offered for its largely sequential struc-
ture. The substantial point is that the form of work associated with the
name of Art & Language now as in the 1970s is only weakly explained
unless some indication is given of the anomalous circumstances of its
production. And among the anomalies to be considered are those
associated with the transcategorial nature of Art & Language work
since the later 1960s, and with the strangeness of its authorial voice
over the same period.

In a narrative of Art & Language which has so long a span to
consider, it might seem that the four-year period I have been discus-
sing could be treated as a relatively brief transitional episode. Yet, in
so far as the name Art & Language designates a form of author with a
history of some sort, the expansion and contraction of the group
between 1972 and 1976 must be allowed a significant presence in any
account of current practice – a presence, moreover, which serves to
frustrate idealization of that practice. It will be a measure of the
theoretical adequacy of such an account that it can admit into some
notional constellation of conditions upon current work whatever are
taken to be the causes and implications of that expansion and contrac-
tion. Among these causes and implications there will be some which
are not easily incorporated in a dispassionate account of artistic and
theoretical developments. Nor should the rhetorical elaboration of
historical themes and motifs be prised apart from the world of *ad
hominem* address in the interests of narrative cleanliness and con-
venience. On pain of denial of the project of historical materialism, it
needs to be remembered that the practice of art is made not only of

theory, competence and critical gain, but also of bad conscience, dirty hands and waste.

The requirement not to forget is today all the stronger in that an 'Art & Language' conceived as a single and consistent artistic author – somehow grounded in the late 1960s but neatly extruded from the chaos of the 1970s – can be said to serve the interested agencies of distribution (which are themselves now in thrall to a more acquisitive and less inquisitive market than they were during the mid-1970s). Where such interests are engaged in the processes of historical representation and authentification, the grounds of anomaly need vigilant protection. That said, it can be observed that between 1972 and 1976 no work was issued in the name of Art & Language from England without the involvement of Michael Baldwin, and no work for exhibition in which he did not have an orginating role, while of the work issued in the name of Art & Language from New York there was none in which Mel Ramsden was not involved, and very little intended for exhibition in which he did not have a determining hand.

It is no coincidence that, of all those variously engaged with the shared practice of Art & Language during the four years in question, these were the members whose productive identity was most clearly and exclusively decided by that engagement. Under conditions in which the concept of the work of art and the concept of the artist as author were both treated as questionable and open, it was they who appeared most determined to maintain a practice, however paradoxical; to maintain it as artists, however apparently replete with contradiction that self-identification might turn out to be; and to maintain it in the name of Art & Language. At the end of the period in question, as those of us who remained as contributors to Art & Language projects gathered around Banbury in England, it was the shared or sharable commitment of these two that ensured a continuing existence for Art & Language as an *artistic* practice.

The sense of 'determined' above is properly understood as ambiguous. It is not just the wilful persistence of two people that I mean to stress. It is also the unavailability to them in the last instance of any other terms in which a practice could be conceived or a form of public identity assumed. Baldwin and Ramsden happened to be left standing in a ruin of which they were in their several ways the principal authors. Among the components of the ruin were some fragments of those principles of anonymity and of collective responsibility by which Art & Language's now damaged public face had been composed. There was no excuse for not continuing. Baldwin and Ramsden shared a need for subsistence. What was required was that this need be capable of being addressed through some mutually agreed project of work. Any continuing identity for Art & Language would have to be built upon an account of the previous decade. In order to establish the grounds of agreement it would therefore have to be admitted that the separate retrospective narratives of Art & Language UK and Art & Language NY were both to be lived with as forms of history.

On 'A Portrait of V. I. Lenin in the Style of Jackson Pollock'

'A Portrait of V. I. Lenin in the Style of Jackson Pollock' is the title of a painting, or, more precisely, it is a title given to some individual paintings within a series produced by Art & Language (see plates I and II). An exhibition of 'Portraits of V. I. Lenin in the Style of Jackson Pollock' was held at the Stedelijk van Abbe Museum, Eindhoven, in 1980.[1] The title is also the title of an essay published by Art & Language,[2] and it is the title of a song with words by Art & Language and music by Mayo Thompson, which was recorded by The Red Crayola in 1980.[3] Before it was any of these things, however, it was a linguistic description, an ironic proposal for an impossible picture, a kind of exasperated joke.

I mean to explore the conditions under which the impossible picture was possibly painted, to trace it back through the various significations of its title, and in the process to review some aspects of the art of the later 1970s and some attendant problems of interpretation and evaluation. I do so in awareness that those kinds of picture we dignify with the name of 'painting' share one important feature with those kinds of utterance we understand as jokes: both are supposed in the last instance to be resistant to investigation of their aetiology. Alike, the unironic art-historical theorization of the artistic image and the unironic psychoanalytical theorization of the joke lead to that dark wood where Alice stared, outfaced and solemn, at a catless grin.

Readings and readers

It is not hard to conceive forms of image which raise – as it were explicitly – problems which attend upon the perception or 'reading' of images. A review of the illustrations of Gombrich's *Art and Illusion*[4]

would throw up several examples. Broadly speaking, these examples are of two kinds: those which suppose the possibility of a confusion between a picture and what it depicts (for instance, *trompe l'oeil* perspectives integrated into architectural settings); and those which contain internal ambiguities and discontinuities and inconsistencies (from Holbein's *Ambassadors* to the irritating graphics of Martin Escher). It is a notable feature of those studies for which Gombrich's is the model that, though highly illuminating about the traditional skills and problems of the artist, they tend to be relatively conservative with respect to the problems of modern art. I mean by this not simply that a concern for the nature of illusion fails to address the kinds of cultural and art-critical problem which seem distinctively to be raised by the art of the modern period. Why should we, after all, expect that forms of art which explicitly question the centrality of mimetic skills will be satisfactorily dealt with by types of theory which accord those skills *a priori* status? The point is rather that the more substantial cognitive activities and dilemmas associated with modern art, and the more intractable problems of evaluation which attend upon them, seem not to be addressed, or to be only tangentially addressed, by those forms of approach which treat visual images solely as *pictures*. There is a sense in which such approaches are too 'microscopic' to notice those features of modern works of art in virtue of which they may be said to bear upon significant problems of perception and reading. (Which is not to say that those who would engage in analysis of such problems can safely disregard the kinds of practical hypothesis upon which Gombrich's work is built.)

A second problem with the normal study of the problems of perception is that it has tended to be pursued as the disciplinary opposite of the social history of art. Work on the psychology of artistic representation tends to assume a single and universally applicable model: the figure referred to in Richard Wollheim's formula as the 'adequately sensitive, adequately informed, spectator'.[5] Yet even if we restrict our interest in paintings to their iconic (picturing) aspects, and our understanding of representation to the matter of how pictures are graphically connected to the world, we will still have to acknowledge (*pace* Flint Schier) that pictorial systems are individuated in terms of competences, and that competences are relative.[6] The 'how' of how pictures are connected to the world, that is to say, is dependent upon who it is that is making the connection and upon the abilities that that person brings to bear. The wiring-diagram which is a kind of systematic picture for one person is a meaningless pattern for another. Furthermore (Schier again), 'the iconicity of a symbol is aspect-relative; it may be iconic *qua* one content and non-iconic *qua* another'.[7] Matisse's *Blue Nude* of 1907 is a form of iconic symbol. In that the blueness of the figure appears to contribute nothing to its iconicity, however, the colour may be assumed to be an 'expressive' (and, in Goodman's terms, a metaphorical) property of the painting.[8] On the other hand, to an observer apprised of the relationship between colonial

exploitation and erotic tourism, the painting might (just) be readable
as a picture of a Taureg woman, her skin tinged with indigo dye.[9] The
matter of whether the blueness of the figure is metaphoric or iconic
appears to be relative to assumptions about the content of the painting
– assumptions about what it is that it is of. Who, then, is competent to
decide what a painting represents? How does one decide, on the
evidence of the picture itself, to what quantifiable range of com-
petences – which is to say, to what sort of competent person – it is
paradigmatically addressed?

The upshot of these remarks and rhetorical questions is not that
attention to the iconic features of works of art is necessarily reaction-
ary or irrelevant, but rather that we may need to review the frame-
work of expectations by which this attention is normally supposed to
be directed. To do this is to open to inquiry a range of assumptions
about the kind of experience which is an experience of art. One way to
do this is to ask *whose* experience it is typically supposed to be. A
related question is, for whom are the problems of perception prob-
lems, or in whose image are these problems framed as problems? It is
in respect of this range of issues that Art & Language's Lenin–Pollock
paintings may be seen as polemical. This polemical aspect is in no way
inconsistent with the opportunities they offer for the 'innocent' enjoy-
ment of traditional illusions.

The paintings in the series 'Portraits of V. I. Lenin in the Style of
Jackson Pollock' were made by Michael Baldwin and Mel Ramsden in
1979–80, in preparation for the exhibition at Eindhoven, where
several large rooms had been reserved for a substantial display of Art
& Language work. The project as a whole commenced with a number
of relatively small pictures, in which appropriate techniques were de-
vised and practised, and culminated in a series of six paintings in oil
and enamel paints on paper, each measuring approximately 7 by 8 feet
(210×239 cm.).[10] (See Plates I and II and plate 71.)

To anyone familiar with the work of Pollock the reference to his
style is likely to be the most immediately noticeable aspect of these
paintings. In fact each painting in the series draws more or less directly
on the appearance of some specific painting by Pollock. In the case of
'*V. I. Lenin' by Charangovitch (1970) in the Style of Jackson Pollock*,
for instance, certain formal and technical characteristics – notably the
colour, consistency and distribution of the paint – are derived from
Pollock's *Mural* of 1950, in the collection of the Tehran Museum of
Modern Art (see plate 64). To those unfamiliar with Pollock's work,
however, the Art & Language painting is likely to seem an irrational
mess, unless, that is, they successfully read the picture of Lenin (by
Charangovitch) which the painting recomposes or reproduces or
somehow contains.

The problems of analysis of the image commence with problems of
description. These latter problems are relative to the competences of
spectators. A set of four notional but conceivable spectators will give
four different possible identities for the painting. The first spectator is

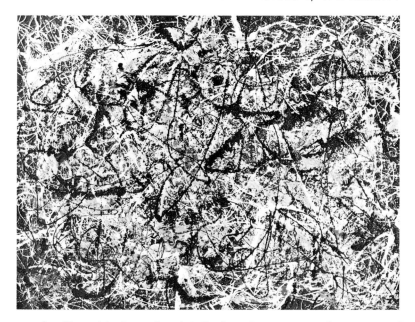

not familiar with the style of Pollock and cannot see the picture of Lenin. For this spectator the painting is an arbitrary and virtually meaningless thing – or, at least, the painting's meaning is largely independent of its intentional character. The second spectator is familiar with the style of Pollock and cannot see the picture of Lenin. For this spectator the painting is a painting by Pollock, or it is a more or less competent, more or less interesting pastiche or fake, depending on the spectator's own competences as a connoisseur of Pollock's work, his or her disposition towards that work, and so on. The third spectator is not familiar with the style of Pollock but can see the picture of Lenin (and sees it *as* a picture of Lenin) (see plate 65). For this spectator the painting is an ingenious or exotic or perverse portrait of Lenin. The fourth spectator is familiar with the style of Pollock and can see the picture of Lenin (and sees it *as* a picture of Lenin). For this spectator the painting is an intentionally paradoxical thing: a work which achieves an ironic stylistic *détente* between supposedly incompatible aesthetic and ideological worlds. It is not simply that the style of Jackson Pollock is supposed to eliminate the possibility of portraiture in general and of portraits of such as V. I. Lenin in particular. More broadly, that estimation of iconic Realism which is associated with the state culture of socialism is generally seen as semantically and ideologically incompatible with those forms of priority which are accorded in Modernist culture to abstract art, to avant-gardism, to individualism and to spontaneity.

These different possible responses have the somewhat bloodless (or swatch-like) quality of philosophers' examples. They are easily animated and complicated in the mind, however, by considering how the various processes of 'seeing', 'seeing-as' and 'seeing-in' might work in practice in front of the painting.[11] Knowledge or ignorance of the

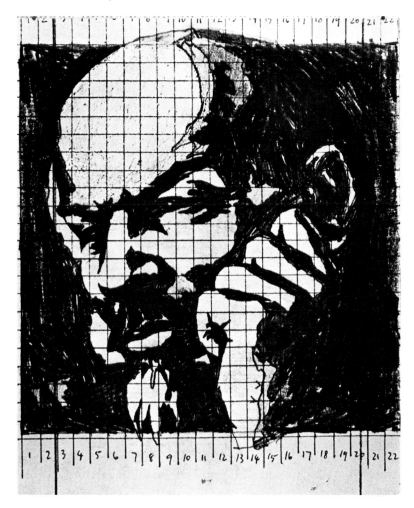

Plate 65 *Art & Language,* Map for 'V. I. Lenin' by Charangovitch (1970) in the style of Jackson Pollock *(1980). Pencil on paper, 23.7 × 20 cm. Private collection, Belgium.*

painting's title is one obvious variable which will effect how it is seen and what it is seen as. Someone who saw the picture of a face in the painting might or might not recognize or see it as the face of Lenin. Someone who did not initially recognize the face of Lenin might still be persuaded to see the picture as a picture of him. More significantly, considerable flesh can be added to the bones of our imaginary spectators if it is allowed that different dispositions towards Pollock, or modern art, or V. I. Lenin, or the Russian Revolution are forms of *competence or incompetence* which will determine reading of such works of art as these. Thus a semantically competent reading of the portrait of Lenin will tend *de facto* to rule against the possibility of a semantically competent reading of the style of Pollock, and vice versa.

We might say that the 'adequately *informed* spectator' of the painting will be one who is familiar both with some discourse within which significance is attributed to Pollock's style and with some discourse within which significance is attributed to V. I. Lenin. After all, without

some acknowledgement of the supposed cultural incompatibility of its two principal referents, the technical ingenuity of the painting is a relatively trivial matter. Another way to put this might be to say that the painting is not competently regarded unless it is seen as issuing from a form of second-order discourse within which the expression-claims of artistic Modernism and the idealizations of Soviet Socialist Realism are both treated as first-order.[12] This may be where the requirement of *sensitivity* is made of the ideal Wollheimian spectator. That is to say, he or she will need to be disposed to make relevant empirical distinctions between the expressive use and the ironic mention of a style, and between the expressive mention and the ironic use of an iconic image. Furthermore, he or she will need to be responsive to the expressive *intention*. The problem is that the Wollheimian spectator exists to celebrate the first-orderishness of art.

A monstrous *détente*

So far I have concentrated on the problems of reading which the 'Portrait of V. I. Lenin in the Style of Jackson Pollock' can be used to demonstrate. It is not my intention, however, to suggest that the painting should be regarded as a merely polemical puzzle-picture – a form of duck–rabbit with cultural and political ramifications. It was not designed simply to make a point about the relativities of pictures to the competences and interests of readers and to the worlds in which those pictures are read. Certainly it serves to animate that universe of dichotomies which is the rhetorical dilemma of Modernist culture: linear or painterly, Apollonian or Dionysiac, descriptive or expressive, plastic or decorative, figurative or abstract, effective or aesthetic, realist or empiricist, collective or individual, East or West. It does so, however, by virtue of its own palpable emergence from within this universe, not by attempting to establish some Archimedean point outside it, nor by privileging one set of terms over another. As represented in and by the painting, that is to say, the dichotomies are not the mere topicalizations of an artistic practice. Within the world which the painting presupposes, they are the very terms by which modern cultural existence is delimited and defined – defined, at least, within the liberal world of modern Western art, for there is no pretence to symmetry in Art & Language's paintings, no intentional claim that these are works which could conceivably have been produced in the East, or that the modernistic appropriation of the icon of Lenin could be logically counterbalanced by a Socialist–Realist account of the style of Pollock. (It is of interest in this connection that, when three of the paintings from the series were selected for a British Council tour of Eastern Europe, they could not be admitted under their proper titles, and instead were catalogued as *Portrait of a Man . . .*, *Portrait of a Man in Winter 1920 . . .* and *Portrait of a Man in Disguise*, respectively.)[13]

To say this much, however, is not to locate the work securely within the framework of Modernist painting. In a painting of 1980, reference to the work of Pollock is reference to an established *stereotype* of Modernist style (among other things) – as reference to the head of Lenin is reference to a hackneyed political symbol.[14] The 'Portrait' is almost not a painting – in any sense consistent with Modernist theories of painting in the wake of Pollock's supposed example. It is almost too self-conscious and too knowing – almost the travesty it appears to be. The illusion of purity which was the asymptote of the Modernist reduction was the illusion of an absolutely unmediated expression. In Greenberg's account of Post-Painterly Abstraction – his own term for the zenith of late Modernist style – pictorial eloquence is firmly decoupled from pictorial imagery and associated instead with 'truth to feeling'.[15] The authentically late-Modernist work of art is proposed as the paradigmatic *oratio recta*, the ideal first-order utterance. Art is 'the least habit-bound of all human activities'.[16] Art & Language's 'Portrait' takes this aspiration to absolute expressiveness and absolute spontaneity as one of its terms, but only in order to represent it as a kind of convention or form of culture; that is to say, only in order to represent it with a disposition which that culture itself must condemn as inauthentic. In the world of the painting – or within that form of second-order discourse which is (almost) not a painting – the culture of authentic feelings is confronted with the spectral representation of its historical opponent.

If the paintings are not simply representations of two opposed and independent systems, neither do they exemplify some ideal resolution between them. I suggested that the rhetorical dilemma of Modernist culture defines the world from which these paintings emerge. But a dilemma is not such a condition as may be resolved dialectically or by thinking the solution to an equation. The culture of Modernism itself is not 'overthrown' by the arguments of Realism, any more than it is transformed by the ironies of Conceptual Art or succeeded by the interests of Postmodernism. In the last instance each of these terms reduces to a form of redescription of an opposing face. In a world of dichotomies, the opposing face of the status quo is a mirror image. What is required for the resolution of dilemma is that the opposing terms be brought into collision so that the whole circumstance is changed. But the change involved is not then within the control of the individual agent. Action in the face of dilemma involves commitment to a more-or-less unpredictable outcome.

The representational materials of the Lenin–Pollock paintings are organized into an allegory of collision. The mythology of individual risk attached to Modernist painting is most compellingly associated with the style of Pollock,[17] while the mythology of historical risk associated with class struggle is a component in the aura of Lenin. To paint the 'Portrait of Lenin in the Style of Pollock' was to force these incommensurable mythologies into momentary coexistence upon a single and synchronic surface.

There was no sense at the time that any aesthetic virtue would be attributable to the results. Indeed, the project was pursued in conditions of alienation from regulative concepts of the aesthetic and of painting. The aim was that painting as a high modern art should be referred to, not 'made'. If the component parts of the Lenin–Pollock paintings are possessed of considerable and complex cultural ramifications, the components themselves are classically simple as types: a single image and a consistent style. No more was needed. It could be said with the advantage of hindsight that Art & Language was reduced to painting in the later 1970s, as it were involuntarily, because there was nothing to lose; because anything was better than going-on living with those dichotomies by which all forms of artistic work appeared to be defined; or, perhaps, because *if* there was nothing to lose, painting offered the best possibility of symbolizing that nothing. In the sections which follow I shall explore the conditions under which this tentative conclusion was reached.

Black propaganda

In fact the 'Portraits', though they turned out to be paintable pictures, were not at the outset intended or envisaged as paintings at all. To be more precise, they were not produced to be seen as paintings. Indeed, it seemed at the time of their production that, if the manipulation of pictures were to play any defensible part in the cognitive activity of a modern world, the kinds of aesthetic disposition which were associated with the viewing of paintings would have somehow to be suppressed or circumvented.

In the wake of Minimal and Conceptual Art, views on the status of painting have tended towards one or other of two contrasting positions. According to the first, identifiable with some forms of 'Semio' or 'Semiological Art', painting is now an irredeemably unmodern cultural medium. As with other surviving crafts, its practice requires the exercise of outmoded and redundant technologies. Furthermore, it is time-consuming, specialized and individualistic. It follows that its products are expensive luxuries, bound to a certain system of distribution and exchange and thus implicated in an inequitable and indefensible economic system. The special status accorded to painting as a 'high art' is simply a function of those ideological mechanisms which maintain distinctions between 'high' and 'popular' cultural forms in general. For these various reasons, painting is ineffective in the cause of emancipation and enlightenment. From the point of view of the constituency of the oppressed and the marginalized, its meanings are forms of mystification. The conjunction of photography and text, on the other hand, is a modern medium – indeed, it might be argued, it is *the* modern medium. Because it is potentially distributable through the same channels as advertising and propaganda, the work of the Conceptual-Artist-as-photographer can be critically engaged, as the work

of the painter cannot, with the forces of exploitation and mystification in society. The artist thus qualified is in a position to intervene in ideology at the point of its generation, in the 'gap' between the world and pictures: 'A job for the artist which no one else does is to dismantle existing communication codes and to recombine some of their elements into structures which can be used to generate new pictures of the world.'[18] According to this view, if we agree to dispense with those incidental aspects of visual representation which depend upon the employment of the individual hand, and with those proprietory forms of evaluation which serve to mystify the single unrepeatable image, no barrier remains to acceptance of photography-and-text, in place of painting, as the paradigmatic medium of (a critical) visual art. '. . . left art practice [then] becomes a matter of practical work in semiotics'.[19]

According to the second view, the attribution of modernity to photography and printing rather than painting is symptomatic of a trivial sense of modernity – one which privileges a simply technological development. Art is not like advertising, which is actually primitive. Semio Art renders art client to an arty form of philosophy, which is itself over-enchanted with the world of images. This is a form of betrayal of the project of Conceptual Art, which was to annex the authority of philosophy in suppressing unreflected content, and thus to render philosophy client to art. The rejection of painting as unmodern because undistributable smacks of the McLuhanite delusion that books become redundant in the global village. If there is good reason to abstain from painting, it is that the practice has become regulated by a specific and contingent set of expectations, and because it is only by such abstinence that these expectations can be frustrated and changed. The business of such expectations apart, the aim of any competing practice should be to meet those requirements of intensional depth and complexity which have traditionally been made of painting. The evaluation of intensional depth and complexity in painting needs not to be *conflated* with the diagnosis of such mystifications as may be involved in the concept of high art – which is not to say that evaluation and mystification are not connected. To establish public persuasiveness, effectiveness or transparency as alternative criteria for forms of artistic practice is to substitute the practical falsehoods of journalism for those risks and contradictions which are the stuff of meaning. Indeed, a theory of art which advances such criteria as more 'modern' will be rejected on the grounds that the operative concept of modernism is at best superficial, however well dressed that theory may appear to be in the latest Paris fashions. Furthermore, it will be questioned whether any practice submitting to the 'alternative criteria' can claim a critical engagement with or independence from the world of advertising and propaganda, since persuasiveness, effectiveness and transparency are precisely the criteria by which that world itself is regulated. An artistic practice grounded in the abstractions of semiology is not inherently any more defensible than a practice grounded in the abstractions of Modernist theory.

Indeed, the former might be regarded as a form of 'progressive' mutation of the latter. From the second point of view the status of painting in the long term is simply left open to question.

Forms of both these views were represented within the expanded Art & Language of 1972–6. The first position was never occupied by more than a minority, however, and by the end of the period views of the second type were clearly predominant. It may be that that predominance was a consequence of the learning of some lessons. It would certainly appear so from the editorial aspect of *Art–Language*, vol. 3, no. 4 (*Fox 4*), and from the conclusion voiced in that issue of the journal that the way to reach a wide audience was to turn oneself into an entrepreneur. Distance from the grounding intellectual principles of Semio Art was clearly marked out in an article entitled 'The French Disease':

> Watching the rise of semiology amongst the academic and lumpen intelligentsia is too, too sick-making. . . . The Gallic disease serves the 'causes' of mystification perfectly in that it encourages us to treat *actual* people and *actual* products as 'subordinate' to abstracted relations. . . . The disease was imported in order to 'sophisticate' the managerial apparatus of 'culture', 'film', 'art' – that is, to sophisticate bourgeois cultural debate. The convenient 'gap' between 'production' and 'consumption' provides shelter for a methodological aberration: it is there to distill *actual* people and *actual* products to determining 'general relations', analytically. These relations are i) treated as if they were prime substances and then ii) the 'gap' itself is treated as if it were a separate cognitivity. This means that the search (sic) for what is common or deep to all manifestations of a society does not expose the 'division between various disciplines' as arbitrary nor does it show 'mind to be common for all men'. On the contrary, the search (sic) merely generates a noetic system: semiology is at one with 'communications' and 'media' – it's what *appears* to happen.[20]

And more baldly in another article:

> No one has to be taught self-consciousness vis-à-vis advertisements in order to succeed in the small historical scuffle he might conceive having with an ad-man.[21]

In work exhibited between 1976 and 1978 Art & Language had mined the imagery of political power and propaganda not in order to borrow its effectiveness, but so as to render it opaque and ironically aesthetic in the context of the modern world of art. Among the materials variously adapted were seventeenth-century English

Plate 66 *Installation of Art & Language 'Dialectical Materialism' exhibition, Galerie Eric Fabre, Paris (1976).*

cartoons and broadsheets, examples of Armenian and Chinese Socialist Realism (see plate 66), a poster designed by the Nazis to recruit industrial labour in Vichy France (see plate 78), a fasces lettered with the statements of artists and philosophers (see plate 67), and a 'people-for-Rockefeller' campaign symbol (see plates III and 68). In Modernist theory the materials of propaganda are the negatives of the aesthetic. In the practice of the Semio Artist they are the negatives of enlightenment. Art & Language's displays from the period 1976–8 were forms of black propaganda (see plate 69). They were distanced by virtue of their irony and their technical blandness or vulgarity from the aesthetic pretensions of Modernist painting, and by virtue of their opacity and irresponsibility from the deconstructive and demystifying pretensions of Semio Art.

An essay, a conjecture and an exhibition

Within this world of intersecting possibilities and foreclosures, the Lenin–Pollock paintings mark a kind of bridge. Though the project from which they emerged was one in which 'painting' was still conceived as approachable only by indirect means, and as matter for debate, the paintings themselves mark the beginning of an explicit engagement on the part of Art & Language with some traditional genres of modern high art. It was a condition of this engagement that it would have to be grounded in some adequate theoretical and practical prescriptions – adequate, that is to say, to the task of distinguishing where necessary between mystification and intensional 'depth'.

Some relevant theoretical work had been done during 1978 in extension of the critique of fashionable artistic forms of left-wing theory which had been offered in *Art–Language*, vol. 3, no. 4 (*Fox 4*). Various forms of inquiry into the relations between 'art', 'society' and 'politics' were published in *Art–Language* and elsewhere.[22] It had been argued in *Art–Language*, vol. 3, no. 4, that to propose the revelatory potential and effectiveness of some artistic work as the measure of its

Plate 67 *Art & Language*, Ten Postcards (1977). *Edition of lithographed postcards, 75 × 20 cm.*

Flag for an organisation for whom the following is axiomatic:

1. That Western society is based upon envy engendered by publicity
2. That publicity works upon anxiety: the sum of everything is money, to get money is to overcome anxiety
3. That the anxiety on which publicity plays is the fear that having nothing you will be nothing
4. That under capitalism money is life
5. That under capitalism money is the token of, and the key to, every human capacity
6. That under capitalism the power to spend money is the power to live
7. That publicity speaks in the future tense and yet the achievement of this future is endlessly deferred. It is judged, not by the real fulfilment of its promises, but by the relevance of its fantasies to those of the spectator-buyer. Its essential application is not to reality but to daydreams
8. That glamour cannot exist without personal social envy being a common and widespread emotion
9. That the industrial society has moved towards democracy and then stopped half way
10. That the industrial society is an ideal society for generating personal social envy
11. That the pursuit of individual happiness has been acknowledged as a universal right
12. That existing social conditions make the individual feel powerless
13. That in the existing social conditions, the individual lives in the contradiction between what he is and what he would like to be
14. That the individual can either (14a) become fully conscious of the contradiction between what he is and what he would like to be and its causes, or else (14b) he lives, continually subject to an envy which, compounded with his sense of powerlessness, dissolves into recurrent daydreams
15. That 14a entails joining the political struggle for a full democracy which itself entails amongst other things the overthrow of capitalism
16. That the process of living within the contradictions of present social conditions is often reinforced by working conditions
17. That the interminable present of meaningless working hours is 'balanced' by a dreamt future in which imaginary activity replaces the passivity of the moment
18. That only one kind of hope or satisfaction or pleasure can be envisaged within the culture of capitalism: the power to acquire is recognised to the exclusion of everything else
19. That the dream of capitalism is publicity
20. That capitalism survives by forcing the majority, whom it exploits, to define their (sic) own interests as narrowly as possible
21. That the survival of capitalism was once achieved by extensive deprivation. Today in the developed countries it is being achieved by imposing false standards of what is and what is not desirable
22. That publicity is the life of this culture insofar as without publicity capitalism could not survive
23. That it is desirable that people come to consciousness of these false standards
24. That they should be assisted in doing so (23)

critical function is to make quantifiable assumptions about the prior condition of an intended audience. It is to envisage the members of that audience as unknowing and passive – at least as regards that domain in which the work of art is supposed to function – and thus as

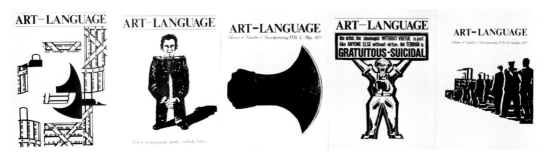

candidates for enlightenment rather than emancipation. Such assumptions, it had been observed, are the propitious fantasies of a section of the ruling class. In such fantasies, that process of enlightenment which is not a process of emancipation results in an audience attractive to the superior ideological resources of the ruling class. The attraction of this audience lies in its very forms of critical perception and dissidence, which may now safely be exploited as pluralistic balm. No artistic work can lay claim to realism, Art & Language asserted, so long as it rests on foundations such as these.

This work was followed by an extended inquiry into the conditions of realism in pictures, the results of which were published in the final form of the essay 'Portrait of V. I. Lenin in the Style of Jackson Pollock'.[23] Consideration of the problem of realism had involved attention to questions about the meaning and significance of pictures and about the grounds on which meaning and significance were claimed *for* pictures. One matter requiring specific attention was the relationship between assumptions about what pictures look like (about their 'iconic' character) and assumptions about the causal circumstances of their production (about their 'genetic' character). The point was not that the two categories are immutable or devoid of subtlety in practice. It was rather that the prevailing tendency in the modern culture of art is clearly to deduce the 'how?' of pictures from assumptions about the 'what?'. In the typical discourses of art criticism and art history, it is presumed that the means by which pictures have come to be what they are can be identified from the empiricist observer's sense of what they are *for him*. The constitutional habit of the 'adequately sensitive, adequately informed, spectator' is to read out meaning from the 'appearance' of pictures, and to adopt the resulting readings as ideologically driven closures on inquiry. And, in general, semiological analysis serves to formalize rather than to criticize the attendant procedures.

In opposition to this tendency, Art & Language offered a hypothesis for discussion and analysis of art which was compatible with the project of historical materialism. Following a model suggested by David Kaplan, it was conjectured that the question of realism in visual representation is a matter of the relationship between pictures and what they are *of*.[24] Priority in the problems of reading was thus shifted away from questions of iconicity and towards inquiry into generative

Plate 69 *Selection from Art & Language,* Ten Posters: illustrations for Art-Language *(1977). Silkscreen on paper, each 108 × 80 cm, edition of 40.*

Plate 68 (left) *Art & Language,* Flags for Organizations *(1978), list of axioms. Photostat, 90 × 60 cm. Lisson Gallery, London.*

conditions. No answer to the question of what a picture is *of* can be seen as adequate, Art & Language concluded, so long as it requires suppression of information about – or, more importantly, of inquiry into – that picture's genesis. 'It is an implicit condition of any realistic criticism that genesis be recognized in general as a more powerfully explanatory concept than resemblance.'[25]

The essay was not written to ratify or to theorize the paintings, nor were the paintings produced as illustrations of the essay, though they were conceived of as essay-like things. For the proposed exhibition in Eindhoven, Art & Language had had in mind a series of all-over displays which would extend the 'black propaganda' of the previous years. It was also intended that these displays should model and make vivid the complex relations between iconic and genetic considerations and aspects. They were to be composed from a range of fragmented images each representing a distinct type of picture – and by implication representing the forms of 'history' and of discourse with which those pictures were associated. One image among many was to be an icon of Lenin in a Socialist–Realist style. Pollock's all-over style of 1947–50 was conceived as a point of reference for the completed displays. The proposal for a portrait of Lenin in the style of Pollock was first mooted in a spirit of irony and of exasperation at the intractability of the project. The very absurdity and unlikeliness of its practical realization immediately rendered it *practical*. The proposal reoriented the entire project and came in the end to define it. After some tentative initial paintings had been produced, the title was applied, adventitiously, to the as-yet-uncompleted essay.

The paintings themselves were produced – after some false starts – by a technique which involved the use of sets of stencils. These were cut from tonal separations of selected images of Lenin (see plate 65). The stencils were laid down in stages while paint was dripped, spattered and poured over them in a representation of Pollock's manner. Two principal competences had to be developed: the reference to Pollock's style had to be plausible, which meant that that style had to be well understood and practised; and the requirements of exact balance and tuning of the relationship between iconic or descriptive content and style (Lenin) and expressive content and style (Pollock) had to be empirically learned and met. The end result of the procedure is that a fully modelled head of Lenin is readable – with a different degree of difficulty in each painting – from the skeins and spatters of the relatively flat surface.

The form in which the Lenin–Pollock paintings now survive testifies to their strange status as remainders of the project for which they were designed, for it is clear enough on viewing them that each was cut up at some stage and subsequently reassembled (as images of fasces appeared to have been in an exhibition of 1977 (see plate 67)).[26] The paintings were in fact produced in order to be photocopied in colour – in order, that is to say, to provide materials for the kind of printed-paper display which had largely characterized Art & Language exhibi-

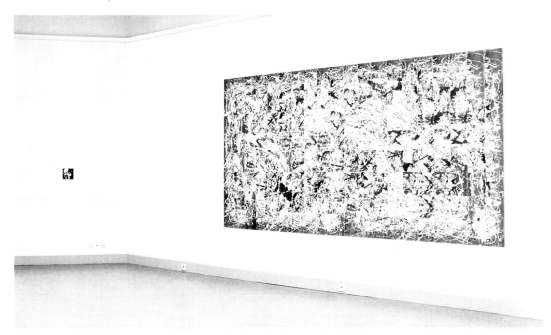

tions since the later 1960s. An A4-sized image was the maximum capacity of available colour-photocopying machines, so the overall dimensions were established as multiples of A4, and each painting was cut up into appropriate units when dry. Each sheet was copied three times. In the exhibition for which they were intended, only the photocopies were shown. One set of copies was assembled into a reproduction of the original painted image. The other two were scrambled together and mounted into a travesty of an all-over abstract painting in the manner of Pollock – or, rather, into an actual semblance of that notional 'apocalyptic wallpaper' which was itself a travesty of Pollock's painting (see plate 70). This scrambled version was given the same title as the unscrambled reproduction: for example, '*V. I. Lenin*' *by Charangovitch (1970) in the Style of Jackson Pollock*. A claim was thus made that some form of reference to Lenin was sustained, as it were genetically, in the absence of any possibly discernible resemblance. The scrambled displays were strategically presented and titled according to the convention proposed in the essay that, 'irrespective of questions of what it is iconically connected to, a picture is *of* what it is genetically connected to'. (A small reproduction of the appropriate likeness of Lenin was also displayed with each pair of scrambled and unscrambled images. This was taken from the drawings on which the stencils were based.)

The last two works in the series departed from the principles laid down for their predecessors (see plate 71). The image of Lenin was derived from a photograph taken in July 1917 when he was disguised by a wig and worker's clothes to evade capture, while the style employed was based on Pollock's black-and-white work of 1951–2, in

Plate 70 *Art & Language*, 'V. I. Lenin' by Charangovitch (1970) in the Style of Jackson Pollock *(1980), scrambled version, installation, Stedelijk van Abbe Museum, Eindhoven, 1980. Colour photocopy on board, 210 × 478 cm.*

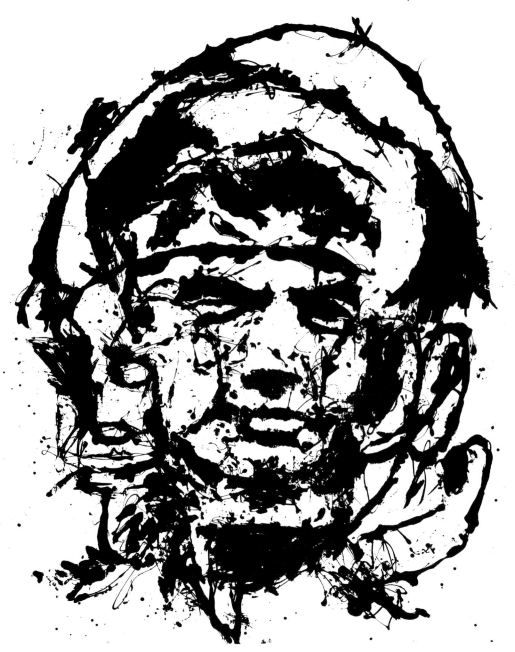

which explicit figurative imagery reappears (see plate 2). The notion of
a portrait in disguise added further paradox and variety both to the
supposed iconic connection to Lenin and to the genetic claim that
these pictures were 'of' him, while the figurative aspects carried over
from Pollock's work established different forms both of iconic and of
genetic association. The decision to show these two paintings at Eind-
hoven only in the form of unscrambled photocopies was a form of

acknowledgement that they were adequately complex and interesting in their own right – as pictures. Sooner or later the question would have to be faced whether or not the originals of these pictures – and by extension of the other works in the series – might be independently interesting as *paintings*.

The orders of discourse

> *The possibility that the fetishes of capitalist aesthetics, objects experienced and understood as 'beautiful', 'expressive', etc., might have* both *an authentic and an inauthentic function for their users is exactly the possibility that the radical iconoclasts cannot countenance.*
> W. J. T. Mitchell, *Iconology*[27]

At one level the history of the Lenin–Pollock paintings might be understood as furnishing a kind of metaphor for the trajectory of Conceptual Art, in which the physical remainders of research-like investigations are destined to become the first-order objects of curatorial fascination. Michael Baldwin has written of the Art & Language indexes of the early 1970s,

> This was *un*-aesthetic art if you like. . . . But that was the point. We did not seek ... to produce an explicit critique of the mechanisms of interpretation and judgement but to abandon them (at least in a *primary artistic sense*) unreconstructed. The paradox if you like was this: that such a possibility as un-aesthetic art would require ... the suppression of 'aesthetic' readings – and any act of suppression could be aestheticized – and so on.[28]

At the time of production of the Lenin–Pollock paintings the 'aesthetic' was still conceived of by Art & Language not as an intentionally attainable quality but rather as an accidental and possibly unavoidable residue. Even when the exhibition was mounted in Eindhoven, the 'originals' were still consigned to the status of decorative remainders (albeit it was recognized that they were more saleable than the materials of the exhibition itself).

And yet the exhibition was disappointing as the paintings were not. Or, rather, the paintings themselves seemed to have changed the terms of reference for artistic action in such a way that the exhibition, for all its systematicness and rigour, appeared to fall short. In the event, those photocopied displays which were supposed to leave the paintings as remainders appeared themselves as kinds of termini. In speaking of the exhibition as disappointing I am lapsing into an unquorate first person and recalling a personal experience which is highly resistant to being

Plate 71 (left) *Art & Language*, Portrait of V. I. Lenin in July 1917 Disguised by a Wig and Working Man's Clothes in the Style of Jackson Pollock II *(1980)*. *Enamel on board mounted on canvas, 239 × 210 cm. Collection Eric Decelle, Brussels.*

theorized. I should try to explain it, however, since the 'lapse' itself is symptomatic. It is symptomatic, I think of an effective shift in the division of labour within Art & Language – a shift which was in turn connected to a change in that world of possible aesthetic and ontological categories by reference to which the production of Art & Language was individuated.

I do not mean to say that the residual effect of the exhibition was to signify that the moment of Conceptual Art was finally 'over'. From the point of view of any collective aspiration it had been over since 1972. Nor, on the other hand, did it appear that a limit had been reached to Conceptual Art's critically prescriptive power. The admonitions against unreflective exegesis, for instance, seemed to remain fully in force in face both of the photocopied displays and of the original paintings. The point was rather, I think, that an unpredictable kind of 'content' had entered the paintings which Baldwin and Ramsden had made, not in spite of but in virtue of the practices these paintings were supposed to continue; that this 'content' had come unexpectedly to define what was learnable from the project as a whole; and that it was not such as to be caught *or deflected* by the kinds of display mechanism which Art & Language had been accustomed to adopt. The public strategies of resistance and refusal inherited from Conceptual Art had by now become available as kinds of avant-garde convention in themselves. The critical perceptions they represented had become recognizable and familiar. The paintings, on the other hand, were like forms of mask, behind which an elusive form of work could be continued.

Baldwin and Ramsden have given their own views on the nature of the change which was enacted or effected by the painting of the 'Portraits'.

> [Ramsden:] When we did 'Portraits of V. I. Lenin in the Style of Jackson Pollock' we did about nine paintings and we discovered that some were better than others. There had to be a reason for that. It rather sneaked up on us that this was connected with making the things rather than thinking them up. . . .

> [Baldwin:] . . . we seemed to be encountering our own preferences and so forth in circumstances where we were not accustomed, normally, to finding them – although in some ways they were not all that different to thinking that some wall display was adequate or not. Nevertheless there was a strange moment in which it was not entirely apparent to us why we would have a basically positive view of one of these items, and a negative view of another. It was apparent that these were not entirely technical considerations. That is to say, the adequacy of the iconic image of Lenin and the technical simulacrum of Pollock's style – that detente was maybe

seventy percent of what was at stake, but it was not
entirely what was at stake. For example some of the
later ones which were black and white were quite simple
... one was rather like a drawing, it produced the image
of a face rather in the way that you might imagine as
'natural' to the Pollock, whereas the earlier ones had
produced the image in a way that was, as it were,
'unnatural' to the Pollock. So there were some strange
transformations there, and it wasn't entirely apparent to
us what these entailed. Certainly they did not entail that
we were suddenly finding that we were *in* our paintings
in any sense that could be narrated by a Hans Namuth
film, but it certainly raised a series of questions as to
what were in the margins of our minds when we were
producing these things. And it was perhaps to find out
what was in these margins that we were placed in a
rather strange hiatus for a while. This hiatus entrained a
kind of search for high genre, of one kind or
another....[29]

The summer after the Eindhoven exhibition, the originals of the
various 'Portraits of V. I. Lenin in the Style of Jackson Pollock' were
shown at Eric Fabre's gallery in Paris, together with Art & Language's
next substantial work, *Courbet's 'Burial at Ornans' Expressing ...*
(see plate IV). The search through the higher genres of painting was to
continue – and indeed continues at the time of writing. If the decision
to exhibit the Lenin–Pollock originals as paintings was a significant one,
what it signified was *not* that Art & Language was now courting a
new identification as a producer of paintings. Virtually all of those
closely involved in the production of Art & Language since its forma-
tion had been to art school, had learned to paint, to draw, to sculpt,
and so forth. Several had made paintings as artists prior to their
involvement with Art & Language. Painting – and particularly history
painting – had accompanied the deliberations of 1972–6 as a form of
hypothetical possibility. And Art & Language had made and exhibited
a large oil painting in 1977 without any sense that long-term commit-
ments would have to be revised or reviewed (see plate 78). It was not
now imagined either that a commitment had been made to painting as
a practice, or that any other forms of production had in principle been
ruled out as prospective forms of Art & Language work. Indeed,
'other forms of production' in the guise of a song, an exhibition
display and an essay were more than marginal accompaniments to the
Lenin–Pollock paintings. They were significant aspects of a diverse
project, and that very diversity was a necessary condition of the
paintings.

The significance of the exhibition of the Lenin–Pollock originals lay
rather in its effective questioning of the orders of artistic discourse as
these bore upon the work of Art & Language as a whole. The ambi-

tion to produce an 'unaesthetic art' had implied a position critical of normative concepts of the aesthetic and outside the contexts of their use. It was from this position that the work of Art & Language had been uttered as a form of second-order discourse, critically engaged with the prevailing forms of first-order production and aspiring to explain them. The entire body of work associated with the title 'Portrait of V. I. Lenin in the Style of Jackson Pollock' – the paintings, the photocopied displays, the essay and even the song – had been envisaged as second-orderish work in this sense. It could be said that the very technical diversity was an aspect and a function of this second-orderishness; for instance, that that diversity was a condition of the possibility that the divisions between 'high' and 'low' or 'popular' art might be transformed. Yet to acknowledge preferences among the paintings which lay at the heart of this larger enterprise, to speak of unforeseen and intuitive content, and to accord a public priority to the 'original' and unrepeatable image, this was to employ the language of the first order. If the 'Portraits' were after all to be seen as paintings – if they were to be allowed to attract the kinds of predicates normally attached to painting as a form of high art – it would no longer be possible for Art & Language to treat questions of relative value in art as subject to dismissal through global forms of redescription. These questions would have to be entertained not only as the characteristic topicalizations of bourgeois debate, and thus as open to powerful forms of paraphrase, but also as determining conditions of Art & Language's own practical existence. The point was not that the one possibility had come to rule out the other, but rather that the continuation of a practical existence had come to mean living with both – the first-order utterance and its corresponding critical redescription. The place where the moral and critical materials of practice were to be found, it transpired, was in the practitioner's own black heart, where aesthetic preferences lie. It was as if the *security* of the second order had been removed, leaving Art & Language's production exposed to the full force of its own – and others' – scepticism. What did this mean? Was the implication that Art & Language had joined, or fallen into, a kind of normal mainstream culture (or that it had actually been a part of the mainstream all along and was simply emerging in its true colours), or was it possible that the redescriptions and paraphrases had themselves become the materials of a transformed aesthetic practice (or both)?

The range of questions can be put in another form. If we say that there was no alternative but to see the paintings as first-order production *of a kind*, a series of possible interpretations will lurk in the shadow of the qualifying phrase. One – which we might call the interpretation of the compulsive avant-gardist – is that Art & Language was now producing mere paintings. Attached to this interpretation are whatever moralizing derogations that 'mere' can be made to bear, concerning reinvestment in the mythology of authorship, readoption of the fixed categories of high-bourgeois consumer-

ship, and so forth. Another interpretation – which we might ascribe to the normal Modernist connoisseur – is that Art & Language had finally succeeded in working through the adolescent episode of Conceptual Art to emerge as a kind of mature 'real' artist making 'real' art. From this second interpretation one or another moral might be drawn according to the vagaries of aesthetic preference: a negative judgement on the paintings would be taken as supporting the prejudice that Conceptual Art had never been better than a form of distraction or alibi for the uncreative; a positive judgement as supporting the prejudice that talent will out in the end and that there is no prescribing the true path to authenticity.

The qualifying phrase will bear a third form of interpretation. It is that the terms of reference for the aesthetic had changed, microscopically as regards the concept of painting and macroscopically as regards the concept of art, and that the previously 'unaesthetic' work of Art & Language had become the condition for a form of (contingently) 'aesthetic' practice. The critical study of the history of art, and particularly of the history of modern art, offers enough precedents to suggest that just such forms of transformation are what we should expect. The world of the 'aesthetic' is not given, except in the self-serving fantasies of those who would prescribe it. It decays and is renewed in and as history, and the materials of its renewal are wrought from the world of the 'unaesthetic'.

It is hard to know to what form of voice to ascribe this third interpretation. I therefore offer it as my own. In doing so, however, I acknowledge that I know of no disinterested ground upon which the merits of these three different interpretations may be compared. There is no death here, either of painting or of the radical spirit, only the classical *figure* of exile, subversion, and return in some form.

'Seeing' and 'Describing': the Artists' Studio

The studio genre

In 1986, Frank Stella, himself a painter of no mean reputation, described the pleasures of Vermeer's *'Allegory of Painting': The Artist's Studio* (see plate 72):

> Our first reaction after pulling back the curtain at the edge of the painting is one of delight. It is as though we have stumbled on the ultimate refinement of art; everything in front of us is suddenly true and clear.[1]

And yet our sense of the enduring presence of the painted scene is stalked by consciousness of another order:

> We have the feeling of invading a private moment as we enter Vermeer's painting, but soon the sense of penetrating detail, the sense of a tapestry unravelling in our hands, suggests that this private moment is merely everyone's accommodation to passing time, and that in the end we are not the observers but simply victims whom Vermeer has trapped. He is, after all, standing behind us, watching us watch art.

Of course Vermeer does not stand behind us, nor do we enter his painting. But metaphors such as these have proved indispensable to the business of criticism. The conceit that seeing a painting is a kind of watching serves to recall art's implication in fictional forms of drama. More significantly, it serves to remind us that representation is an activity and that both seeing and describing are forms of represen-

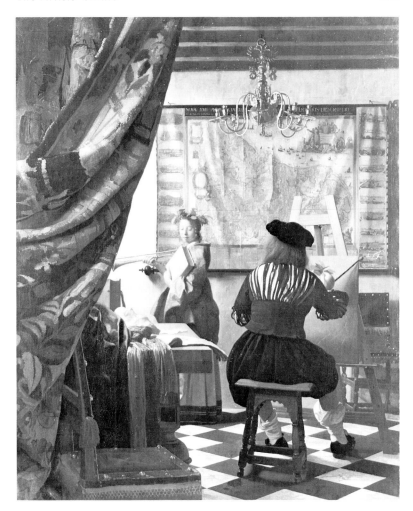

Plate 72 *Johannes Vermeer, 'Allegory of Painting': The Artist's Studio (c.1666–7). Oil on canvas, 120 × 99.5 cm. Kunsthistorisches Museum, Vienna.*

tation. Here, the imaginary figure of the artist watching us from behind our shoulders stands for that form of self-consciousness which occupies us as viewers when our own powers of representation are engaged by art.

It is from within this state of self-consciousness that this essay is written. It concerns a more modern allegory and a more modern studio. The work of this studio is work which I watched in the literal sense; that is to say, I was present as it was being done. The problem of describing what is being done or has been done by Art & Language has been a measure of significant difficulty and interest for me since my late twenties. I have a methodological lesson to offer on my own behalf, but it is one which I have learned in the company of Art & Language. It is this: first, that the critical business of seeing is not only 'seeing what' but also 'seeing how'; and, secondly, that the art of describing is not simply to tell what a thing looks like, but to suggest how it must be that which it is.

The narrative of this essay concerns the development of an artistic theme through a series of related works. On the face of things it is a story of the progressive abandonment of truth and clarity and penetrating detail; a story, rather, of travesty and misrepresentation and opaqueness. As such, it is a kind of parable of the tendencies and mechanisms of modern painting, for it appears to be a general characteristic of modern artistic culture that powers of description are devalued or rendered insecure in the face of impenetrable surfaces and oblique forms of reference. I must first establish a character for the genre in question.

In those works which may be included under the genre of the Artist's Studio a particular poignancy attaches to the artist's presence – and even, sometimes, to the signification of the absent artist. The genre offers a means of representation of the practice of art, and of the artist as a personification of that practice. The variations of the genre are vivid illustrations for a social history of art. The typical studios of the seventeenth century, for example, testify both to the developing professional character of art and to the isolation or alienation of aesthetic production in a market economy. The searching self-portrait and the panorama of the dealer's or connoisseur's gallery are mutually implicated themes. The traditional Artist's Studio unites them, or, to be more precise, it establishes a context of inquiry not only into the artist's practice but also into the terms in which that practice is defined and valued within a larger world. In the pre-modern studio, images of fame and power, poverty and wealth, success and failure appear alongside references to the artist's iconographical and technical resources, and serve as signs for other value systems. We see the artist sometimes as he sees himself, sometimes as he wishes to be seen, sometimes as he sees us seeing him.

In 1854, when Courbet was at work on his *Artist's Studio* – one of the greatest of all contributions to the genre – he wrote that it represented 'the whole world coming to me to be painted' (see plate 73).[2] He also subtitled the painting 'a real allegory summing up seven years of my artistic and moral life'.[3] According to the kinds of priority with which Modernist criticism was to be associated, Courbet's *Studio* is a form of grand failure. The allegory remained unreconstructable. Situated as it was on the threshold of the cultural era of Modernism, the work fell foul of those very technical determinations and interdictions upon painting by which the art of Manet was supposedly to be shaped. No longer could the symbols of a political and intellectual history be feasibly incorporated as consistent signifying features of some whole decorative scheme.[4]

Since then painting has turned in upon itself. This, at least, has been the dominant view of the development of modern art, and it is a view which evidence seems to confirm. The determining presence of a larger social world is not easily read out of the expressive surfaces of Matisse's 'Studios' or Braque's (see plate 74), nor have they customarily been identified as allegories. For Picasso, the studio is

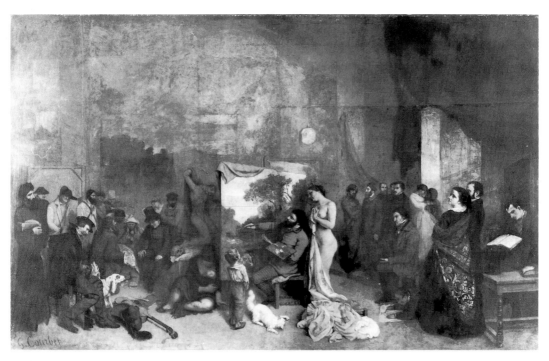

typically the site of an encounter between artist and model, and
between model and image, in which the relations between levels of
representation are suggestive of psychological and sexual relationships
(see plate 75). These too are private worlds. The nature of that privacy
may be disclosed as a kind of commentary upon the nature of art, but
art itself is thereby pictured as the outcome of an individual creative
passion: the will to express.[5] Studios are ideological things. In so far as
they represent the practice of art, that is to say, they will tend to
represent it as it has already been cast in the mould of an ideology of
art.

According to the dominant account of Modernism so far rehearsed
in these essays, the technical character of the modern has been associ-
ated with an increasing emphasis upon expressive rather than descrip-
tive functions and with an increasing concentration upon the *means* of
art. In Modernist theory these two tendencies have been related and
explained in terms of a divorce between art and literature; or, rather,
in terms of a withdrawal of art from the power of language to describe
its content. This withdrawal has in turn been seen as the means to
safeguard a threatened autonomy. The untranslatability of its symbols
has been seen as a measure of the integrity of modern art and as a
guarantee of the independence of artistic expression in the face of
literary or political interests.

The prevailing theories and accounts of modern art have been con-
cerned first and foremost with art's expressive character. As suggested
in the first of these essays, the dominant account of post-war culture
has represented unfettered self-expression (whatever that might be) as

Plate 73 *Gustave
Courbet,* The Artist's
Studio *(1855). Oil
on canvas, 359 × 598
cm. Musée d'Orsay,
Paris. Photo: Réunion
des Musées Nationaux.*

Plate 74 *Art &
Language,* Study after
Georges Braque
'Atelier V' (1949);
Study for 'Index: The
Studio at 3 Wesley
Place' *(1981). Ink on
paper, 8 × 8 cm.
Artists' collection.*

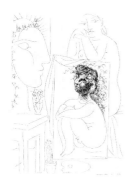

Plate 75 *Pablo Picasso*, Paris, March 21, 1933 (Seated Nude with Painting and Sculptured Head) *(1933), from 'The Sculptor's Studio', The Vollard Suite No. 43. Etching, 27 × 18.5 cm. © DACS, London, 1990.*

the goal and the measure of freedom and democracy (whatever they may be), while individuality, spontaneity and immediacy have been generally entrenched as unquestionable virtues in the ruling stereotypes of artistic personality and performance. In accordance with these stereotypes, the artist's studio has been envisaged as a theatre of solitary self-assertion, 'uncontaminated by any conceptualization, isolated from all echoes of the past and from all threats and promises of the future, exempt from all enterprise.'[6] From this unreal point of production there issue forth those immaculate objects in which the modern connoisseur recognizes his own understanding of the authentic, the serious and the meaningful.

In the mid-1960s, when I first tried to write about modern art, a certain protocol seemed to regulate the relationship between 'seeing' and 'describing'. The proper proceeding was to stand before the work of art, passive, alert and disengaged from all interests and preconceptions. If emotion welled into the resulting cognitive void, the work was taken to be good. The task of the critic was then to describe those characteristics of the work by which this emotion was supposed to be caused. In procedures of this kind, the expressive character of the work of art was unquestioningly identified with the feelings of the sensitive observer. In face of the engulfing canvases of Mark Rothko, or Barnett Newman, or even of Morris Louis or Kenneth Noland, this was a deeply seductive idea. What good motives could there be for doubting that that solemn exhilaration one felt in the presence of the work was actually caused by the work itself?

In our manipulative culture, however, 'feelings' are cultural or ideological levers, not ends in themselves. The claim to sensitivity is effectively a claim to authority. If we are not mindlessly to submit to this authority in ourselves and in others we have to inquire into the cultural and linguistic templates of meaning and significance. It can be salutary to discover how little is sometimes left once these templates are identified and set aside. It is from that little, however, that the aesthetic is made – contrary to the normal prejudices of civilization. Art teaches us this lesson if we will learn it. For me, as for some others of my generation, it was the Minimal and Conceptual Art of the 1960s and the early 1970s, and the theory attendant on its development, which exposed the critical discourse of 'authoritative feelings' in all its pretentiousness, and which revealed the emptiness of those metaphysical presumptions by which that discourse was structured.

The early works of Conceptual Art were wholly unamenable to rhapsody. They were devoid of any of the conventional signifiers of artistic personality and were opaque to the psychological interests of the sensitive observer. Instead they posed questions about the logical and cultural identity of the work of art itself, and about the protocols and conventions of spectatorship, rather than its metaphysics. Because meaning could not easily be woven around them, such works were seen as empty by those competent in literary exegesis. In fact the critical plenitude of Conceptual Art lay precisely in its reassertion of

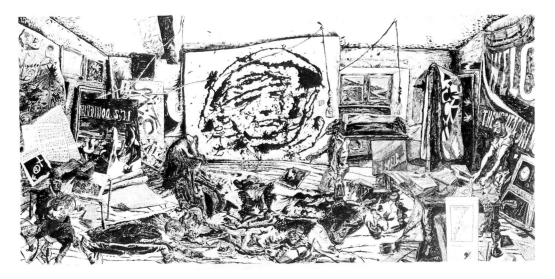

art's conceptual dependence upon language and in its power to frustrate the reading-in of self-serving meaning. The problems of description were what such art was principally made of. The literary problems of the sensitive critic were shown to be largely trivial and always irrelevant. The aesthetic void was filled up, literally, with a *reading*.

Of course, the forms and materials of Minimal and Conceptual Art were hardly such as would lend themselves to an iconic representation of the artist's studio. Nor, indeed, were the kinds of intellectual and psychological disposition assumed in Art & Language work such as to match the normal image of the solitary self-regarding artist. It could be said of the *Documenta Index* of 1972, however, that it was a product of those modes of investigation by which the Studio genre has largely been shaped. That is to say, it represented an examination of the conceptual and referential materials of practice, and availed an inquiry into the autonomy of that practice *vis-à-vis* the world in which it had its being. Albeit it had more in common stylistically with the library or the office, the *Index* was a representation, however schematic, of a place where meanings could be made – or unmade. In this sense at least it was a transformed kind of picture of a transformed kind of studio.

I suggested earlier that the exhibition in which the *Index* was shown marked the high point of curatorial interest in Conceptual Art and also, perhaps, the moment of its degeneration as a critical movement. Precisely ten years later, Art & Language was represented again at 'Documenta', and again the title 'Index' was used. Two large paintings were shown under the designation *Index: The Studio at 3 Wesley Place Painted by Mouth* (*I* and *II*) (see plates VI and 76). These were the first two works in that series with which this narrative is concerned. The ensuing text is largely dictated by the illustrative com-

Plate 76 *Art & Language*, Index: The Studio at 3 Wesley Place Painted by Mouth (II) *(1982). Ink on paper mounted on canvas, 343 × 727 cm. Private collection, Paris.*

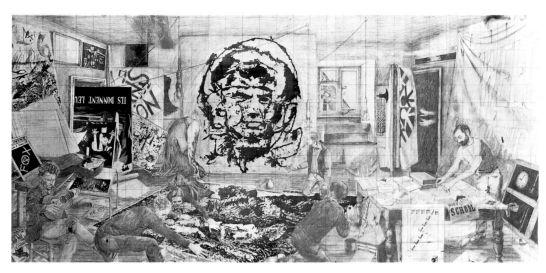

Plate 77 *Art &
Language*, Index: The
Studio at 3 Wesley
Place; Drawing (i)
*(1981–2). Pencil, ink,
watercolour and
collage on paper, 76 ×
162 cm. The Tate
Gallery, London.*

ponents of these paintings, by the narrative which those components
themselves were designed to construct, and by those formal develop-
ments in the series by which both illustrative components and narra-
tive were apparently deformed or obscured or erased. The items
included in the 'Studio' paintings were originally assembled in a
maquette (see plate 77). This will serve as an illustrative index for an
account of the paintings themselves.

Painting and expression

In view of the nature of Art & Language's earlier work, and because
various other pictures are represented within the studio, the first ques-
tion the 'Studio' paintings raise is 'Why paint pictures?' Some
materials for an answer can be derived from the scenario of fatalism,
miscalculation and accident presented in the preceding essay. It should
also be stressed that the culture of painting had never been as distant
from the practice of Art & Language as it was from those Conceptual
and Semio Art avant-gardists who tended to regard paint and brushes
as forms of Kryptonite. Though it is true that painting appeared
contingently unreachable past that wall of hieratic predicates which its
sensitive admirers had constructed around it, the possibility of some
(modern) form of re-engagement with the high genres of art was a
fascination or fantasy which had continually accompanied Art &
Language's provisional enterprises during the later 1960s and early
1970s. If it now seemed possible to address the culture of painting *by*
painting, this was partly because the address was both conceptually
and practically oblique, because it was not fully *intentional* in any
sense in which intention could be recovered by the sensitive admirer.
The possibility that a painting could be conceived and organized as an
'index' was a possibility that the normal *culture* of painting could be
circumvented in thought. That is to say, it was largely the feasibility of

a connection to the 'Indexes' of the early 1970s which made painting itself feasible for Art & Language as the means to a sustained project of work. The signifying character and potential of the Artist's Studio as a historical genre thus offered a point of entry into painting which was not presented by any prevailing painterly modes. (Components of various forms of index are represented within the maquette for the 'Studio' pictures (*Drawing (i)* as it came to be designated). Panels from *Index 01* and *Index 02* (see plate 47) are shown leaning against the left-hand wall. Filing-cabinets from the same two indexes (see plates 43, 44 and 46) are shown on the windowsill and under the table at the right. The *Alternate Map for Documenta* is shown partly unrolled on the floor behind the table at the left (see plate 45). And a part of the display for *Index 002 Bxal* is shown under the table at the right (see plate 52).)

Once the possibility was entertained, the pursuit of painting in the higher genres offered certain tactical advantages. It served to distance Art & Language from the post-Conceptual world of the graphic and photographic media, to reassert the opacity of art, and to recover irony, mannerism and anomaly in face of what was by now the all-too-automatic virtue of art as 'theory'. It served also as a means of engagement with that phenomenon which the promotional sections of the art world were preparing to celebrate as a New Spirit in Painting.[7] As Conceptual Art degenerated into a form of anti-Modernist theatre, a form of beholder was put back into business by a conjunction of mercantile acumen and primitive historicism. This was not, however, the professional and patrician beholder presupposed in Abstractionist theory, but the representative of a clientele always covertly hostile to abstract art and hungry for talk of the human condition. The so-called 'New Image' and 'neo-Expressionist' painting of the late 1970s and early 1980s was greeted by large sections of the international art world as recovering forms of significance, spirituality and spontaneity suppressed during the lean years of Minimal and Conceptual Art – and methodologically excluded from consideration even before then in that professional form of Modernist criticism which Greenberg had initiated.

Against the grain of these celebrations, Art & Language conceived of 'Expressionism' not as a possible style or mode of practice, but rather as the subject of ironic fascination and reference. The recent history of painting offers no real possibility of spontaneity. The assumption underlying Art & Language work was that the reinsertion of pictures into painting, and of painting into avant-garde practice, could be achieved only in conditions of travesty and misrepresentation. With the exception of some 'early works' of the mid-to-late 1960s, each of those previous paintings by Art & Language which are represented in the 'Studio' maquette may be seen variously to address a single complex and persistent condition: the inauthenticity of conventional expression-claims for art in face of the penetration of the aesthetic by the ideological.

Plate 78 *Art &
Language*, Ils donnent
leur sang: donnez
votre travail *(1977).
Oil on canvas, 236 ×
474 cm. Private
collection, Paris.*

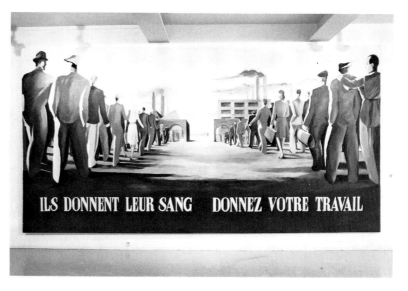

A first venture into the heights of 'oil on canvas' had been made in
1977, at a time when Art & Language was concerned to address 'the
recent fashion for caring' among certain conscience-striken sections of
the art world.[8] The painting *Ils donnent leur sang: donnez votre
travail* was based on a poster produced by the Nazis to recruit
industrial labour in Vichy France (see plate 78). In the original image
an artistic idealization of the (French) working class had been
rendered according to a (German) political idealization of (French)
artistic modernism. A section of the resulting painting is represented
upside-down at the left of the studio, between a maquette made from
Picasso's *Guernica* and a reduced representation of the painting for
which this maquette was made, *Picasso's 'Guernica' in the Style of
Jackson Pollock* (see plate 79). The last of the Lenin–Pollock paintings
features at the centre of Art & Language's studio, the *Portrait of V. I.
Lenin in July 1917 Disguised in a Wig and Working Man's Clothes in
the Style of Jackson Pollock II*, realized in a representation of Pol-
lock's black-and-white manner of 1951–2 (see plate 71).

Behind the index panels on the left-hand wall of the studio hangs a
section of another Art & Language painting, *Courbet's Burial at
Ornans Expressing (States of Mind that are Obsessive and Compelling)*
(see plate IV). For this painting a representation of Courbet's *Burial*
(see plate 80) was mapped onto a hugely enlarged version of a Pollock
sketch (the small pen-and-ink drawing of 1945 known as *War*[9]) (see
plate 81). As an integral part of Art & Language's work, the finished
picture was accompanied by a printed poster (see plate 82). Each
section of this text specified the expressive content of one of the three
sections of the painting. The original was printed in French. (Art &
Language's own English version was printed when the work was
acquired by the Tate Gallery in 1982.) The claim made for the section
represented in the studio reads as follows.

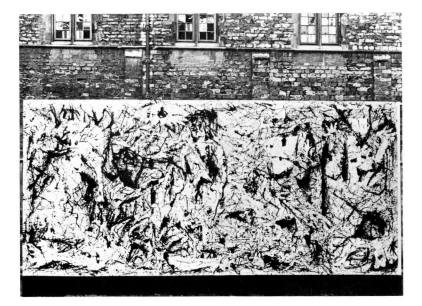

Plate 79 *Art & Language,* Picasso's 'Guernica' in the Style of Jackson Pollock I *(1980), installation* 'Kunst in Europa na '68', Ghent, 1980. *Enamel on board, 360 × 782 cm. Destroyed (version II, Museum van Hedendaagse Kunst, Ghent).*

Le tiers de la partie droite de L'enterrement à Ornans de Courbet est l'expression d'états d'esprits obsessionels et compulsifs, mais derrière lesquels se tiennent les années impitoyables de l'exploration de soi aussi bien que celle de la peinture. Elle exprime la passion et la conscience de chaque nuance du sentiment; elle est l'expression d'une vision cauchemardesque entr'aperçue d'une prise au filet de sorcières le jour du Sabbat, une masse noire, groupes impies semblables à ceux du jour du jugement dernier; elle est l'évocation d'un monde de rêves hanté par les êtres primitifs: démons, monstres, figures

Plate 80 *Gustave Courbet,* Burial at Ornans *(1849–50). Oil on canvas, 314 × 665 cm. Musée d'Orsay, Paris. Photo: Réunion des Musées Nationaux, Paris.*

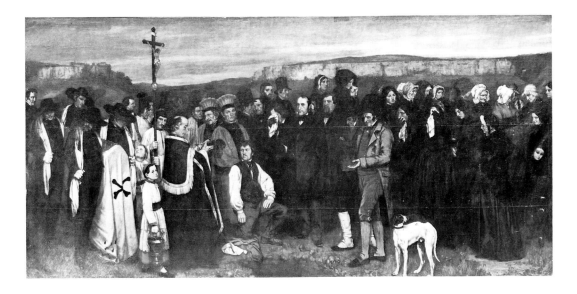

humaines et formidables, têtes de femmes énigmatiques. Elle exprime des images automatiques émotionelles dans une vision de suggestion horrifiante; elle est l'expression d'une protestation d'origine anarchique, une mise en garde, un message, une vision de la liberté, l'énergie et le mouvement sont rendus visibles: la réalité non pas d'hier mais de demain, la structure métaphysique et psychologique des choses, les alternations rythmique pleines de force sont fondées sur le processus de vie lui-même.

[The Right-Hand Third of Courbet's *Burial at Ornans* expressing States of Mind that are Obsessive and Compelling, but behind which lie Years of Ruthless Exploration of Self as well as Medium; expressing Passion and an Awareness of every Nuance of Feeling; expressing a Nightmarish Vision of a Half-Glimpsed and Enmeshed Witches' Sabbath, a Black Mass, Unholy Groups of Doomsday Aspect, through the Evocation of a World of Dreams haunted by Primordial Beings, Demons, Monsters, Human Figures and Huge Enigmatic Female Heads; expressing a Protest of Anarchic Origin, a Warning, a Message, a Vision of Freedom, Energy and Motion Made visible – the Reality not of Yesterday but of Tomorrow – and the Metaphysical and Psychological Structure of Things, the Powerful Rhythmic Alternations based on the Life Process Itself.]

Plate 81 *Jackson Pollock,* War c. 1944–46, *subsequently inscribed '1947'). Ink and crayon on paper, 52.7 × 66 cm. The Metropolitan Museum of Art, New York. Gift of Lee Krasner Pollock, in memory of Jackson Pollock, 1982.*

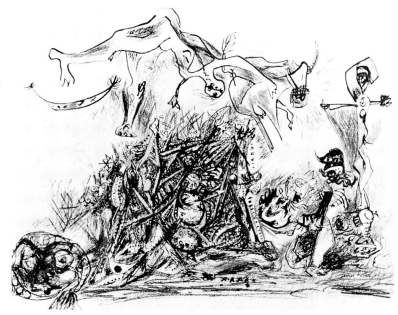

Plate 82 *Art & Language, text to face* Gustave Courbet's Burial at Ornans Expressing. . . . *Photostat, 122 × 122 cm.*

I The Left-Hand Third of Courbet's 'Burial at Ornans' expressing a Sensuous Affection which, in calling into Question the Autonomy of the Viewer as Separate from the Painting Itself – by setting Himself loose and drifting in Very Deep, Very Vague, and Immensely Generalised Reminiscences which have to do with a Sensuous Co-existence and which at Moments merge into a Sense of Fusion – touches upon Primitive Anxieties; expressing Hopes for a Better Personal and Social Future, not by a Flight into a Supra-Historical Domain of 'Timeless' Spiritual Essences, but rather, by a Penetration Metaphorically into the Region of Psycho-Biological Being – that Great Reservoir upon which these Hopes ultimately rest; expressing the Emotions and Sensations experienced through the Body and in the Rhythms and the Energy of the Body, in Responses to Human Bodies or the Feelingful Experience and Imaginings of Others in their Nakedness at Levels 'below' those of Language or Culturally Determined Signifying Practices; expressing Elements of Human Being and Potentiality which are not so much Historically Specific as 'Relatively Constant'. Love, the Brevity and Frailty of Human Existence, or the Contrast between the Smallness and Weakness of Man and the Infinity of the Cosmos, 1981

II The Central Third of Courbet's 'Burial at Ornans' expressing a Vibrant Erotic Vision, a Beckett-like Loneliness and a Haunting Monumentality through Volcanic Form and Colour and an Unbending Formal Self-Control meeting in the Common Ground of a Dark Anarchic Archetypal Configuration; expressing the Spirit of a Creative Obsession, which sweeps aside Unnecessary Convention so as to establish a New, Poetically Forceful Relationship between Image and Reality in a Cosmos of Hope – of the Raw and the Gruff, of the Turgid, Sporadically Vital Reelings and Writhings of the Ever-Renewed Active Dialogue between Spirit and Matter in a Transformation of Living Energy, 1981

III The Right-Hand Third of Courbet's 'Burial at Ornans' expressing States of Mind that are Obsessive and Compelling, but behind which lie Years of Ruthless Exploration of Self as well as Medium; expressing Passion and an Awareness of every Nuance of Feeling; expressing a Nightmarish Vision of a Half-Glimpsed and Enmeshed Witches' Sabbath, a Black Mass, Unholy Groups of Doomsday Aspect, through the Evocation of a World of Dreams haunted by Primordial Beings, Demons, Monsters, Human Figures and Huge Enigmatic Female Heads; expressing Automatic Emotional Images in a Vision of Horrific Suggestion; expressing a Protest of Anarchic Origin, a Warning, a Message, a Vision of Freedom, Energy and Motion made Visible – the Reality not of Yesterday but of Tomorrow – and the Metaphysical and Psychological Structure of Things, the Powerful Rhythmic Alternations based on the Life Process Itself, 1981

The different sections of text were collages composed of pastiches and quotations from the various writings of excited critics and journalists. When the painting was shown in Paris, the critic of *Flash Art* took the poster not as integral to the work but as a straightforward artist's statement; that is to say, as a first-order claim about it.[10] This error was a form of confirmation of the point Art & Language was concerned to make about the character and disposition of artistic culture and about the normal habits according to which meaning is read in to painting. (Such supine idleness is the other face of a more sinister necessity: that ironical inquisitiveness be suppressed in so far as it is bad for trade.) The kinds of deep significance which the sensitive observer is accustomed to read in to paintings – and particularly to expressionistic paintings – were presented by Art & Language as literally superficial; that is to say, as components of the painting's actual surface.

As suggested earlier, it has been a conventional assumption of criticism that what is felt in front of a painting is what is expressed by it, and that the expressive content of works of art is somehow traceable back to the psychology or even to the soul of the artist. But paintings live in the margins of lies. The actor on the stage expresses sadness. Is he therefore sad? Need he ever have experienced authentic sadness? No. All that is required to make him a competent actor is that he

should be able competently to *represent* sadness – that he should know how to fake it. If we are disposed to idealize the actor as 'sincerely' moved, then that is a function of our own cultural and psychological make-up. The task of criticism is to distinguish and to characterize the mechanisms of production of those effects we notice and are moved by. But first we must set aside those effects and meanings which we ourselves have caused and produced, for in describing these we do no more than to reproduce our culture – and ourselves as its clients. This is to say that an adequate reading of a work of art will need to be reflexive as well as descriptive – or reflexive in order to be descriptive. The *mechanisms* of 'reading' will have to be considered as they bear upon the language of description.[11]

The *Burial* was followed in Art & Language's oeuvre by a series of paintings of women. The second and most successful of these is represented on the floor of the studio, surrounded by figures apparently at work with paintbrushes held in their mouths: in the foreground, Michael Baldwin and Mel Ramsden, the artists who did indeed paint the picture by mouth; sprawled across the picture to the left of centre, Victorine Meurend, the model for Manet's *Olympia* (see plate 83), who assuredly did not; and to the right of centre the kneeling figure of this author, here fraudulently represented as an artist. The work represented at the centre of this stage shows a figure based on David's picture *The Death of Bara*, itself derived from Poussin's *Narcissus*. Its title is *Attacked by an Unknown Man in a City Park: A Dying Woman: Drawn and Painted by Mouth* (see plate V).

Each of the three paintings in this series shows a woman as the victim of some act of violence.[12] Each was largely drawn and painted with pencils and brushes held in the mouth. In a climate in which painting was supposed to have recovered its machismo, what Art &

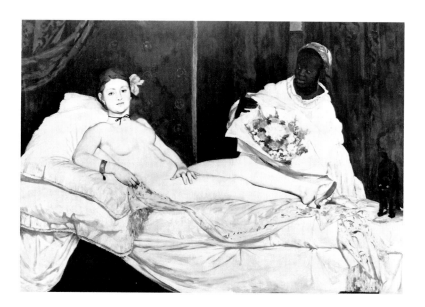

Plate 83 *Edouard Manet,* Olympia (1863). *Oil on canvas, 130 × 190 cm. Musée d'Orsay, Paris. Photo: Réunion des Musées Nationaux, Paris.*

Language intended by this device was that the male aggression involved in the emotive subjects and in 'expression' should be ironically reflected and displaced. It was also thought that the by-mouth procedure, in so far as it would automatically generate a kind of expressionist distortion and surface, would subvert the notions of competence and spontaneity associated with expressionist painting. Taken at face value, painting the female nude by mouth was a potentially provocative act, redolent of that hysterical eroticism sometimes discovered in the hinterland between the aesthetic and the pornographic. The effects of pornography depend upon forms of self-importance, however, and they are defused by bathos. In the conventional apologia for expressionistic forms of painting, distortions are interpreted as symptoms of spasms of the (artistic) soul. It was Walter Benjamin who suggested that 'there is no better starting point for thought than laughter; . . . spasms of the diaphragm generally offer better chances for thought than spasms of the soul'.[13] Art & Language offered stylistically 'serious' forms of distortion which were the consequences of absurd and bathetic procedures:

> We do not produce these pictures and index them with this symbol – P B M [painted by mouth] – with the specific object of assisting the enfranchisement of the artistically disenfranchised. We produce them in order to live with the hiatus and the project of work it encounters. We produce them in order to say that the prevailing discourses of art enshrine arbitrary closures on substantive and open enquiry. The suppression of enquiry by analogous means is the mark of the age, misrepresenting its mechanisms to itself as a necessary condition of its persistence.[14]

There was also some interest in the idea of a painting which 'failed to signify'. This possibility had been raised by T. J. Clark with regard to Manet's *Olympia*. Clark had asked of *Olympia*'s public appearance in 1865 'whether what we are studying . . . is an instance of subversive refusal of the established codes, or of a simple ineffectiveness'.[15] What would it be like, Art & Language speculated, to *intend* a painting which failed to signify, and how would it be distinguished from one which 'refused established codes'? And how might either be represented by viewers to themselves? What resources of description would be available? In the event the *Dying Woman* looked competent and seemed expressive in ways not entirely to be accounted for by those technical devices which had been adopted in making it. It was not so much that the 'by-mouth' technique invoked questions of artistic competence, intention and so on, as that the *claim* that the picture had been painted by mouth seemed to stalk the spectator's experience of the painting. To attempt to describe that experience was to confront a hiatus. Apparently expressive in itself, ironic and alienated in its actual

means of production, the painting seemed to dramatize the nature of aesthetic experience as a compromised form of psychological life.

This painting appeared to raise more acutely than the Lenin–Pollock paintings that range of questions which I considered at the close of the previous essay. Speaking from a personal position as a kind of compromised connoisseur, I know how hard I found it to reconcile my detailed knowledge of the conditions of production of the painting with the effect it produced upon me; or, to put it another way, how hard to accept that the apparent expressive aspect of the painting could have been produced through those procedures which I knew to have been employed. It was not simply that I was caught in the trap the painting was intended to be: that the meanings and values of my own first-order discourse had been brought into play by the painting, only to be reflected back from its actually second-orderish surface in forms of critical paraphrase and redescription.[16] It was also that my assumptions about the critical and second-orderish enterprise of the project were thrown into confusion by the quite unexpected character of the painting, and by its power to elicit those very first-order predicates which were the objects of its own irony. The *Dying Woman* was not the last work to have been completed prior to the commencement of the long 'Studio' project. Its positioning at the centre of the activity of the studio, however, was a form of acknowledgement that some continuing interest and urgency attached to the complex problems it raised.

These various paintings were among the more recent materials assembled for the representation of the artists' studio. Scattered around the imaginary room are various other works by Art & Language dating back over the previous sixteen years: black paintings from the mid-to-late 1960s (see plate 20); various forms of Conceptual Art from the years 1967–72 (see plate 33); a banner made for the Venice Biennale in 1976 (proclaiming 'WELCOME TO VENICE – THE DICTATORSHIP OF THE BOURGEOISIE' (see plate 51)); the *Ten Postcards* comprising a fasces upon which an exhibition had been based in 1977 (see plate 67); one of a series of *Flags for Organizations* exhibited in 1978 (see plate III); designs for the covers of the journal *Art–Language* and for the covers of records made with The Red Crayola, one including an ironic reference to the work of Georg Baselitz (see plate 84). (This was the cover for the album *Kangaroo?*. From the point of view of England, kangaroos in Australia are upside-down, which is how Baselitz paints his figures.)

The works of various other artists feature in the studio. In acknowledgement of the challenge it represents and is represented as, Courbet's *Artist's Studio* is quoted twice, once in the overall dimensions of the Art & Language 'Studio', which are comparable to Courbet's, and a second time as a reproduction on the table at the left, where it appears just below a reproduction of Manet's *Olympia*, itself included in reference to the uncompleted opera *Victorine*, for which we were then writing a libretto.[17] Braque's *Studio V* appears at the top left (see

Plate 84 *Art & Language, drawing for a poster for* Kangaroo? *(1981). Ink on paper, 37 × 32 cm. Private Collection, London.*

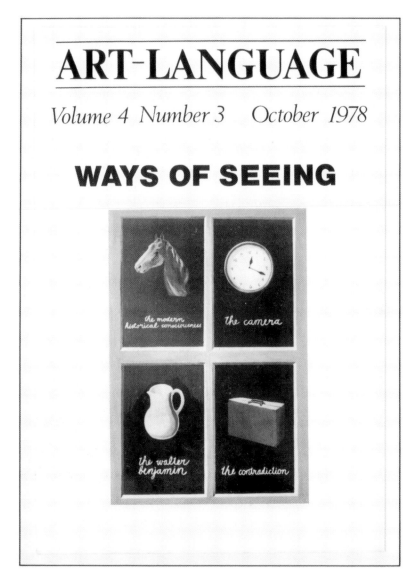

Plate 85 *Cover of
Art-Language vol. 4
no. 3 (October 1978)
('Ways of Seeing').*

plate 74).[18] Magritte's *Key of Dreams* (and family) is referred to at the extreme right in a version made by Art & Language for the cover of *Art–Language*, vol. 4, no. 3 (October 1978), an issue which took the form of a sustained critique of John Berger's *Ways of Seeing* (see plate 85).[19] Among the books and magazines on the table a double-page spread of Daniel Buren's stripes testifies to his ubiquity.[20] The hands emerging from the cupboard at the extreme right are taken from Picasso's *Minotaur and Dead Mare before a Grotto.*[21] The mourning figure to the left of Lenin is taken from a painting by William Blake, *God Smiting Job with Plague Boils.*[22] The guitarist at the left is Mayo Thompson. His positioning and pose are taken from an allegory on the studios of Clésinger and Roqueplan, published in the *Magasin*

pittoresque in 1849.[23] The figure at the right is the art historian Fred
Orton, with whom I was working on a history of Art & Language
during the period when the first 'Studio' painting was being
produced.[24]

Art & Language has published a 'list of some of the things represen-
ted in *Index: The Studio at 3 Wesley Place*', which cites over sixty
items.[25] These can be named and described. But, in the index which
the painting forms, each of these citations – a painting, a book, a
person – could be seen to stand for an open set of references or
incidents or interests. No description can adequately circumscribe all
that is possibly caught by the index, or even trace through all its
pathways the genetic material carried through a single citation.

Some functions of allegory

At this stage it needs to be clearly acknowledged that iconographic
richness and complexity, however attractive to art history's clerks and
scholars, has never been a sufficient measure of aesthetic power and
interest. Viewed as a picture, the maquette in which the contents of the
studio are assembled presents a traditional, even a conservative, face.
Its referential and illustrative materials are the materials of a modern
art, but it is not itself technically modern. I mean by this not simply
that the maquette presents a relatively traditional composition, in
which various items are illustratively described. I mean also that the
tendency of the picture is literally to conserve that which it includes, as
if the studio were the site of preparation of a retrospective exhibition –
a kind of museum in the making. In the most telling examples of the
genre – in the pictures of Vermeer, of Velázquez, of Courbet – the
Studio painting is a form of allegory. Its component items draw their
vividness as symbols from the possibility of their resonance in another
world. And it is in the nature of allegory that it devastates its own
subjects. As the pattern of symbols develops and achieves autonomy,
as the allegory develops according to its own strange logic, it must
progressively deform that conceptual order to which it refers and
relates. In the end it must leave in ruins that world of references which
it first organized into a system. Though they may be connected, the
displacements of allegory are more radical than those of irony. Irony
entails a kind of 'spatial' relocation, a move to an adjacent position
from which the same subject may be differently regarded. Allegory is,
or entails, a form of 'temporal' displacement. It aims to model the
possibility of being in some different order, where the meaning of that
being is critically changed. According to this view of the nature of
allegory, the supposed failure of Courbet's *Artist's Studio* might be
seen as a kind of success within some transformational world.

This view of allegory, which is largely derived from Walter
Benjamin and Paul de Man, accords with the idea that the critical
function of art lies in its autonomy.[26] It is intriguingly compatible with

Clement Greenberg's Modernist theory.[27] This is to say that the tendency of allegory to develop at a critical distance from its referents may be related to the apparent tendency of expressive and decorative qualities of surface to develop in modern painting at the expense of descriptive and referential detail. Both tendencies seem consistent with the development of an ethical independence in artistic form. The latter tendency has normally been stressed in justifications of abstract art. It might be more interesting to consider the two tendencies together as complementary conditions of realism in the practice of modern art.

Certainly those processes of self-criticism which appeared to direct the Art & Language 'Studio' paintings may be represented in terms of some such reconciliation of the resources of critical theory. From the perspective of hindsight, that is to say, the series may be seen as caught within and shaped by a series of quasi-logical relations connecting the concept of high genre, the Abstractionist theorization of Modernism, and the autonomizing tendencies of allegory as here explored. It can be said, for instance, that the very idea of a high art, so central to Modernist theory, is hostage to an antecedent hierarchy of genres. According to academic convention, the status and potential of the genres was assessed in relation to their respective capacity to sustain moral and allegorical meanings. The theorization of abstract art as high art thus invokes a legacy which is not so much a legacy of allegorical themes as a legacy of allegorizing mechanisms and tendencies. It also invokes a legacy of 'readings' and of possible ways to read. In addressing the genre of the Artist's Studio explicitly as a high genre, Art & Language was also bound to be engaged with that body of theory which advanced abstract art as the paradigmatic form of modern high art. Further, to engage practically with painting as a high-art form was – albeit agnostically – to conjure up those very autonomizing tendencies which Abstractionist theory represented as fulfilled in abstract art.

It should be stressed that the version of autonomy canvassed here is to be equated not with some world of non-contingent values, but rather with the specialization of systems and practices within a world of practices. Though the Abstractionist elaboration of Modernist theory has generally been seen as antithetical to the interests of realism, the concept of high art means nothing to that theory if it is not sustained in the face of or in some kind of tension with a world of lower genres, a world of non-aesthetic interests, a wider, more pervasive, more popular culture.[28] Modernist theory is empty if it is not pursued in some state of awareness of the conditions of exploitation which are invoked, if not required, by the maintenance of the relevant differences and contrasts. As the arch-aesthete Walter Benjamin knew, as Clement Greenberg knew in 1939[29] and no doubt remembered, the artistic consciousness of Modernism must have its Nietzschean bad conscience. Without it, the idea of the aesthetic is no more than the seal upon complacency and privilege.

It should be clear that the concept of allegory employed here is

Plate 86a–d *Manet's Olympia in details of plates 77, VI, 76 and VII.*

wider than the one normally employed in Modernist theory, according to which all such 'literary' forms are inimical to painting in its pursuit of a technical modernity. It is according to this more restricted view, for instance, that the 'Studios' of Matisse and Braque appear to resist interpretation as allegories. The citation of Braque's *Studio V* in the Art & Language 'Studio' was made in recognition of just this conventional resistance (see plate 74). And yet how is such a surface to be *read* – indeed, how is the surface of the all-over abstract painting to be read – if not as some structured system of symbols of some kind? 'What would it be like to paint an allegory now?' was the question which Art & Language addressed. What could a moral and physical history of the studio be like as a modern painting? Could the critical function of allegory be recovered without lapsing into conservatism *vis-à-vis* the technical prescriptions of Modernism? The answer, I believe, turned out to be yes, though, to anticipate the conclusion of my narrative, the price that was paid was a reduction of the indexed contents of the studio to the status of genetically present but empirically untraceable components of an all-over 'abstract' surface (see plate 86 a–d). In practice the unfolding technical drama of the Artists' Studio was played out as a dialectic between those vulgar illustrative items which referred to things in the world and those expressive and decorative aspects which referred to the artistic necessities proclaimed in Modernist culture.

The transformation of the index

In Art & Language's paintings of women the by-mouth device had served to render the spectator's predicates insecure. Now the same device served to subvert the simple legibility of the 'Studio' maquette, to prise the spectator loose from those kinds of linguistic competence which are exercised in mere listing and naming, and to dislocate the conventions and conventional claims attached to the Studio genre. The adequacy of this maquette as an index made it inadequate as a compositional study for an ambitious modern painting. A second drawing was made from it using a pencil held in the mouth (see plate 87). A

level of distortion and accident and bathos was thus introduced into the composition, representing a first stage in the ruination of its referents. This by-mouth drawing was squared up and transferred exactly by hand to the full-sized paper on which the first 'Studio' painting was to be produced. This was then coloured in by hand and finally painted over in black ink by mouth with reference to the original maquette. This last stage was intended to unify the overall composition in a manner suggestive of expressionistic abstract art. The finished painting was first shown in Holland in April 1982.[30]

By then Baldwin and Ramsden were at work on the second 'Studio' painting. This time the by-mouth copy of the first drawing was copied directly and without squaring-up onto the full-sized paper. This work was done entirely with brushes and black ink on the floor of the studio. Since the actual working space was less than half the length of the painting, less than half of the paper could be unrolled at any one time. Furthermore, painting with their heads close to the surface, the artists had to navigate by dead reckoning. The scale of distortion increased dramatically.[31] The figurative detail was still present, and was still determining upon the forms of the painting, but much of it became unreadable or unreconstructable. Neither this painting nor the first had been seen in its entirety by the artists before it was first installed for exhibition. When they were seen together at 'Documenta' in the summer of 1982, the effect of the second 'Studio' painting was to make the first look highly illustrative and relatively classical. This impression might be reformulated as a kind of confirmation of Modernist theory: a decrease in the significance of illustrative detail could be seen to coincide with an increase in apparent expressive character. And yet the expressive aspect was a kind of travesty or scandal, and the truth-value of the 'confirmation' was therefore compromised.

At the start of the 'Studio' project, a series of four paintings had been planned according to a system of permutations involving different 'scales' of distortion effected at different stages. The vanity of planning, however, is often exposed in the contingencies of practice. The continuation of the project involved a conceptual shift. A third drawing was produced by hand showing the studio in the dark – or

Plate 87 *Art &
Language,* Index: the
Studio at 3 Wesley
Place Painted by
Mouth (I); Drawing (ii)
*(1982). Pencil on
paper, 93 × 174 cm.
Private collection,
England.*

showing, at least, what was still notionally discernible of the original
index after a theatrical form of chiaroscuro had been applied to it (see
plate 88). A fourth drawing was then produced without squaring-up,
by mouth, to generate a relatively large scale of distortion (see plate
89), and this was transferred by hand to a canvas of approximately the
same dimensions as Courbet's. On the basis of these two drawings
Index: The Studio at 3 Wesley Place in the Dark (III) was gradually
worked out in the autumn of 1982 (see plate VII). As the accidents of
this surface came increasingly to determine practical moves, the by-
mouth device became redundant and was abandoned along with the
'by-mouth' claim. Given the epistemological norms associated with
the Studio genre, sufficient scandal-making potential was, anyway,
involved in the imaginary eventuality and the dramatic absurdity of
the 'darkness'. As the work proceeded, the signifiers both of style and
of imagery were largely cancelled or obscured. In the finished painting
the bulk of the original detail, though painted in at the initial stages,
has become indecipherable in the darkness of the surface except as the
occasional origin of a literally superficial texture. To say this,
however, is perhaps to misrepresent the nature of the mechanisms
involved. It might be more appropriate to describe the darkness as a
kind of metaphorical figure for that *necessity* of loss of definition and
reference which seems to be the price of modern 'expression'.

Plate 88 *Art &
Language,* Index: The
Studio at 3 Wesley
Place in the dark (III)
and illuminated by an
Explosion nearby (V,
VI, VII, VIII); Drawing
(iii) *(1982). Pencil and
acrylic on paper, 78 ×
162 cm. The Tate
Gallery, London.*

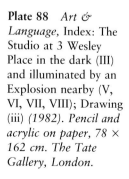

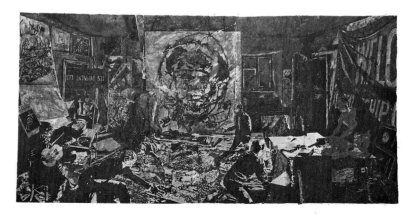

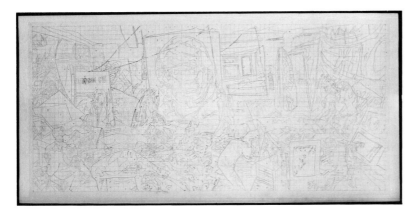

Plate 89 *Art & Language,* Index: The Studio at 3 Wesley Place Painted by Mouth (II); Drawing (iv) *(1982). Pencil on paper, 93 × 174 cm. The Tate Gallery, London.*

In fact, even after its once-vivid colour and detail had been largely suppressed, *The Studio in the Dark* still seemed too redolent of the actual presence of persons and things – too suggestive, in its tenebrous atmosphere, of the untransformed world of its referents. It appeared that something had to be done to the painting (see plate 90). In a final stage of work Baldwin and Ramsden stencilled across the surface representations of Art & Language's most embarrassing failures – works which had been excluded from the original list of the contents of the studio: irredeemable early works, failed attempts at Socialist Realist paintings in the style of Pollock, unincisive agit-prop posters and cute projects for unrealized exhibitions. These grey figures are clearly on the surface, though they twist and turn in casual acknowledgement of the illusion of depth. This lip-service to the picture space merely serves to confirm its fictional character, destroying its theatrical integrity and asserting the presence of a literal surface as emphatically as does the paper on a collage by Braque. Nor is it simply the illusionistic scheme of the painting that is compromised by this act of ironic disclosure and fraudulent penitence. The stencilled representation of the embarrassing failures serves also to call into question the autobiographical integrity and authenticity of the original index of contents and the history which this might be seen to illustrate.[32]

Plate 90 *Art & Language,* Index: The Studio at 3 Wesley Place showing the Position of 'Embarrassments' in (III); Drawing (v) *(1982). Ink and crayon on photograph, 79 × 168 cm. The Tate Gallery, London.*

That ethical functions may be subsumed under technical considerations is the strong hypothesis supporting Modernist claims for the autonomy of art. It is with justice that Modernist theory calls attention to that assertion of the literal surface in the face of illusion and mimesis which was a feature of modern art's Copernican revolution. In Modernist theorization of the supposed dialectic between surface and signification (which dialectic is the principal theme of the following essay), pursuit of a relative autonomy for the decorative surface has been associated with a form of aesthetic imperative. It is a suggestion readable from Art & Language's 'Studio' series that this pursuit might with more justice be seen as a requirement of realism, in so far as it involves the abandonment of those cherished and self-interested forms of imagery which fail to withstand practical self-criticism.

Realism is certainly not to be equated with illustration or with any merely descriptive or even mimetic correspondence between pictures and things in the world. Indeed, the significant requirement of realism appears now to be that, whatever cultural, conceptual, psychological and other materials art is made from, and whatever commitments may be represented in their selection, these materials must be put at risk by the trajectory of practice. It may well be that the price of some form of aesthetic autonomy for the end result is that these materials are ruined, pulled out of shape, engrossed, left as no more than remainders. It seems that the tendency of art as a critical practice is constantly to exhaust its own resources of representation and expression.

In the spring of 1983, a form of dialogue was published by the artists of Art & Language as a parody of the 'X Paints a Picture' formula employed by *Art News* during the period of institutionalization of Abstract Expressionism.[33] One voice was made to say, 'The "Studio" series began in one world and it will end, if it ends, in another. Indeed it is already in another.' Beyond this date, the continuation of the 'Studio' project required a further shift of representational levels, a further fragmentation, obliteration and distancing of the component references of the original composition. In a sixth study, produced photographically, the surface of *The Studio in the Dark* was treated as a pictorial subject in itself, a reflecting wall upon which light was made to fall from an event in another temporal and logical space (see plate 91). The four works derived from this study were given the title *Index: The Studio at 3 Wesley Place illuminated by an Explosion nearby (V to VIII).*[34] In these the all-revealing light of the first 'Studio' painting is now remote and dim. There is no firm perceptual line to divide the fragmentary illumination of depicted people and things within a represented space from the accidental features of an actual illuminated surface. The language of description fails in a welter of dilemmas. Light 'in' the painting becomes confused with light 'on' the painting (see plates 92 and VIII).

In this confusion we might see symbolized the paradoxes of expression and interpretation. The nature of the allegory has changed. It is not now the historical nature of an artistic practice that is being

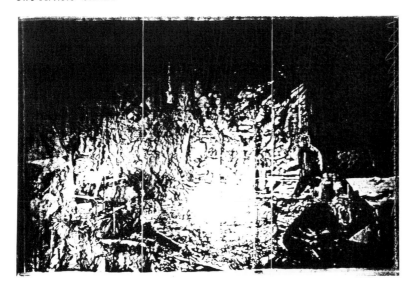

Plate 91 *Art & Language,* Index: The Studio at 3 Wesley Place illuminated by an Explosion nearby (V); Drawing (vi) *(1982). Photograph, 106 × 160 cm. The Tate Gallery, London.*

symbolically examined and translated, but the ontological character of representation and the psychological conditions of watching art. In what turned out to be the last completed work in the series, the quasi-allegorical confusions of illumination, reflection and darkness are further displaced by slashes through the literal surface of the canvas (see plate IX). Inserted into the 'slashes' are what appear to be precisely

Plate 92 *Art & Language,* Index: The Studio at 3 Wesley Place illuminated by an Explosion nearby (VI) *(1982). Photograph and mixed media on canvas, 240 × 360 cm. Courtesy of Lisson Gallery, London.*

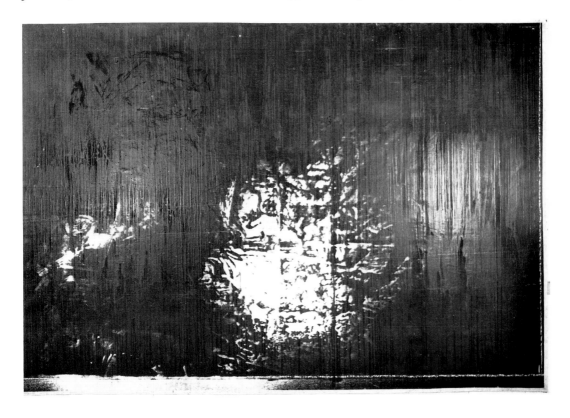

matching photographic representations of the excised material. These representations are in fact blurred accounts of an antecedent surface: not the surface of the painting but a surface which the painting itself depicts. As each representational 'layer' is uncovered, the iconographical furniture of the original studio becomes ever more remote. The prospect of a total erasure is what next confronts the practice of Art & Language.[35]

From the 'Studio' series as a whole a kind of theoretical lesson can be drawn. What is described and expressed in art is always indirectly described and expressed. There is no simple truth-value in artistic forms of description and expression. The project of painting must live with the ironies involved, and with the constant exhaustion of its own resources of description and expression. The critic must take account of this. The art of seeing is not to uncover meaning but to watch what is being done and to see what cannot be done again and meant. The art of description lags behind, outreached both by the uniterated imperatives of the practice of art and by the interests of the art of seeing.

To say this is not to mystify either art or vision. It is simply to point to the limits of descriptive language. It is a condition of what we mean by art that some philosophically and psychologically exotic objects are generated in its name. These may be generated in readings, including those readings which form the unarticulated stuff of intentionality. It does not follow, however, that works of art need in themselves to be exotic auratic objects. Indeed, it is part of the burden of this essay that the subversive generation of these strange and mysterious cultural materials may depend upon the work of art's presenting *as much as it can* of a proper and classical face.

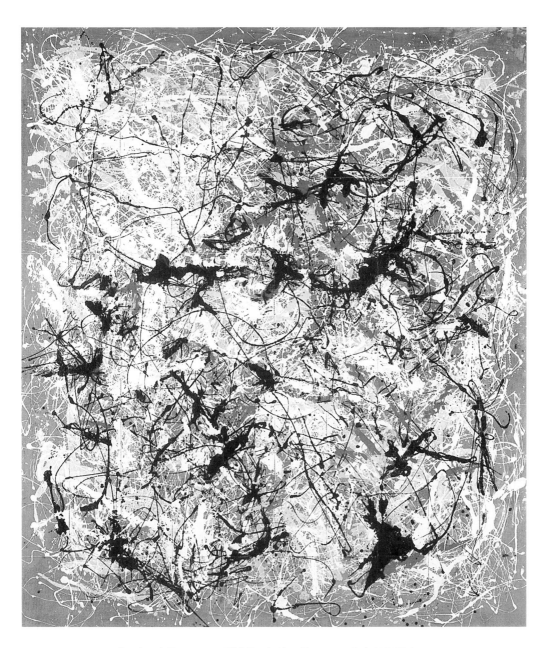

1 *Art & Language*, 'V. I. Lenin' by Charangovitch (1970) in
the Style of Jackson Pollock *(1980). Oil and enamel on board
mounted on plywood, 239 × 210 cm. Private collection, Paris.*

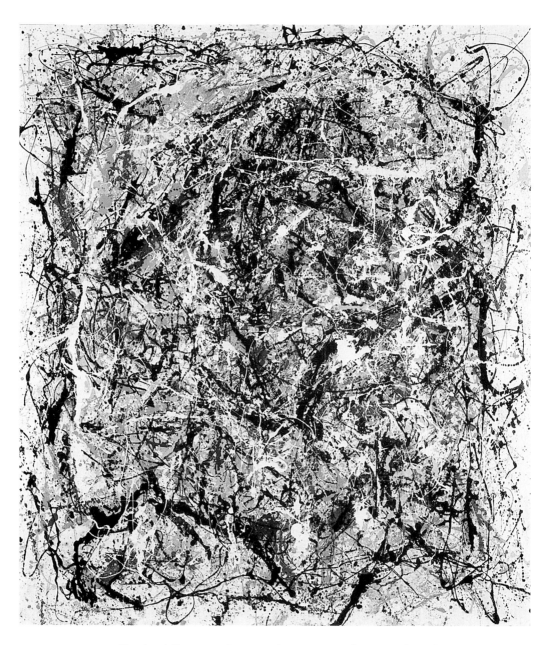

II Art & Language, Portrait of V. I. Lenin with Cap, in the Style
of Jackson Pollock II *(1980). Oil and enamel on board mounted
on plywood, 239 × 210 cm. Private collection, Paris.*

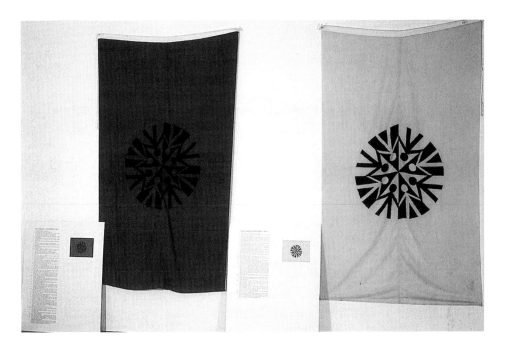

III *Art & Language*, Flags for Organizations 1978, *installation
at Lisson Gallery, London. Wool and black cambric flags, each
155 × 239 cm; lists of axioms, photostat with acrylic, each 90
× 60 cm; edition of 4. Courtesy of Lisson Gallery, London.*

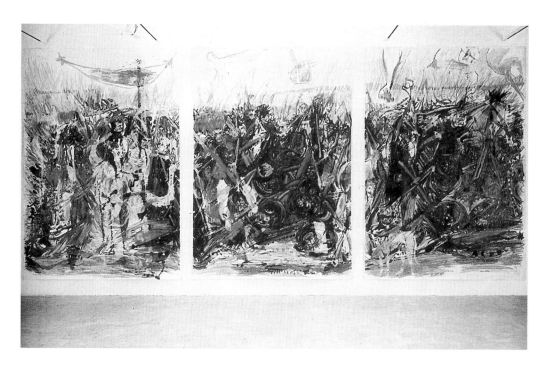

IV *Art & Language*, Gustave Courbet's Burial at Ornans Expressing . . . *(1981). Ink and crayon on paper mounted on canvas, three sections each 324 × 233 cm, overall size 324 × 699 cm. The Tate Gallery, London.*

V *Art & Language,* Attacked by an Unknown Man in a City Park: a Dying Woman; Drawn and Painted by Mouth *(1981). Ink and crayon on paper mounted on wood, 175 × 258 cm. Private collection, Paris.*

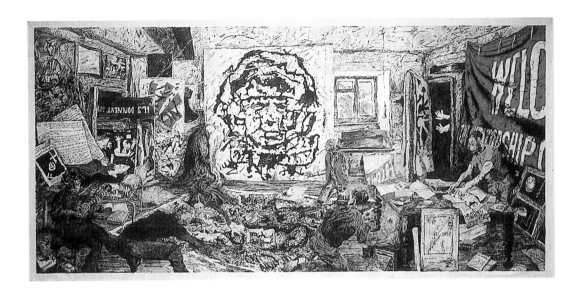

VI Art & Language, Index: The Studio at 3 Wesley Place
Painted by Mouth (I) *(1982). Ink and crayon on paper, 343 ×
727 cm. Collection Annick and Anton Herbert, Ghent.*

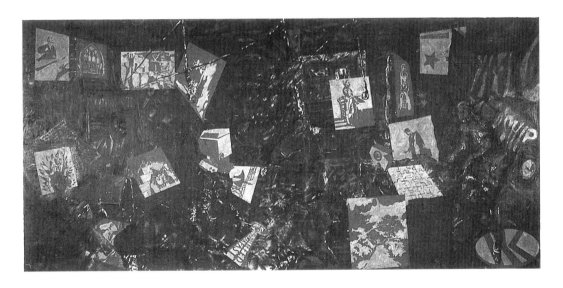

VII Art & Language, Index: The Studio at 3 Wesley Place in
the Dark (III) *(1982). Acrylic on canvas, 330 × 780 cm. Private
collection, Paris.*

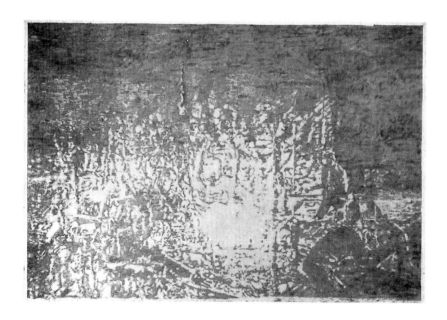

VIII Art & Language, Index: The Studio at 3
Wesley Place illuminated by an Explosion nearby
(VII) *(1983). Oil on canvas, 305 × 360 cm.
Museum Moderner Kunst, Vienna.*

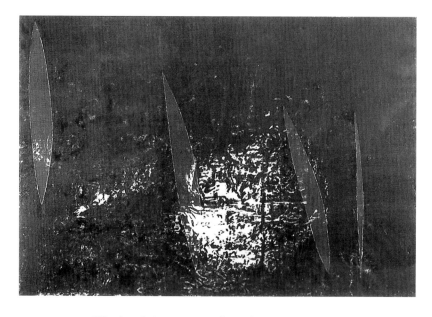

IX Art & Language, Index: The Studio at 3
Wesley Place illuminated by an Explosion nearby
(VIII) *(1983). Oil and collage on canvas, 305 ×
360 cm. Museum Moderner Kunst, Vienna.*

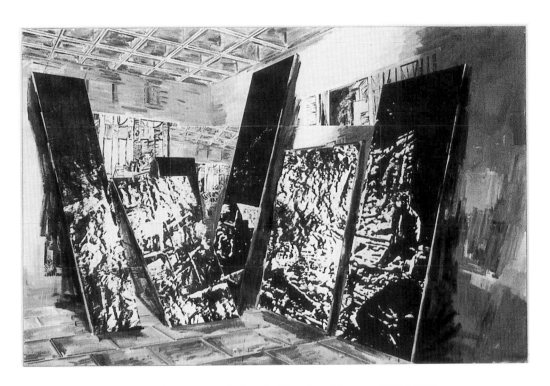

X *Art & Language,* Index: Incident in a Museum XXI *(1987).*
Oil and photograph on canvas mounted on plywood, 234 ×
379 cm. Courtesy of Lisson Gallery, London.

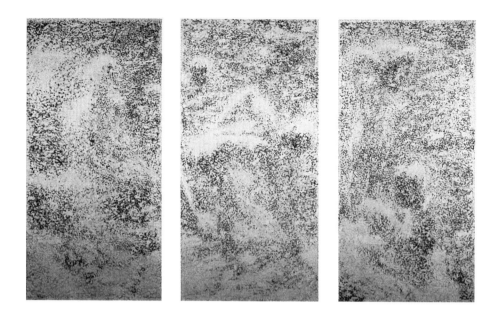

XI *Art & Language,* Impressionism returning Sometime in the
Future (1984). *Oil on canvas, three sections each 234 × 112
cm, overall size 234 × 336. Private collection, London.*

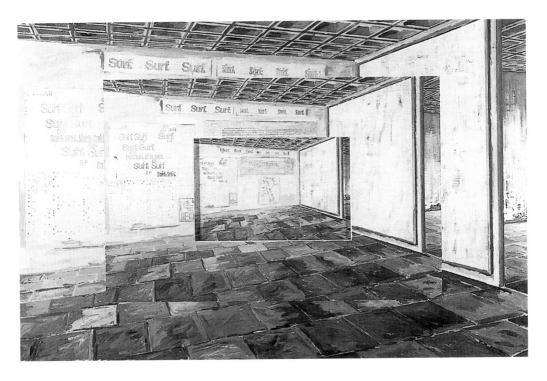

XII *Art & Language,* Index: Incident in a Museum III *(1985).*
Oil, collage and Alogram on canvas mounted on plywood, 174
× *271 cm. The Levy legacy, the McMaster Museum of Art,*
Hamilton, Ontario.

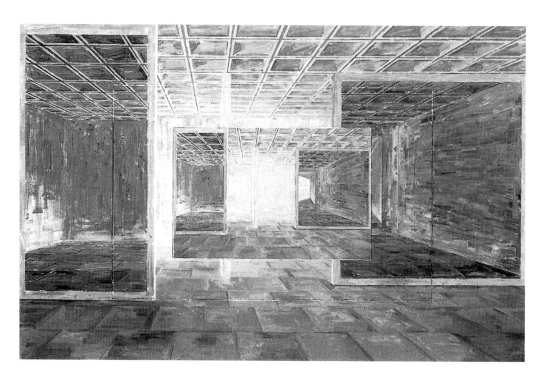

XIII Art & Language, Index: Incident in a Museum XIII
*(1986). Oil on canvas mounted on plywood, 174 × 271 cm.
Private collection, Antwerp.*

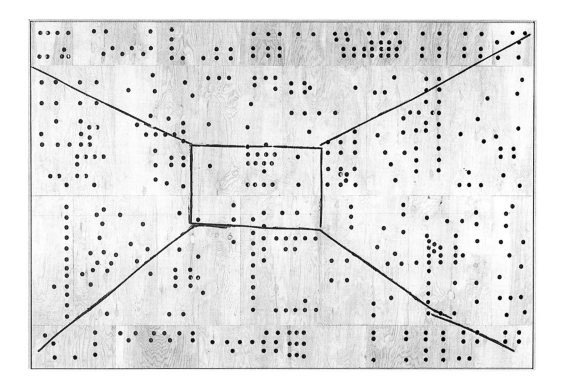

XIV Art & Language, Index: Incident in a Museum (Madison
Avenue) XIV *(1986). Oil on plywood over oil on canvas
mounted on plywood, 243 × 379 cm. Collection Eric Decelle,
Brussels.*

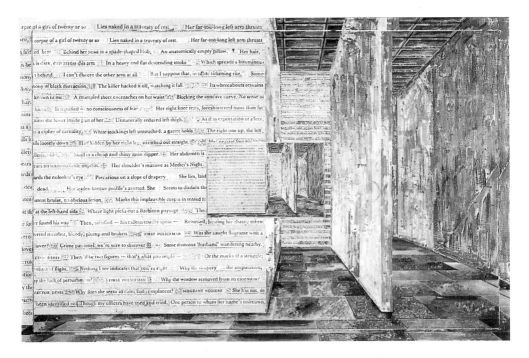

XV *Art & Language*, Index: Incident in a Museum VIII
*(1986). Oil and Alogram on canvas mounted on plywood, 174
× 271 cm. Private collection.*

XVI *Art & Language*, Index: Incident in a Museum XVI
*(1986). Oil and Alogram on canvas mounted on plywood, 243
× 379 cm. Private collection, London.*

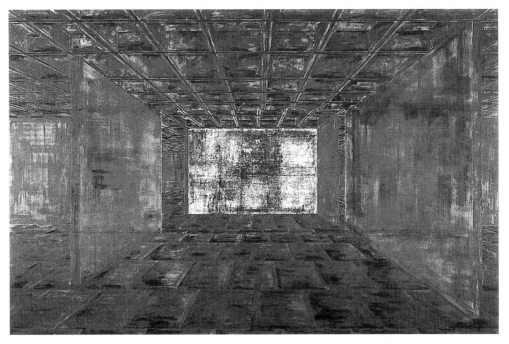

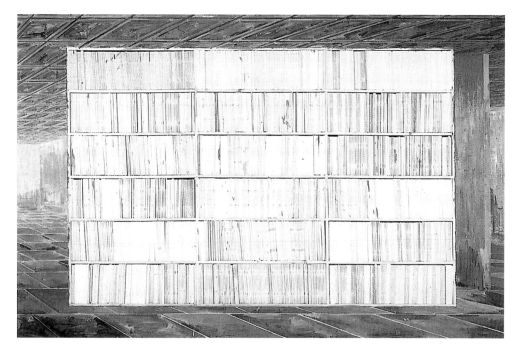

XVII Art & Language, Index: Incident in a Museum XXV
(1987). Oil on canvas mounted on plywood with bookcase and
books, 174 × 271 cm. Courtesy Marian Goodman Gallery,
New York.

XVIII Art & Language, Unit Cure, Unit Ground I (1988). Oil
on canvas mounted on plywood with mixed media, 190.5 ×
254 cm. Private collection, Belgium.

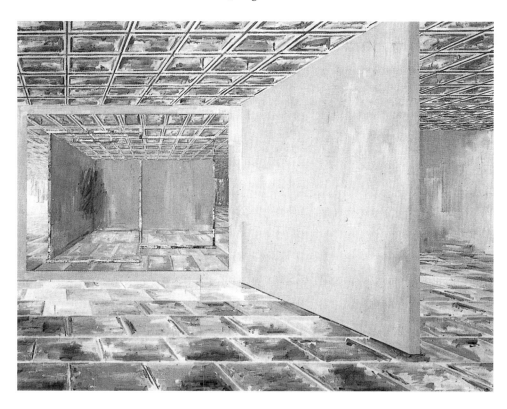

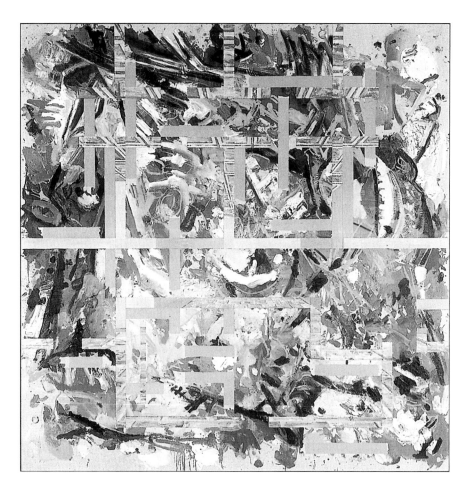

XIX *Art & Language,* Hostage XIII *finished*
state (January 1989). Oil on canvas mounted on
plywood, with acrylic on canvas on plywood
inserts, 305 × 305 cm. Courtesy of Lisson
Gallery, London.

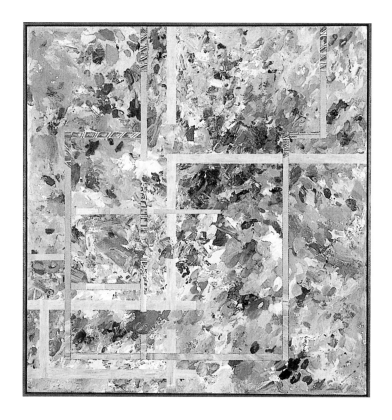

XX *Art & Language,*
Hostage III *(1988). Oil
on canvas on plywood,
with acrylic on canvas
on plywood inserts,
190 × 183 cm. Private
collection, Belgium.*

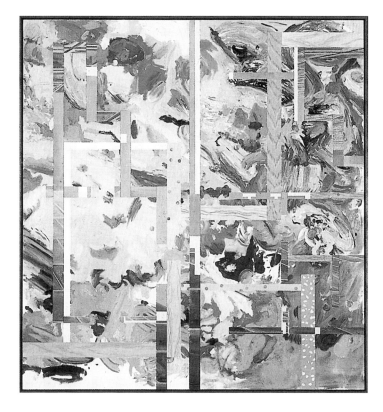

XXI *Art &
Language,* Hostage V
*(1988). Oil on canvas
on plywood, with
acrylic on canvas on
plywood inserts, 190 ×
183 cm. Private
collection, USA.*

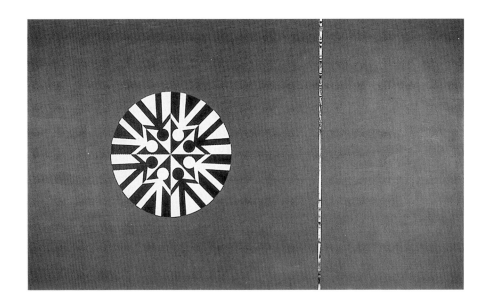

XXII *Art & Language*, Hostage: An Incident and a People's
Flag III *(1988). Oil on canvas, with oil on canvas on plywood
insert, 274 × 457 cm. Courtesy of Max Hetzler Gallery,
Cologne and Lisson Gallery, London.*

XXIII *Art & Language*, Hostage: An Incident and a People's
Flag IV *(1988). Oil on canvas, with oil on canvas on plywood
insert, 274 × 457 cm. Courtesy of Max Hetzler Gallery,
Cologne and Lisson Gallery, London.*

7

On the Surface of Painting

For some two years between 1983 and 1985 Michael Baldwin and Mel Ramsden painted pictures which ended up white. Though these works were not viewed without irony, and though few of them survived the exercise of self-criticism, the intuition has persisted that the problem-field of the project was generated by some significant conditions of art. At an early stage in this phase of work Baldwin and Ramsden happened across a snow scene painted in the sixteenth century. Within a conversation which I subsequently joined, 'snow' was adopted as a kind of ironic metaphor for the expressive all-over surface of the Modernist painting – or, rather, the conceit of 'snowing on the canvas' was adopted as a laconically practical way of referring to that gradual cancellation or erasure of descriptive signifying content which has seemed to be a necessary and indeed over-determined process in the technical resolution of Modernist painting.

The aim of this essay is to explore that metaphor; or, rather, to try to think some pathway through the conditions which made it one. In doing so I am not offering a *post hoc* analysis of the paintings, but attempting to remember the continuing conversation of the studio and to reassemble and to represent those theoretical and historical problems which have been the conceptual materials of the practice. The evidence of practice led us to question the conventional antithesis according to which accentuation of surface is supposed to be a defining tendency of Modernist painting and the development of plasticity a feature of conservatism or of Realism. What this questioning leads to, however, is not some philistine conviction that the property of modernity may now be reclaimed for robustly modelled forms of so-called Realism; rather it is the intuition that the stressing of the surface of painting may be more tellingly associated with some acute historical forms of realism than it is with that tendency towards a 'pure opticality' with which Modernism in painting has been identified.[1]

Viewed through the organs of art-critical fashion, the 1980s saw a

significant (and putatively 'Postmodernist') alternation or intersection of painterly styles: on the one hand a return to those kinds of suggestive and theatrical themes and images which have conventionally attracted the predicates of profundity, spontaneity and authenticity; on the other, the plastic assertion of a militant superficiality. An adequate critique of the painted surface seems all the more necessary. Initially at least, such a critique will have to address itself to normal and well-rehearsed means of fixing the significance of that surface.[2]

The speculative content of a continuing conversation is not easily reproduced as an essay. I have used some relatively artificial, though conventional, antitheses as kinds of markers. I take the apparently accidental connection between the snow painting of the 1580s and the strange problems of the 1980s as a kind of pretext – one which allows me to relate the issues of Modernism, realism, competence and contingency across a wide historical span.

Surface

Lucas van Valckenborch's *Winter Landscape* hangs in the Kunsthistorisches Museum in Vienna (see plate 93). It was painted 400 years ago as one of a set of the Four Seasons. Measured by sales of reproductions, it is one of the most popular paintings in the museum, though it is by no means the most distinguished example of the genre to which it belongs. The picture is a snow scene. In the long series of represented planes which recedes from foreground to horizon, fallen snow covers fields and roofs. Across the surface of the canvas and scarcely diminishing in scale from bottom to top, touches of white paint

Plate 93 *Lucas van Valckenborch,* Winter Landscape *(1586). Oil on canvas, 117 × 198 cm. Kunsthistorisches Museum, Vienna.*

Plate 94 *Oscar Claude Monet*, Snow at Argenteuil *(c. 1873). Oil on canvas, 54.6 × 73.8 cm. Courtesy of Museum of Fine Arts, Boston. Bequest of Anna Perkins Rogers.*

represent falling snow. It is not a small painting and these are not mere feathery indications, but palpable dabs from a loaded brush. To a taste fed on Modernist painting – or, for the pedantic, to a prejudice fuelled by Modernist accounts of painting – it is by virtue of this surprising frankness that the painting achieves more than mere anecdotal charm. It is not the illusion of depth in the picture that holds our sophisticated attention, nor the atmospheric re-creation of a leaden sky, nor do we admit to being engaged by the over-rehearsed animation of the peasants. What gives us pleasurable pause is that strange and distinctive form of scepticism about appearances which is set in play when the allure of imaginative depth meets resistance from the vividness of decorated surface.[3]

What is meant by scepticism here is not some hostile withdrawal of sympathy on the part of the viewer. It is rather an imaginative reconstruction of the artist's practical enterprise: an alertness to artifice; an appreciation in this case that the picture must have been painted to be snowed on. Whatever may have been the nature of the artist's imaginative projection into the fictional space he was creating, no other destination could sensibly be envisaged for the coming fall of snow than the literal and factitious surface of the canvas. And those white dabs, when they came, would not only obscure much of his own painstaking work; they would call into question that form of mimetic relation to the world which is conventionally secured by gradual modelling, rational perspective and consistent tonal organization. It is this very calling-into-question – this deliberate cancellation of the fruits of a moderate competence – that renders the painting potentially appealing to a modern interest (and it is surely a matter of indifference here whether 'modern' translates as 'Modernist' or as 'Postmodern-

ist'). There may have been no possible thought of 'foregrounding of
the device' in the conceptual world of van Valckenborch, no conceiv-
able distinction between writerly and readerly texts or between a naïve
plaisir and a sceptical *jouissance*. But we can still allow his art to have
been touched by that critical self-consciousness about reference and
technique which in recent years has been topicalized in such terms as
these.

It may seem that to discuss the painting in such terms is to give it the
benefit of a considerable doubt. We appear to be assuming that the
manifest facticity of those touches which signify falling snow is a
function in some intentional system of artifice and reflexiveness, and
not the mere accidental result of incompetence on the part of a painter
who would have produced a more seamless illusion had he been
technically able – had he possessed the kind of skill, for instance,
displayed by Monet in his painting of *Snow at Argenteuil* (see plate
94). But is this assumption actually implied? Are the relations between
intention and competence quite so easily decided? And what if we said
that, while Monet was painting a decorous and suburban fall of snow,
an *effect* for which the technology of Impressionism was well suited,
van Valckenborch was painting a blizzard, a natural event which
strains the competences of painting itself? It is indeed a careless habit
of our culture – entrenched in connoisseurish talk about skill and
accomplishment and style – to assume a straightforward antithesis
between intentional competence and involuntary incompetence. But
this antithesis is far too simple to cope with actual cases. It also rests
on a misleading isolation of the matter of authorial intention and
competence from the question of determining conditions.[4] The history
of art and the practice of criticism instruct us that the processes of
judgement and interpretation are all too often vexed by the insecurity
of distinctions between intentional competence, intentional
incompetence, accidental competence and accidental incompetence. It
is not simply that these distinctions are fuzzy and philosophically
fraught. The point is that their fields of reference change with chang-
ing conditions. Among these changes are shifts in such contingent
factors as the interests of social classes. Competence is relative to
such interests. The popularity of van Valckenborch's *Winter Land-
scape* is presumably due more to its status as a kind of ideal Christmas
card than to the kinds of verdict upon its accomplishment which may
be expected of art historians. According to the conventions of com-
petence which are supposed to regulate unspecialized judgement, a
sense that the snow is literally *on* the surface would be inconsistent
with the snow being figuratively *in* the picture – as it more clearly
seems to be in Monet's painting. Once this inconsistency became
noticeable and describable it would tend to undermine the plausibility
of the illusion and thus the supposed competence of the painting.

It is only in a world emptied of external determinations and con-
tingent interests that distinctions between the intentional and the
accidental remain immutable. In such a world the test of time (applied

Plate 95 *Paul Cézanne*, Bathers *(1883–5). Oil on canvas, 63 × 81 cm. Staatsgalerie, Stuttgart.*

in the attentions of that notable empiricistic gentle*man* the 'adequately sensitive, adequately informed, spectator')[5] necessarily singles out some art as competent and as authentic. The meaning thus given to authenticity is one which conflates an existential claim about the artist with a claim that the works in question are not fakes. In that nexus which connects the university, the museum and the auction house, the interests of causal inquiry are satisfied by an unbroken provenance and an unquestionable attribution. Unless we are content passively to accept or to await the verdict of the test of time, however, we need further to explore the relations between relative judgements of competence, notions of intention and assumptions of authenticity.

The case of Cézanne is exemplary. The status of his work seems now unquestionable, yet, given the criteria of competence which regulated admission to the Salon between the 1860s and the early 1880s, how could his submissions have been seen as other than incompetent? How could his *Bathers* (see plate 95) have been seen as a deliberate and successful attempt to paint the picture he actually painted – a picture which bore the unmistakable and humiliating stamp of involuntary incompetence? Was it not bound to be regarded as a failed attempt at the prevailing manner (see plate 96)? We are nowadays inclined to associate such views with an overthrown conservatism or with the uneducated prejudices of the vulgar, but it is perhaps worth considering their lingering merit. There may after all be some justice to the idea that Cézanne, *unable* to be competent under the conditions of the 1860s and 1870s, persisted in his incompetence until the grounds of judgement changed; that until then, to repeat a familiar tag, his art necessarily 'failed to signify'.[6] It may also be salutary to conceive of a

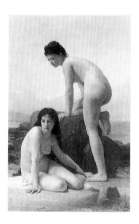

Plate 96 *William-Adolphe Bouguereau,* The Bathers *(1884). Oil on canvas, 201 × 129 cm. Courtesy of the Art Institute of Chicago. Collection, A. A. Munger 1901.458.*

possible world in which the grounds of judgement never did change in Cézanne's favour, a history of art in which he remained incompetent and unregarded.[7] The thought serves to alert us both to the dangers of historicism and to the fallibility of the commonly held belief that canonical status is non-contingent. We are entitled to ask both what kind of relation those who now apply the test of time in Cézanne's favour bear to those who supported him through the 1870s, and what kind of relation those same adjudicators bear to the uncertificated art of their own time. The history of art is conventionally told as a history of triumphs of the will. There is another history to be thought: a history of unredeemed incompetence, of unpainted and unpaintable pictures, a history of the wasted and the unauthenticated, the abandoned and the destroyed.

In thus elaborating on the basis of van Valckenborch's *Winter Landscape* it may seem that I have been making a rhetorical mountain out of a molehill of a painting. I should make it clear that the revaluation of van Valckenborch's work is not my concern. The *Winter Landscape* serves as a peg on which to hang some questions. Its status as example is by no means arbitrary, however, in that it served antecedently as such a peg in the practice of Art & Language. The conditions which made it topical within that practice are deserving of inquiry. At some level, no doubt, the coincidences between paintings testify to moments of some possible congruence between descriptions of the world. It should be clear, though, that this congruence is not reliably to be perceived in terms of simple *similarities* between pictures.[8] According to one of the most widely subscribed theories of modernism in the arts, the problem of modern culture is not from whence adequate images of its drama and contingency are to be derived, but rather by what forms of device a critical account of modernity may be realized or embodied or enacted. The requirement was expressed by Jackson Pollock in a somewhat disingenuous note to himself: 'Experience of our age in terms of painting – not an illustration of – (but the *equivalent*).'[9] To ask what an equivalent for the experience of our age might *look like* is to ask a fruitless question. For Art & Language, the concept of snow as surface was not simply a resonant metaphor for paintings with bland surfaces. Rather, it was a promising device by means of which to address that technical problem which was posed by the apparent necessity of cancellation and erasure.

Like others in the dissenting minority of our particular generation, the artists of Art & Language have been concerned to represent and to recover the critical aspect of the tradition of modern art, or, rather, to recover that tradition as a tradition of critical representation. This enterprise involves the destabilization of those genres which have become fixed within both artistic and art-historical discourses; and this in turn implies the admission or introjection of the signs of contingency and anomaly into the self-constituting and immaculate forms of modern culture. The moment of the encounter with the *Winter*

Landscape defined a hiatus in the practice of Art & Language. The long project of work on the theme of the Artist's Studio had come to a close. Baldwin and Ramsden had exhausted a repertoire of alienating devices: paintings executed by mouth, paintings in the dark, paintings figuratively illuminated by explosions, paintings slashed and ironically repaired. Through a series of large works, representations of the accumulated physical, iconographical and epistemological furniture of some fifteen years of Art & Language production had been progressively deformed and obscured and obliterated. The signifying detail of the initial composition had finally disappeared under the black impasto of a surface represented both as expressive and as inauthentic. The artists were left with nothing figurative to be going on with, though with an interest in the destabilizing potential of pictorial 'atmosphere' which the later versions of the 'Studio' series had aroused. (One of the last two paintings to be undertaken in the series had had the aspect of a *Götterdämmerung* painted in an overcooked late-Impressionist manner (see plate VIII).)

Under these conditions the surface of falling particles was initially envisaged by Baldwin and Ramsden as a form of indexical sign: as the pulverized residue of figurative content lingering in the studio like motes in the wake of an implosion (see plate 97). The potentially all-white surface would symbolize both the obliteration of translatable representation and the build-up of a kind of surfeit – the surfeit, as it were, of Modernism's nuclear winter, in which nothing is signified with increasing depth. It would be both a kind of allegory of Modernism as a tendency and a Valckenborchian picture of an unpaintable event.

Plate 97 *Art & Language,* Study for Index: Incident in a Museum 2 *(1985). Gouache, ink, pencil and crayon on paper, 100 × 153 cm. Collection Charles Harrison, England.*

Contingency

My object is defeated if Modernist painting becomes the sole subject of this essay, but, in order adequately to ground the discussion of surface, I need further to explore the critical meaning of contingency, and the examples are most easily drawn from the art and art theory of the modern period. We should in any case acknowledge the ways in which our understanding of the history of painting has been penetrated by Modernist theory, and thus encourage some scrutiny of those normal protocols according to which we tend to relate the past and the present of art. The following account is therefore offered by way of recapitulation and résumé of various relevant strands from the foregoing essays.

As I have previously suggested, many of our normal art-critical and art-historical protocols can be traced back to the second and third decades of this century, when a general thesis about all works of art was elaborated in the writings of Clive Bell and Roger Fry.[10] The initial aim and purpose served was that of embedding the modern movement and propagandizing it to the English-speaking bourgeoisie, but the basic ideas proved highly persuasive and were unreflectively entrenched in much subsequent writing about art of various periods. According to the thesis, it is more important that works of art share a common property – call it 'significant form' or aesthetic merit or whatever – than that they are distinguishable in terms of materials, or forming-techniques, or cultural origins or functions. The sensitive response of the global connoisseur unites such disparate objects as 'Sta. Sophia and the windows at Chartres, Mexican sculpture, a Persian bowl, Chinese carpets, Giotto's frescoes at Padua, and the masterpieces of Poussin, Piero della Francesca, and Cézanne'.[11] A kind of autonomy and necessity is thereby accorded to their phenomenal form. That this form elicits an aesthetic response is seen as the definition of competence and the proof of authenticity in the work of art. This derivation of the property of authenticity from the psychological reactions of the connoisseur will tend to regulate any inquiry into the work's causal conditions. That is to say, since the authentically sensitive response is what decides what a work of art is, an explanation of the work which is not consonant with that response will be deemed irrelevant.[12] Instead of the appropriateness of the response being called into question by what causal inquiry may have thrown up, the tendency is for the discrepant information to be treated as information about something other than the essential response-producing aspect.

In the world of Modernist theory 'the value judgement comes first',[13] and relevance, to paraphrase Clement Greenberg, is 'relevance to the quality of effect'.[14] This quality is identified in the response of the viewer, which, in so far as it is an authentic response, is involuntary and disinterested and thus immunized against the incidental.[15] The only causal conditions to which any explanatory status is accorded are the necessities of the discipline – which are forms of

trope in what needs to be seen as a metaphorical picture. As Greenberg asserted in a now-notorious passage,

> Each art had to determine, though the operations peculiar to itself, the effects peculiar and exclusive to itself. . . . It was the stressing of the ineluctable flatness of the support that remained most fundamental in the processes by which pictorial art criticized and defined itself under Modernism. Flatness alone was unique and exclusive to that art . . . and so Modernist painting oriented itself to flatness as it did to nothing else.[16]

Both in its earlier and more recent form, the critical theory of Modernism is a theory of consumption masquerading as a theory of production. Through the apparently autonomous tendency noted in Modernist theory, the power of a determining agency is revealed only in a pattern of omissions and exclusions. In turn these omissions and exclusions become necessities for the production of authentic Modernist culture.[17] The metaphorical picture is taken literally.

It might seem that such ideas are no longer either fashionable or effective and that we are done with the fiction of disinterested connoisseurs, involuntary judgements and inexorable tendencies. There is evidence enough, though, that these notions are still determining, even in the practices of many who would claim to have seen through them in their articulated form. (Most insecure in making this claim are those who have failed or refused to acknowledge the professional and metaphorical character of Modernist criticism.) Think, for instance, of the case of Renoir, whose work received considerable attention in 1985 when a large retrospective was shown in London, Paris and Boston.[18] Though a toadying male chauvinism might be thought to be a causal determination of some sort, that form of information about Renoir which has made him the *bête noire* of feminist art historians is not admitted by admirers of his work to be information relevant to the explanation or evaluation of his pictures – which remain beautiful in their eyes (see plate 98).[19] It is not my intention to suggest that all value is drained from Renoir's work by evidence about his sexual politics. But how can the aesthetic mode be made independent of the moral unless the work of art is to be seen as entirely independent of the character of the artist?[20] Where the information uncovered is so clearly relevant to the conventional *terms* of admiration, one might at least expect that the conceptual foundation of that admiration would be allowed to have been shaken. But no, that kind of psycho-sexual aspect-blindness which is revealed in Renoir's representations of women is not allowed to be a form of incompetence relevant to the assessment of his work. The constitutive account of Renoir the artist is protected against the contingencies of Renoir the man. Or, to paraphrase Walter Benjamin, the account of Renoir's work as aesthetic is secured by a view of Renoir as author, or worse, creator.[21]

Plate 98 *Auguste Renoir,* La Loge *(1874). Oil on canvas, 80 × 63.5 cm. Courtauld Institute Galleries, London (Courtauld Collection).*

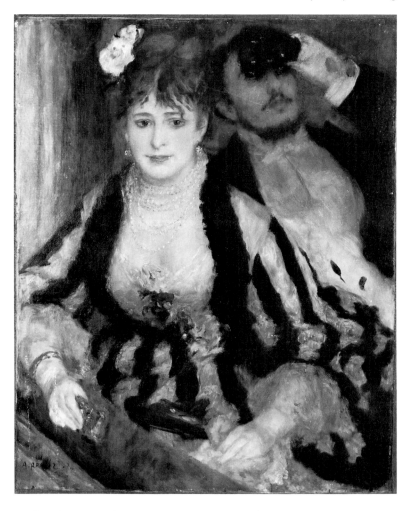

Within this view there is no cognitive place for a critique of Renoir as producer – as someone, that is to say, whose position within some set of relations of production must have a determining effect upon the meaning and value of his work, whatever may be the autonomous tendencies of 'painting itself'.

It is still, I think, the habit if not the avowed principle of the majority of art critics, art historians and curators to assume that inquiry into the 'how' of art is properly guided and restricted by prior values placed upon the 'what'. The tendency to chant that it is hard to separate them reveals a form of aspect-blindness. There is no actual difficulty in conceiving that, while a given work of art may be considered under the question 'what?' (and in relation to some putatively relevant set of descriptions), it may also be considered under the question 'how?' (and in relation to some putatively relevant constellation of conditions); nor is it difficult to understand that these operations, though they may be related, are not the same operation. The aspect-blindness is not surprising, however. If art historians and

curators cannot claim special powers of discrimination over some special range of objects, how are they to safeguard their business against the predations of the encroaching social anthropologist? (It is no wonder that the problem of the fake haunts the conscience of the connoisseur. If the inauthentic becomes indistinguishable from the authentic, what price his authority over the ontology of art?)

We seem to live in a world of antitheses. These are features of the hermeneutic circle. Either the work of art is interpreted by reference to the notion of the artist as author, in which case 'he did it from inner necessity' is a governing assertion and causal inquiry is closed; or it is interpreted by reference to the notion of artist as producer, in which case 'he did it for the money' is a governing assertion and it is hard to know just how to limit the processes by which causal mechanisms are traced back into underlying conditions and structures.[22] Either the problems of causal inquiry become dislocated from the procedures of evaluation, or the problems of evaluation become dislocated from the procedures of causal inquiry. In the one case close attention to the work of art and to its effects is what produces a reading, so that competition between readings becomes a matter of proliferating translations of the pictorial text (or of the pictorial picture), with the danger that no sense of the work's connectedness to the world can be adduced to arbitrate between them. In the other case the work is supposed to derive its meaning from its context, so that the adequacy of an interpretation tends to be measured in terms of the quantity of contextualizing detail by which it is supported, with the danger that there may be no independent means to judge the relevance of this detail to the actual form of the work of art. It is no solution to allow one set of procedures to be proper to the critic, who is supposed to be concerned with aesthetic value, and the other to be proper to the art historian, who is supposed to be concerned with social-historical meaning, since this particular division of labour is just another symptomatic condition of life in a world in which value and meaning have been wrenched apart. Whatever status we accord to aesthetic predicates, we still need to be able to think about how we think about that world.

If we want to establish a realistic approach to the surface of painting, we shall need to supersede the terms of this antithesis, while including what is usable in each of the two opposed tendencies: the requirement of relevance which is made by the Greenbergian formalist, and the commitment to causal inquiry which is made by the social historian. We will suppose that, while we wish to free ourselves from the idealization of the artist as creator, we also wish to resist that absolute reduction of the artist to producer which dissolves the specific form of the work of art in an over-determined world of social and economic relations. We will agree (for a moment) with Clement Greenberg that 'the best way of seeing any kind of picture' is to see it as a picture first, to be 'aware of its flatness before seeing what that flatness contains',[23] though we will not go so far as to accept his

Plate 99 *Piet Mondrian,* Composition, Tree *(1913). Oil on canvas, 100.2 × 67.2 cm. The Tate Gallery, London. © DACS, London, 1990.*

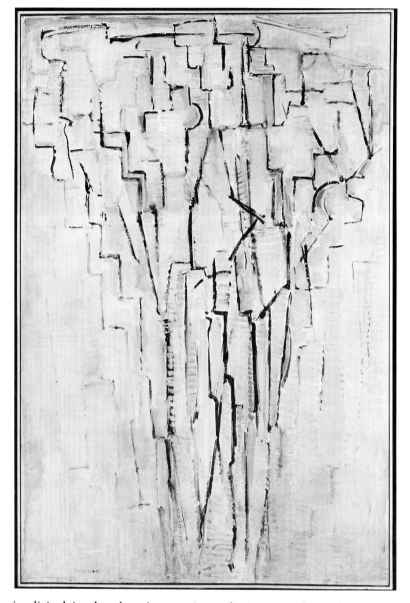

implicit claim that there is a consistent distinction to be made between the visual and the non-visual or literary aspects of art.[24] While it is in terms of its surface that the formal autonomy of the work must be perceived, it is upon that same surface that the signs of its contingency will also have to be sought. If hopes of transcendence are expressed in the fiction of the 'purely visual',[25] the signification of contingency is like a form of utterance which certifies the implication of painting in language, time and mortality.

To circumvent the empiricistic protocols of the connoisseur, we will impose a form of historical materialism upon our understanding of what a painting is. We will assume that it is not what a painting looks

like that is significant, but rather what it is *of*, where what a painting is of is decided not by what it depicts or describes or resembles but by what it is causally connected to or determined by. What it is of is what it is made of.[26] The extent to which Mondrian's paintings of trees are 'of' trees in this strong sense is a matter for open inquiry (see plate 99). What they certainly are of is Parisian Cubism and his own antecedent painting. A Mondrian painting of around 1930 is supposedly a hard-won thing, an aesthetically autonomous configuration wrestled from the contingencies of the apparent world (see plate 100). An identical copy or an indistinguishable fake cannot be that thing, for it has its existence at the end of quite another causal chain. Indeed, the *more* like the first the second version is, the more *unlike* the first's its conditions of production must have been. To learn what a painting is of in this sense may be to *unlearn* assumptions about what it looks like, for it is to learn how it *must* look, whether or not this is the guise in which it happens to appear to us. To discover that a painting is inauthentic is literally and unmysteriously to see it differently.

According to this schema, we replace the damaged notion of authenticity with a concept of critical power and interest. The critical power of a painting is a matter of what it is actually made of, and is therefore not to be arbitrated by the responses of the connoisseur or other sensitive observer. Nor is it decided in terms of authorship. In

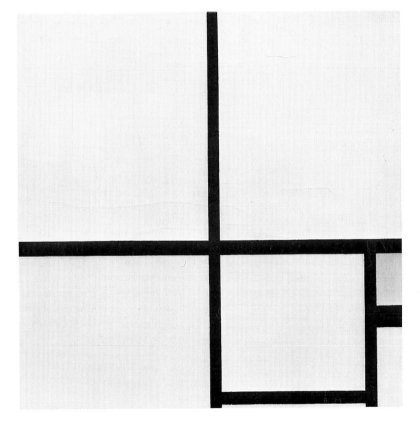

Plate 100 *Piet Mondrian,* Composition *(1930). Oil on canvas, 46 × 46.5 cm. Kunstsammlung Nordrhein Westfalen, Düsseldorf. © DACS, London, 1990.*

fact we will regard as *inauthentic* a painting which conscripts the very predicates and stereotypes of authenticity. Such a painting will not be a fake, but it will be one which imposes conditions of falsehood upon consumption, or which exploits such conditions of falsehood and euphemism as may already be entrenched as the enabling habits of consumption. It will be a feature of such a painting that, if it is not to fail, what it is actually made of must necessarily be misrepresented in the perception of what it looks like. That is to say, it must take upon itself the panoply and the language of authenticity. In the Paris Salon of 1893, Paul-Joseph Jamin's painting *The Brennus and his Share of the Spoils* pretended a late contribution to the genre of history painting (see plate 101). It purported to present a moralizing allegory of the overthrow of classical decorum by unprincipled barbarity (or of the Salon, perhaps, by the 'incompetent' Cézanne). The real enabling con-

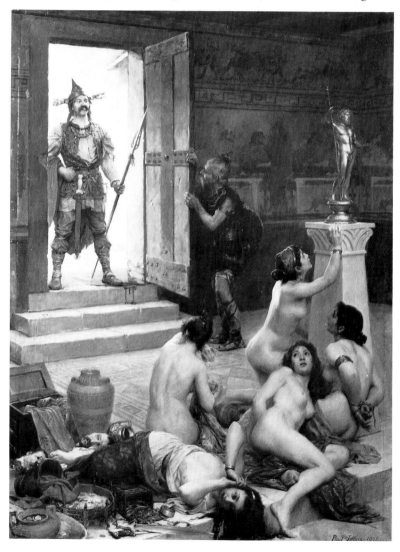

Plate 101 *Paul-Joseph Jamin,* The Brennus and his Share of the Spoils *(1893). Oil on canvas, 162 × 118 cm. Musée des Beaux-Arts, La Rochelle. Photo: Réunion des Musées Nationaux, Paris.*

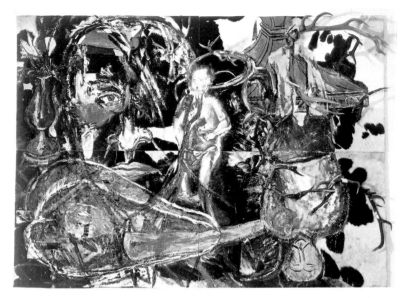

Plate 102 *Julian Schnabel*, Prehistory, Glory, Honor, Privilege, Poverty *(1981). Oil, antlers on pony skin, 300 × 480 cm. Saatchi Collection, London.*

dition of the painting, which is misrepresented by this moralizing aspect, is the imaginative anticipation of rape. We may note that no barrier to the enjoyment of this prospect is offered by the surface of the painting. Those readers who feel that Jamin's painting offers too easy and too cardboard an example are invited to reflect upon the ways in which the signifiers of authenticity are deployed in the work of a Clemente or a Schnabel, and to consider how very successful this unironic deployment has been (see plate 102).

In pursuit of an adequate critique we shall also need to circumvent the reductivist and relativistic strategies of the social anthropologist, and to this end we will impose a requirement of relevance to the painted surface. Traditionally the enterprise of painting has involved the structuring of some relationship between literal surface and illusion of depth. Modernist theory rightly draws attention to the importance of changes in this relationship, though it tends to close off inquiry into the possible causes of change with talk of inexorable tendencies and autonomized necessities. The task left to us is to open this relationship to explanation, but without losing sight of the actual work of art which is the object of our inquiry. One way to do this is to approach the painting itself, rather than the artist, as the potential bearer of a history – as a thing which may itself have changed, and which may have changed in its relationship to what it is of. In signifying this change the work will necessarily admit signs of its own contingency. The painting which draws attention to its own surface is one which narrates the problems it is made of, and which thus inhibits unreflective and uncritical consumption. It is time to return to the snow. . . .

Change

For Art & Language, caught up in the representations and mis-representations of Modernism, circumscribed by the genres of modern art and fascinated by the discourse of necessities attendant upon them, the attraction of the *Winter Landscape* lay not so much in the conceit of its premature (Post-)Modernism as in the fact that it was clearly reconstructable as a painting to which something had happened, and which had been significantly changed in the process. The idea that works of art have lives of their own is somewhat compromised. It tends to be associated with the rhapsodies of art appreciation, and with Picasso playing to the gallery. It is worth remembering, though, that it was a *practical* concept for Pollock. The idea of an independent life should not be taken as according to works of art some mysterious animistic property, but rather as recognizing that in the production of such things as paintings a kind of feedback can be generated which is independent of the will of the artist. It may also be independent of the artist's powers of comprehension in so far it is unreconstructable in language. It does not follow that the feedback is independent of the determinations of history and thus mystical. Indeed, it may be precisely the moment of the emerging work's penetration by history – its moment, as it were, of conception of its historical meaning – that we are seeking to isolate. The suggestion is that there may be a kind of painting – a category cutting across the normal genres, across normal assumptions about authorship and about the wilfulness of creativity, and possibly even across established periodizations – for which 'Something happened to this picture' is both a relevant and a non-trivial statement.

Of course, there is a sense in which something happens to the picture which is blasted by a lunatic or slashed by the representative of a political cause. In such cases, however, the change effected is understood as accidental and as irrelevant to the symbol system which we identify as the work of art. It follows that restoration is the obvious course. The damage inflicted upon the *Rokeby Venus* by a protesting suffragette is conventionally seen as incidental to the painting, which has been repaired so that the damage is concealed (see plate 103). As an indexical sign, the disruption of the surface is interpreted in terms of the antecedent life of the vandalizing agent rather than the antecedent life of the painting. Yet this interpretation may seem to come more easily than it should. Many paintings have achieved canonical status in forms significantly different from those which reflect the last touch of the originating artist's hand. The line which divides such things from works which have been purposefully damaged is by no means a fixed one, depending as it does upon some prior insulation of one world of values from the effects of another – a prising-apart of the political and the aesthetic. It is true that most attempts to reconcile these values tend towards the absurd. In 1963 when paintings by van Gogh and Gauguin were hijacked by revolutionary students in

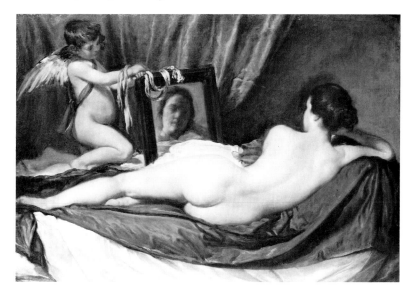

Caracas, the Situationist Guy Debord wrote that this was a form of homage true to the spirit of the work, 'an exemplary way to treat the art of the past, to bring it back into life and reestablish priorities'.[27]

Such flamboyant notions gain a shred of credibility by virtue of the wholesale co-option of art to the meanings of the dominant. Between the studio and the museum there is a hiatus.[28] Works of art are indeed held hostage by the institutions which represent them. For those not possessed of the compulsion to direct action, however, the reclamation of these works is an intellectual pursuit. But what of those forms of culture which are seen from some defensible point of view as implicated in the mechanisms of oppression? We may suppose the *Rokeby Venus* to be insulated (by what? by its aesthetic merit? by the test of time?) against the accusation that it somehow connives at the exploitation of women, but just how offensive would a picture have to be before we saw its defacement as somehow entailed by what it was, and therefore as a relevant continuation of its history? Did the removal of 'popish clutter' from English churches in the seventeenth century result in an aesthetic gain, or can it only be interpreted as an act of vandalism? Is the 'adequately sensitive, adequately informed, spectator' the best-qualified adjudicator of issues such as these? Iconoclasm is surely a relative matter. In cultures such as ours, however, resistance to iconoclasm is regarded as an absolute measure of liberalism, and such problems are generally reduced to the status of philosophers' puzzles – or to squabbles over whether or not dirty masterpieces should be cleaned.

And yet the actions of the iconoclast are not easily seen as accidental to the work to which they are addressed. An act of iconoclasm is after all the consequence of a kind of 'reading', and it implies a form of idolatry: a recognition – if not an overestimation – of the power of images.[29] It could be said that the removal of 'popish clutter' did

indeed result in an aesthetic gain, but not from that point of view within which high-church furnishings are accorded an aesthetic status. The removal of a swastika is not the same act as the defacement of a pro-Nazi image, and so on. The meaning of the defacement depends upon the commitments of the observer but also upon what it is that the defaced image is of, in the strong sense of 'of' canvassed above: that is to say, it depends upon what that image is causally connected to. And that question is far from being a mere philosopher's puzzle. The paintings envisaged by Art & Language were to be such as would animate this world of problems.

There are of course other forms of change to which the work of art may be subject. If alien acts of damage are ruled structurally irrelevant or accidental to 'the work', what of damage inflicted or at least tolerated by the artist? (See plate 104.) Unless we posit some idealistic object of thought, to which only the successful work of art may be allowed an uninterrupted progress, how are we to read the evidence of self-critical cancellation and destruction? We tend to interpret all pentimenti as signs of progress towards an estimable end. But how clear in practice is the borderline between revision and cancellation? No clearer, I suspect, than the division between snow in the painting and snow on the painting. It is a borderline which tends to be allowed to drift as the individual artist's works gain in estimation and in rarity value. The quintessential catalogue raisonné is an academic instrument of authentification serving the best interests of a rapacious market. Alongside the fully canonical works of a Cézanne or a Pollock it will document canvases once abandoned or scored, prints from cancelled plates, drawings salvaged from the studio floor. What has happened to the concept of the immaculate and authentic work of art, the wilful and intended creation of the authentic author? By now, surely it is not so much frayed at the edges as damaged

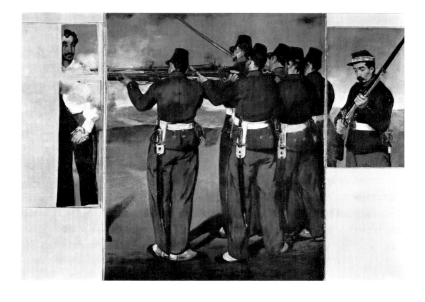

Plate 104 *Edouard Manet*, The Execution of the Emperor Maximilian (1868). *Oil on canvas, three fragments, 89 × 30 cm, 190 × 160 cm, 99 × 59 cm. Reproduced by courtesy of the Trustees of The National Gallery, London.*

beyond profitable repair.

In talking of pictures to which something has happened, I mean to introduce a category open enough to include both paintings which we assume finished and which have survived, and paintings which may not have 'stood the test of time' – paintings destroyed or abandoned in whole or in part. The aim is not to propose an alternative canon, but to destabilize those assumptions about competence, intention, finish and representativeness by which the very idea of a canon tends to be sustained. The category will be filled by paintings which appear to have been significantly changed in the process of their production. That is to say, they will be paintings for which there is a powerful argument that some significant change must be seen as integral to the work and to the understanding of what it is of, though this argument will sometimes be stalked at the margins by doubt. Such paintings will embody drama of a kind, not solely by virtue of the agitation of their surfaces, nor simply by virtue of what's enacted in the figurative depth of their illusionistic space, but rather through some locutionary quality in the relationship between surface and depth. They will be paintings in whose production it appears that two or more separate and distinct cognitive and practical schemes have been involved. These different schemes may appear to have their causal connections in different, perhaps incommensurable, practical or ethical worlds. This is to say that it will not be possible to deduce from such works a coherent account of the world of their production. Rather, those who work to interpret them will be faced with their own moral aspect as agents in the formation of that account.

A negative example may help to clarify this point. Around 1790, Joseph Wright of Derby painted a picture which he called *A Cottage in Needwood Forest* (see plate 105). It was commissioned by a Yorkshire cotton manufacturer and reflects that taste for conventionally picturesque landscape which was to become widespread during the nineteenth century. Wright's speciality, however, lay in more exotic if less civilized effects, and he was not one to waste a motif. In a subsequent painting he turned the cottage round and set it on fire (see plate 106). We might say that the second picture represents a form of destabilization of the genre to which the first belongs; it makes something happen in the landscape, as it were, and this also involves a sense of something being done to the painting as a landscape painting. We don't need to have seen the first painting to understand that the second invokes the idea of dramatic change. But the change is not embodied technically. It is merely illustrated. In the event, no picture of the world was set at risk in the *Cottage on Fire*, nor was any competence hazarded. There is no possibility of confusion between fire in the painting and fire on the painting. The second picture remains connected to the world – it is of what it is of – in much the same way as the first.[30]

Here it is easy enough to sustain a conceptual distinction between what has happened to the painting and what is happening in it. Like

Plate 105 *Joseph Wright of Derby*, A Cottage in Needwood Forest *(c. 1790). Oil on canvas, 100 × 126 cm. Derby Museums and Art Gallery.*

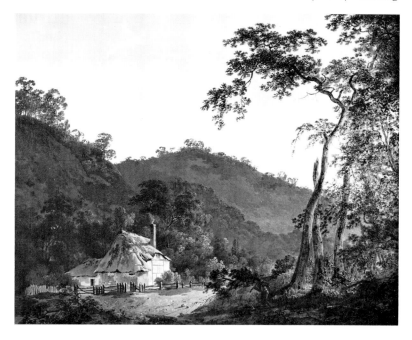

Plate 106 *Joseph Wright of Derby*, A Cottage on Fire *(c. 1793). Oil on canvas, 64 × 76 cm. Derby Museums and Art Gallery.*

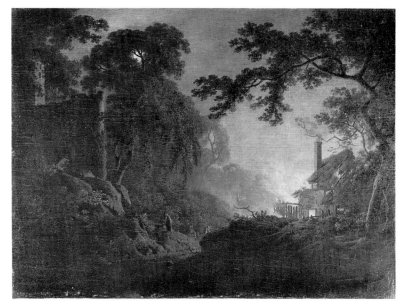

the relation between snow in and snow on van Valckenborch's *Winter Landscape*, the distinction between enactment and illustration turns largely upon whether the surface is seen or simply seen through. In Wright's painting the encrustations of the surface turn out to be the mere technical abbreviations of an eighteenth-century professional. Such manneristic demonstrations of the surface are not to be confused with those forms of acknowledgement of contingency which are in

some sense hard-won. On the contrary, they are the signs of limitation upon what the work can be of, and thus of the painting's containment within a normative set of conditions. Virtually the same meaning is conveyed by saying that they are the signs of limitation on the investment of the artist's time. For us, though, the time of Wright's picture is the frozen moment, extended backwards or forwards, if it is, by our own imaginative narration of events quite irrelevant to the history of the picture. The act of perception is an act of consumption in which we hazard nothing. The world of our own antecedent associations is pandered to and privileged in ways which distract us from the uninteresting contingencies of the work's production, and thus from the relative ordinariness of what it is actually of.[31]

By contrast, the kind of painting I have in mind is one which presents some aspect of its own production as a bar to unreflective consumption; which renders problematic the relationship between what it represents and how it represents it; which figuratively embodies time as a necessary aspect of its own coming-into-existence; which is therefore not possibly perceived as a mere glimpse or scene or effect, but which imposes upon the spectator a necessity for engagement with what it is of – an engagement which is disciplined by acknowledgement of the painting's own factitious character, and which is objective to the extent that the spectator's own preferences and predispositions are regulated by the priority of that acknowledgement (compare plates 107 and 108).

The more familiar candidates for inclusion in such a category are indeed drawn from the art of the modern period. Exploration of the distinction between the represented and the means of representing, lately claimed as a distinguishing feature of Postmodernism, has been a practical and conceptual priority in the development of modern painting since the 1860s. Manet, Cézanne, Picasso, Matisse, Pollock – we are back with the Modernist canon. Are what T. J. Clark has called the 'practices of negation'[32] – techniques of cancellation and erasure, of figurative scare-quoting and alienation – the forms of a refusal to signify in the historical culture of late capitalism, and are we thus to see them as distinctively modern or Modernist; or are they rather discoverable as the bearers and signifiers of a complex realism in the painting of previous centuries?

I believe that there are distinctive cases to be found in the art of earlier periods. It should come as no surprise to us to discover, however, that they tend to be found at those moments when the sense of something happening to the picture tends to invoke some other scale of change: not simply an event in the mind or practice of the artist as author, but a transformation of the producer's world.

One of the most notorious of these is Hans Holbein's picture of Jean de Dinteville and Georges de Selve – the so-called *Ambassadors* (see plate 109). The work is a consummate demonstration of the state of the painter's art in the early sixteenth century – or, to quote the date which the painting narrates as its own, at 10.30 in the morning of

Plate 107 *Edouard Manet,* Woman with Fans *(c. 1874). Oil on canvas, 113.5 × 166.5 cm. Musée d'Orsay, Paris. Photo: Réunion des Musées Nationaux.*

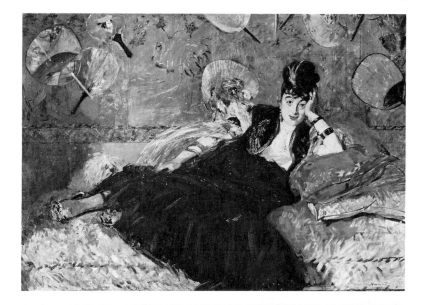

Plate 108 *E. A. Carolus Duran,* Mademoiselle de Lancey *(c. 1876). Oil on canvas, 157.5 × 211 cm. Ville de Paris, Musée du Petit-Palais, Paris. Photo: Photothèque.* © *DACS, London, 1990.*

Plate 109 (above right) *Hans Holbein,* Jean de Dinteville and Georges de Selve (The Ambassadors) *(1533). Oil on panel, 207 × 209.5 cm. Reproduced by courtesy of the Trustees of The National Gallery, London.*

11 April 1533. The rich vocabulary of descriptive techniques, evoking surfaces of brass and of gold, of wood and of stone, of satin and of velvet, of fur and of flesh; the consistent skill in modelling and in the achievement of plastic effects; the rigorous perspective shaping complex forms with apparently effortless consistency – these are the arts of painterly mimesis painstakingly and expensively deployed, and deployed in apparent fulfilment of the ends of celebratory portraiture. The two men, twenty-nine and twenty-four years old, as the painting informs us, are immortalized in what they may have had good reasons to regard as a successful maturity, accompanied by the symbolic

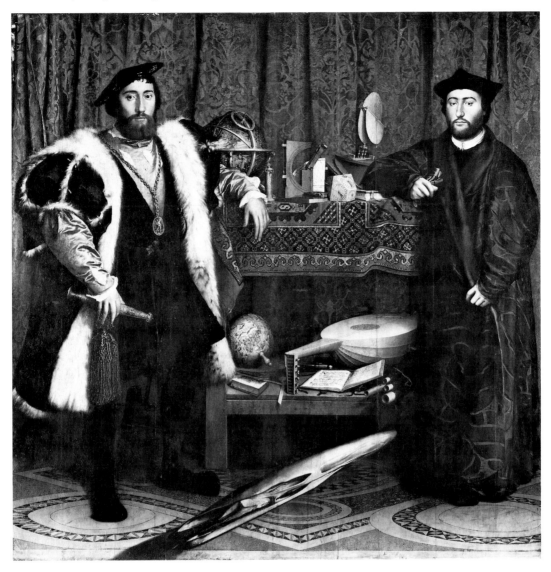

tokens of property, learning, accomplishment and discovery, as if they in their own persons were the bearers of the advanced knowledge and civilization of their time.[33]

Across the floor of the picture space, or, rather, slanting across the figurative space above it, Holbein has painted a detailed but indecipherable smear. For the spectator standing back to the wall in a position to the right of the painting the smear is readable as the anamorphic representation of a human skull (see plate 110). The device is a *memento mori*, a reminder of the contingency of all that the picture represents and particularly of the mortality of the two men. While we confront the painting as a picture, the skull is ontologically irreconcilable with the main illusionistic scheme. Its mimetic form is

Plate 110 *Detail of anamorphic skull in plate 109.*

perceptible only when the painting itself cannot properly be seen. Yet, once this identification is made, because the symbol is inscribed across or on the illusory surface of the painting, its signification overrides or cancels the significance of what is depicted in the painting. Like scare quotes around a sentence, it shifts the truth-value of all that the surface contains, including all that may be seen as evidence of competence and accomplishment, and does so as a function of that same literal surface upon which all else is inscribed. How strange a thing to conceive; something which could only be realized if the painting were irreparably transformed – the carefully achieved illusion of its instantaneity, its 'presentness', damaged beyond repair by the representation of its contingency. Is it a relevant question to ask whether this damage is or is not aesthetic ruin? Perhaps the point is that the ruination of the aesthetic whole goes to the possibility of a transformed aesthetic. The change which the skull represents is only integral to the painting, that is to say, from a perspective in which the status of the painting, and perhaps of pictorial representation as a whole, is cast into serious doubt.

Lest it be thought that I am attempting to smuggle the artist as creator in again through the back door of radical invention, I should make clear that the conceit of the anamorphic skull was most unlikely to have been the invention of Holbein alone. Though he was certainly the bearer of the technique by means of which it could be realized, and though he may well have been glad of the opportunity to advertise a specialized if not unprecedented skill, the conceit itself is likely to have been the product of some conversation between the three men. It is possible that the artist was directed by a whim of the melancholy de Dinteville alone. Holbein could certainly not have produced what he did unless he was willing to put at risk the painting as an achieved illusionistic scheme, but the chances he took with his own accomplishment would not have extended to the unilateral display of a disruptive virtuosity. Authorship and competence are complex and relative concepts in face of such a painting. Certainly, the art-historical establishment of the artist as an authentic author in the modern mould should not require suppression of the artist as a sixteenth-century producer demonstrating his competences and thus deserving of his fee. It is a condition of the painting's possibility that Holbein could have been a contributor to the Ambassador's conversation, but we will make poor sense of the moment of its production if we assume that the enabling intellectual and moral competences were his alone. It can only have been with the accord of those responsible for its commission that the surface of the painting was used conceptually to evacuate that figurative depth within which their own very existence was represented. And in making this accord the three men were knowingly or unknowingly giving expression to the philosophical aspect of a historical change.[34]

Having noticed how this is done, we are not provided with a simple means to identify other moments of significant transformation. The language of painting changes, as do the social determinants upon

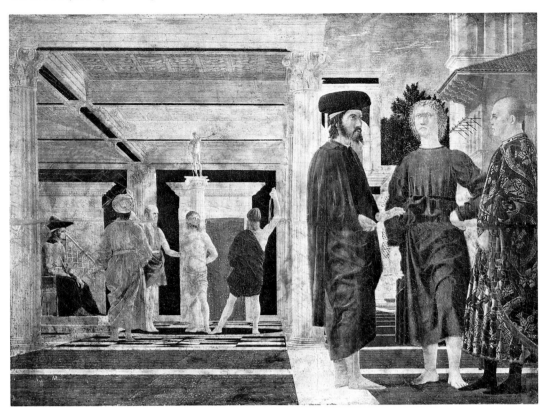

those acts of representation which include both picturing and seeing. In ways which are neither automatic nor easily traceable, forms of historical change bear both upon the relations of literal surface to figurative depth, and upon the kinds of meaning which can be read out of these relations. It is hard to know just what we might be looking for in another case. The relevant indication is that our sensuous and imaginative activity is structured by some picture and implicated with its surface in such a way as to require some form of cognitive work. Piero della Francesca's so-called *Flagellation* is a candidate, with its perspicuous construction upon one geometrically divided surface and within one integrated pictorial space of two seemingly dislocated episodes, each framed in its own time, yet each apparently testifying to the conditions of conception of the painting (see plate 111).[35] David's *Death of Marat* is another, not simply because the figurative and metaphorical placing of the inscription to Marat renders the surface problematic, but rather because an uneasily critical relationship is thus established between the surface and all that the painting refers to and is historically and conceptually composed of (see plate 112).

Plate 111 *Piero della Francesca*, The Flagellation of Christ *(c. 1450). Tempera on panel, 58.4 × 81.5 cm. National Gallery of the Marches, Ducal Palace, Urbino. Photo: The Mansell Collection, London/Alinari.*

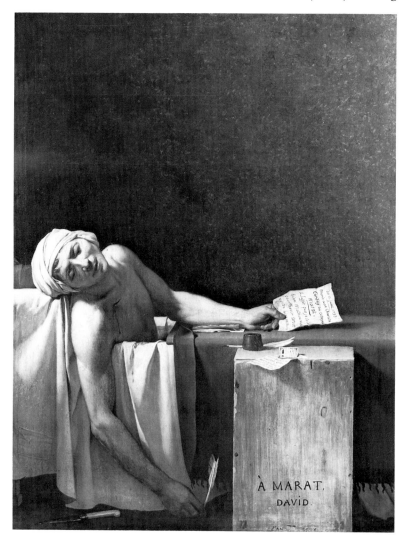

Erasure

One last candidate will serve to return us to snowing on the surface and to the vexed practice of the 1980s. Camille Pissarro's *Hoarfrost – the Old Road to Ennery* was painted in 1873 (see plate 113). In most respects it is a typical and highly competent Impressionist landscape, and as a landscape its virtues are those which the technical vocabulary of Modernist criticism so satisfactorily describes: the broken, all-over surface, the carefully modulated range of tones, the avoidance of sculptural modelling, the chromatic equivalence to an atmospheric effect, and so on. And yet, from this landscape, this surface, the form of the peasant seems awkwardly extruded. In the terms of a Greenbergian analysis, the figure palpably breaks the plane of the picture, and in so doing disrupts that decorative integrity which is the

very hallmark of the canonical Impressionist landscape. This is too weak a way of describing the strangeness of the effect, however, and its very weakness is a form of restriction on inquiry. The figure of the peasant fails to be either in the picture or on the ground. Its figurative presence is, as it were, an event of a different order. An adequate account of the picture will be one which gives the measure of this difference. The normal conventions of art criticism and art history suggest various forms of valuation of the picture attached to various forms of supposedly explanatory reading. Either it is a successful Realist painting or it is an unsuccessful Impressionist painting. As a known sympathizer with the plight of the rural poor, Pissarro intended to draw attention to the peasant and to his isolated state. He has succeeded in doing so and the painting is therefore competent. Or, Pissarro intended to represent the peasant as integrated with the landscape and has failed to do so and the painting is therefore incompetent. And so on and so forth. We are back with the crippling confusions of competence and intention.

Let us follow the evidence of the surface and accept that what has happened to the painting is that the figure of the peasant has been both attached to and dislocated from it. It is attached to the painting in so far as it is a part of the total figurative scheme. It is dislocated from the picture in so far as the plastic form of its inscription is technically

Plate 113 *Camille Pissarro,* Hoarfrost – the Old Road to Ennery, Pontoise *(1873). Oil on canvas, 65 × 93 cm. Musée d'Orsay, Paris. Photo: Réunion des Musées Nationaux, Paris.*

inconsistent with the rest of the painted surface. It seems that the peasant could not be represented within a technically consistent Impressionist landscape without losing just that monolithic property which was both his normal pictorial identity and his conventional Realist attribute. The price of preserving that attribute is that the figure is, as it were, refused by the technically resolved Impressionist landscape. What the painting narrates is the divergence of two trajectories: on the one hand those discourses within which rural labour and the identity of the peasantry were possibly realistic topics; on the other hand the developing discourses of artistic modernism, with their emphasis on the autonomy of expression and of pictorial form. Pissarro no doubt wished and intended to bring these discourses together and to articulate them both within one practice. The vivid testimony of the painting is that in 1873 this could not be done. In attempting to include the peasant in the painted landscape without either anomaly or idealization, Pissarro was painting an unpaintable picture. If *Hoarfrost* can be called a realistic work, it is not by virtue of what it depicts, nor because the artist has realized a vision of his own. It is as a consequence of what it happens to be made of. It is despite the will of the artist that the historical impossibility of reconciliation between an actual political and an actual cultural world is worked out and narrated upon the surface of his picture. Contingency of this kind serves to remind us that we can't make the world better with art.[36]

If a painting which thus catches the moment of this impossibility is to be denigrated for its aesthetic disunity, it might be thought that we should consider revising our aesthetic priorities. According to the conventional wisdom of Modernist theory, however, our present priorities are dictated by what subsequently happened – or, if you like, by the evidence of the test of time. In the realist climate of early Impressionism the concept of pictorial 'atmosphere' had been grounded in the naturalistic and even in the social conditions of the represented world. However, as Pissarro's painting seems to show, this grounding became increasingly hard to achieve. During the 1880s, by a conceptual shift which the term 'crisis of Impressionism' denotes but fails to describe, the project of Realism was largely abandoned and the notion of atmosphere was autonomized and internalized.[37] Atmosphere was seen, as it were, as something spontaneously generated from the expressive surface rather than metaphorically represented by it, and whatever could not be accommodated to that surface was seen as alien to painting. It was the pragmatic Monet who solved Pissarro's problem. He simply omitted the peasant, and in omitting him as token removed a type of obstruction to the progress of the plausibly modern surface. In Monet's work after 1873 the contingently irreconcilable gives way to the aesthetically resolved. This shift involves a change in the kinds of places – the kinds of worlds – that are viewed as potentially picturesque.[38] By the early years of the twentieth century pictorial atmosphere had come to be represented in the dominant critical discourse as signifying emotional or psychological or even spiritual

climate. By the 1950s the aesthetic integration of the canvas was being conceived in terms of a form of realization of the artist's self.

This is one way in which the history of the modern is told. A supposedly unbroken genetic chain connects the atmospheric all-over-ness of the typical post-war painting to such integrated surfaces as those of Monet. Its dynamic is the triumph of individualism and of independent expression. As implied in the first of these essays, however, the same history can also be recounted as a dislocation or transformation of the irresolvable pictorial demands of realism into a language of displacement, evacuation and exhaustion. According to this second version, the art-historical prising-apart of realism and expression, realism and autonomy, realism and the practical surface misrepresents and abbreviates the critical power of modern painting. To counter this misrepresentation all that is required is the kind of shift in truth-value which is achieved by putting scare quotes around such terms as 'triumph', 'individualism', 'independence' and 'expression'. From the concept of the all-over expressive painting it is then a small step into the ironies of the surface of snow.

For Art & Language, the connection of a potentially all-over surface with the sense of a redolent pictorial atmosphere invoked both the history of Impressionism as an *uncompleted* project and the meaning of its mutation into what came to be curated as Post-Impressionism. Under threat of collapse into the echoing void of internal representations, Baldwin and Ramsden attempted to increase the stakes and reached for a resonant iconography. If snow was to signify the cancelling and autonomizing power of the Modernist surface, then the canvas would be initially charged with some sort of imagery. Furthermore, that imagery would be psychologically or culturally or politically vivid. It would represent a maximal resistance to the processes of evacuation and erasure. The intended result would effect a collision of two powerful historical and cultural representations: on the one hand the cliché of Realism, a Realism seen as fulfilled by the investment of the plastic image *in* the painting with some social or political of psychological vividness; on the other hand the cliché of Greenberg's Modernism, a Modernism seen as established *on* the painting by the investment of its surface with a decorative and expressive autonomy. It was thought that the collision would be a kind of 'writing': the 'image' projected into a clash of descriptions by the orthography of erasure – the 'snow'.

The project was a kind of failure. Under the generic title *Impressionism Returning Sometime in the Future*, some relatively small-scale pictures were produced by snowing on Socialist Realism (see plates 114 and XI) and by snowing on Courbet, but attempts to address the idea to some plausible higher genre in the end drove Baldwin and Ramsden to virtual distraction. The very existence of Art & Language as a practice was jeopardized by the psychological conditions and epistemological implications of the project. The point is not that it proved unbearable to cancel one set of achieved images after another.

Plate 114 *Alexander Deineka*, A Fine Morning *(1959–60). Mosaic, 3 panels. Tretyakov Gallery, Moscow.*

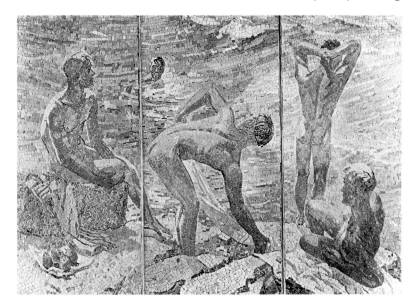

What made the project unsustainable was that there was no point at which an aesthetic closure could be applied to the process – not even so slight a limit upon the tendency to obliterate as presumably stayed Pollock's hand in 1953 before he had altogether whited over the dark and cliché-ridden depths of *The Deep* (see plate 115).[39] For Art & Language, no perceptible difference of activity nor any change of moral disposition marked the transition from cancellation of redundant signification to build-up of surface, the mutation of erasure into surfeit.

Not all imaginable paintings are paintings which can be realized, but we should bear in mind that other conditions than simple lack of competence arbitrate between the imaginable and the practical. However frenetically we may nowadays join in celebrating the endless parade of perfected and completed paintings with which our culture is being decorated, it may be that the conditions of abandonment of this project have a significant bearing upon the current problems of artistic practice. As this essay has aimed to show, these are not entirely new problems, though their historical nature has become increasingly hard to perceive through the marketing-strategies of the Postmodern. The Art & Language project suggests that we should ask of the practice of art no less than that it confront what the practice of art has confronted under different circumstances in the past: the problem of how – on what conceptual grounds – truly to distinguish between necessity and excess; the problem of how to restore realism to the surface. The abandonment of the project suggests a kind of answer: only, it seems, through a shift of representational levels; through a change in the 'truth-value' of the surface itself which is enacted as an event in its own life.

One large version of Art & Language's all-white paintings does

Plate 115 *Jackson Pollock,* The Deep *(1953). Oil and enamel on canvas, 220 × 150 cm. Musée National d'Art Moderne, Centre Georges Pompidou, Paris.* © *A.R.S., New York 1990.*

survive as a kind of mendacious representation – which will serve now as a final reminder that the relations between intention, expression, authenticity and realism, like the relations between surface and depth, are nothing if not complex. The long series of works which followed the abandonment of the snow project was coming to a close as this essay was written. Its collective title is 'Index: Incidents in a Museum'. In each of over twenty large paintings the figurative surface is disrupted by changes of scale and by repetition. Both collaged onto the actual surface of *Index: Incident in a Museum III* and located within its fictional space, a large white canvas hangs in the improbable setting of the Whitney Museum of American Art, between the palimpsests of Conceptual Art and a distant and fragmentary view of *Index: The Studio at 3 Wesley Place painted by mouth (II)* (see plate XII and plates 55 and 76). In the world surveyed in a spirit of irony, that which history rules out may finally be realized. The impossible painting hangs within the all-too-possible museum, its figurative surface of snow now fraudulently recuperated into the imaginary space of an official culture, where no cold wind blows and there are no peasants.

Reading the Museum

A picture is not worth a thousand words, or any other number. Words are the wrong currency to exchange for a picture.

Donald Davidson, 'What Metaphors Mean'[1]

'Incidents in a Museum'

The works produced in the Art & Language studio between the summer of 1985 and the winter of 1987–8 – between the abandonment of the 'snow' project and the first of the 'Hostages' – constitute an extended series under the title 'Index: Incidents in a Museum'.[2] If Art & Language's paintings of the studio at 3 Wesley Place represent the studio as a point of production – albeit under conditions of increasing strangeness and obscurity – the 'Incidents in a Museum' both represent the alienation of that production within the curating institutions of modern culture and picture those institutions as themselves the producers of kinds of representation.

The practical and symbolic move from the Artist's Studio to the Gallery or the Museum involves not simply a transition from private to public – an incorporation or alienation of the intimate within the institutional – but an engagement with a different though overlapping range of traditional symbol-systems and allegorical themes: the demonstration of Taste, the Homage, the elevation of the Profession, the appeal to Fame, the celebration of Culture (in some cases allied to the graphic condemnation of iconoclasm), the pictorial equivalent of the Ideal Library, and so on. These themes and their attendant scandals hover in the background of the 'Incidents in a Museum', as traces of another world and time. Such works of art as are shown or referred to within the figurative museum are works by Art & Language. In so far as the 'Incidents in a Museum' collectively 'contain' a retrospective survey of Art & Language's own work, they might be said pessimistically to pre-empt the initiative of the curator.

In the world they propose, the prospective artistic objects of curatorial celebration and enthusiasm already have their being as travesties, fragments and ruins.

The museum in question is a figurative presence in every work in the series. It does not appear each time in the same guise or under the same aspect, but it is plausibly the same institution which is referred to in each of the paintings, and in each of them this institution serves to establish the dimensions of a large illusory space. It also serves to define and to delimit a form of allegorical world, a world aesthetically removed from the actual conditions of distribution of high culture, yet one within which those conditions can be referred to and their paradoxes figuratively elaborated and explored. The paintings also refer to painting itself, to the modern art of the past twenty years, and to the present conditions of production of high art. The extent to which these latter conditions now coincide with or are determined by the conditions and mechanisms of distribution of culture is a question to which the paintings themselves are addressed. For example, it is a matter of interpretation – of how the paintings are *read* – whether we see the idea or the image of the museum as necessarily entailed by the appearance of the works it figuratively encloses, or whether we see the works as figures somehow generated by or in thrall to the museum. It may also be that these questions are themselves figures independent of the paintings – and ultimately irrelevant to them.

Though the pictorial schemes of the paintings tend towards the overtly theatrical, the paintings themselves are devoid of drama. More precisely, though it is in the nature of theatrical forms of pictorial space such as these that they evoke the expectation of human presence, the 'Incidents' are devoid of those forms of mimesis which are associated with the interrelationships of depicted figures. They are also devoid of those opportunities for psychological elaboration which occur when depicted figures achieve animation within the spectator's imaginative world. This is not because no works in the series contain representations of human figures. But such figures as do appear are shown as locked into other pictures and thus as already subject to those processes of re-representation which are supposed to divert and to satisfy the imaginative viewer. In *Incident XXI*, for instance, a version of *The Studio at 3 Wesley Place Illuminated by an Explosion nearby* is both figuratively depicted and literally included as a series of fragments, its various illustrative motifs and *dramatis personae* distributed across several canvases shown stacked against the gallery wall (see plate X).[3] By practical forms of displacement the representational levels which these figures occupy are rendered impenetrable to the consciousness in search of empathy.

If the 'Incidents' themselves are devoid of the dramas of a represented social world, however, it does not follow that no activity occurs to the spectator. Shifts in scale take place both across the literal surfaces of the paintings and within the figurative worlds that those surfaces establish. These serve to render insecure the spectator's relationship to

the paintings. There is uncertainty not simply about their figurative and illustrative content, but also about the functioning of those technical conventions and devices by means of which relations of figuration and illustration are suggested. Normally, within a work of a certain size and scale, a given cluster of brushstrokes may be allowed to have a certain figurative function. That is to say, the brushstrokes are seen as constituents not simply of a painting but also of a form of picture (or 'icon'). Their function as such is underwritten by a logical scheme which is the symbol-system of the painting as a whole. In a normal autograph reduction or enlargement of such a painting, that same cluster of brushstrokes may appear reduced or enlarged without damage to the credibility of the figurative scheme concerned.[4] But to set this reduction or enlargement within the very body of that which it reproduces is to invest the truth-value of descriptive and expressive marks, techniques and devices with doubt and insecurity. It is also to question the relative meanings of originality and reproduction.

At a technical level the 'Incidents' court incoherence. So far as the spectator is concerned, they are ontologically unstable. Categories that are normally distinct cease to be so. Description falters, for instance, in face of actual or potential overlap between the statements 'This is the painting', 'This is a representation of the painting', 'This is a part of the painting', 'This is a representation of part of the painting', 'This is a detail of the painting', 'This is a representation of another painting', and so on. Such uncertainty is trivial, however, if it serves merely to recognize a set of logical puzzles. The aspiration of the paintings is to represent in allegorical form the spectator's activity as structured within the imaginary museum. What is required if the spectator is to be critically engaged is that reflection upon the uncertainty involved be at some level a form of reflection upon the culture of the modern. In so far as the paintings succeed, that is to say, the conditions of consumption and distribution of modern artistic culture are taken into them and reflected back as formal effects.

The museum in question is clearly identified as a modern museum, not simply by those works for which it is made the notional container, but also by the style of its slabbed stone floor, ceiling grid of lighting-tracks, and movable interior walls. This is more than just a modern art museum. It is the paradigm of a modern art museum, a paradigm here characterized by reference to the (new) Whitney Museum of American Art in New York, opened in 1966.[5] *Incident XIII* clearly shows the distinctive single window in the Whitney's Madison Avenue face (see plate XIII). The plywood façade of *Incident XIV* refers to the pattern of granite cladding on the exterior walls (see plate XIV). (The use of the Whitney as model serves ironically to signify the hegemonic character of Modernism as a culture of art, and to indicate the effective chauvinism by which its cosmopolitan self-image is sustained. In so far as the museum is shown as the container of actual works of art, the works referred to are works by Art & Language; that is to say, they are works which have no prospect of acknowledgement within an

actual Museum of American Art.)[6] If it is not the continual figurative presence of the Whitney Museum which defines the 'Incidents' series as such, it is clear that reference to the type of the modern museum is an indispensable resource in each of the paintings by which that series is composed. The museum is represented not merely in its guise as a modern type of institution, in which certain sorts of things are encountered and certain forms of psychological event transpire, but also as a space within which Modernism itself is interpreted and made, a space within which readings are produced and elaborated. It is a notable technical characteristic of the works in the 'Incidents' series that, within their various figurative schemes, texts, signs of texts and metaphors for texts and for reading are liberally distributed.

Through closer consideration of three works from the series I mean to inquire further into the character of the series as a whole. In particular I aim to examine the relationship between its figurative components and its distinctive means of address to the spectator. I also aim to follow what I take to be the lead offered empirically by the paintings themselves, and to inquire into the relations between 'seeing-in' and 'reading'.[7] It is a contention endemic to the paintings themselves that the self-image of modern artistic culture is betrayed by the form in which these relations – and by extension the relations of 'images' and 'words' and of 'art' and 'language' – are contingently conceived and represented.[8]

Index: Incident in a Museum VIII

This painting (see plate XV) is composed of three separate and concentric canvases, upon each of which exactly the same scene – or what shows of the same scene – is painted in a different scale. The scene appears entire only upon the smallest canvas, which is set into the centre of the overall configuration. The largest version of the scene appears only as a narrow border around the intermediate version, which in turn shows all but the section interrupted by the smallest canvas. The vanishing-point of the scene painted on the intermediate canvas is slightly to the right of the overall centre and slightly lower than the mid-point of the vertical axis, which places it within the area occupied by the smallest canvas. The vanishing-point of the scene painted on the smallest canvas is to the left of this point and above it. This non-coincidence of vanishing-points produces an effect of dislocation or divergence both within the overall pictorial space of the painting and between its different components.

The left half of the scene is occupied by a wall set parallel to the picture plane a short distance into the figurative depth of the painting. The wall is covered with bands of text. It is not at first easy to tell whether the text has been printed on the canvas or whether what we are looking at is the representation of a printed text. This wall forms a right-angle with another which recedes into the figurative space. A

free-standing screen wall is set parallel to this second wall and thus also at a right-angle to the picture plane. Its nearest edge is set the same distance into the figurative space as the surface of the first wall. The narrow central space between the two receding walls is closed off by a fourth, which, like the first, is set parallel to the picture plane, though at a deeper level. This wall is also decorated with bands of text, which are in scale perspectively with those on the first wall. The right-hand side of the figurative space is closed off by a wall placed at right-angles to the picture plane and thus receding in steep perspective towards the centre of the overall composition. Between the left-hand edge of this wall and the nearest point of the free-standing wall there is a narrow vertical gap which is the deepest segment of the total illusionistic scheme.

The composition of the painting – or, rather the composition of the predominant 'painting', which is the intermediate version of the scene – presupposes a viewer located in a position to read the text. It is arguable that this imaginary viewer is what Wollheim calls a 'spectator *in* the painting'; that is to say that his or her notional presence is a part of the content of the painting. If this is the case, competently to view *Incident VIII* is to be able to become, in imagination, the reader of the text on the museum wall – and not simply the reader of the text on the surface of the painting.[9] Yet, if we say this of the intermediate painting, we can hardly say the same of that smaller version of the same scene which is set in its centre. The imaginary viewer who reads the text in the larger version must be seeing the smaller as an entire picture. And, if the actual viewer approaches close enough to read the (same) text in the smaller version of the scene, the larger picture must lose its power to shape an imaginary world. The painting as a whole plays not merely with the differences of scale associated with different forms and genres of painting, but also with those different forms of psychological activity and with those different means of bearing on the world which are the conditions by which the genres themselves are distinguished.

It is a commonplace of the social history of art that paintings of different sizes both satisfy and presume different forms of consumption and different kinds of disposition on the part of consumers. The 'gestural brushstroke' of the 'wall-sized painting' cannot be reduced in scale without becoming a symbol of a very different order, and one normally described in a different kind of discourse. The size and scale of the academic history painting allows for the organization of life-size figures and establishes an analogy with theatre. It also presumes that moral content in painting is feasible in some sense which is measurable against the moral aspect of theatrical drama. Further, it offers the spectator a characterization of himself or herself which is compatible with the image of the connoisseur of elevated drama: one competent in that higher order of sensibilities required to identify the meaning of tragedy and the achievement of catharsis with the dispassionate fulfilment of a necessary form. The cabinet painting, on the other hand –

the small still-life or boudoir nude – is supposed to cater to a lower order of sensibility: to the taste for actual or imaginary possession and consumption, or, more precisely, to a taste for confusion of the actual with the imaginary. In face of certain paintings, taste for such a confusion is a form of enabling *competence*, albeit one despised in the discourse of the higher order. In the critical perceptions of that discourse, the cabinet picture is rendered suspect by its modern status as progenitor of domestic kitsch.

In reading across the literal or figurative changes of surface in Art & Language's paintings we read across these cultural hedges also. If *Incident VIII* presupposes a spectator in the painting, it is a spectator beset by unaccustomed uncertainties as to his or her place in the (artistic) scheme of things – uncertainties unaccustomed, at least, in the world of the 'adequately sensitive, adequately informed, spectator'. Shifts in size and scale open the processes of reading to a dialogue of values and competences. The dialogue takes place not simply, as it were, between the genres themselves, but also between the imaginary members of their respective audiences. Even as it elicits one form of reading, each of the 'Incidents' misrepresents itself to another reader. The spectator is left in doubt as to the nature of the incident which the paintings represent or contain. What is supposed to have occurred, where and to whom? On the basis of what evidence should we seek to reconstruct the event? The particularized space of the imaginary museum serves to elicit this and other situational questions which are addressed to the contingencies of art. The 'Incidents' are replete with the fragments and traces of art itself. These are of some significance as forms of testimony to Art & Language's own production and practice over the course of some twenty years – albeit there are signs that that testimony is unreliable – but it is not primarily the story of Art & Language that these paintings tell. Rather they testify to that order of events within which the practice of Art & Language has been caught up. Evidence at the scene of a crime may be used to construct a personality for the victim. The principal object of forensic inquiry, however, is to discover the circumstances and the nature of the crime and of the agency behind it.

The colour of *Incident VIII* is other than naturalistic. That is to say, though the organization of colour and tone contributes to the construction of the illusionistic scheme, the requirements of that scheme would be as well satisfied with a narrower range of hues and a less dramatic brushwork. Certain details appear straightforwardly inconsistent with those requirements: the crescent shape a third of the way up the free-standing wall, for instance, and the crossed lines at the base of the right-hand wall. To say that the painting is 'of' the museum is clearly not to rule out the possibility of its being connected iconically and/or genetically to other features of the world. It would appear that to match the painting naturalistically against the imagined museum is, among other things, to perceive how it is *unlike* its overt subject. To seek to explain the departure is to ask what else it may be like. The

answer, in this case, is that it is like certain paintings produced by Braque and Picasso between 1909 and 1912. It is from these paintings that the broad colour scheme of the museum painting has been taken. The treatment of the floor refers to the planar construction of the Cubist picture. The otherwise inexplicable crescent shape is a specific (though inverted) quote from Picasso's *Aficionado* of 1912,[10] where a similar form represents the barb of a bandarilla. If the configuration of the pictured interior refers to a paradigmatic modern art museum, the technical character of much of the painting refers to a paradigmatic form of modern art and to the conceptualization of its problem-field.

And what of the texts lettered on the two walls parallel to the picture plane? A careful reading suggests that both are excerpts from the same verse drama. The speakers named in the first extract are a 'First Policeman', '[Inspe]ctor [Maurice] Denis' and 'Sergeant Nozière'. The opening speaker clearly inhabits a world of category mistakes. (He is Inspector Denis, though the evidence of the painting alone may not establish this beyond question.) He is reading a painting. His description evokes the kind of female nude prevalent in French art of the mid nineteenth century, but he is viewing the picture as if it were a photograph, and he sees the female figure as actually inert. Unable to distinguish between the represented and the means of representation, he regards the picture as forensic evidence of a murder. Driven by the misperceptions of a compulsively literal vision, his thoughts skitter out into a world of deeds and motives. These he attempts to map back onto the painting, as explanations for what he sees in it. He is a kind of Modernist *manqué*, sticking to what he takes to be the text of the painting, yet without having surrendered the assumptions of a primitive realist. In the second extract, lettered on the deeper facing wall, the same Inspector Denis interrupts Edouard Manet in his studio, where the painter is talking with a Monsieur Barbin. The Inspector is seeking a murderer – of nudes or of models for nudes, it is not clear which – and he treats Manet as a suspect. The practice of the painter is both fascinating and dangerous to one beset by the delusions to which Inspector Denis is subject.

The excerpts are taken from *Victorine*, the libretto for a projected opera by Art & Language, published as *Art–Language*, vol. 5, no. 2, in March 1984 (see plate 116).[11] The title refers to Victorine Meurend, the model for various paintings by Manet, his *Mademoiselle V. in the Costume of an Espada*, his *Déjeuner sur l'herbe*, and, most notoriously, his *Olympia* (see plate 83). The opera is a kind of murder mystery, which ends as Victorine prepares to go out for what may be her last rendezvous. It is also a form of sustained allegory upon the established conventions of reading of paintings – an allegory of the various forms in which paintings have meaning attributed to them in virtue of the ways in which they are matched against the world. As a reader of the text which *Incident VIII* presents, the spectator in the painting is caught up in a drama of conflicting significations. As the literal viewer of the painting, the spectator may find him- or herself

ART-LANGUAGE

Volume 5 Number 2 March 1984

Plate 116 *Cover for*
Art-Language *vol. 5
no. 2 (March 1984)
('Victorine').*

attempting to relate the allegorical fragment which the text presents to
the actual business of reading the *Incident in a Museum*. In Woll-
heim's formulation the relation between the spectator in the painting
and the spectator of the painting is a relatively straightforward one.
The former serves as amanuensis to the latter, as agent of the latter's
imaginative absorption in the content of the work of art. That Manet's
Olympia presupposes the presence of a client allows the suitably quali-
fied spectator to take on the persona of the client in imagination – that
is to say, to take it on as the function of an aesthetic disposition
without adopting this persona as an actual moral state.[12] The spec-
tator-*in*-the-picture as client is no threat to the spectator-*of*-the-picture
as aesthete. Indeed, the impossibility of such threat has conventionally

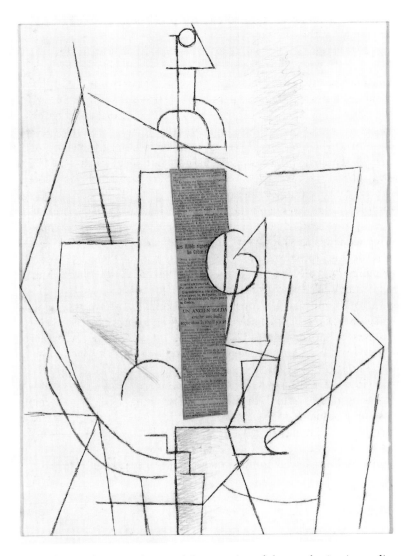

been taken to be a condition of the security of the aesthetic. According to the traditional protocols of Modernist aesthetics, it is only in pictures – or spectators – deemed aesthetically impaired that the 'emotions of life' (i.e. of the 'life' *depicted*) are supposed to be determining upon emotional response.[13] Before *Incident in a Museum VIII*, however, the relative psychological dispositions and activities of the two forms of spectator are bound together aporetically. What is read *in* the painting threatens to disqualify that which the painting is seen *as*, while the conditions of the painting's being viewed as a painting tend to remainder the findings of the imaginary reader.

The painting's invocation of the precedent of Cubism serves both to recall a relevant precedent and to locate the materials of a current controversy within its own intensional margins. How are we to establish the meaning and the ontology of the Cubist collage? Does a

competent 'reading' of Picasso's *Bottle and Glass* of 1912 (see plate 117)[14] require that we literally read the text of the newsprint, with its story of a former soldier who, twenty-six years after being shot in the head, spat out the bullet which had wounded him? And, if so, with what kind of intensional object are we finally confronted? Or should we take the simpler course and treat the newsprint simply as surface and texture, managing somehow – by keeping our distance perhaps – to prevent our sense of the aesthetic integrity of the painting from being invaded and compromised by the absurd story of the soldier?[15]

Art & Language's painting offers no solution to dilemmas of this form, nor any escape from aporesis. Rather, it is in the intentional nature of the painting that the *persistence* of such questions is a condition of the competent spectator's experience. The dilemmas of looking and reading are both symbolized and played out through those changes in scale which enact differences of focus. And in *Incident VIII* it is first and foremost in terms of the relativities and meanings of scale and thus of 'reading-distance' that these changes make themselves felt. From the assumed aesthetic distance of the Modernist connoisseur – one for whom the newsprint on the Cubist collage is merely the means of situation of an autonomous plane – it may be that the text of the opera is literally insignificant, or, rather, it may be insignificant that the text is the text of an opera, or of anything else. Yet, if the aesthetic disposition is to be accorded any non-idealistic virtue, it will have to be maintained in cognizance of what it is that art is made of – and this will include language and texts. From the close-up reading-distance of the compulsive literary iconographer, on the other hand, it may be that the painting fails to signify as a painting. Yet, if paintings are forms of any abiding interest, it is because they inhabit and invest and animate the margins of language.

Index: Incident in a Museum XVI

Like *Incident VIII*, this painting is composed of separate canvases, forming three concentric images (see plate XVI).[16] In this case the principal configuration of the scene is established by the outer canvas, which occupies most of the total area. The museum interior is seen as if in near-darkness. The painting is large (8 × 12 ft; 243 × 379 cm) and its immediate effect is theatrical and atmospheric. The vanishing-point is very near the centre of the composition and the sides are left open. Two free-standing walls recede at right-angles to the picture plane, the one on the left set deeper into the picture space than the one on the right. A further wall shows at each side of the painting, well into the picture space and parallel to the picture plane. The intermediate canvas repeats the same scene on a smaller scale, though, because of the relative obscurity of the whole and because the two vanishing-points almost coincide, the two separate versions of the scene tend initially to read as continuous. Read as if in unbroken perspective, that

is to say, they appear to delineate a space which extends into depth beyond the plane of the walls which face us at either side. To perceive the repetition is to perceive that the space of the total painting is shallower than at first appeared, and that the walls at either side may in fact be two sections of one continuous wall which marks the deepest level of the depicted interior.

As before, the smallest canvas occupies the centre of the total painting. It appears relatively luminous, though its surface is marked with the darkest tones present in the painting as a whole. In our attempts to make the whole image cohere, we tend to read this canvas as representing a large abstract painting mounted, perhaps, on a free-standing wall deep in the centre of the figurative space. But, once the intermediate canvas is correctly perceived as a smaller-scale repetition of the outer one, it becomes clear that the space which the notional abstract painting occupies, if translated to the outer canvas, would fill the area from the nearest edge of the receding left-hand wall to a point about a quarter of the way along the wall which recedes at the right. This is to say that it would obscure the entire space occupied by the intermediate canvas. What had previously appeared as a represented painting set within the figurative space now presents itself as an actual painting set within the literal surface of the intermediate canvas, not merely unassimilated to the illusionistic scheme but positively disruptive of its rationale. The effect of the exaggerated perspective and theatrical atmosphere is to enshroud the smaller inserted canvas in a miasma of figurative depth, but, so long as we can hold the literal identity of the abstract painting in mind, the two sections of the surrounding canvas take on the status of a flat and decorated frame.

The two outer pictures are executed in oil paint. The surface of the central canvas is both thinner and blacker, as if it had been printed rather than painted. The light-toned ground has indeed been darkened over with printing-ink, though by means of a technique invented in the studio and widely used in the 'Incidents' series. Designated by the neologism 'Alogram', this technique involves the transfer of ink from printed or photocopied images directly onto canvas. Where necessary – for instance, where the transfer is intended to produce a literally legible text – an intermediate process is employed to produce a reversed image. This will then read correctly when transferred. It was by means of such an intermediate process that the various passages of text were transferred to canvas in *Incident VIII*. In *Incident XVI*, however, no intermediate stage was employed and ink was transferred directly from undistributed back numbers of the journal *Art–Language* and from other Art & Language publications. The abstract painting recapitulates and refers to a brief and abortive series of works which Baldwin and Ramsden produced in this fashion in 1985. Page after printed page was literally erased as a reversed deposit of words, sentences and paragraphs built up on the canvas into a new form of obscurity. These paintings were not avant-garde *jeux d'esprit*, nor forms of *tabula rasa*. They were the fruits – and causes – of a kind of

desperation. (Words may indeed be the wrong currency to exchange for a picture, but what if the picture *is* a thousand words?)

To all evident appearances, *Incident XVI* is a picture without a text. A realistic criticism will seek to take some adequate account of what it is made of, however. It may be that this will entail consideration not simply of the prose which has been erased in the process of its composition, but also of those texts by which its margins are defined – of which this present essay is possibly one, participating as it does in the process of establishment of reference.

> Establishment of the referential relationship is a matter of singling out certain properties for attention, of selecting associations with certain other objects. Verbal discourse is not least among the many factors that aid in founding and nurturing such associations.... Pictures are no more immune than the rest of the world to the formative force of language even though they themselves, as symbols, also exert such a force upon the world, including language. Talking does not make the world or even pictures, but talking and pictures participate in making each other and the world as we know them. (Goodman)[17]

Each painting in the 'Incidents' series invokes a range of possible references, some more explicitly than others. Each of them bears the prefix 'Index'. Each is indeed the complex and constructed trace of a history, or a repository of such traces. The nature of this history matters to the painting. The ethical character of the work – which is not to be prised apart from its aesthetic character – is decided in part by the content of the history it refers to and in part by the critical relationship to that content which the painting exemplifies. It is a matter of some relevance that the materials erased in the making of the painting are materials for which Art & Language was responsible.

> When we say that [painting] *p* expresses *s*, we are, if we are not to produce gratuitous idealisations, saying that an individual *i* is expressing *s* in *p*, and that *p* also is symbolic and has the property of also referring to *s*. The really exotic (or rather interesting) question is whether or not *s*'s being the cause of *p* is the same thing as *p* referring to *s*.
>
> The emancipatory potential of art is minimal. But if art discourse is to have *any* such potential, it must depend upon the possibility that the circle of interpretation can be broken in a causal discourse which is a moment in the unfolding of what it describes. But causality is vanity. The real project is to do without it: to make do with nothing.[18]

It should be acknowledged that, if *Index: Incident in a Museum X V I* is somehow haunted by the cancelled texts of which its central darkness is the product, what registers within the figurative scheme of the painting is not the intellectual character of the texts themselves but rather the technical character of the act of cancellation. To what extent can the expressive aspect of a painting be made of that which is *excluded* from its figurative content? And how might a given exclusion register as significant?[19] As regards *Incident X V I* the most we can say with absolute confidence is that it is in the observable and recoverable nature of the act of cancellation that it places the literal and material substance of print – though not of language – at the heart of the figurative, and figuratively dark, museum.

And yet the painting itself does invite a stronger and more interesting conjecture. Would it not be a different kind of thing – and would it not thus in some sense have to be *seen* as different – if the texts erased in its making were texts of a quite different order? Imagine a painting the central darkness of which was built up of ink transferred from *Mein Kampf*, or from *Fortune* magazine, or from the collected poems of Sylvia Plath. The point is not that such a painting would be visually distinguishable. The point is rather that it would have to have had its becoming and its being in a different practical and ethical world, at the end of a different kind of causal chain. It would therefore be different. In face of the force of that difference it seems a relatively trivial matter whether or not the painting would be distinguishable by the disinterested eye for the purposes of empirical connoisseurship.

If there is a spectator in the picture here, is he or she the missing figure presupposed by the figurative space: the spectator in the museum, benighted, disappointed and confused? And, if so, to what extent can this imaginary spectator in the picture be made to function as agent of the actual spectator of the painting, confronted as the latter is by that literal and literally obscured central surface by which the hypothetical position of the former is occupied or blotted out? Or is it perhaps the very absence or implausibility of the spectator in the picture – and of all he is made to stand for – that the actual spectator of the painting reads out of the printed surface?

> 'Reading-in' and 'seeing-in': are these real hermeneutical mistakes? Is 'reading-in' or 'seeing-in', in the sense of 'projection onto' or 'transference', the 'not yet' of a hermeneutical 'no longer' or the 'no longer' of a hermeneutical 'not yet'?[20]

Index: Incident in a Museum XXV

Incident X X V put a virtual end to the series, by effecting a change of emphasis among the practical and conceptual materials from which the series as a whole had been composed (see plate X V II). Unlike its

companions it contains no internal shift of scale, though it does play upon the conflict between two irreconcilable viewpoints. Occupying or obscuring most of the picture surface, an actual bookcase is let into the centre of a canvas 5 ft 9 in. high by 8 ft 11 in. wide (174 × 271 cm). The depth of the bookcase is such that its nearest edge rests flush with the surface of the canvas, as do the spines of the publications with which it is filled. The publications contained in the bookcase are unsold copies of *Art–Language* and of an anthology of Art & Language texts published in French and English in 1978, interspersed with occasional copies of associated pamphlets, catalogues and student journals. Though the contents of the shelves look like the makings of a library, further examination reveals something closer to storeroom stock.

The interior of the museum is depicted on the canvas surrounding the bookcase. This time the notional vanishing-point of the interior view is set outside the left-hand side of the painting, level with its vertical centre. A free-standing wall shows to the right of the bookcase, receding into depth at right-angles to the picture plane, which is to say diagonally from the right-hand foreground into the left-hand distance. What may be assumed to be the same wall (since it continues in the same plane) shows to the left of the bookcase, where it meets another wall running parallel to the picture plane. This second wall defines the point of maximum spatial depth at the far left. At the extreme right of the painting, past the near edge of the receding wall, a narrow view opens into a further interior space. The palpable function of this last device is to balance the effect of sharp spatial recession towards the left, and thus to render almost plausible that frontal viewpoint on the represented scene which the presence of the bookcase presupposes.

Initially the viewer tends to locate the literal bookcase within the surrounding figurative scheme – such is the power of a consistent pictorial scale, and of our conventional expectations of pictures. It seems just possible, that is to say, to conceive a spectator in the picture who is an imaginary reader of the books in the bookcase. But it is a requirement of the spectator in the picture as Wollheim conceives him both that he should be able to see all that the picture shows, and that we should be able to see all that he sees, know all that he knows.[21] The imaginary spectator who is also an imaginary reader, on the other hand, knows what the actual spectator cannot learn; unless, that is, the latter were literally to break the plane of the picture, to reach into it for a book and thus to violate that surface which is the surface of a painting, leaving a black line.

Paradoxically, the actual bookcase appears the more emphatically integrated with the surface of the canvas as it becomes clear that the rationale of the perspective tends to exclude it. To be more fully incorporated into the illusionistic scheme the bookcase would have to be represented *as if* free-standing and solid; which is to say, given the location of the vanishing-point, that it would have to show a left-hand

side apparently receding in line with the overall perspective. That it does not show such a side serves not merely to assert its literal flatness but also to call attention to the fact that this property of literal flatness is shared with the surrounding canvas. In fact the painted surface is made to invade the bookcase itself, as it were to claim it as its own, though the nature of the claim is itself ambiguous. Lines of perspective continue across the top left-hand corner of the bookcase, tracing the lighting-grid where the insert interrupts it. Paint oozes onto the wood where it abuts the canvas. And, as if to mark out the taboo against violation of the surface, the spines of the books and magazines are touched with blobs and streaks of paint. The paradox of the painting is that the spectator can be literally a reader, but only if the painting is no longer treated as a painting.

The full title of each of the works in the 'Studio' and the 'Incidents' series commences with the word 'Index': for example, *Index: The Studio at 3 Wesley Place Painted by Mouth (I)* and *Index: Incident in a Museum XXIV*. In according these paintings this form of designation Art & Language appears to invite a response on the part of the spectator which is indeed not the form of response conventionally associated with paintings. Art & Language's first 'Index' was the work shown at 'Documenta 5' in 1972. What the spectator then saw on entering the room was a group of filing-cabinets and a printed index. The files contained texts, collected as evidence of a form of activity on the part of various contributors. *Index 01* suggested ways in which this evidence might be organized into a representation of a discursive world. Art & Language furnished the forms and protocols by which surveillance of its activity might be conducted. In the opera *Victorine*, the files of Inspector Maurice Denis are full of paintings, which he takes as evidence of crimes committed. Meanwhile, the murders continue.

Think of a painting as a form of forensic file. Or imagine a forensic file which contained one painting and a body of related material. What would that material be like? What criteria of relatedness would determine inclusion in the file? What representations of Courbet, Pollock, David, Poussin, Braque, Picasso and Manet would appear in a file which had as its title a painting which referred to them, as Art & Language's 'Studio' paintings do? What texts would appear in a file which had as its title a painting which included a bookcase? Whose activity would the assembled contents of such a file facilitate? What would the spectator in such a painting be *doing* in it?

To envisage making a painting is to accept the operation of certain principles of autonomy and of certain closures. Some of these are restrictions upon what can be included. Others are restrictions upon the potential use of the resulting object. Concepts of representation – beliefs about the scope of representation and about the cognitive activities with which it is associated – function between the world and paintings as conditions of exclusion and inclusion. They also function between spectators and paintings as protocols of regard and response.

Among the most powerful features of concepts of representation are those which serve to demarcate between the verbal and the visual, between language and pictures. The painting called *Index: Incident in a Museum XXV* has its being as a form of representation – and as an object open to being represented – within the very ground upon which such demarcations are supposed to be made.

It has been a longstanding convention of our culture that works of visual art represent in a way categorically different from the ways in which words do, and that this difference is a matter of *how* works of art look and *that* they are to be looked at. That this looking must also involve a requirement of likeness – of looking *like* – is a further once-conventional assumption which has been abandoned under attack from works of art which look like nothing (except other works of art), by works of art which simply are what they appear to resemble, and by various other extensions of homelessness in representation. The latter assumption has also been vulnerable to the critique of similarity itself.

> The conviction that resemblance is the necessary and sufficient condition for representation is so deeply ingrained that the evident and conclusive arguments to the contrary are seldom considered. Yet obviously one dime is not a picture of another, a girl is not a representation of her twin sister, one printing of a word is not a picture of another printing of it from the same type, and two versions of the same scene, even from the same negative, are not pictures of each other.
>
> All this proves, of course, is that resemblance alone is not enough for representation. But where reference has been established – where a symbol does refer to some object – is not similarity then a sufficient condition for the symbol's being a representation? Plainly *no*. Consider a page of print that begins with 'the final seven words on this page' and ends with the same seven words repeated. The first of these seven-word inscriptions surely refers to the second, and is as much like it as can be, yet is no more a picture of it than is any printing of a word a picture of another printing. (Goodman)[22]

A text is a text. A picture *qua representation* is a picture, though it is not through similarity alone that an image achieves the status of a representation.[23] On the other hand, texts as conventionally envisaged are disqualified from representing as pictures are supposed to, and this disqualification is at least in part because their meaning is not supposed to inhere in their graphic form – i.e. in what they look like. Under what conditions, then, might a text stand a chance of being a representation of another – a picture of another in some sense which is not reduced to triviality in the face of Goodman's strictures? There is

no opening of the closures on representation without critical review and revision of the fixed relations of reading and looking. What kind of possible picture is 'A picture *of* a thousand words'?

9

Unit Cure, Unit Ground

The painting refers to the modern art museum, a place of circulation and display (see plate XVIII). It evokes the appearance of a specific museum, perhaps as a token of its type. That much appears to be given by the representations of paved floor, ceiling coffered with a grid of lighting-tracks, and movable screen walls. The museum appears in two versions, in two different scales, one contained within the other. The nature of this containment is ambiguous. The smaller painting is (on) a separate canvas. Has one painting been literally inserted into another painting, interrupting it? Is the larger picture shown thereby to be incomplete, as if its centre had been removed and replaced with something else, something other? Or does the smaller painting represent a smaller picture, hanging within the fictional space which the larger painting contains and thus, in a sense, completing it?

Within the smaller picture the museum is empty. Within the larger painting the museum is represented as empty but for the represented picture. Between the two pictures the viewpoints differ, as if a viewer had moved. Do the different pictures refer to different moments, different times? Is the memory of one moment referred to in the picture of another? How is the whole image held in the mind?

There are different kinds of edge. The wall in the picture ends where an edge is represented. The smaller painting ends where it is contained within the larger painting. The smaller picture ends where its edge shows against the depicted wall. The larger painting ends where its edge shows against the actual wall. How does the viewer distinguish in perception between literal surface, representation of surface and representation of depth? What is the relationship between painting and picture?

Within the smaller painting the image of a ground plan appears in, or on, the surface. The pattern of shapes is formed by literal insertions into the canvas. It contradicts the illusion of depth, yet the illusion of depth persists. We 'see' at one and the same time the illusion which

invests the surface with depth, the pattern of the plan which invests the surface with a metaphorical flatness, and the actual flat surface into which insertions have been made. And we see all of this as surrounded by and included in a painting of a modern museum.

Close up, we see more. The surface of the inserted pattern is composed not of paint but of paper. On the paper are printed details from a painting of a museum, with paved floor, coffered ceiling and movable screen walls. The painting has been reproduced. Perhaps it has been exhibited in a museum, on a movable screen wall. We carry this thought with us as we step back from the surface and look again at the whole painting – the whole picture. The thought changes how we see what we see, but does not resolve it. Unreassuringly, the painting works at the viewer.

10

On Pictures and Paintings

A work in process

This is a kind of narrative about an unfinished painting – a painting, at least, which was unfinished at the time it presented itself as an appropriate subject or example (see plate 118). The purpose of this essay is to review the relations of practice and criticism: both to inquire into the processes of criticism in recent art and to consider what criticism has to learn from practice. I mean also to touch on the question of interpretation in the history of art – or at least to suggest how it is that the evidence of practice may bear upon the art historian's acts of interpretation.

The painting in question is[1] large and square: 10 × 10 ft (305 × 305 cm). When this essay was written it was still hanging in the Art & Language studio. It was made by Michael Baldwin and Mel Ramsden. Though I didn't help to make the painting, I am implicated in it. The medium is oil paint on canvas stretched over plywood on a wooden frame. The principal area is painted grey. In places, some pink under-painting shows through the grey. If the surface of grey is intended to represent or to refer to some other surface, it is by no means clear what it might be. A form of design is distributed across this surface. Painted details of slabbed floor and gridded ceiling appear upon a configuration which itself composes a form of ground plan. It is possible to read these details as fragments of one single and continuous interior, viewed in perspective with a projected vanishing-point near the centre of the grey canvas. The interior which the details compose is like the inside of a modern museum, with bands of relatively unmodulated colour at the centre referring, perhaps, to the movable screen walls of an up-to-date gallery. (Those familiar with the Whitney Museum of American Art might notice a resemblance.) Closer examination reveals that the bands of detail are not continuous with the grey-painted surface. They are painted on strips of canvas which have been

Plate 118 *Art &*
Language, Hostage
XIII *state 1 (October,*
1988).

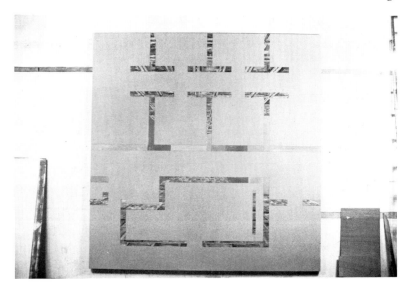

separately stretched, then let into that surface and fixed flush with it
(see plate 119). The detail doesn't quite read as if it were viewed
through the grey surface, since that surface itself tends to recede
spatially. One strip of detail runs across the lateral centre of the grey
area, literally bisecting it. If the pattern of the inserted strips is read as
a kind of ground plan, it suggests an arrangement of enclosures,
partitions and free-standing walls such as might be found in the typical
modern art museum. The painting, then, refers at two levels to the
kind of space within which such paintings might be hung – though, in
so far as that space is actually pictured, it is pictured as empty both of
spectators and of paintings.

So what we have is a large opaque abstract surface, a form of
ground plan inserted into that surface, and a kind of illusionistic
painting of a deep interior space – existing only as a series of frag-
ments or slices – which interrupts the surface but is nevertheless com-
pact with the total image which it composes.

If we attempt to represent to ourselves what it is we are perceiving –
to give the thing a generic name and a theme – the painting presents us
with a series of dichotomies. How are we to decide the relative priori-
ties of figure and ground, of plan and elevation, of literal surface and
figurative depth, of object and image? Such questions are by no means
unfamiliar to the viewer of modern painting – indeed, it could be said
that the posing of such questions has for some while been a condition
of painting's modernity. The history of modern painting is replete with
stage-managed collisions between illusionistic depth and decorative
surface. Such collisions have been the stuff of technical virtuosity in
the modern manner from Manet, through the Cubists, to Hans Hof-
mann and his followers. These collisions tend to occur, though, as
dialectical features of one integrated picture, and not, as in the Art &
Language painting, as virtual alternative and clashing identities for the

Plate 119 *Art &*
Language, Hostage
XIII *detail of state 1.*

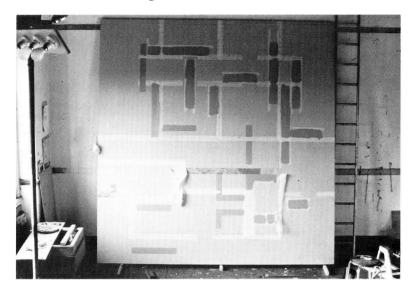

Plate 120 *Art &
Language,* Hostage
XIII *state 2 (November
1988).*

image as a whole. This painting appears to present the supposed antinomies of the modern in a particularly literal form – a consequence, I think, of the visual co-presence and actual physical disjointness of a highly theatrical illusionistic space with a thoroughly bland and impenetrable surface.

This impression of alternative possible identities – alternative readings for the image as a whole – suggests a kind of conceit: we might interpret the painting as a representation of the condition of painting itself, viewed through the larger history or rather through the rival histories of the modern period as that period has been conceived in these essays. On the one hand there is painting as it features in the narratives of Modernist theory – notoriously in Clement Greenberg's

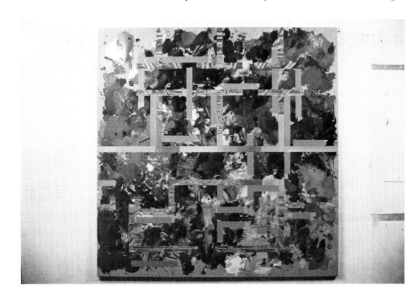

Plate 121 *Art &
Language,* Hostage
XIII *state 3 (December
1988).*

1961 essay 'Modernist Painting'.[2] This is painting progressively purging itself of its anecdotal, literary and theatrical inessentials, painting orienting itself to flatness as to nothing else, since virtual flatness is the condition which painting shares with no other art form, and since survival of painting as a modern high art depends upon its capacity to entrench itself within the domain of its own distinctive competence. On the other hand, there is that narrative which the hopeful advocates of Realism (here intended to refer to a naïve or sentimental 'pre-Brechtian' Realism) have sought to install in place of or alongside the narratives of Modernism. This is a story of painting struggling to retain its engagement with the social, the cultural and the moral, painting persisting in its attempts to carry forward the highest of its own traditional genres and to demonstrate, by achieving forms of modern history painting, that history painting is capable of modernization.

It is in terms of the relative transparency or opacity of the surface of painting that the validity of these rival histories has conventionally been decided. History painting, of all the genres of visual art, is traditionally the closest to theatre. Epic, tragic and uplifting statements in the grand manner require an adequate cast and an ample space – a space that can notionally be looked into. This is indeed the kind of space our painting seeks to establish, though in only one of its dual aspects. What we have is not, of course, half a history painting. But we might say something like this: that the suggestion of a theatrical space evokes in the spectator the expectation of drama and mimesis. This expectation is not satisfied by the painting. Rather, what the painting does is to make manifest or to display the very circumstances of disappointment or absence. The space so carefully constructed is constructed to be empty, and it is perhaps in some sense that very emptiness which the grey surface represents – and represents as engulfing and inescapable.

In the world of art history the Greenbergian orientation to flatness has been given a different interpretation or different explanation in the writing of T. J. Clark, who, if he is no standard Modernist, is certainly no simple-minded Realist either. Clark gives flatness a kind of sociological meaning: the presentation of surface is a type of desperate reference to the actual. It is, as it were, the form of self-expression that capitalism leaves us.[3] Clark uses the phrase 'practices of negation' to refer to those forms of artistic work in which he sees that condition as itself made manifest.[4] What is negated and refused in such work is the illusion that repeatable meaning and unmediated self-expression are ever possible in modern culture. It is worth observing that, if his teleology is different, the notion of critical and dialectical change at work in Clark's account of Modernism runs more or less parallel to some more standard accounts – to the Modernism of Michael Fried's *Three American Painters*, for instance, if not to the Modernism of Clement Greenberg's 'Modernist Painting'. Given the life-enhancingness normally and tediously claimed for modern art, the connection

between Modernism and negation could indeed do with some further examination.

Whichever account of Modernism we prefer, it does seem that painting's literal superficiality has somehow to be acknowledged if its procedures are to be seen as modern. To fail to make this acknowledgement is to fall short of the requirements of modern scepticism. In the conventional wisdom of art history, that taste for embodiment to which paintings once catered could no longer after a certain point be satisfied; or, at least, it could not be satisfied through such whole and sensuous figures as paintings used to picture. 'It was with the utmost reluctance that I found the figure could not serve my purposes. . . . But a time came when none of us could use the figure without mutilating it' (Rothko).[5]

For whatever reason, in Modernist painting from Manet onwards, those evident factive procedures by which figures were realized rendered them increasingly contingent as components of decorative schemes. In Cézanne's painting an envigorating sense of difficulty marked those passages where the conflicting requirements of expressive surface and figurative depth had made themselves most keenly felt. In the typical analytical Cubist painting these previously exceptional moments of crisis were gradually spread across the surface of the painting. Finally, what was proposed in the high-Modernist art of the late 1940s and the 1950s was that the entire painting should be approached as a kind of body in itself, its total surface animated, sensible and open. It became as it were a point of honour that a painting should not pretend to be something else. Pollock conceived of painting as 'equivalent' rather than 'illustration'.[6] Newman wrote, 'We are making it out of ourselves, out of our own feelings. The image we produce is the self-evident one of revelation, real and concrete. . . .'[7] Investing the canonical Rothko painting is a dream of the absolutely non-hierarchical, absolutely non-dichotomous, absolutely non-manipulative relationship – an act of utter disclosure demanding to be experienced as an end in itself (see plate 122). It is hard to imagine an aspiration for culture that is less easily assimilated than this to the socio-political morality of the Cold War. It is perhaps also worth noting how very unfashionable such aspirations were to become in the age of the artistically Postmodern.

The old humanistic claim for art reappears in such works as Rothko's, but it reappears in the form of a negation. The work which is always and only itself is a form of paradox, for its identity depends very precisely upon those identifications it both courts and avoids. In the case of the Rothko painting, it could be said that the identifications it refuses are all those which are incompatible with the spirit of humanism. The important point, I think, is that making this refusal count in practical terms was for Rothko largely a matter of tuning the spatial characteristics of his paintings. And this was a matter of finding out what kind of place art could decently have in the modern world. The self-critical progress of Rothko's work involved the

gradual elimination first of those forms which were redolent of organic life, and then of those aspects which allowed the reading-in of atmospheric effects. Both had become compromised by their cultural associations and uses. His aim, I believe, was to keep at bay the possibility of translation of the painting as symbol and thus to keep it unfixed to any available system of meanings and values. His *work* was learning the necessity of doing this, and learning how to do it. It was no doubt a demanding task. One technical consequence was that his paintings tended to get darker, closer-toned and more opaque as his career progressed. Conventionally, this tendency has been interpreted as expressive of a gathering pessimism on Rothko's part. The symbol is translated in terms of the artist's psychology, the painting turned back into a picture which simply reflects the biography of the artist. This is, of course, to betray the endeavour of Rothko's art, since it accords no independent identity to the painting. The characteristics of his paintings are trivially explained as the consequences of his depression. In fact we might instructively consider his difficulty in being in the world as following on from – or at least as consistent with – the requirements of his practice. That is to say, there may be some explanation of Rothko's depression which is also explanatory about certain characteristics of his paintings. But co-occurrence is not necessarily a causal or other explanatory relationship. (The objection to seeing co-occurrence as causal and explanatory can be made on two grounds. First, though an artist may paint dark pictures when depressed, his being depressed does not explain – or only marginally explains – the property of darkness in his pictures. Rothko's depression may explain why he had a tendency to paint dark pictures. Equally, it may not. Secondly, the artist's depression might arise in face of difficulties in his work. In such a case his practice would be potentially explanatory as regards his depression, and not vice versa.) The psychological reading makes a partial selection from an open set of causal conditions and organizes it into a vector. It also reintroduces just that illusion of depth which Rothko himself worked to eliminate, and reintroduces it, moreover, as the ultimate cliché of artistic profundity: the echoing void of depression and death.

Like the echoing void, the deep illusionistic space of the theatrical painting is now a technically conservative space, redolent of the once-authoritarian values of the academy and of the abiding aspirations of the amateur. More significantly, perhaps, it is the space of modern communication, and thus of manipulation, since manipulation is what communication has now largely come to mean. In the eighteenth century the idea of the imaginative world within the text was rightly satirized as the philistine product of bourgeois culture.[8] The imaginative world within the picture is now the world of the idiot consumer. The deep space of illusion is usable for the purposes of modern art only if somehow rendered equivocal. Nothing demonstrates this so clearly as the negative cases: those implausible attempts to retain the illusion of depth – and therewith to retain the possibility of moral

content – which have been launched in the modern period either in the name of 'traditional values' or in the name of a Realist 'truth'. Such works rarely survive even a moderate scepticism. We have only to look at the decorated surface – to refuse to see the picture as the painting – and their pretended authority fails absolutely.[9]

The work I am concerned with runs no such risk of failure – or none, at least, of failure on these grounds. Notwithstanding its evocation of theatrical space, it would be hard to read it either as an attempt at Realism or as the intended repository of some set of traditional values. More significantly, however, in so far as it achieves the status of a painting, it already includes the defeat of the pictured interior as a part of its content. Indeed, the possibility of the work's being considered at all as a modern painting seems to depend upon the frustration and failure of whatever authority might attach to the pictorial scheme. It is as if the imaginary museum were there only in order to be deprived of plausibility and significance, to be left as a kind of residue, or ruin. Or we might say that the pictured interior is subordinate to the grey surface, that it exists merely as a form of interruption and irritant.

To speak of the painting in such terms is to represent it as a kind of self-deconstructing thing – as the potentially exciting occasion of some now-fashionable play of cancellations and differences. The very appropriateness of such an account offers grounds for unease. There are reasons for caution when some work seems caught too readily in the available critical discourse. In the language of its most excited interpreters, the work of Mark Rothko was only too easily fixed as High Art in the Age of Tragic Agnosticism; that is to say, it was fixed as a mirror of the bourgeois soul in its cherished moments of penitence and of Godless exaltation. Crying in front of Rothko's paintings became the last refuge of those whom Nietzsche described as *littérateurs*[10] – and of those who are impressed or coerced by such creatures. For this reason if for no other, the kinds of surface effects associated with Rothko's paintings have come to be numbered among those which cannot now be used or even quoted without irony. It is always important to know what the *littérateurs* are up to. One of the real problems for the practice of art now is that the *littérateurs* have attempted to make irony their stock-in-trade. In the current language of academic enthusiasm, a place is prepared for the Postmodernist artwork as high art's next significant mutation; that which serves and dignifies the tenured intellectual's self-image as one competent in contradiction – which is to say, as one who camouflages intellectual complacency as morally significant irresoluteness. 'Practices of negation' are now the stuff of artistic and intellectual fashion.

It might seem that to say even this is to play into the hands of one fashionable form of the practices of negation, for there are those who would have it that (agnostically) to capture the ground of artistic fashion is to practise a form of critical negation. It is true that everything is unlike everything, except in those respects in which it is not;

that everything disimplies everything, except in those respects in which it does not; and so forth. This trivial truth compasses a vast range of domestic and other forms of likeness and unlikeness, of denial, affirmation and negation. Similarity and difference are vacant and promiscuous relations, easily conscripted in the pursuit of significance.[11] The risk involved in the very idea of 'practices of negation' is that it is available to invest the utilitarian and the venal with the habit of resolute moral purpose. And such investiture is indeed the stuff of mere artistic and intellectual fashion.

The moment of criticism

In fact, far from celebrating the unfinished painting in these or other terms, I mean to explore its inadequacies. For this is a work which would not do, or not, at least, as it stood. In fact, to call it unfinished is to be imprecise. There are two different ways in which a painting may be considered unfinished. In the first case it is clear that some planned and envisaged procedure has yet to be carried through or completed, or some technical criterion of finish has yet to be met. In the second case some set of intended procedures has been completed – and completed according to some relevant set of standards or tolerances. Work on the painting ceases, it is looked at and thought about as *if* it were finished, and the result of this scrutiny is that the painting is deemed somehow unsatisfactory or inadequate. This is a critical judgement made in the studio, and it follows that something needs to be done to the painting, though it may by no means be clear what that something is. In the first sense of 'unfinished', what is supposed to follow involves the working-through of some already-envisaged system. In the second case what may be required is the application of some systematically different procedure, a shift to some different level of reference, a revision of tolerances, or an action of some morally different order. The requirement is not for further development along the same lines, but rather for substantive change. As a kind of aside to my argument, I suggest that some of the most fascinating of modern paintings are works in which this requirement of change is not so much satisfied as left hanging in the air. (The suspension of criteria of finish appears as a virtual condition of modernity in some early works of Manet – for example, his *Music in the Tuileries* of 1862 and *The Universal Exhibition of 1867* – and in Monet's sketches of *La Grenouillère* made in 1869. Among other paintings that come to mind are certain of Cézanne's late *Bathers*, Picasso's *Demoiselles d'Avignon* and Pollock's *Portrait and a Dream*.)

It is this second sense of unfinished that concerns me here. I want to consider the nature of the judgement that is made when someone says, in the studio, 'Something ought to be done to this painting' – whether this means something more or something different. I'm interested in that moment of reflection and dissatisfaction, in the ways in which it is

informed, and in the implications and consequences which follow. As regards Art & Language's unfinished painting, I wish to ask for what sorts of reasons it might have been seen as unsatisfactory and unfinished. The purpose of this exercise is not primarily to develop a critique of this particular proto-painting. Rather it is to use the specific case to ask what self-critical activity in art can *now* be like. I emphasize the 'now'. I do so to signal an out-of-hand rejection of those essentialist and reactionary notions which would have it that the fundamental determinations upon artistic work are everywhere and always the same. Far from attempting to pin down some essential moment of creativity in the practice of art, I am concerned that that moment should be properly historicized. There is no one crucial point in the creative process, any more than there is one fundamental criterion of artistic success. At different times in history critical attention focuses on different stages in art's procedures of invention, production and distribution, no doubt in response to wider changes in the social and intellectual world and to consequent changes in the function of art. Whatever stage is isolated thus becomes the moment of specific interest for the purposes of criticism and self-criticism. To ask what is now the crucial moment and what it is like is not to inquire into the nature of art in general. Rather, it is to ask about the self-image of current artistic culture. Beyond that question there is the further question of how – by what mechanisms and in response to what demands – this self-image is generated and sustained. Work along these lines is beyond the scope of this essay, but it is work which art history has no good grounds to disdain.

One thing is clear. Since the mid-1960s we have seen a significant shift in the location of the critical moment. Or, to put this another way, we might say that significant critical argument over the period in question has concerned the point at which criticism itself should bear upon art. The current practice of art inhabits this area of controversy and is shaped by its terms. In the Modernist account of art – of art from Cézanne to Pollock, and, perhaps, from Gonzalez to Caro – the moment of self-critical contemplation and action was located at some nodal moment *during* the working-process. Considerable theoretical weight was attached to this moment and to the nature of those changes which were supposed to follow from it. I suggested in the first of these essays that at a certain point Pollock's work became central to a body of argument. It was above all with the achievement of his abstract all-over paintings of 1947–50 that Modernist theory identified virtue in practical self-criticism. For Pollock more than any previous painter, the possibility of transformation of a picture into a painting did indeed depend upon the relationship between improvisation and self-criticism. Despite the image of spontaneity and unreflectiveness which clung to his work, its deliberate and deliberative intellectual character is generally readable from the evidence of the paint (see plate 1). The virtue of Greenberg's and subsequently of Michael Fried's account of Pollock is that it represents his practice as a

process of learning about the problems of painting – and, indeed, as establishing a further agenda.

It is hard to overestimate the power of Pollock's example within the critical self-image of Modernism. In those schools of art where the artistic protocols of Modernism were most wholeheartedly adopted, the group critique of work in progress became the focus of teaching-strategy. The assumption made for the purposes of teaching was that criticism involved intervention at some significant moment in the evolution of the work of art. This was the moment at which the student was supposed to learn not simply how to improve a painting or a sculpture, but how to transform an aesthetic decision into a requirement for ethical action – or, to put a different face on it, how to strike the right tough attitude in front of the teacher, whose countenance was set in the image of flinty resolution.

My text is painting, but I am reminded of the sculpture department of St Martin's School of Art in London, where Caro's presence was dominant in the 1960s (see plate 6) and where Clement Greenberg and Michael Fried were both welcome visitors. My impression, exaggerated in memory no doubt, is of long sessions of struggle devoted to such issues as whether or not one more section ought to be added to some more-or-less arbitrary assemblage of scrap metal. If I strike a sceptical note in remembering such scenes, it is because they are associated for me with a different kind of learning. They remind me forcefully of that process of transition from one model of practice to another which I, like others of my generation, was caught up in at the time. For the reaction against mainstream Modernism which set in during the mid-to-late 1960s was in part a reaction against just such images of rigour and self-criticism as those which the sessions at St Martin's were supposed to inculcate.

Those of us who then sought to throw off the authority of Modernism in its Greenbergian version were committed also to opposing its notion of the place and purpose of self-criticism. By then there were some alternative models on offer. The three-dimensional objects of the Minimalists, for instance, presented no obvious moment at which taste could usefully intervene in the forming-process. Sol LeWitt published a catchy slogan, 'The idea becomes a machine that makes the art.'[12] This was to become an epigram of Conceptual Art. In fact, ideas are not such as to become machines and without some practical implementation they make nothing. The strategy, though, was to shift the emphasis of criticism, and to shift it in favour of the kind of work that LeWitt and others were then doing. In face of a floor piece by Andre (see plate 28), a row of boxes by Judd (see plate 9) or a felt sculpture by Morris (see plate 10), to deliberate on whether or not another element should be added would be to show that one had missed the point. The order and proportions of the work were supposed to follow from a set of initial decisions. In the presence of such things the discriminating-skills of the Modernist connoisseur were rendered redundant. Indeed, it was a significant intention that they

should be. If the completion of the work was a procedure which merely followed from some set of intellectual operations, at what point was the critic or teacher to intervene? It turned out that those practised in criticizing paintings and sculptures were not necessarily the best judges of ideas – not, at least, as ideas were conceived in the wake of Minimalism by those who aspired to the title of Conceptual Artist.

It was with Conceptual Art that the change I have in mind was really effected. I believe it's necessary, though, to distinguish between two different types of Conceptual Art or Conceptual Artist. Conceptual Artists of the first type were committed, as the Minimalists had also been, to the form of Modernist historicism discussed in the second of these essays; that is to say, they believed that art develops according to a kind of self-critical logic. Their vaunted opposition to Modernism reduced to a disagreement with standard Modernists about which were the significant links in the art-historical chain. They didn't want painting singled out on the basis of its achieved decorative qualities. They wanted art as a history of radical ideas about art. Not Matisse but Duchamp, not Rothko but Reinhardt, not Noland but Johns. Taking more literally than Greenberg himself the notion that development in art involved the paring-away of art's supposed inessentials, they aimed to produce the next form of reduction, the next least object. Painting with light, painting with air, painting with words. Superficially opposed to the Modernist emphasis on radical taste, these Conceptual Artists were obsessed with style. Conceptual Art of this first variety was nothing if not tasteful. Their rigorous logos were these artists' most distinctive properties. The typical form of their work was a kind of radical publicity. Though they appeared to shift the focus of criticism towards the moment of intellectual invention, this was largely done by a kind of sleight-of-hand. In fact the effect of the work depended largely on the conditions of its display – and thus upon decisions taken about those conditions. This was the age of installation art and of critical intervention in the 'prevailing codes'. Managing the most prominent and interesting contexts of intervention and display occupied much of the artists' time.

It followed that the boldest course for the critic was to ignore all claims for the original invention and to go for the display, for it is one of the stronger theses of Modernist criticism that art is compromised as it approaches the conditions of design. Installation art proved highly vulnerable to the kinds of comparisons with the real world of design and publicity which its practitioners must have thought they had transcended. Much of it tended to disappear without disturbance into the very culture it was supposed to be deconstructing. There is an argument that this represented a kind of Postmodernist success: the desacralization of the notion of art, and the engagement of artistic workers with the pressing cultural issues of class, race, gender and media. This argument is all very well, but those who would live by it cannot have it both ways: that is to say, they cannot also claim a

special power for the aesthetic. As suggested in the fifth of these essays, they remain saddled with 'effectiveness' as a criterion – and it is a criterion they share with publicity, with propaganda and with religious indoctrination. They may choose to make the rottenness of capitalism their subject matter, but it is also the rottenness of capitalism that makes their practice.

One illustration will serve as measure of the gap which separates the first kind of Conceptual Artist from the second. The French artist Bernar Venet, an artist of the first type, used in the early 1970s to exhibit blow-ups of title pages and diagrams from 'serious' theoretical texts. Where Marcel Duchamp had searched for his ready-mades in hardware stores, the radical Venet found them in libraries. Art & Language's *Index 01* was a kind of library (see plate 43). When it was exhibited at 'Documenta 5' in 1972, Venet assumed we were working along similar lines. This was before he discovered, to his evident surprise, that we were the authors of the texts we used.

Like the Conceptual Artists of the first type, Art & Language acknowledged the power and interest of the Modernist account of art, but also sought to stand outside it. This was not to be done simply by latching onto some other and avant-garde tradition, nor by proclaiming an independent position and then proceeding to make radically new art-works. We saw no alternative cultural ground upon which such a position could be sustained – not, at least, unless 'living in your head'[13] was seriously to be considered as a form of social life. We therefore assumed that the supposedly new art-works would rapidly be absorbed into the gravitational field of the dominant culture – which was indeed what happened. So what could art-work be like, if it were not merely to extend the list of sensitively decorated surfaces or of rigorously bland least objects? The answer seemed to be that 'the work' was the examination and critique of Modernism; that the task was critically to represent Modernism and whatever Modernism itself represented. The risk that a practice along these lines might fail to produce anything which could be ratified as art seemed preferable to the alternative prospect: that one might be doomed to the continuing pretence of radicalism within the self-reflecting spirals of Modernist culture.

For Conceptual Artists of the first type, painting and sculpture were simply redundant and embarrassing technical categories, to be left behind in the avant-garde pursuit of art and ideas. For the Conceptual Artist Joseph Kosuth, for instance, what was of potential interest in Pollock's practice was that he painted on the floor. By the time the painting was hung on the wall its radicalism was already exhausted.[14] For the representative members of Art & Language, on the other hand, painting and sculpture were seen simply as practices which could not sustain their historical potential under the cultural conditions of the time. To proclaim the death of painting was simply to indulge in Futurist rhetoric. That a form of history painting might one day again be possible was for Art & Language a practical if also an

ironic aspiration. There was no knowing what such a painting could
be like. The point was that the possibility would have to be earned, for
there could be no history painting without the accumulation of some
non-dogmatic set of historical meanings and motifs. The task was not
to set up in avant-garde opposition to the meanings of Modernist
culture, but rather to denature them from within. (It was consistent
with this view of the job in hand that, when Art & Language came to
exhibit a form of history painting in 1981, it should have taken the
form of ironic comment on the Realistic legacy of Courbet – as that
legacy might be viewed through the clichés of born-again Expression-
ism (see plate IV).)

From the perspective of Art & Language, the practical criticism of
the Modernist was distinguished by nothing so much as its liturgical
character. A great divide appeared to separate the Modernist congre-
gation from the unbelievers and the unwashed. For those who con-
trolled it, the intention of the Modernist struggle-session was that it
should be open, speculative and critically acute. The experience of
many who observed or were subjected to its rituals was that it was
coercive, dogmatic and entirely arbitrary. Across this divide there was
often little negotiation. Central to the issues involved is an argument
about the nature of taste. For the Greenberg of the 1960s and after,
and for those many artists for whom he spoke, 'taste means that all
that is in you is in your eye';[15] it is ungovernable, disinterested,
informed by the examples of the past but propitiously immune to the
contingent interests of the present, be they matters of fashion, of
morality or of politics. According to this scheme, the aesthetic is the
most demanding and thus perhaps the most virtuous of critical values.
From this notion of taste there follows an ideal notion of self-criticism
in art as similarly disinterested and intuitive, since no taste is so
important in the development of art as the taste of the artist. It follows
in turn that art must be free from theoretical prescription; that its
practical procedures should ideally be absolutely empirical.

Those antagonistic to the authority of Modernism in the later 1960s
were generally possessed of a different understanding of taste. The
Modernist concept of taste as disinterested they saw merely as a means
to misrepresent a comprador culture as a form of immaculate and
ineffable nature. The idea of an art free from theoretical prescription
masked the extent to which Modernist art was already subject to the
prescriptive decorum of Modernist criticism. This dissenting view
entailed a quite different notion of the role of self-criticism in art.
From the point of view of Art & Language, the obligation upon the
artist was not simply to exercise an intuitive faculty. It was to know
what he or she was doing, and to be capable of giving a relevant
account. This account was not primarily one of what had been done or
made, but an account, rather, of the conditions which made that doing
or making necessary and defensible – or not. The focus of criticism
was thus diverted from the object of art, be it either the Modernist art-
work-in-process-of-being-put-together, or the radical post-Minimalist

display, and was located in the material and generative conditions of the practice. By what kind of tradition, what kind of culture, what social world, what politics, what philosophy had this practice and its preoccupations been shaped? These were the concerns of criticism as framed in the second version of Conceptual Art. The change of critical focus was a shift from the world of achieved effects to the world of causal conditions.

The change had clear political implications. In practice the aim was not to boldly go where no man had gone before, but rather to map the ground one happened to be standing on. If this was a modest aim, the assumption which underlay it was catastrophist in nature. It was this: that in so far as a view of the ground was already available, that view was a massive and systematic misrepresentation. The task of self-criticism, then, was not primarily to decide whether the work in hand looked right or not, but to assess through the evidence furnished by whatever might be its outcome, whether the initial conception had been informed by a properly disenchanted regard. If the work appeared to be failing in this respect, it would have to be corrected – something would have to be done to it.

Potential and loss

I have gone a roundabout route and it is time at last to return to the unfinished painting. I hope I have done enough to suggest that the painting as I have represented it signified more than a mere meeting of Modernist abstraction with the ghost of a theatrical Realism. Art & Language saw it rather as caught in the collision of those critical and aesthetic values topicalized in Modernist discourse with the deconstructive legacy of Conceptual Art – a collision between the ideal of an absolutely empirical regard, on the one hand, and the necessity of theory, on the other. It is in this sense that the unfinished painting is exemplary. Or, rather, the unfinished painting represents an unresolved meeting between the aesthetic interests and aspirations historically associated with Modernism and the disenchanted account of those interests from which some Conceptual Art was made. In the state in which I have discussed it, the painting is a kind of inadequate Modernist painting. It fails to achieve that state of expressive integrity and all-overness, that tension between literal flatness and optical shallowness, which Modernist theory has led us to demand of painting. On the other hand, the work could be seen as an adequate piece of late Conceptual Art. Its relative adequacy as Conceptual Art consists in its literal presentation of certain dichotomies – which are those the Modernist dialectic is supposed to be made of.

The unfinished painting does have a kind of Conceptual Art lineage. Its iconography can be traced back through previous Art & Language works. In the 'Incidents in a Museum' of 1985–7, the same interior

features more or less entire as the ironic container for Art & Language's own work – some of which derives from the heyday of Conceptual Art (see plate XII). But, in so far as the painting intrudes into the territory of Modernist competences – in so far as it has surface, depth, pictorial shape, pictorial form and so on – it renders itself hostage to that very critical discourse which Conceptual Art sought to paraphrase and to disempower. This does not in itself deprive the painting of all credibility. Its didactic aspect as a late form of Conceptual Art could include or allow for its being an unsuccessful painting in Modernist terms. We are still stuck, however, with a 10-foot-square object we don't much want to look at. And, more significantly, we are stuck with the sense that that dissatisfaction is resistant to being theorized – and may thus have to be faced as aesthetic in some sense.

What the unfinished painting illustrates, I think – or, rather, to try to recapture the spirit of my title, what it pictures – is precisely this dilemma. On the one hand the theory and practice of Modernism equips us with a useful and vigorous scepticism about the world of mimetic effects and dramas, about graphics and messages and technology-fetishism and about the delusions of 'cultural relevance' and 'effectiveness'. It reminds us that the artistic text is always opaque. In the self-critical practice of the Modernist, the notion of 'ungovernable taste'[16] stands for the requirement that the work realize itself in its own formal terms. On the other hand the lessons of Conceptual Art equip us with scepticism about Modernist claims for the disinterestedness and critical power of taste and intuition, and with distrust of the supposed mysteries of artistic meaning. In the self-critical practice of the Conceptual Artist, the contingency of all representations must be practically acknowledged.

What the unfinished painting does, I think, is make symbolic material of this dilemma. For this is indeed our present world and our current history. We are in both states, and in each equipped with scepticism about the other. We are not outside both or outside either. Those sets of beliefs and attitudes and practices we refer to as Modernist were not overthrown by Conceptual Art any more than they have been exorcized by the proclamation of Postmodernism. Modernism is still our culture. But the sceptical representation of Modernism is also our culture. We exercise taste, but not without irony. We make judgements, and we do so in a state of shame. I make no claim to have known, or, rather, to have known better than my friends, what was to be done with the painting in question. And, anyway, the practical question 'What is to be done?' is not always best answered with a text. Indeed, it may have been one of the most telling signs of the inadequacy of the painting as it stood that it served to generate *this* text – that it was recountable in terms of those contrasts I have used. For these terms are now available to become the stock-in-trade of the art historian, who would always rather translate pictures than interpret paintings; who is inclined to demonstrate his theories about how

to read art by avoiding precisely the *artistic* aspect of that which he reads.[17] If the unfinished painting itself did not stand outside the circumstances it narrated, it allowed the spectator to do so – to escape from the painting into the picture. A glorious noonday this may briefly have appeared to be, but it was nevertheless the sign of a technical failing – a failure which had to be corrected.

In the event, what did seem clear was that the painting would not succeed unless and until it somehow shifted the ground of those contrasts which it served to illustrate and to symbolize. For the terms of this dichotomy have become over-rehearsed and almost wholly enslaving. What do we opt for: Modernism or the disenchanted redescription of Modernism? The surface of expressive effects or the surface of artificial differences? The formal and aesthetic categories of the idealist connoisseur, or the historical and political perspective of the 'critical thinker'? On the one hand this, on the other that. The symbolic materials fall neatly into two halves, with the state of the painting itself pictured as unresolved between them and with no significant and untranslatable remainder. The consequence was that, while the symbolic components of the painting might be isolated – the bland surface on the one hand, the fragmentary museum on the other – the object itself had no very arresting integrity as a symbol.

I have suggested that Rothko tuned his paintings so they would stand as negations of a certain cultural and moral world. Of that suite of paintings originally commissioned to decorate the Seagram-building restaurant he is reported to have said,

> I accepted this assignment as a challenge, with strictly malicious intentions. I hope to paint something that will ruin the appetite of every son of a bitch who ever eats in that room. If the restaurant would refuse to put up my murals, that would be the ultimate compliment. But they won't. People can stand anything these days.[18]

In so far as Rothko did in fact succeed, his paintings were realistic expressions of some actual moral condition. Nothing less will do. It's still cold out. The problem is still how to see through the misrepresentations of the modern – how to actualize the moral aspect of history in the experience of the spectator of painting, and how to ensure that for those who will not have that experience the painting is not so much a deconstructable thing as a thing that self-destructs – even in the face of those practised in deconstruction. Current fashion offers us two versions of modernity. In one, commodities and cultural icons are ironically represented as forms of whole body. In the other, representations of the body are shown as picturesquely fragmented. Both are knowing. We should be satisfied with neither. For it is the experience of being torn apart that the deeply modern work may have somehow to represent – and to represent as more than a merely psychological matter.

I am, I suppose, trying to make a case for the *transgression* of the knowing by the aesthetic. And this implies that the virtues of the Modernist struggle-session may have to be reconsidered or reinterpreted. One thing is sure: 'neo-Conceptual Art' is as vacant a prospect now as neo-Constructivism was in the 1930s and *a fortiori* in the 1950s. The point at issue is the kind of relationship a work of art can or should have with its own past; the way in which it narrates its own place within a practice and a history. This is the question which both criticism and self-criticism have to address. To say that a painting is unfinished in the sense of inadequate is to say that it fails to live up to its own antecedents – to the demands of its own history. Yet, for those not possessed of certainty about the trajectory of history, the nature of this failure is unlikely to be clear. Indeed, the artist as ideally envisaged goes back to his or her painting and does something to it largely in order to learn the nature of its inadequacy. For it often happens that it is only when the painting has changed that the artist can understand the nature of those limits within which it had been confined. And to understand this is to learn something about the consequential character of history – be it a social and political history, a history of art, a history of the artist's own practice or of his or her psychological being, or some conjunction of all or any of these. It is a matter not of stepping outside the dichotomies by which our culture is defined, but rather of living the collision between them.

In the case of our exemplary picture or painting, the problem, I think, was how to meet the requirement bequeathed by Conceptual Art that the values of both picture and painting be rendered precarious, contingent and unstable; and yet how, in the process, to make the picture inseparable from the painting – which is the requirement that Modernism has traditionally and persistently made. For, while a

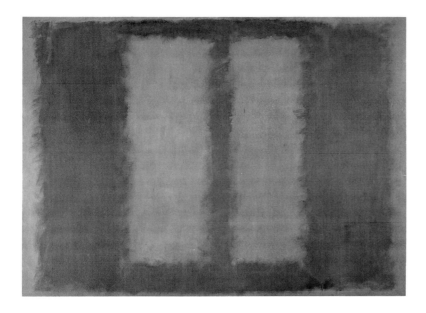

Plate 122 *Mark Rothko*, Black on Maroon *(1959). Oil on canvas, 105 × 180 cm. The Tate Gallery, London.* © *A.R.S. New York, 1990.*

picture is something that tells a story, while it is constructed on the basis of what is known or imagined, a painting knows something which neither the artist nor the critic knows. It is smarter than they are – and harder. If aesthetic quality has any non-idealistic meaning, this hardness is its sign.

In offering this analysis of the unfinished painting I claim no overview of the problems of practice nor any special insight into the means of their solution. I have merely attempted to represent in the form of an essay both the deliberations of the studio and the conceptual materials of which those deliberations were made. The chronology and the trajectory of the painting are both largely independent of my narrative. After I had begun to draft this essay, the painting was changed, leaving behind the argument here woven around it (see plate 120). The surface of grey was cancelled, though the nature of this cancellation was itself subject to further change (see plate 121). In the end the painting extended a series which it seemed in its unfinished state to close off (see plate XIX). This series has the generic title 'Hostages'. It continues at the time of writing and is considered in more detail in the two following essays.

Of the various levels of reference and irony involved in the now-finished painting, I single out only those which are of particular relevance to the issues I have already touched on. First, it appears to have been tuned according to some requirements of aesthetic integrity – criteria of balance, of decorative complexity and harmony, criteria of *wholeness*. At the same time there are suggestions that the stance of the painting towards these requirements is one of resolute irony. Secondly, it appears to have a strongly indexical character; that is to say, it has been clearly marked by the events and procedures of its own construction, as a palette is somehow marked by the progress of that painting it was used to make. But there are suggestions that this indexical character is fraudulent, an effective masking of the real history of the painting, a fake footprint leading the wrong way. Thirdly, the composition and decoration of the surface is such as to render insecure such distinctions as might be made between the literal and the figurative, between the expressive and the intentional, or between the arbitrary and the accidental. In the long allegory of art and culture which this painting has now joined and extended, it is not clear whether the object of art is rendered hostage to the controlling power of an aesthetic discourse – a discourse which is supposed to speak of our sense of human potential – or whether evidence of scepticism and alienation in the making of art is such as to deprive that discourse of credibility, leaving us with the evidence of waste and of loss. In so far as Art & Language's painting may now be considered finished, it is this actual ambiguity that it embodies and that we, as its viewers, confront.

I believe that an ability to generate relevant accounts of this ambiguity between celebration and loss is a measure of adequacy in modern art criticism. I also believe that an ability to explain the grounds of this

ambiguity is a measure of adequacy in modern art history. But neither the representatives of art criticism nor the representatives of art history should allow themselves to stand back and treat works of art as if they were simply parables. It will not do to keep our hands clean by analysing *paintings* as if they were no more than *pictures*.

'Hostages' 1:
Painting as Cure

Art & Language's 'Hostages'[1] look at first glance like abstract paintings, which they are not. In their most evident aspect, they refer to abstract painting, but obliquely, through the intervention of a kind of device. They are in part pictures of surfaces on which paint has been mixed. They are not those surfaces themselves. That is to say, they are not and have not been palettes, though they are largely painted to look like palettes. A given painting from the series is not necessarily a picture of a specific palette (though it may be); rather, each painting refers to the palette as a certain kind of painted surface – one which is both accidental and indexical. It is accidental in so far as it is not composed, or not, at least, in accordance with any sensible aesthetic considerations; indexical in so far as a palette is marked by the consequences of certain technical decisions and procedures which have featured in the genesis of some painting.

A picture of such a thing bears a strange relationship to what it is of. What forms of significance, for instance, are we to attribute to detail and to texture? The representation of an accidental surface requires careful contrivance. The representation of an indexical surface is a misrepresentation of that surface's indexical character. The fake obscures the conditions of its own genesis by annexing a history which is not its own. A represented footprint misleads the careless tracker. And what decides the scale of a represented palette? *Hostage I–III* look as if painted on a one-to-one scale (see plate X X). (Over twenty years ago Art & Language produced a *Map of Itself* as a print.) *Hostage IV–X* look as if painted on a larger scale, but may simply refer to those more prodigal forms of painting which require an ampler palette (see plates X X I, 123 and 125). In *Hostage VII* and *IX* 'slices' of detailed brushwork are juxtaposed with broader swatches and splotches of paint. It is as if these paintings were related through some untraceable causal chain to other paintings in two or more different scales and sizes. If this is what we believe, we must also take

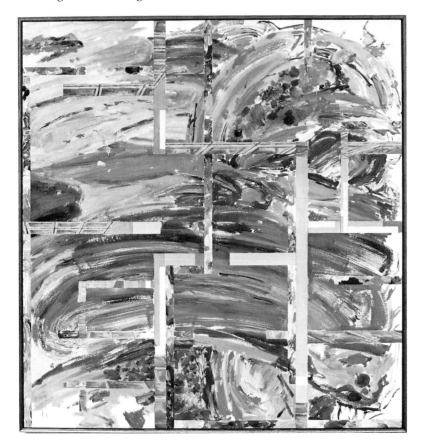

Plate 123 *Art &
Language*, Hostage IX
(1988). *Oil on canvas
on plywood, with
acrylic on canvas on
plywood inserts, 190 ×
183 cm. Private
collection, Vienna.*

account of the relative flatness of the represented surfaces of *IV–IX*.
They appear more decidedly marked by a figurative aspect than do the
surfaces of *I–III*, and perhaps of *X*, as if some other level of represen-
tation had intervened between the painted surface which is pictured
and the painted surface which is the surface of the picture. In a paint-
ing which is a picture of a palette, 'rich' colour and 'prodigal' brush-
work must betray the very predicates they attract – though they may
reinstate them after a different fashion and in a different logical and
aesthetic space. A fraudulent representation of rich brushwork may
itself be richly painted, but as a move in a kind of game, yielding a
different pleasure. To the extent that the predicates of authenticity
become fixed and dogmatized, the possibility of innovation and
change will reside with the inauthentic. We are on shaky ground.

Within the depicted palette and flush with its surface, sections of a
very different kind of painting are inserted on separately stretched
canvases. These show details of slabbed floor, coffered ceiling and grey
walls – as if of the interior of a modern art museum. Though they are
distributed across the area of the painting, and though their scale is
consistent with a single perspectival scheme, the details do not read as
glimpses into one notionally consistent interior (except in *Hostage XI*

Plate 124 *Art & Language,* Hostage XII *(1988). Oil on canvas on plywood, with acrylic on canvas on plywood inserts, 128.5 × 128.5 cm. Private collection, Minneapolis.*

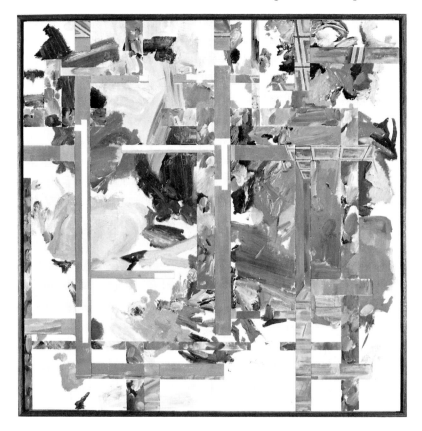

and *XII*, where they do (see plate 124)). Their literal profiles, however, compose a form of ground plan – one which suggests the kind of modern art museum which the details evoke, though no complete architecture can be read out from the figurative details themselves. Plans and details haunt the agitated 'all-over' surfaces as if with a promise of dramatic or cultural content, never quite resolving into detached and independent grids, never quite merging into the looser texture which surrounds them.

The paintings seem to be tuned to this end – to the end that there shall be no final position, no resolution into figure and ground, nor any resolution of those multiple and complex forms of difference for which the relationship between figure and ground has long between one of our most seductive metaphors. 'That which must necessarily be taken as literal in order to define the figurative is itself figurative, and so the distinction breaks down.'[2] This breakdown is contrived. If the details do not read as spatial and figurative interruptions of a flatter and more loosely painted surface, it is because that surface is itself redolent of a figurative intention; which is to say that it is other than flat and loosely painted. If the details are not isolated as shapes of a certain colour and tone, it is because their constituent colours and tones are distributed about the surrounding brushwork, as if the palette had been covered in the process of painting just such an

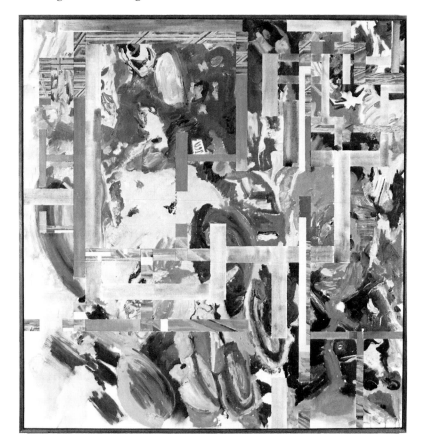

Plate 125 *Art & Language,* Hostage VI *(1988). Oil on canvas on plywood, with acrylic on canvas on plywood inserts, 190 × 183 cm. Collection Isy Brachot, Belgium.*

interior of just such a museum – perhaps the very interior of which these are the remaining fragments. Did some picture which has been fragmented once grow from some palette which has been depicted, or is the depicted palette a form of decorative ratification of the fragmented picture? How, by mere looking, can we tell the causal from the coincidental? Infinity in its bathetic aspect is symbolized – and perhaps in some pathetic sense experienced – in the conundrum of the chicken and the egg. Linear concepts of cause are kinds of rational vanity. In the top right-hand corner of *Hostage V* the smeared representation of a blue-grey smear is made to chime with the blue-grey detail of a carefully depicted distant ceiling (see plate XXI). In the logical scheme of the painting these forms of reference can be related – but related as two points are which are drawn upon a map which is drawn over an abyss.

In *Hostage IV–XII* the inserted strips of canvas show unpainted areas. These serve to confirm that the pictorial aspects of the inserts are insecure, provisional and contingent. Their pictorial function appears the more strongly marked by their dual status as the shards of an iconography and the symbolic rejectamenta of a material studio practice. In the long series of 'Incidents in a Museum' which immediately preceded Art & Language's 'Hostages', the power of the museum

as a determining cultural agency (and as a metaphor) survived in the deciding figurative framework of the pictured interior. The more recent paintings suggest that the survival was not simply in virtue of that power's being symbolically represented. They testify to its persistence as a form of irresistible presence in the psychology of the practice – a presence which cannot simply be named and described and thus externalized. It is a matter of some ambiguity whether the enterprise of painting remains hostage to that civilization which the museum both actually and metaphorically represents, or whether the represented museum is hostage to the devices of painting, or – which is the more interesting and the more 'realistic' possibility – whether the two readings are possibly and actually coincidental.

A further component of the 'Hostage' paintings complicates 'reading' of the inserted details and of their overall configurations. Painted bands run horizontally and vertically across the surfaces in related but independent arrangements. To be more precise, the bands are not so much painted as covered with representations of painting. The forms of representation employed are distinct from those which compose either the 'palettes' or the inserts but they furnish kinds of technical bearing from which each may be viewed. Like the inserts, the painted bands form kinds of interruption in the principal painted surface. Unlike the inserts, they are physically of that surface. While they read as compositional elements related to the inserts, and while they also contain depictions of a kind, the depicting is done according to different types of convention from those which characterize the inserts. In *Hostage I–IV* and *X* the most notable difference is that, while the technique used for the inserts is one which sustains the illusion of depth, the 'wood-grain' technique used for the painted bands is one conventionally associated with the representation of flat surfaces. The flatness signified is of a particular type, distinct from the form of flatness signified by the surrounding area of 'palette'. The bands refer, that is to say, not to a literal but to a pictorial flatness – and more specifically to a distinctively *artistic* flatness: the flatness signified in Cubist collage, and referred to in the frontal planes of synthetic Cubist painting and of all subsequent painting – figurative and abstract alike – that partakes to any degree of those forms of spatial organization which are inherited from Cubism. This is the form of pictorial flatness which is topicalized in the Modernist critical tradition. The stain-painted bands which replace the wood-grain in *Hostage VI* can be read as a form of reference to Post-Painterly Abstraction, in which pictorial flatness was supposed by the adherents to that tradition to have reached its most sheerly 'optical' form (see plate 125). In so far as the painted bands thus establish or refer to a flat and frontal pictorial plane, they contradict both the glimpses into pictorial depth offered by the inserts as individual details and the plan-like level established by the inserts as overall configurations. In so far as they establish reference to intentional forms of artistic artifice the painted bands also contradict that reference to the accidental aspect of the palette (and, at

another level of irony, to the accidental aspect of certain forms of gesticulative abstract painting) which is carried through the main surface area. As potential tokens of the types and levels of reference which the paintings sustain, these painted bands thus compete both with the representational character of the rest of the principal surface and with the figurative aspects of the inserts.

In *Hostage V* the painted bands are composed both of 'wood-grain' and of other types of represented surface which refer to antecedent phases of Art & Language's own painting. Bands with painted holes refer to various works in the series 'Incidents in a Museum' (see plate XIV). In these, actual holes bored through plywood surfaces reveal glimpses of a fictional museum immured beneath – or, to retranslate the image, permit glimpses of a museum from which the viewer is (symbolically) excluded. The reference serves to add a further resonance to the wooden surfaces 'quoted' in this and the preceding 'Hostage' paintings and to associate the suppression or refusal of the museum with the image of the museum as itself the site of certain forms of exclusion.

To go so far is to indulge in a kind of reading-in of meaning and significance to the actually mute surface of *Hostage V*. In the same painting a single band with spots of white on grey may be read as a symbolic warning against such excess. It refers to previous Art & Language works in the series 'Impressionism Returning Sometime in the Future', in which various forms of signifying imagery were cancelled or erased by accumulating surfaces of 'snow' (see plate XI). I suggested in the seventh of these essays that such works proposed the all-over white-painted surface as the ironic destiny of all signifying content. Nothing may be read from them which is not a recovery of cancelled meanings – those meanings intentionally obliterated in the process of making them what they are. Yet to extract this promise of the suppression of content from the painted band of *Hostage V* is but to extrude another reading, another interpretation: Modernism's nuclear winter seen as symbolized in a few square inches of patterned canvas. Caught in a web of reference the iconographer stumbles on, nearer and nearer to the painting's iconoclastic heart . . . from which he will always be excluded. It is the effective function of the painted surface to spoil the validity of any exegesis, for exegesis finds its end and its justification in an *oratio recta* – a reduction of symbolic aspects and properties to what it is the painting 'says' – and there are no *orationes rectae* in painting. These paintings take that very absence as the condition of their discursiveness. Each aspect of their surfaces frames an account or way of conceiving of each other which detaches it, as a kind of sign, from the world of its potential signifieds. In the 'dialogue' between any two aspects, every expressive 'use' is deformable into an ironic 'mention'.

The 'Hostages' are hard to see clearly. When viewing a painting, we seek to represent it to ourselves. We ask what we are seeing it *as*, and the words we find tend to locate it in a familiar cultural geography, a

world composed of conceptual contrasts. Between surface and depth, between coincidence and succession, between abstraction and figuration, between the authentic and the fake, between iconoclasm and idolatry, between words and pictures, between language and art we maintain certain distinctions which are the socializing habits of our culture. To be cured of these forms of addiction, we fear, would be to wake to a disarticulated world, and to be judged incoherent. The 'Hostages' require that we court this danger – or do not see them. To pursue the question of their identity is to confront apparent conceptual contrasts as the actual moments of conceptual dichotomies. For each term hazarded in response, they offer a contradiction, an absence, an image of that ghostly other which each designation would exclude. If these are not curative paintings, they are nothing.

12

'Hostages' 2:
Some Other Sense

Four paintings by Art & Language were shown in January 1989 at the Max Hetzler Gallery in Cologne. The collective title was 'Hostages: Incidents and People's Flags' (see plates XXII and XXIII). This essay is principally addressed to a single painting from the series. The aim is neither to explain nor to assess it, but simply to attempt an interpretation by puzzling at its genealogy and its effects.

Art & Language's previous 'Hostages' formed the basis of an exhibition at the Lisson Gallery in the summer of 1988. This second group of works extends the series, though they are substantially different in format and in style. Each of the new paintings also refers to two previous groups of work by Art & Language: 'Flags for Organizations' of 1978 (see plates III and 68)[1] and 'Incidents in a Museum' of 1985–7. Crudely, each painting is 'flag-like' in so far as the same motif or logo appears once, rendered sharp and flat, upon a single ground colour which extends to all four edges, while each includes an incident in the form of an interrupting vertical band of figurative detail. The motif of the flags is derived from a 'People for Rockefeller' campaign of 1968. The idealization which it graphically reduces is of black and white figures joining hands to form a ring. The vertical bands are composed of separately stretched canvas, upon which a narrow glimpse into the interior of a modern museum is represented with thick paint and emphatic brushwork. Given the overall size of the work, the conventional form of perspective used tends to connote a theatrical space and thus to arouse the expectation of some form of presence or event.

A particular fascination attaches in hindsight to those moments when one sustained project of work reaches a point of apparent exhaustion while no sense of necessity is yet associated with any alternative programme. They are moments of trying-out and flailing-about. Such finished products as may emerge from these episodes tend to be rejected as embarrassments, shelved as dead ends and curiosities, or occasionally set aside with a view to some future re-examination. If

the works of these moments can be taken as introducing some subsequent phase of sustained activity, it is rarely by virtue of their total formal aspect. Indeed, it may only be through the process of self-critical abandonment of some propitiously finished work or 'composition' that a usable technical device gets singled out and redeployed in a different context to some different critical end.

In the winter and early spring of 1988, between the last of the 'Incidents in a Museum' and the first of the 'Hostages', there was just such a hiatus in the practice of Art & Language. In the last work in the long 'Incidents' series an actual bookcase, loaded with Art & Language publications, was located both within the literal surface of the painting and within the fictional space of the painted museum (see plate XVII). In the transitional works which followed, details of the pictured museum interior appeared on 'spines' inserted into the larger surfaces of pictured museum interiors (see *Unit Cure, Unit Ground*, plate XVIII). The expectation was that these insertions would function both decoratively and disruptively within the larger pictures. Instead they appeared to possess an independent signifying power – or emphatic decorative autonomy – such that the surrounding pictorial schemes were for the most part rendered relatively bland and insignificant. It was as if there was *nothing* left of the figurative surface into which the 'spines' had been inserted – or, rather, it was as if no figurative aspect could possibly be conceived which was compatible with a realistic position *vis-à-vis* that surface. That 'nothing' is in a sense what was thematized in the first group of 'Hostages'. In that first series, figurative glimpses of museum interior on separately stretched canvas inserts were matched against painted bands signifying 'painting' and an overall ground of dabs, smears and brushstrokes representing a form of palette. The possibility of figuration was sustained by a form of paradox. The decorative aspect of the surface was produced through a form of acknowledgement of its literal and material flatness – by treating it both as the site of certain conventional forms of signification of pictorial surface and by appearing to use it as if it were a palette. Works in the first series of 'Hostages' were – of all things – realistic, in the sense that they were made of all they *could* be made of, all that was left. They also seemed – again, of all things – strangely prodigal.

It could be said that it was the spines which made it possible for these earlier 'Hostages' to read as paintings, in the sense that they made it possible for what was done to the rest of the surface to 'mean' something; that is, to be invested with some differentiated intentional character (which was recoverable by the competent reader). This claim could be reinterpreted, however. It could also be said that the spines imposed the requirement that the rest be *nothing but* painting. In the second series of 'Hostages' the meaning of that 'nothing but' changes. Where the presence of painting as remainder was previously rendered decorative by a series of literally artificial moves, it is now invested with a gross and vacuous meaning – in the generation of which the

ordinarily qualified reader is uncomfortably implicated. The anxiety about what to do with the remaindered pictorial surface, if it persists, is dealt with in summary fashion by reference to the earlier 'Flags for Organizations'. The coloured field and its black-and-white emblem stand for, or stand in place of, the putative painting. In the earlier 'Hostages' the decorative surface was, as it were, salvaged from the sceptical effects of the inserts. In the present series, a different aspect of the transitional works of the previous winter seems to have been reconsidered and reanimated. It is now the power of the inserted 'incident' which holds the attention. The surrounding surface is greatly enlarged but is also rendered the more contingent.

One way to express the apparent shift is to suggest that works in the new series put the question 'What is this?' (or, perhaps, 'What is the painting?') in front of the question 'What does this (painting) look like?' We are normally willing enough to let the latter question serve as propaedutic to the former. With the recent 'Hostages' this will not do, though it seems at first as if it will. That is to say, we can get so far by reading the painting as a whole as one normally reads a painting. Ordinary procedures and expectations lead one to review compositional aspects: to think about size in relation to shape, to sort out relations of scale, distance, and so on. Viewed on this basis, the insert reads as a kind of interrupting but still compositional vertical band. This reading is modified by examination of the detail, which gives the half-way competent viewer a kind of picture – the slice of museum interior. This picture serves to complicate the reading both of the insert and thence of the overall composition; that is to say, it is clear that there is quite a lot to be made out of the dialogue of figurative levels, levels of reference, the general sense of iconographic interchange and intersection which can be seen as taking place within the overall configuration of 'the painting' – and even, if you like, between some notional 'overall painting' and some *other* sense of 'painting' to which the insert might correspond or which it might exemplify or which it might otherwise demonstrate by standing as sample or swatch. Looking within the new series from one painting to another, one can see how these various relations are shifted – or how the modalities of these relations are shifted – by changes in the scale and position of the logo relative both to the overall outline of the surface and to the position of the insert, by changes in the viewpoint assumed in construction of the museum perspective, and so on. For example, the positioning of the insert and the logo relative to each other, as they affect the centring of the emblem, will in turn affect reading of the relations between 'flag' and 'painting'. The notional vanishing-point selected for the museum interior will affect readings of relative pictorial space and depth, and will in turn affect reading of the complex ontological relations between surface *qua* surface, surface *qua* flag, insert *qua* insert, and insert *qua* museum interior. What we are noticing are the organizing decisions and procedures according to which the graphic image as a whole has been structured and articulated.

So far so good. But the effect of the painting in question goes further than this. It seems, moreover, that one can't adequately deal with or analyse that effect simply in terms of the kinds of proceeding sketched above. Maybe one clue is that, if one *could* make sense of it on this basis, there would be a high degree of technical (and other) redundancy in having the slice of museum on a physically separate surface, whereas in fact the physical separateness of the insert seems somehow central to the identity of the whole configuration. Note that it seems inappropriate here to refer to the 'whole painting'. The point is that the work doesn't appear as a painting with an insert – or even as a painting which has another painting inserted into it. Rather it is the insert that appears as 'the painting'. This is strange – and the consequences are stranger.

The question of how this happens may be open to some relatively simple answers, *once given* the physical separateness of the inserts, and given those antecedent conditions and expectations *vis-à-vis* 'modern painting' to which the technical characteristics of the inserts clearly make reference. Very crudely: all other things being equal, in establishing the intentional character of some surface as the surface of a painting, priority will tend to be given to an area of manifest 'brush-work' – especially if it reads figuratively – as against an area which reads as (relatively) flat. (Among those who play clever games with this tendency are Newman at one end of the technical range and Johns at the other.) Put a small 'painting' (that is to say, a physically distinct canvas) in the middle of an all-over field and the field will just read as background to it – even if it's really a Mark Rothko or whatever. In the case of the recent 'Hostages' the 'background' isn't even a Rothko. It's something readable on a literal pictorial level as a coloured field containing a logo; that is, as a bit of graphics given public scale. Modern painting may encroach on the territory of such things and may engage in some skirmishing with their non-aesthetic power, but only in order to demonstrate its own ethical and aesthetic distinctness. Taken on its own, the 'flag' is not 'art' – not even by courtesy of Jasper Johns. In establishing the ontological priorities according to which something gets seen as a painting, then, the inserts make a stronger claim than the surrounding fields.

Of course there are all sorts of paradoxes at work here. For instance, it is actually the breadth of the surrounding field that enables one to take the insert as 'a painting' at all. The insert wouldn't read (or wouldn't read better than trivially) as 'painting' were it not, as it were, held in, compressed, contained by the field which is its context. The field is a kind of foil for it. The inserts are not like Newman's *The Wild* of 1950 or like any other of those long thin paintings where he takes the 'zip' out of the extended field of colour and shows he can make it stand on its own (or stand, at least, with the thinnest of margins) (see plate 126). This said, we might imagine a 'Hostage' painting which was a 10-foot-high, 2-inch-wide strip of museum bordered by an inch or two of 'flag' – or, as it would then read, of coloured canvas. To

conceive of such a thing is also to consider how far the flag and logo could be remaindered without loss to the work as a whole. The question is worth considering, but intuition suggests that absence of the emblem would blunt the enterprise. The presence of the logo or at least of some flag-connoting or logo-like identity seems to be required to signify or to suggest a form of non-aesthetic quantification – the brutally contingent world which is graphically misrepresented and actually signified.

And this seems to be where the 'technical' account gets filled out iconographically. That is to say, it is not solely by virtue of its being brushy and painting-like that the insert reads as a (proto-)painting. It is also by virtue of the ways in which it operates upon that potentially total image which is the image of a flag. The way in which the inserts are 'in' the flags is ambiguous – in ways discernible from the ordinary 'compositional' reading sketched above. The telling ambiguity concerns the relations of figure and ground – as it has to do in anything with claims to technical adequacy in the discipline of modern painting. The recent 'Hostages' sharpen the intuition that painting is nothing if it does not animate the relations of figure and ground, and that *modern* painting is nothing if it does not both modernize and historicize that relationship in some critically significant way. (The point, incidentally, is not to limit this hypothesis to painting, but rather to find out where the limit might be.) The weakness of weak abstract art is that it can cope with the first requirement but not the second; that is to say, it can set up novel figure–ground relations but can't index that novelty to a non-artistic history. This could be to say the same as that weak abstract art does not significantly represent. (According to these criteria, who have been the producers of strong abstract art? Malevich, Mondrian, Still, Rothko, Stella from around 1959 to 1967 – these, perhaps, though not these exclusively.) Art & Language's 'Hostages' are not abstract paintings, but they engage in a form of dialogue with abstract painting. The ethical world of abstract art is a barely possible world in the world which they themselves address. (This observation serves to mark a form of continuity in Art & Language work over a period of more than twenty years. It was its address to the moral culture of abstract art that distinguished the teleological aspect of Conceptual Art from Conceptual Art pursued as a mere alternative style. The task of taking on abstract art was never to be discharged simply by opposing it from the high ground of 'other media'. Rather it entailed that one dress in its garments and assume its responsibilities.)

At one level the insert appears to haunt the area of the larger picture. The almost-contrasting readings of that picture as 'space' and as 'flag' are both thereby rendered insecure, leaving the logo formally homeless. But at another level the insert actually seems to *generate* the surrounding area of flag/picture – as if this were a kind of emanation from within the constricted figurative space of the museum-as-painting. This is what gives the work in question its dual property of gravity

Plate 126 (left) *Barnett Newman,* The Wild *(1950). Oil on canvas, 243 × 4.1 cm. The Museum of Modern Art, New York. Gift of The Kulicke Family.*

and menace. If the whole configuration is read figuratively, the aspect logo + field = flag seems to emblematize a form of threat barely contained within the museum and contiguous with its public style. In the world represented by the figurative museum, that is to say, the actual democratic aspirations to which the logo opportunistically refers are present as plausible and containable abstractions. But if the configuration is read, as it were, formalistically – if the insert is read as 'the painting' and the reading of the rest adjusted accordingly – both the logo and the banner on which it is emblazoned are rendered contingent, flat and empty. They reduce to a form of bombastic graphics, an empty decorative remainder in face of the stylistic irony (physical excess and figurative scarcity) of the inserted painting. In the world of the painting thus acknowledged, the democratic aspirations travestied in the logo remain simply unrepresented.

Like the previous 'Hostages', paintings in the new series are hard to see. They tend to tear themselves to pieces even as their formal(istic) integrity impinges on the spectator. The added twist in the new works is that they exact a kind of revenge on what they are (figuratively) made of, rendering it disarticulate. It is as if the moral universe of parades and platforms and causes were shot through by the intellectual/aesthetic concerns of 'Shape as Form'[2] – and, as a kind of threat, vice versa.

Notes

Essay 1 A Kind of Context

1 Philip Leider, 'Literalism and Abstraction: Frank Stella's Retrospective at the Modern', *Artforum* (New York), vol. VIII, no. 8 (April 1970), p. 44.

2 For two texts influential in the critical and art-historical embedding of Pollock, see Michael Fried, *Three American Painters: Kenneth Noland, Jules Olitski, Frank Stella* (Fogg Art Museum, Harvard University, Cambridge, Mass., 1965); and William Rubin, 'Jackson Pollock and the Modern Tradition' (four parts), *Artforum*, vol. V, nos 6–9 (February–May 1967). I do not mean to imply that the workings of adequate criticism are indistinguishable from the mechanisms of an institutional apparatus.

3 The moment of apparent resolution may be associated with a one-man show of thirty-two paintings at the Betty Parsons Gallery, New York, which opened on 28 November 1950. Among the works shown were *Lavender Mist, Autumn Rhythm, Number 27* and *One (Number 31)*, all painted during the year. These works are now in the collections of, respectively, the National Gallery of Art, Washington DC, the Metropolitan Museum of Art, the Whitney Museum of American Art, and the Museum of Modern Art, New York.

4 Ad Reinhardt, from a talk on 'Art as Art Dogma', given at the Institute of Contemporary Arts, London, May 1964; excerpts from a transcript published as 'Ad Reinhardt on his Art', *Studio International* (London), vol. 174, no. 895 (December 1967), p. 267.

5 'Modern Art in the United States: A Selection from the Collections of the Museum of Modern Art, New York' opened at the Musée National d'Art Moderne in Paris on 31 March 1955 as '50 ans d'Art aux Etats-Unis'. The exhibition travelled between July 1955 and August 1956 to Zürich, Barcelona, Frankfurt, London (Tate Gallery, 5 January – 12 February 1956), The Hague, Vienna and Belgrade.

6 'This is Tomorrow', Whitechapel Art Gallery, 9 August – 9 September 1956. The exhibition was 'devoted to the possibilities of collaboration between architects, painters, and sculptors'. In his introduction to the catalogue Lawrence Alloway suggested that the exhibits should be viewed as 'display stands of ideas'. Among those taking part were William Turnbull, Richard Hamilton, Anthony Hill, John Ernest, Eduardo

Paolozzi, Nigel Henderson, Alison and Peter Smithson, Victor Pasmore, Erno Goldfinger, James Stirling, Kenneth and Mary Martin, Robert Adams, Colin St John Wilson and Adrian Heath.

7 As a form of this 'voice', consider the following: 'There is therefore good and bad writing: the good and the natural is the divine conception in the heart and the soul . . . writing of conscience and of the passions as there is a voice of the soul and a voice of the body. . . . The good writing has therefore always been comprehended. Comprehended as that which had to be comprehended . . ., but first thought within an eternal presence' – Jacques Derrida, *De la grammatologie* (Paris, 1967), tr. Gayatri Chakravorti Spivak as *Of Grammatology* (Baltimore, 1976), pp. 17–18. This does nothing to shift the ground of the aesthetic. It merely projects a (thoroughly orthodox) aesthetic taste into the realm of the philosophical.

8 Alasdair MacIntyre has drawn attention to the historical characterization of the 'rich aesthete' furnished by Henry James, most vividly in his novel *The Portrait of a Lady*, which 'has a key place within a long tradition of moral commentary. . . . The unifying preoccupation of that tradition is the condition of those who see in the social world nothing but a meeting place for individual wills, each with its own set of attitudes and preferences and who understand that world solely as an arena for the achievement of their own satisfaction, who interpret reality as a series of opportunities for their own enjoyment . . .' – MacIntyre, *After Virtue* (London, 1981) p. 24.

9 For a discussion of the relationship between interpretations and the mechanisms and conditions of their production, see Art & Language, 'Author and Producer Revisited', *Art–Language* (Banbury), vol. 5, no. 1 (October 1982); repr. in C. Harrison and F. Orton (eds), *Modernism, Criticism, Realism* (London and New York, 1984).

10 See, for instance, the material anthologized in Roger Taylor (ed.), *Aesthetics and Politics: Debates between Bloch, Lukács, Brecht, Benjamin, Adorno* (London, 1977).

11 Walter Benjamin, *Ursprung des deutschen Trauerspiels* (1928; Frankfurt am Main, 1963), tr. John Osborne as *The Origins of German Tragic Drama* (London, 1977), p. 105.

12 See especially his paper, 'The Author as Producer', originally delivered as an address to the Institute for the Study of Fascism in Paris in April 1934 – tr. Anna Bostock in Walter Benjamin, *Understanding Brecht* (London, 1977). The tightrope argument of the paper makes sense if one envisages an audience composed – as were many of the 'Broad Front' anti-Fascist organizations in the West during the mid-1930s – of liberal art-loving intellectuals on the one hand and loyal Party members (Stalinists) on the other.

13 Quoted in Gershom Scholem, *Walter Benjamin: The Story of a Friendship* (London, 1982), p. 207.

14 This drama of reciprocating (mis)representations is figuratively represented in Art & Language's 'Portraits of V.I. Lenin in the Style of Jackson Pollock', which are discussed in essay 5. For a discussion of the 'monstrous stylistic *détente*' which these paintings propose, see Art & Language, 'Joseph Stalin Gazing Enigmatically on the Body of Lenin as it Lies in State in Moscow in the Style of Jackson Pollock', *File* (Toronto), vol. 4, no. 4 (Fall, 1980).

15 Robert Motherwell, 'The Modern Painter's World', *Dyn*, VI (New York,

1944). See Barbara Rose, *Readings in American Art since 1900* (New York, 1968), pp. 130–1.

16 See, in particular, two important essays by Meyer Schapiro: 'The Social Bases of Art', first published in *First American Artists' Congress against War and Fascism* (New York, 1936), repr. in D. Schapiro (ed.), *Social Realism: Art as a Weapon* (New York, 1973); and 'The Nature of Abstract Art', first published in *Marxist Quarterly* (New York), vol. 1, no. 1 (January 1937), repr. in M. Schapiro, *Modern Art: 19th and 20th Centuries* (London, 1978). The second of these essays was addressed specifically against that construction and interpretation of modern art history which had been furnished by Alfred Barr, curator of the increasingly influential Museum of Modern Art, New York, in his exhibition and catalogue 'Cubism and Abstract Art' in 1936. Barr's curatorship of what was largely the Rockefellers' museum furnishes a vivid case-study of the organization of Modernist culture and history in its celebratory and distributional aspects, while Schapiro's essays have furnished a kind of alternative epistemology for the dissenting art history of the 1970s and 1980s. They are accorded pride of place, for instance, in Thomas Crow's revisionary essay 'Modernism and Mass Culture in the Visual Arts', in B. Buchloh, S. Gilbaut and D. Solkin (eds), *Modernism and Modernity: The Vancouver Conference Papers* (Halifax, NS, 1983), while T. J. Clark's study *The Painting of Modern Life: Paris in the Art of Manet and his Followers* (London and New York, 1985), opens with an extensive quotation from 'The Nature of Abstract Art' and with an acknowledgement of the agenda established by Schapiro.

17 See Max Kozloff, 'American Painting during the Cold War', *Artforum*, vol. XI, no. 9 (May 1973); and Eva Cockroft, 'Abstract Expressionism, Weapon of the Cold War', *Artforum*, vol. XII, no. 10 (June 1974). These two articles are reprinted in Francis Frascina (ed.), *Pollock and After: The Critical Debate* (London and New York, 1985), together with more recent social-historical studies of the conditions of entrenchment and exportation of American Modernism.

18 This parenthesis was added by Clement Greenberg to his 1957 essay 'The Late Thirties in New York' on the occasion of its reprinting in his collected essays, *Art and Culture* (Boston, Mass., 1961).

19 This term was coined by Greenberg to refer to that tendency in painting which he saw as following from and succeeding the 'painterly' style of the Abstract Expressionist 'first generation'. See, for example, Clement Greenberg, *Three New American Painters: Louis, Noland, Olitski* (exhibition catalogue, Norman McKenzie Art Gallery, Regina, Sask., January 1963).

20 See, for example, Clement Greenberg: 'Louis and Noland', *Art International* (Lugano), May 1960; 'Modernist Painting', *Arts Yearbook IV* (New York, 1961), repr. in *Art and Literature* (Lausanne), Spring 1965, and in C. Harrison and P. Wood (eds.), *Art in Theory 1900–1990* (Oxford, 1982, and Cambridge, Mass., 1983); 'After Abstract Expressionism', *Art International*, May 1963. See also Fried, *Three American Painters*, and articles in *Artforum* published 1965–9.

21 See note 17.

22 In his essay 'The Work of Art as Object', Richard Wollheim argued that the conceptual priority accorded to the assertion and expressive use of surface in modern painting reveals the workings of a dominant theory in

'the mainstream of modern art'. As supporting examples he cited works by Matisse, Louis and Rothko. It is at least questionable whether the same thesis could be argued today – or even whether it was proof against counter-example at the time of its first publication, in *Studio International*, vol. 180, no. 928 (December 1970). The essay was revised and reprinted in Wollheim, *On Art and the Mind* (Cambridge, Mass., 1973); an edited version is included in Harrison and Orton, *Modernism, Criticism, Realism*.

23 I have attempted to argue this view more fully in two related essays: 'Modernism and the "Transatlantic Dialogue" ', in Frascina, *Pollock and After*; and 'Expression and Exhaustion: Art and Criticism in the Sixties' (two parts), *Artscribe* (London), nos 56 (February–March 1986) and 57 (April–May 1986). I do not mean, however, that the abstract art of the 1960s or even of the 1970s should simply be written off as empty; rather, that we may need to rethink our interpretation of it and of the mechanisms of its production if we are to perceive the possible grounds of its virtue. There is some connection between the disfiguring effects of Modernist culture in its managerial aspect and the tendency within Modernism for expressive properties (of works of art) to be prised apart from descriptive properties, to be autonomized and dogmatized. The practice of abstract art presents a form of critique of this disfiguration and dogmatization, and is thus a potential resource of critical virtue and realism. Benjamin's observations on allegory, and on the requirement that allegorical systems develop in critical independence of their referents (in *The Origins of German Tragic Drama*), offer a basis for thinking about the tendency to abstraction and reductiveness in Modernist art which is not entirely incompatible with the views expressed by Greenberg in 'Modernist Painting'. The likes of Noland, Olitski and Caro would not automatically be reclaimed by this theoretical reconciliation. We might still have to view them as the unseeing and involuntary patients of a historical process, rather than the agents of a cultural one. But we might wish to acknowledge that their work is in certain respects free from implication in the manipulative and managerial aspects of that culture which puts them to use – and that this is more than can be said for some other art which wears its 'progressive' credentials on its sleeve.

24 'Stella's black paintings [shown at the Kasmin Gallery, London, in 1965] were the final word for me (and for him). They said "forget it young man – go do something else" ' (Mel Ramsden, note to the author, 1988). Stella's shaped polygons of 1966–7 should also be mentioned. Michael Baldwin was clearly impressed by a show of them he saw on a visit to New York in 1966. Fried discussed them in a long and influential essay, 'Shape as Form: Frank Stella's New Paintings', *Artforum*, vol. V, no. 3 (November 1966).

25 This was the time of Experiments in Art and Technology (EAT) in America and of 'Cybernetic Serendipity' (the title of a 1968 exhibition at the Institute of Contemporary Arts) in England. For a while it seemed to some as if fascination with design and technology might be significantly injected into artistic modernism. The boot was on the other foot, however.

26 Note to the author, 1989.

27 In conversation with Benjamin, Gershom Scholem observed that Brecht lacked a 'delight in infinity' and was concerned only with 'revolutionary manipulation in the finite'. Benjamin replied, 'What matters is not infinity but the elimination of magic.' See Scholem, *Walter Benjamin*, p. 208.

28 The names of the four original partners featured as 'editors' of *Art–*

Language up to vol. 1, no. 3, of June 1970. From vol. 1, no. 4, published in November 1971, the present author acted as editor. Though 'Art & Language' soon came to designate a larger and looser group of individuals, the partnership itself was never enlarged and the 'business' aspect was increasingly seen as a source of distraction. Other forms of organization were tried at different times: there was an 'Art & Language Institute' which surfaced briefly in 1971–2, an 'Art & Language Limited Company' which never traded, and an 'Art & Language Foundation Inc.' which attracted grants in New York in 1975–6 (see essay 4). Each had different nominated personnel. Each had the same distracting effect. Organizational autonomy has never furthered the autonomy of Art & Language work.

29 The Society for Theoretical Art and Analyses was founded by Burn, Ramsden and Roger Cutforth in New York in 1969. Cutforth exhibited as a member of the Society at the New York Cultural Center in April 1970 (in the exhibition 'Conceptual Art and Conceptual Aspects') and was listed as a co-contributor to *Art–Language*, vol. 1, no. 3, in June 1970, but he had effectively disassociated himself from Burn and Ramsden before there was any question of merging with Art & Language.

30 Of the members of the original partnership, Terry Atkinson had begun his career as a late-Pop artist and he and Bainbridge had shared an interest in notions of style and modernity. Bainbridge and Hurrell worked together on the 'Hardware Show' (Architectural Association, London, February 1967), which included 'customized' furniture and electromagnetic 'installations'. It was in part due to Hurrell's interventions that concepts of rigour and tolerance derived from engineering practice played their part in Art & Language conversation well into the 1970s. Otherwise the legacies of Pop-Art-and-technology featured little in the Art & Language agenda.

31 Ramsden in a note to the author, November 1981. He was referring to his own 'Guarantee' and 'Secret' paintings of 1966–8.

32 The phrase is taken from T. J. Clark's 'Clement Greenberg's Theory of Art', first published in *Critical Inquiry* (Chicago), vol. 9, no. 1 (September 1982). In a subsequent version published in Frascina, *Pollock and After*, Clark added a gloss: 'I meant some form of decisive innovation, in method or materials or imagery, whereby a previously established set of skills or frame of reference – skills and references which up till then had been taken as essential to art-making of any seriousness – are deliberately avoided or travestied, in such a way as to imply that only *by* such incompetence or obscurity will genuine picturing get done . . .' (p. 55).

33 What is suggested here is a connection between tendency in art and dominance in society which is not thought of as if one were simply the reflection of the other, but rather as if some kind of *match* were achieved between 'representational technique' on the one hand and 'cognitive style' on the other (and as if that match were likely to be of interest to a social history). This suggestion is an attempt to reconcile three somewhat disparate resources of theory: Walter Benjamin's concept of technique, as expressed in his paper 'Author as Producer', in *Understanding Brecht*; Michael Baxandall's concept of 'period cognitive style', as expressed in his book, *Painting and Experience in Fifteenth Century Italy* (Oxford, 1972), pp. 36–40; and Barry Barnes's concept of representations as 'actively manufactured renderings of their referents, produced from available cultural resources', and as 'constructs for use in activity', where 'activity' can embrace the exercise of cognitive functions, and where such functions

are related to the 'objectives of some social group' – see Barnes, *Interests and the Growth of Knowledge* (London, 1977), pp. 1–10. Relevant sections of Baxandall and Barnes are reprinted in Harrison and Orton, *Modernism, Criticism, Realism*.

34 Rosalind Krauss, 'The Originality of the Avant-Garde', in *The Originality of the Avant-Garde and Other Modernist Myths* (Cambridge, Mass., and London, 1986), p. 161. See the review of this book by Paul Wood, 'Howl of Minerva', *Art History* (London), vol. 9, no. 1 (March 1986), p. 121: 'It is a curious feature of "postmodernist" thought about art that while it goes for the throat of modernism because of its view of history, and because of an imputed failure to reflect upon foundational concepts, other features which have elsewhere been regarded as deeply problematic (e.g. within an historical materialist critique of modernism) re-appear as planks of the new stage. In this theatre of debate a few old boards are being danced on. . . .'

35 From a letter to Gershom Scholem, 17 April 1931. Quoted in Scholem, *Walter Benjamin*, pp. 231–3.

36 From a rejected press release (!) for the exhibition 'Confessions: Incidents in a Museum', Lisson Gallery, London, 10 April–10 May 1986.

Essay 2 Conceptual Art and the Suppression of the Beholder

1 'Op Losse Schroeven' ('Square Pegs in Round Holes') was mounted at the Stedelijk Museum, Amsterdam, 15 March – 27 April 1969. The exhibitors were Giovanni Anselmo, Ben d'Armagnac, Marinus Boezem, Bill Bollinger, Michael Buthe, Pier Paolo Calzolari, Gerrit Dekker, Jan Dibbets, Ger van Elk, Pieter Engels, Barry Flanagan, Bernhard Höke, Paolo Icaro, Immo Jalass, Olle Kaks, Hans Koetsier, Roelof Louw, Bruce McLean, Mario Merz, Marisa Merz, Bruce Nauman, Panamarenko, Emilio Prini, Robert Ryman, Gianni Emilio Simonetti, Frank Viner, Lawrence Weiner and Gilberto Zorio. 'When Attitudes Become Form: Works – Concepts – Processes – Situations – Information' was mounted at the Kunsthalle, Berne, 22 March – 27 April 1969 and at the Institute of Contemporary Arts, London, 28 September – 27 October 1969. The exhibitors were Carl Andre, Anselmo, Richard Artschwager, Thomas Bang, Jared Bark, Robert Barry, Joseph Beuys, Alighiero Boetti, Mel Bochner, Boezem, Bollinger, Victor Burgin (London only), Buthe, Calzolari, Paul Cotton, Hanne Darboven, Walter de Maria, Dibbets, van Elk, Raphael Ferrer, Flanagan, Philip Glass, Hans Haacke, Michael Heizer, Eva Hesse, Douglas Huebler, Icaro, Alain Jacquet, Neil Jenney, Stephen Kaltenbach, Jo Ann Kaplan, Ed Kienholz, Yves Klein, Joseph Kosuth, Jannis Kounellis, Gary Kuehn, Sol LeWitt, Bernd Lohaus, Richard Long, Louw (London only), McLean (London only), David Medalla, Mario Merz, Robert Morris, Nauman, Claes Oldenburg, Dennis Oppenheim, Panamarenko, Pino Pascali, Paul Pechter, Michelangelo Pistoletto, Prini, Marcus Raetz, Alan Ruppersberg, Reiner Ruthenbeck, Ryman, Fred Sandback, Alan Saret, Sarkis, Jean-Frédéric Schnyder, Richard Serra, Robert Smithson, Keith Sonnier, Richard Tuttle, Viner, Franz Erhard Walther, William Wegman, Weiner, William Wiley and Zorio.

2 See Lucy Lippard and John Chandler, 'The Dematerialization of Art', *Art International*, vol. XII, no. 2 (February 1968); Donald Karshan, 'The Seventies: Post-Object Art', *Studio International*, vol. 180, no. 925 (September 1970). The latter essay was originally intended as an introduction to the exhibition 'Conceptual Art and Conceptual Aspects', New York Cultural Center, April 1970.

3 See particularly Clement Greenberg, 'Modernist Painting' (1961), in C. Harrison and P. Wood (eds.), *Art in Theory 1900–1990* (Oxford, 1982, and Cambridge, Mass., 1983), pp. 755–6.

4 See Michael Fried, 'Art and Objecthood', *Artforum*, vol. V, no. 10 (June 1967), pp. 21–2: 'The concepts of quality and value – and to the extent that these are central to art, the concept of art itself – are meaningful, or wholly meaningful, only *within* the individual arts. What lies *between* the arts is theater . . . faced with the need to defeat theater, it is above all to the condition of painting and sculpture . . . that the other contemporary modernist arts, most notably poetry and music, aspire.'

5 I have specifically in mind Kenneth Noland's *Trans Echo*, a painting 7 ft high by 30 ft long (approx 230 × 915 cm) shown at the Kasmin Gallery, London, in June 1968. For a faltering attempt to represent the experience of this work in the terms of contemporary Modernist criticism, see my 'Recent Works by Kenneth Noland', *Studio International*, vol. 176, no. 902 (July–August 1968), pp. 35–6.

6 See Greenberg, 'Modernist Painting', in Harrison and Wood, *Art in Theory 1900–1990*, p. 756.

7 Michael Fried, *Three American Painters* (1965), edited excerpt in Harrison and Wood, *Art in Theory 1900–1990*, p. 770. Fried's parenthetical phrase supports a long and interesting footnote on the frustration of Manet's 'realist' ambitions by the problems of (self-)consciousness.

8 It should be said that for Greenberg, though the *major* art of our time is abstract, it does not follow either that most abstract art is good, or that most good art is abstract. Indeed, according to his thesis, a higher expectation of relative quality will be associated with forms of figurative art. So long as 'high' abstract art is accorded canonical status, however, this relative quality will tend to be secured at the level of craft practices and of minor and conservative genres. See Greenberg's 1954 essay 'Abstract, Representational and So Forth', repr. in *Art and Culture* (Boston, Mass., 1961), p. 135: 'Experience, and experience alone, tells me that representational painting and sculpture have rarely achieved more than minor quality in recent years, and that major quality gravitates more and more toward the nonrepresentational. Not that most of recent abstract art is major; on the contrary, most of it is bad; but this still does not prevent the very best of it from being the best art of our time.'

9 See Fried, 'Art and Objecthood', *Artforum*, vol. V, no. 10, and also his *Absorption and Theatricality: Painting and Beholder in the Age of Diderot* (Berkeley, Los Angeles and London, 1980). I should make clear that in employing the concept of beholder in the present essay I have not sought to argue with the interesting thesis of the latter work, or to do justice to its complexities.

10 Duchamp: 'Since Courbet, it's been believed that painting is addressed to the retina. That was everyone's error. The retinal shudder! Before, painting had other functions: it could be religous, philosophical, moral. If I had the chance to take an antiretinal attitude, it unfortunately hasn't changed

much; our whole century is completely retinal, except for the Surrealists, who tried to go outside it somewhat' – Pierre Cabanne, *Dialogues with Marcel Duchamp* (London, 1971), p. 43.

11 See Michael Fried, 'The Achievement of Morris Louis', *Artforum*, vol. V, no. 6 (February 1967), p. 37.

12 Fried, *Three American Painters* in Harrison and Wood, *Art in Theory 1900–1990*, p. 773.

13 In Greenberg's *Art and Culture*, a substantially revised text is given the two dates 1948 and 1958. The passages quoted are from pp. 140 and 145.

14 On the function and significance of 'thematization' in painting, see Richard Wollheim, *Painting as an Art* (London and Princeton, NJ, 1987), pp. 20ff: 'For this process by which the agent abstracts some hitherto unconsidered, hence unintentional, aspect of what he is doing or what he is working on, and makes the thought of this feature contribute to guiding his future activity, I use the term "*thematization*".'

15 See Fried's comments in the symposium 'Theories of Art after Minimalism and Pop', in H. Foster (ed.), *Discussions in Contemporary Culture No. 1* (Seattle, 1987), pp. 71–2.

16 See Fried's introduction to the catalogue of an exhibition of Caro's work at the Whitechapel Art Gallery, London, September 1963. See also Clement Greenberg, 'Anthony Caro', *Studio International*, vol. 174, no. 892 (September 1967).

17 I use the concept of intension in its logical form, to refer to the qualitative or connotative aspect – and in that sense to the meaning – of a work of art, as distinct from that identity the work has by virtue of its inclusion in a given category or class. Intension is contrasted with extension, as in the nice example given in the *Oxford English Dictionary*: 'The essence of farming on virgin soils is extension: on old land it is intension.' There are those who would argue that no distinction is required between intension and intention, since the meaning of a work of art is properly identified with the intention of its author (see, for example, the arguments of Richard Wollheim in *Painting as an Art*). I regard the identifiability of intensions with intentions as an open question, and I accordingly retain the distinction in spelling.

18 See, for instance, Clement Greenberg, 'Complaints of an Art Critic', *Artforum*, vol. VI, no. 2 (October 1967), repr. in C. Harrison and F. Orton (eds), *Modernism, Criticism, Realism* (London and New York, 1984), p. 6: 'That analysis and description without anything more should so often be inferred to be a program reveals something like bad faith on the part of those who do such inferring. . . . The bad faith derives from the need to pin a critic down so that you can say, when you disagree with him, that he has motives, that he likes this and not that work of art because he wants to, or because his program forces him to, not because his mere ungovernable taste won't let him do otherwise.'

19 Fried, *Three American Painters* in Harrison and Wood, *Art in Theory 1900–1990*, pp. 773–4.

20 The phrase is Greenberg's, from a passage on Louis's painting in his introduction to *Three New American Painters: Louis, Noland, Olitski* (exhibition catalogue, Norman McKenzie Art Gallery, Regina, Sask., January 1963): 'Louis is not interested in veils or stripes as such, but in verticality and colour. . . . And yet the colour, the verticality . . . are not there for their own sakes. They are there, first and foremost, for the sake of

feeling, and as vehicles of feeling. And if these paintings fail as vehicles and expressions of feeling, they fail entirely.'

21 Fried, *Three American Painters* in Harrison and Wood, *Art in Theory 1900–1990*, p. 773.

22 Donald Judd, 'Specific Objects', *Art Yearbook VIII: Contemporary Sculpture* (New York, 1965), edited repr. in Harrison and Wood, *Art in Theory 1900–1990*, pp. 809–813.

23 Ibid., p. 811.

24 See Clement Greenberg, 'After Abstract Expressionism', *Art International*, vol. VI, no. 8 (October 1962).

25 Judd, 'Specific Objects', in Harrison and Wood, *Art in Theory 1900–1990*, p. 812.

26 Donald Judd, 'Complaints Part I', *Studio International*, vol. 177, no. 910 (April 1969), p. 183: 'I don't understand the link between Noland and Caro, since wholeness is basic to Noland's work and Cubist fragmentation is basic to Caro's'.

27 Judd, 'Specific Objects', in Harrison and Wood, *Art in Theory 1900–1990*, p. 813.

28 As reported by J.N. Findlay in 'The Perspicuous and the Poignant', in Harold Osborne (ed.), *Aesthetics* (Oxford, 1972), p. 93: 'The only profitable way to study concepts and their relations is to study them at work in language: phenomenology, or the study of the necessary forms of being and experience, must be linguistic phenomenology. It is further held that the forms and workings of our concepts as shown in language are infinitely more complex and varied than philosophers, with their passion for simplicity and generality, like to suppose: this is particularly true in a rather nebulous field like the aesthetic. There we encounter in men's ordinary usage no single simple concept of the beautiful but a vast number of aesthetic concepts, tangled up in the most various ways. We have such concepts as that of the ironic, the ethereal, the robust, the grotesque, the pure, etc., etc. I remember Austin devoting a whole session to a discussion of the philosophically despised aesthetic category of the "dainty", and its contrary the "dumpy". . . .'

29 Robert Morris, 'Notes on Sculpture', *Artforum*, vol. IV, no. 6 (February 1966), p. 42.

30 Fried, in Foster, *Discussions in Contemporary Culture No. 1*, p. 73.

31 Robert Morris, 'Notes on Sculpture, Part 3: Notes and Nonsequiturs', *Artforum*, vol. V, no. 10 (June 1967), p. 25.

32 Robert Morris, 'Notes on Sculpture, Part 2', *Artforum*, vol. V, no. 2 (October 1966) p. 23.

33 In the symposium cited in note 15 Rosalind Krauss observed that the arguments of Fried's essay 'have often been seen as having driven a theoretical wedge into '60s discourse on art, somehow dividing that period into a *before* and an *after*' (Foster, *Discussions in Contemporary Culture No. 1*, p. 59). The general tenor of the symposium itself offered further testimony to the lingering power and relevance of Fried's demarcations.

34 Fried's concluding paragraph deserves quoting in full: 'This essay will be read as an attack on certain artists (and critics) and as a defense of others. And of course it is true that the desire to distinguish between what is to me the authentic art of our time and other work which, whatever the dedication, passion and intelligence of its creators, seems to me to share certain characteristics associated here with the concepts of literalism and theater, has specifically motivated what I have written. More generally, however, I have wanted to call attention to the utter pervasiveness – the virtual

universality – of the sensibility or mode of being which I have charac-
terized as corrupted or perverted by theater. We are all literalists most or
all of our lives. Presentness is grace' ('Art and Objecthood', *Artforum*, vol.
V, no. 10, p. 23).

35 An 'Art Strike against War, Racism and Repression' was mounted by the
Art Workers' Coalition in New York in May 1970.

36 Philip Leider, 'Literalism and Abstraction: Frank Stella's Retrospective at
the Modern', *Artforum*, vol. VIII, no. 8 (April 1970), p. 44.

37 Ibid.

38 Judd, 'Specific Objects', in Harrison and Wood, *Art in Theory 1900–1990*,
p. 812.

39 First published in *Artforum*, vol. V, no. 3 (November 1966).

40 See the catalogue of 'Sixteen Americans', Museum of Modern Art, New
York, 1959.

41 Fried, in Foster, *Discussions in Contemporary Culture No. 1*, p. 79.

42 Fried, *Three American Painters* in Harrison and Wood, *Art in Theory
1900–1990*, p. 772.

43 'Primary Structures' is the title of an exhibition held at the Jewish
Museum, New York, in 1966, in which a large number of artists – includ-
ing some English sculptors of the 'New Generation' – were presented as
contributors to a stylistically homogeneous 'Minimal' movement.

44 Alice Adams, Louise Bourgeois, Eva Hesse, Gary Kuehn, Bruce Nauman,
Don Potts, Keith Sonnier and Frank Viner were shown together under the
title 'Eccentric Abstraction' in a show organized by Lucy Lippard for the
Fischbach Gallery, New York, in September 1966. 'Art in Process' was
staged the same year at the Finch College Museum, New York. Jan Dib-
bets, Barry Flanagan, Bernhard Höke, John Johnson, Richard Long,
Konrad Lueg, Charlotte Posenenske and Peter Roehr were shown together
at the Galerie Loehr in Frankfurt in September 1967, and a month later the
first 'Arte Povera' manifesto appeared in Genoa. In the same year the
Dwan Gallery, New York, staged a show of 'Language to be Looked at
and/or Things to be Read'. The first three parts of Morris's 'Notes on
Sculpture' were published in 1966 and 1967, and several essays by Robert
Smithson were published during the same two years. Smithson was respon-
sible for the publication of Michael Baldwin's 'Remarks on Air-Condition-
ing' in *Arts* (New York) in November 1967.

45 Morris, 'Notes on Sculpture, Part 2', *Artforum*, vol. V, no. 2, p. 21.

46 This was the year in which Seth Siegelaub came to attention in New York
as a Conceptual Art dealer, publisher and entrepreneur, specializing in
such genres as the art-work-as-publication and the catalogue-as-exhibi-
tion. His rationale is quoted (from an interview of September 1969) in
Ursula Meyer (ed.), *Conceptual Art* (New York, 1972), p. XIV: 'When art
does not any longer depend upon its physical presence, when it becomes an
abstraction, it is not distorted and altered by its reproduction in books. It
becomes "PRIMARY" information, while the reproduction of conventional
art in books and catalogues is necessarily (distorted) "SECONDARY" infor-
mation. When information is PRIMARY, the catalogue can become the
exhibition.'

47 Of those who were or who were to become associated with Art &
Language, work by Joseph Kosuth and by Christine Kozlov was included
in both 'Language II' and 'Language III' and work by Mel Ramsden and
by Terry Atkinson and Michael Baldwin was included in 'Language III'.

48 For a typical interpretation of the idea of 'art as idea' as an alternative

Modernist historicism, see Joseph Kosuth, 'Art after Philosophy' *Studio International*, vol. 178, no. 915 (October 1969), p. 135: 'The function of art, as a question, was first raised by Marcel Duchamp. In fact it is Marcel Duchamp whom we can credit with giving art its own identity. (One can certainly see a tendency towards this self-identification of art beginning with Manet and Cézanne through to Cubism, but their works are timid and ambiguous by comparison with Duchamp's.) "Modern" art and the work before seemed connected by virtue of their morphology. Another way of putting it would be that art's "language" remained the same but it was saying new things. The event that made conceivable the realization that it was possible to "speak another language" and still make sense in art was Marcel Duchamp's first unassisted *Readymade*. With the unassisted *Readymade*, art changed its focus from the form of the language to what was being said. Which means that it changed the nature of art from a question of morphology to a question of function. This change – from "appearance" to "conception" – was the beginning of "modern" art and the beginning of "conceptual" art. All art (after Duchamp) is conceptual (in nature) because art only exists conceptually.

'The "value" of particular artists after Duchamp can be weighed according to how much they questioned the nature of art; which is another way of saying "what they *added* to the conception of art" or what wasn't there before they started. Artists question the nature of art by presenting new propositions as to art's nature. And to do this one cannot concern oneself with the handed-down "language" of traditional art, as this activity is based on the assumption that there is only one way of framing art propositions. But the very stuff of art is indeed greatly related to "creating" new propositions.'

49 For example, compare the position represented in the previous note with the views expressed in the editorial 'Introduction' to *Art–Language*, vol. 1, no. 1 (May 1969), in which greater emphasis is laid upon the contingencies of practice: 'Duchamp wrote early in the century that he "wanted to put painting back into the service of the mind".... There is no question of putting painting, sculpture *et al.*, back in the service of the mind.... Painting and sculpture have physical limits and the limit of what can be said in them is finally decided by precisely those physical limits. Painting and sculpture *et al.* have never been out of the service of the mind, but they can only serve the mind to the limits of what they are. The British conceptual artists found at a certain point that the nature of their involvements exceeded the language limits of the concrete object. Soon after they found the same thing with regard to theoretical objects. Both put precise limits on what kind of concepts can be used. There has never been any question of these latter projects coming up for the count as members of the class "painting" or the class "sculpture", or the class "art object" which envelops the classes "painting" and "sculpture". There is some question of these latter projects coming up for the count as members of the class "art work"' (p. 7).

50 Sol LeWitt, 'Paragraphs on Conceptual Art', first published in *Artforum*, vol. V, no. 10 (June 1967). This was not by any means the first published use of the term 'Conceptual' or 'Concept Art'. The entry on Conceptual Art in Harold Osborne (ed.), *The Oxford Companion to Twentieth-Century Art* (Oxford, 1981), p. 122, quotes Henry Flynt's 1961 essay on 'Concept Art' printed in La Monte Young's *Anthology* of 1963: ' "Con-

cept Art" is first of all an art of which the material is concepts, as the material of e.g. music is sound. Since concepts are closely bound up with language, concept art is a kind of art of which the material is language.'
51 See note 10.
52 *Art–Language*, vol. 1, no. 1 (May 1969), pp. 11–12.
53 See, for instance, the essay by Grégoire Müller printed in the catalogue for the exhibition 'When Attitudes Become Form': 'For all those polemicists who, from the point of view of the sociology of art, fight against the traditional concepts of the museum, the gallery, the work of art ... this movement is a godsend. The majority of the artists in this exhibition are, for other reasons, united with their position: their work is made everywhere or anywhere, in newspapers, on the walls of towns, in the sand, in the snow ... some of these "works" can be redone by no matter whom, others are untransportable, perishable, unsaleable, still others invisible and known solely through documentation.... With this new movement art is liberated from all its fetters' (my translation).
54 Quoted by Lucy Lippard in her introduction to *Minimal Art* (catalogue of an exhibition at the Gemeentemuseum, The Hague, 23 March – 26 May 1968), p. 29.
55 LeWitt, 'Paragraphs on Conceptual Art', *Artforum*, vol. V, no. 10, p. 83.
56 Roberta Smith, 'Conceptual Art', in N. Stangos (ed.), *Concepts of Modern Art*, 2nd edn (London and New York, 1981), p. 264.
57 This concise characterization of the beholder is to be found in Wollheim, *Painting as an Art*, p. 22 and *passim*.
58 The use of the masculine pronoun here is not merely conventional. The paradigm beholder was male – and masterful. Thomas Crow has noted the 'ideologically masculine' position represented by Fried's 'detached and isolated viewer', citing the following passage on Louis's stripe paintings from Fried's *Morris Louis* (New York, 1971), p. 35: 'They are wholly abstract embodiments or correlatives of human will or impulse – specifically, the will or impulse to *draw*, to make one's mark, to take possession, in characteristic ways, of a plane surface. [They are] the instantaneous, unmediated realization of the drawing impulse, the will to draw.' See Crow's paper 'These Collectors, They Talk about Baudrillard Now' in the symposium 'The Birth and Death of the Viewer: On the Public Function of Art' published in Foster, *Discussions in Contemporary Culture No. 1*, p. 6.
59 See, for instance, the conclusion to 'Art and Objecthood' quoted above, note 34.
60 Lawrence Weiner's *Statements* was published in 1968 by Seth Siegelaub under the imprimatur of the 'Louis Kellner Foundation'. The separate 'General Statements' and 'Specific Statements' of which the small booklet was composed were both forms of and specifications for Weiner's 'works'. The first was 'A field cratered by structured simultaneous TNT explosions'. The purchaser or 'receiver' of a work by Weiner was made aware of the following text: '1 The artist may construct the piece. 2 The piece may be fabricated. 3 The piece need not be built. Each being equal and consistent with the intent of the artist the decision as to condition rests with the receiver upon the occasion of receivership.'
61 Barry, Huebler, Kosuth and Weiner were shown together by Seigelaub in an 'exhibition' in New York, 5–31 January 1969. The previous year Seigelaub had published a *Xerox Book* with contributions from Andre, Barry, Huebler, Kosuth, LeWitt and Morris. Atkinson and Baldwin were invited

to contribute to his 'March' catalogue/exhibition in March 1969. See also note 46.

62 Though the tendency of relevant art history and journalism has been to make precisely this assumption; that is to say, to interpret a claim about what it is that *practice* is of necessity made of as a wilful and avant-garde claim about what is or can be art. For instance, Frances Spalding, in *British Art since 1900* (London, 1986), p. 216, describes Art & Language as 'a collective of artists and art historians who decided [*sic*] to make an art form out of the discourse about art.'

63 See the pamphlet *Blurting in A & L* (Halifax, NS, 1973), p. 8.

64 The material of some of these problems may appropriately be associated with the different competences and dispositions of individuals. For instance, between 1966 and 1971, during the period of effective collaboration between Atkinson and Baldwin, it appeared that Baldwin generally manned the research department while Atkinson occupied the front office.

65 Michael Baldwin, from a note to the author, 1989.

66 Particularly among those whose notion of the potential of sculpture had been formed both by and in reaction to the teaching of sculpture at St Martin's School of Art, London, during the 1960s: Barry Flanagan, Richard Long, Bruce McLean, Gilbert Proesch, George Passmore and others.

Essay 3 Indexes and Other Figures

1 The space was secured by Joseph Kosuth on an advance visit to Kassel.

2 David Rushton and Philip Pilkington produced the booklet *Statements* in January 1970, while they were first-year students on the Fine Art course in the Faculty of Art and Design at Lanchester Polytechnic. The aim was to provide an outlet for work 'either written on topics set, or developed from work that was begun within the five areas of study covered by the course: Art Theory, Audio Visual, Epistemology, Romanticism and Technos'. A second *Statements* was published in November 1970. This was followed in July 1971 by *Analytical Art*, no. 1, edited by Pilkington, Rushton and Kevin Lole, and including writings by Atkinson and Baldwin and by Burn and Ramsden. *Analytical Art*, no. 2, was published in June 1972 with this introductory note: 'This is the final issue of *Analytical Art*. The editors will subsequently be publishing in *Art–Language*.'

3 See the 'The Art–Language Institute: Suggestions for a Map', in the catalogue to 'Documenta 5' (Kassel, 1972), section 17, p. 17: 'The institute may be looked at as a corpus of ideological commitments comprising a field. The problems are essentially regarded as "objective". The activity may be regarded as a generally focussed search for methodologies: i.e. for a general methodological horizon. . . .' (This was by no means the only understanding of the 'institute' then prevailing among the affiliates of Art & Language, but it was the one which proved decisive.)

4 The relations of authorship and 'community' were to be subjects of various forms of anxiety over the ensuing five years. (They are discussed at more length in the following essay.) See, for instance, the essay 'Problems of Art & Language Space', published by Burn and Ramsden in *Art–Language*, vol. 2, no. 3 (September 1973), but largely written by Burn during the

summer of 1972: 'The initial concern is with the overall conversations in and around this journal. But we are just as concerned with these conversations as a framework and how they fit together with normative art-activities (painting, sculpture and so-called "post-object" art) and the writings concerning those activities. But more than that we are concerned with how this framework fits into the expansive network of other frameworks and disciplines and activities' (p. 53). Burn was preoccupied, then as later, with the *use* of Art & Language work.

5 Ian Wilson's contribution to the exhibition 'Conceptual Art and Conceptual Aspects' (New York Cultural Center, April–August 1970) was listed as 'Oral Communication'. Robert Barry's contribution to Seth Siegelaub's 'July, August, September 1969' exhibition/catalogue was *Everything in the unconscious perceived by the senses but not noted by the conscious mind during trips to Baltimore during the summer of 1967.*

6 *Alternate Map for Documenta (Based on Citation A)*, published by Paul Maenz (Cologne, 1972).

7 For a reduction along these lines, see Carter Ratcliff's 'Adversary Spaces', *Artforum*, vol. XI, no. 2 (October 1972), p. 40. In reviewing various installations at 'Documenta 5', Ratcliff dismissed the Art & Language *Index* as 'an unusable demonstration of "good office design" ' and related it to the office established at 'Documenta' by Joseph Beuys, the purpose of which was the dissemination of his own aesthetic–political proposals.

8 Quoted, for example, in Michael Corris and Mel Ramsden, 'Frameworks and Phantoms', *Art–Language*, vol. 3, no. 2 (September 1973), p. 49.

9 See, for instance, Nelson Goodman, *Languages of Art* (Indianapolis, 1968), which sketches a general theory of symbols cutting across normal compartmentalizations of cognitive behaviour; and W. J. T. Mitchell, *Iconology: Image, Text, Ideology* (Chicago, 1986), in which the relations between image and text are eloquently historicized.

10 'There is no doubt whatever that the board [i.e. the reviewing body responsible for validation of the "Art Theory" course at Lanchester Polytechnic] and the Council [i.e. the then National Council for Diplomas in Art and Design] used the term "studio work" in its commonly accepted meaning, that is to say the production of tangible visual art objects. This is confirmed by the terms in which approval was expressed, including, it should be noted, specific reference to Painting and Sculpture as chief studies. The Council at no time had in mind any deviation from the basic principle of chief studies in those terms' – from a letter from the Chief Officer of the NCDAD to Sir Alan Richmond, Director of the Lanchester Polytechnic, 29 July 1971. For an account of the circumstances of this bureaucratic adjudication and of its aftermath, see Philip Pilkington, Kevin Lole and David Rushton, and Charles Harrison, 'Some Concerns in Fine Art Education' (two parts), *Studio International*, vol. 182, nos 937 and 938 (October and November 1971).

11 See especially Terry Atkinson and Michael Baldwin, 'De Legibus Naturae', *Studio International*, vol. 181, no. 932 (May 1971). The essay concerns the status of the Art & Language work *Theories of Ethics* (1971).

12 Note to the author, 1989.

13 See, for instance, the Introduction to *Art–Language*, vol. 1, no. 1 (May 1969), and the essay cited in note 11. Between 1967 and 1971 artists associated with Art & Language produced various 'art-works' in the form of essays, pamphlets or booklets. See, for instance, Terry Atkinson and

Michael Baldwin, *Hot–Cold* and *22 Predicates: The French Army*, letter-press books (1967); Mel Ramsden, *The Black Book*, indexed book (1967); Ian Burn, *Xerox Book* (1968); Harold Hurrell, *Fluidic Device*, letterpress book (1968).

14 Since 1972 Art & Language has shown a persistent (ironically self-critical or fatalistic) tendency to use up and to transform its own accumulated and redundant forms of production by incorporating them into new and different systems. In *Index: The Studio at 3 Wesley Place in the Dark III* (1982), representations of previous embarrassing failures are stencilled across the surface of the painting. A white painting of 1984–5 was cut up and used to represent a white painting in *Index: Incident in a Museum III* (1985; see essay 7). In *Index: Incident in a Museum XXI* (1987), actual fragments of *Index: The Studio at 3 Wesley Place Illuminated by an Explosion nearby IV* (1983) are collaged onto the surface. Some black paintings of 1985 were made by transferring to canvas the ink from back issues of *Art–Language*, while *Index: Incident in a Museum XXV* includes an actual bookshelf fully stocked with unsold Art & Language publications (see essay 8).

15 See, for instance, Marvin Minsky, *The Society of Mind* (London, 1987); and, for a contrasting application of related theory, Richard Frost, *Introduction to Knowledge Base Systems* (London, 1986).

16 For a contrasting topicalization of indexicality in the art of the 1970s, see Rosalind Krauss, 'Notes on the Index: Part 2', in *The Originality of the Avant-Garde and Other Modernist Myths* (Cambridge, Mass., and London, 1986), pp. 210–12. Krauss interprets recent 'attitudes towards the index' in terms of the hold exerted upon abstract art by 'the conditions of photography'. 'In the photograph's distance from what could be called syntax one finds the mute presence of an uncoded event. And it is this kind of presence that abstract artists now seek to employ.'

17 'The Art–Language Institute: Suggestions for a Map', in the catalogue to 'Documenta 5'.

18 *The Sunday Times*, 2 July 1972.

19 See Walter Benjamin, 'The Author as Producer' (1934), tr. Anna Bostock in *Understanding Brecht* (London, 1977).

20 Terry Atkinson and Michael Baldwin, 'The Index', in *The New Art* (exhibition catalogue, Arts Council of Great Britain, Hayward Gallery, London, August 1972), p. 16.

21 Art & Language, from a statement written in connection with a seminar at Leeds University, February 1979. Printed in *Art & Language* (Stedelijk van Abbe Museum, Eindhoven, 1980), p. 239.

22 T. S. Kuhn, *The Structure of Scientific Revolutions* (Chicago, 1962); K. Popper, *Logik der Forschung* (Vienna, 1934), tr. as *The Logic of Scientific Discovery* (London, 1959). See also the symposium *Criticism and the Growth of Knowledge*, ed. I. Lakatos and A. Musgrave, Proceedings of the International Colloquium in the Philosophy of Science, London, 1965, vol. 4 (Cambridge, 1970), especially Imre Lakatos, 'Falsification and the Methodology of Scientific Research Programmes'. Popper's critique of naïve falsificationism, discussed by Lakatos, was seen within Art & Language as relevant to the critique of Modernist historicism.

23 T. S. Kuhn, *The Structure of Scientific Revolutions*, 2nd, enlarged edn (Chicago, 1970), pp. 209–10.

24 Ibid., p. 202.

25 See note 22. For an example of the uses made of this material by students, see Kevin Lole, 'Progress in Art and Science', *Analytical Art*, no. 1 (July 1971); and Ian Johnson and Paul Tate, 'Alienation and Theories of Art and Science', *Analytical Art*, no. 2 (June 1972).

26 These were designated *Index 03, 04* and *05*. They were first shown at, respectively, the Lisson Gallery, London (as *Li Proceedings*), in September 1973; at 'Contemporanea', Rome, in 1973; and at 'Kunst über Kunst', Kunstverein, Cologne, in 1974.

27 From *Poster: Index 05* (1973), printed in *Art & Language* (Eindhoven, 1980), pl. 58.

Essay 4 The Conditions of Problems

1 Paul Wood, 'Winters of Discontent', *Oxford Art Journal*, vol. 13, no. 1 (Spring 1990), p. 94.

2 Quoted in Philip Pilkington and David Rushton, 'Introduction: Don Judd's Dictum and its Emptiness', *Analytical Art*, no. 1 (July 1971), p. 2.

3 Ibid., p. 4.

4 The phrase is Meyer Schapiro's, from a discussion of early Impressionism in 'The Nature of Abstract Art' (1937), repr. in *Modern Art: 19th and 20th Centuries* (London, 1978), p. 192: 'These urban idylls not only present the objective forms of bourgeois recreation in the 1860s and 1870s; they also reflect in the very choice of subjects and in the new aesthetic devices the conception of art as solely a field of individual enjoyment, without reference to ideas and motives, and they presuppose the cultivation of these pleasures as the highest field of freedom for an enlightened bourgeois detached from the official beliefs of his class.' The continuation of Schapiro's account is of some methodological relevance to my discussion: 'As the contexts of bourgeois sociability shifted from community, family and church to commercialized or privately improvised forms . . . the resulting consciousness of individual freedom involved more and more an estrangement from older ties; and those imaginative members of the middle class who accepted the norms of freedom, but lacked the economic means to attain them, were spiritually torn by a sense of helpless isolation in an anonymous indifferent mass' (p. 193).

5 See Noam Chomsky, 'Some General Features of Language', in his *Reflections on Language* (London, 1976). The relevant passage is reprinted in C. Harrison and F. Orton (eds), *Modernism, Criticism, Realism* (London and New York, 1984), p. 263. Chomsky envisages such a crisis as 'marked by a sharp decline in the general accessibility of the products of creative minds, a blurring of the distinction between art and puzzle, and a sharp increase in "professionalism" in intellectual life, affecting not only those who produce creative work but also its potential audience. Mockery of conventions that are, ultimately, grounded in human cognitive capacity might be expected to become virtually an art form in itself. . . .'

6 I refer to the use of this phrase, as contrasted with the 'meanings of the dominated', in T. J. Clark, 'Preliminaries to a Possible Treatment of *Olympia* in 1865', *Screen* (London), vol. 21, no. 1 (Spring 1980), edited reprint in F. Frascina and C. Harrison (eds), *Modern Art and Modernism: A Critical Anthology* (London and New York, 1982), p. 272. In quoting

Clark's terminology I do not take a turn at cranking the handle of that system of beliefs within which 'culture' is seen as *culture à dominante*.

7 Originally published in *Zeitschrift für Sozialforschung*, vol. V, no. 1 (1936); repr. in Walter Benjamin, *Illuminations* (London, 1970).

8 See Chomsky, 'Some General Features of Language', in Harrison and Orton, *Modernism, Criticism, Realism*, p. 267: 'The principle that human nature, in its psychological aspects, is nothing more than a product of history and given social relations removes all barriers to coercion and manipulation by the powerful. This . . . may be a reason for its appeal to intellectual ideologists, of whatever political persuasion. . . . Creativity is predicated on a system of rules and forms, in part determined by intrinsic human capacities. Without such constraints, we have arbitrary and random behaviour, not creative acts.'

9 See, for instance, the writings of such critics and commentators as Jack Burnham, Germano Celant, Piero Gilardi, Lucy Lippard and Grégoire Müller. The changing nature of the critical climate was indicated by the contents of *Artforum*, vol. IX, no. 1 (September 1970). Still true to its role as the flagship of American Modernist criticism, the journal opened with an essay by Michael Fried on 'Caro's Abstractness'. This was followed, however, by a symposium on 'The Artist and Politics' and by a contribution from the editor (Philip Leider) entitled 'How I Spent my Summer Vacation or Art and Politics in Nevada, Berkeley, San Francisco and Utah.'

10 See, for example, Barbara Rose, 'Problems of Criticism VI: The Politics of Art, part III', *Artforum*, vol. VII, no. 9 (May 1969), p. 47: 'That there is art that does not traffic in objects but in conceptions has both economic and political consequences. If no object is produced, there is nothing to be traded on the commercial market. This obvious consequence defines at least part of the intention of current anti-formal tendencies. The artist does not cooperate with the art market. Such non-cooperation can be seen as reflective of certain political attitudes. It is the aesthetic equivalent of the wholesale refusal of the young to participate in compromised situations (e.g., the Vietnam war).' The assumption that the 'objectless' art of the late 1960s left nothing to be traded on the commercial market has been revealed as a naïve journalistic idealization in the light of countless actual transactions.

11 See, for instance, Michel Foucault, 'What is an Author?' (second version of a paper of 1969), in J. V. Harari (ed.), *Textual Strategies* (London, 1979), p. 158: 'The modes of circulation, valorization, attribution, and appropriation of discourses vary with each culture and are modified within each. The manner in which they are articulated according to social relationships can be more readily understood, I believe, in the activity of the author-function and in its modifications, than in the themes or concepts that discourses set in motion.' (The ideas here expressed may be compared with T. S. Kuhn's account of the discursive formation of science, discussed in the previous essay.)

12 Benjamin, 'The Author as Producer' (1934), tr. Anna Bostock in *Understanding Brecht* (London, 1977). See also Art & Language, 'Author and Producer Revisited', *Art–Language*, vol. 5, no. 1 (October 1982), repr. in Harrison and Orton, *Modernism, Criticism, Realism*.

13 Foucault, 'What is an Author?', in Harari, *Textual Strategies*, p. 159.

14 See essay 2, note 60.

15 Issued independently under Art & Language copyright.

16 From the transcript 'Somewhere to Begin', *Art–Language*, vol. 3, no. 1: 'Draft for an Anti-Textbook' (September 1974), p. 2.

17 Note to the author, 1988.

18 This phrase is used by T. J. Clark ('Preliminaries to a Possible Treatment of *Olympia* in 1865', in Frascina and Harrison, *Modern Art and Modernism*, pp. 268–71) *à propos* Manet's *Olympia* and in contradistinction to what he sees as the 'resistance to vision in normal terms' offered by Courbet's *Bather* of 1853. For a critical discussion of Clark's thesis, see Michael Baldwin, Charles Harrison and Mel Ramsden, 'Manet's *Olympia* and Contradiction: apropos T. J. Clark's and Peter Wollen's Recent Articles', *Block* (Middlesex Polytechnic), no. 5 (September 1981).

19 Subsequently redesignated *Index 03*.

20 Published by Art & Language Press, New York, and The Mezzanine, Nova Scotia College of Art, Halifax, 1973.

21 Subsequently exhibited at the Institute of Contemporary Arts, London, and the National Gallery of Victoria, Melbourne, 1974. Now in the collection of the Stedelijk van Abbe Museum, Eindhoven.

22 From a typescript in the possession of the author.

23 *Art–Language*, vol. 3, no. 1 (September 1974), p. 52.

24 Note to the author, 1989.

25 Terry Atkinson and Michael Baldwin, 'The Index', in *The New Art* (exhibition catalogue, Arts Council of Great Britain, Hayward Gallery, London, August 1972), p. 17.

26 From a document circulated at the exhibition 'Projekt '74', Cologne, 1974. This was written in response to the account of Art & Language practice contained in Joseph Kosuth's 'Notes on "Anthropologized" Art', published in the catalogue of 'Projekt '74'. The former document was published as Art & Language, 'Dialectical Materialism', in *Extra* (Cologne), no. 2 (October 1972), together with a reply from Kosuth, printed as 'A Letter to the Editor (1974)'. *Extra*, no. 3 (1975), carried a reply to Kosuth from Atkinson.

27 'Pedagogical Sketchbook (AL)', *Art–Language*, vol. 3, no. 2 (May 1975), pp. 20–1.

28 'Somewhere to Begin', *Art–Language*, vol. 3, no. 1: 'Draft for an Anti-Textbook' (September 1974), p. 2.

29 'Retrospective Exhibitions and Current Practice', in *Art & Language 1966–1975* (Museum of Modern Art, Oxford, September 1975), pp. 2–3.

30 Note to the author, 1988.

31 The following names and references are caught by a trawl of two issues of *Art–Language* which are largely based on transcripts (vol. 3, nos 1 and 2, September 1974 and May 1975): Theodor Adorno, Louis Althusser, A. R. Anderson and O. K. Moore ('The Formal Analysis of Normative Concepts'), Leo Apostel, J. L. Austin, Nicolai Bakunin, Jehoshua Bar-Hillel, Daniel Bell, Basil Bernstein, Max Black, Rudolf Carnap, Lewis Carroll, Noam Chomsky (*For Reasons of State*), Tony Cliff (*The Crisis: Social Contract or Socialism*), Ken Coates and Tony Topham (*The New Unionism: The Case for Workers' Control*), Paul Feyerabend, Jerry Fodor, J. K. Galbraith, Lucien Goldmann, Nelson Goodman, Arturo Gramsci, Clement Greenberg, Tirril Harris ('WR: World Revolution or Wishful Revisionism?'), Martin Heidegger, Jakko Hintikka, Thomas Hobbes, T. E. Hulme, Edmund Husserl, Richard Hyman (*Marxism and the Sociology of Trade Unionism*), Frederic Jameson, David Kaplan, Jerrold Katz, Michael Kidron

('Imperialism, Highest Stage but One'), Søren Kierkegaard (*Concluding Unscientific Postscript, Either/Or* and *Concerning my Work as an Author*), Karl Kraus, Leszek Kolokowski, Saul Kripke, T. S. Kuhn, Imre Lakatos, V. I. Lenin, Claude Lévi-Strauss, S. M. Lipsett, Georg Lukács, Lu Hsun, Karl Marx, Richard Montague, Talcott Parsons, Chaim Perelman, Karl Popper, W. v. O. Quine, Wilhelm Reich, Nicholas Rescher, J. B. Rosser and A. R. Turquette ('Many Valued Logics'), Jean-Paul Sartre, Helmut Schnelle ('Language Communications with Children'), Dana Scott, John Searle (*Speech Acts* and *The Campus War*), P. F. Strawson, Leon Trotsky, R. C. Tucker, Max Weber, Paul Whorf, Ludwig Wittgenstein.

32 The *Cologne Index* was stuck to display panels and was accidentally destroyed when the exhibition was dismounted.

33 See, for instance, George Heard Hamilton on Surrealism in his substantial *Painting and Sculpture in Europe 1880–1940* (Harmondsworth, 1967), p. 383: 'The only political activity worth mentioning is Aragon's resignation from the group in 1932'.

34 'Cubism and Abstract Art' was the title of an exhibition organized by Barr at the Museum of Modern Art, New York, 1936. The catalogue of the same name was one of the first in a long line of publications by the museum which have been influential in establishing a Modernist art history. Schapiro's 'The Nature of Abstract Art' (see note 4) was written as a critique of Barr's publication. *Circle: International Survey of Constructive Art* was edited by Gabo, J. L. Martin and Ben Nicholson and was published in London in 1937.

35 See, for instance, Clement Greenberg, 'Review of an Exhibition of Joan Miró', *The Nation*, 7 June 1947, repr. in J. O'Brian (ed.), *Clement Greenberg: The Collected Essays and Criticism*, vol. 2 (Chicago, 1986), pp. 153–5.

36 See, for instance, material published in those English student magazines whose editors and contributors had been exposed to an Art & Language point of view: *Statements* (1970) and *Analytical Art* (Lanchester Polytechnic, 1971–2), *Number One* (Newport College of Art, 1971–2), *Ratcatcher* (Hull Regional College of Art, 1975–6), *Issue* (Trent Polytechnic, 1976–9) and *Ostrich* (Royal College of Art, London, 1976).

37 'Putative Art Practice. . .', *Art & Language 1966–1975*, p. 27.

38 The publication was untitled. It was compiled by David Batchelor, Mike Fyles, Steve Lawton, Alan Robinson, Dave Rushton and Paul Wood, and was financed by the Student Community Action Resources Programme. According to the legend which began on its front cover, 'The noises within echo from a gimcrack, remote and ideologically hollow chamber of the educational machine: Art School. . . . The work drew its inspiration from that of the Art Language group.' Much of the material was drawn from publications cited in note 36.

39 See the exchanges cited in note 26. Kosuth must have received an early indication of the problem in 1972 when *Index 01* was shown at 'Documenta'. While the rest of those present were completing the job of installation, he took upon himself the task of lettering the artists' names in the doorway. He used two different sizes of Letraset: one for the 'first generation'; a smaller size for Philip Pilkington and David Rushton. It was pointed out to him that both the latter had done considerably more work on the *Index* than he had.

40 The distinction employed here between the cognitive and the non-cogni-

tive is one normally used with regard to conditions of rationality (and thus
of relevance) in science. Consider two scientists in a laboratory, mutually
concerned with the progress of an experiment. In the context of that
concern – and of that shared scientific practice which is defined in terms of
such concerns – what one scientist says to the other about the state of the
experimental materials has potential cognitive significance. What one says
to the other about the state of her husband's ulcer does not. However, *pace*
Roy Bhaskar, 'To conceive critique as conditioned by factors outside itself
[i.e. by non-cognitive conditions] is not to impugn its normative power,
merely to be realistic about its practical impact.' (R. Bhaskar, 'Scientific
Explanation and Human Emancipation', *Radical Philosophy* 26,
(Brighton, Autumn 1980), p. 16.)

41 Mao Tse-tung, *On Practice*, 6th edn (Peking, 1966), pp. 7–8.

42 See, for instance, Sarah Charlesworth, 'Memo for the Fox', *Fox 2* (New
York, 1975), p. 37: '*The Fox* was not . . . at first even initiated as a project
of Art & Language. It emerged in part out of my struggle to come to terms
with a very stagnant, alienated and alienating art culture of which Art &
Language New York at the time was very much a part. It had a lot to do
with Joseph [Kosuth] rethinking and needing to rethink his relationship to
the world. It had to do with the frustration felt by Andrew [Menard], by
Michael [Corris] and Preston [Heller] with the extremely oppressive nature
of a very elitist and rather irrelevant (in terms of effective practice)
theoretical debating society which was Art & Language.'

43 *The Fox*, vol. 1, no. 1 (1975), p. 66.

44 Ibid., p. 83.

45 Ibid., p. 8.

46 The recommendation that readers of *Artforum* should read *The Fox* was
made in an advertisement in the former signed by contributing editors Max
Kozloff and John Coplans.

47 *Fox 2* (1975), p. 93.

48 For an account of the two organizations, of the relations between them,
and of Art & Language involvement with both, see 'Method 7.0 – AMCC
and AICU', *Art–Language*, vol. 4, no. 2 (October 1977).

49 See, for instance, Ramsden's 'Review: Jeremy Gilbert-Rolfe's as-silly-as-
you-can-get "Brice Marden's Painting" ', *Fox 2* (1975).

50 Text used in *Proceedings 0012: Child's Play*, photographic print (1974),
and in *Dialectical Materialism: El Lissitsky 0015* (1975).

51 See Ian Burn, 'The Art Market: Affluence and Degradation' ('While we've
been admiring our navels . . .'), *Artforum*, vol. XIV, no. 4 (April 1975);
and Art & Language, 'Mr. Lin Yutang Refers to "Fair Play". . .?', *Art–
Language*, vol. 3, no. 2 (May 1975).

52 Ian Burn, 'Review: *Art–Language* Volume 3 Number 2', *Fox 2* (1975), p.
53.

53 The only English contributors to *Fox 2* were Terry Atkinson ('Looking
back, Going on – Part 2') and David Rushton and Paul Wood, again
writing together on art education ('Direct Speech'). All three were by this
time working independently of Art & Language in England.

54 See note 15.

55 Note to the author, 1988.

56 On Kosuth's suggestion, the names of the interlocutors were protected
behind pseudonyms in the published text of 'The Lumpenheadache'. Their
actual identities were revealed, however, in a *dramatis personae* rubber-

stamped on the inside cover by Paula Ramsden and Christine Kozlov after the magazine was printed but before its distribution.

57 Burn, Cutforth and Ramsden exhibited at the Pinacotheca Gallery, Melbourne, in August 1969. Art & Language held the exhibitions 'New York – Australia' at the Art Gallery of New South Wales, Sydney, and the National Gallery of Victoria, Melbourne, in June 1975, and 'Piggy-Cur-Prefect' at the City Art Gallery, Auckland, in June 1976. An article by Burn, 'Conceptual Art as Art', was published in *Art and Australia* in September 1970.

58 'Us, Us and Away', *Art–Language*, vol. 3, no. 4 (*Fox 4*) (October 1976), pp. 1, 2, 4–5.

Essay 5 On 'A Portrait of V. I. Lenin in the Style of Jackson Pollock'

1 Thanks to the initiative and support of Jan Debbaut, a substantial retrospective collection of Art & Language texts was published in place of a catalogue on the occasion of this exhibition. See *Art & Language* (Stedelijk van Abbe Museum, Eindhoven, 1980). A number of the texts were translated into Dutch.

2 First version published in *Artforum*, vol. XX, no. 2 (February 1980). A more extended version was published in *Art–Language*, vol. 4, no. 4 (June 1980), repr. in C. Harrison and F. Orton (eds), *Modernism, Criticism, Realism* (London and New York, 1984).

3 'A Portrait of V. I. Lenin in the Style of Jackson Pollock I & II', on Art & Language and The Red Crayola, *Kangaroo?*, record issued March 1981 by Rough Trade (Rough 19). A videotape of this song and two others was played as part of the Art & Language exhibition at Eindhoven.

4 Ernst Gombrich, *Art and Illusion: A Study in the Psychology of Pictorial Representation* (London, 1960).

5 Richard Wollheim, *Painting as an Art* (London and Princeton, NJ, 1987), p. 22 and *passim*.

6 Flint Schier, *Deeper into Pictures: An Essay on Pictorial Representation* (Cambridge, 1986), p. 47.

7 Ibid., p. 52.

8 See Nelson Goodman, *Languages of Art* (Indianapolis, 1968), excerpt in Harrison and Orton, *Modernism, Criticism, Realism*, pp. 175–9.

9 See, for instance, how this and other information is used by Francis Frascina in his discussion of the *Blue Nude* in 'Cubism: Picasso and Braque', *A315: Modern Art and Modernism: Manet to Pollock* (Open University, Milton Keynes, 1983), block V, pp. 36–8. (In citing this example I do not mean to endorse the author's interpretation of the painting.)

10 Apart from preliminary studies and a miniature version produced for reproduction in *Artforum* (see note 2), four relatively small paintings 'in the style of Jackson Pollock' were completed in 1979. The first two were exhibited at Leeds University Art Gallery in January 1980 and all four at the Lisson Gallery, London, in March (*Portrait of V. I. Lenin . . .*; *Portrait of V. I. Lenin with Cap . . .*; *The Dying Trotsky . . .*; and *Joseph Stalin Gazing Enigmatically at the Body of V. I. Lenin as it Lies in State in Moscow*: all 126 × 177 cm). The paintings 'in the style of Jackson Pollock'

used for the Eindhoven exhibition were all made in 1980 and measured 210 × 239 cm (*Portrait of V. I. Lenin . . . II*; *Portrait of V. I. Lenin with Cap . . . II*; *Portrait of V. I. Lenin in the Winter of 1920 . . .*; '*V. I. Lenin*' *by V. Charangovitch (1970) . . .*; and *Portrait of V. I. Lenin in July 1917 Disguised by a Wig and Working Man's Clothes . . . I* and *II*). All works were executed in oil and enamel on board.

11 For discussion of 'seeing', 'seeing-as' and 'seeing-in', see Ludwig Wittgenstein, *Philosophical Investigations* (Oxford, 1953), excerpt in Harrison and Orton, *Modernism, Criticism, Realism*, pp. 57–68; N. R. Hanson, *Patterns of Discovery* (Cambridge, 1958), excerpt in Harrison and Orton, *Modernism, Criticism, Realism*, pp. 69–83; Richard Wollheim, *Painting as an Art*, pp. 46–75, and *Art and its Objects*, 1st edn (Harmondsworth, 1970), pp. 31–7, and 2nd edn (Cambridge, 1983), Supplementary Essay V: 'Seeing-as, Seeing-in, and Pictorial Representation'; Schier, *Deeper into Pictures*, passim.

12 'Our sense of the relative "orders" of discourse is as follows. Within any practice a first-order discourse characterises the normal terms in which discussion, business, exegesis, etc. is conducted. A second-order discourse is conventionally understood as conducted in a type of meta-language by means of which the terms and concepts etc. of the first may be related, analysed etc. and their referents explained. The requirement upon a second-order discourse is that it should be capable of "including" the first (i.e. describing what it describes and explaining what it explains) but that it should also furnish an explanation of *how* (and perhaps *why*) that describing and explaining is done. A second-order discourse thus presupposes a position somehow "outside" but engaged with the contexts of the first. It is suggested that a cognitively defensible discourse for the recovery of meaning from art will have a second-order character with respect to the normal and current means of interpretation. To the extent that this is true the second-order discourse might be expected to supersede the first, except in so far as it is prevented from doing so by the agency which invests and maintains the normal order. Attendant upon such a reordering of discourse would be a transformation of concepts and categories and of their fields of reference. The relations between orders of discourse (and there can plainly be more than two such orders) may be characterised in different ways according to different practices. It is suggested here that the relations between Modernist art discourse (or Modernist art) and historical materialist discourse (or some art practice compatible with the projects of historical materialism and an analysis and critique of capitalism) may be considered in terms of the above outline' – Michael Baldwin, Charles Harrison and Mel Ramsden, 'Manet's *Olympia* and Contradiction: apropos T. J. Clark's and Peter Wollen's Recent Articles', *Block*, no. 5 (September 1981).

13 'Current Affairs: British Painting and Sculpture in the 1980s', Museum of Modern Art, Oxford, March 1987, subsequently mounted at Mücsarnok, Budapest, the Národni Galerie, Prague, and Zacheta, Warsaw, April–October 1987. Compare the titles given in note 10. This was before the recent thaw. Informed opinion from Poland, however, suggests that at the time of writing the paintings would be still more, rather than less, inadmissible under their proper titles.

14 There are some ironic twists in the genetic composition of the iconic symbol. The culturally stereotypical image of Lenin is in part derived from

Eisenstein's film *October*; that is to say, from an actor's *representation* of Lenin.

15 Clement Greenberg, introduction to *Three New American Painters: Louis, Noland, Olitski* (exhibition catalogue, Norman McKenzie Art Gallery, Regina, Sask., January 1963).

16 Lawrence Alloway, introduction to *Modern American Painting* (exhibition catalogue, USIS Gallery, American Embassy, London, May 1961): 'This ability to learn from the creative act, to arrive at a point which one recognizes as an acceptable formality, but which one could not predict before beginning, is the central experience of art, the least habit-bound of all human activities.'

17 For some exploration of the clichés of risk in art, see my 'Modern Art and the Concept of Risk' and 'Jackson Pollock: What Kind of Risk?' in *U201: Risk* (Open University, Milton Keynes, 1980), unit 27 and TV 10.

18 Victor Burgin, quoted in 'The French Disease', *Art–Language*, vol. 3, no. 4 (*Fox 4*) (October 1976), p. 33. Burgin has been one of the most consistent and articulate advocates of the point of view here characterized. See his collected essays *Thinking Photography* (London, 1982) and *The End of Art Theory* (London, 1986).

19 Burgin, from *Two Essays on Art, Photography and Semiotics* (London, 1975), quoted in 'Semiotique, Hardcore', *Art–Language*, vol. 3, no. 4 (October 1976), p. 36.

20 'The French Disease', ibid., pp. 23–5.

21 'Interdisciplinary Studies: Urology, Arachnodidactics', ibid., p. 44.

22 See, for instance, 'Art for Society?' in *Art–Language 1975–1978* (Eric Fabre, Paris, 1978); and *Art–Language*, vol. 4, no. 3 (October 1978), a monograph edition published under the title 'Ways of Seeing' as a sustained critical examination of John Berger's book of that name.

23 See note 2.

24 David Kaplan, 'Quantifying in', in D. Davidson and J. Hintikka (eds), *Words and Objections: Essays on the Work of W. V. Quine* (Dordrecht, 1969). A name, Kaplan suggests, may be of its object (for someone) by virtue of a relation of resemblance, or descriptiveness or iconicity (*x* is *like* its object for *p*); or it may be of its object (for someone) by virtue of a causal or genetic connection (*x* can be traced to its object by *p*). A name may also be vivid for someone by virtue of some interest on that person's part, and can be so independently of either descriptive or genetic considerations. Kaplan illustrates his argument by analogy with pictures.

25 Art & Language, in Harrison and Orton, *Modernism, Criticism, Realism*, p. 155.

26 'Illustrations for *Art–Language*', Robert Self Gallery, London, May 1977. The materials of the exhibition were numerous sets of *Ten Postcards*, each of which composed the image of a fasces, lettered with appropriate texts. In one room of the gallery, a completed fasces was mounted on each wall. In the other, various sets of postcards were scrambled together and recomposed as 'abstract compositions'.

27 W. J. T. Mitchell, *Iconology: Image, Text, Ideology* (Chicago, 1986), p. 203.

28 Note to the author, 1988.

29 Typescript of an interview with David Batchelor, 1989. Hans Namuth was the author of a notorious film of Jackson Pollock at work in 1950. In 'My Painting', *Possibilities*, I (New York, Winter 1947–8), p. 79, Pollock

wrote, 'When I am *in* my painting, I'm not aware of what I'm doing. It is only after a sort of "get acquainted" period that I see what I have been about. I have no fears about making changes, destroying the image, etc., because the painting has a life of its own. I try to let it come through.'

Essay 6 'Seeing' and 'Describing': the Artists' Studio

1 Frank Stella, *Working Space*, The Charles Eliot Norton Lectures, Harvard University, 1983–4 (Cambridge, Mass., and London, 1986), p. 9.

2 The full text of Courbet's letter to Champfleury, from which this quotation is taken, was published in the catalogue of the Courbet exhibition organized by the Réunion des Musées Nationaux and held in the Galeries Nationales d'Exposition du Grand Palais, Paris, 1 October 1977 – 2 January 1978.

3 On the occasion of the private exhibition mounted by Courbet following rejection of the painting by the selection committee for the World Exhibition of 1855.

4 Writing of the painting in 1881, Champfleury declared that Courbet had 'embarked on the treacherous slope of symbolization' – *Les Chefs-d'oeuvre du Luxembourg* (Paris, 1881), p. 116.

5 See, particularly, the forty-five graphic images of 'The Sculptor's Studio' in the Vollard Suite, 1933–4.

6 This is the conventional view of 'the aesthetic attitude' as characterized by Nelson Goodman in 'Art and Inquiry', in *Problems and Projects* (Indianapolis and New York, 1972), p. 103. He continues, 'The philosophic faults and aesthetic absurdities of such a view need hardly be recounted until someone seriously goes so far as to maintain that the appropriate aesthetic attitude toward a poem amounts to gazing at the printed page without reading it.' For a thoroughly stereotypical account of the genre of the Artist's Studio, see A. Bellony-Rewald and M. Peppiatt, *Imagination's Chamber: Artists and their Studios* (London, 1983).

7 'A New Spirit in Painting' was the title of an exhibition held at the Royal Academy, London, 15 January – 18 March 1981. Although 'senior' artists such as Picasso, Bacon and de Kooning were included, the exhibition was notable as the first substantial showing in England for a new expressionistic and angst-ridden tendency in European painting.

8 Art & Language, 'On the Recent Fashion for Caring', *Issue* (Nottingham), no. 3 (1979).

9 Francis O'Connor and Eugene Thaw, *Jackson Pollock: A Catalogue Raisonné of Paintings, Drawings and Other Works* (New Haven, Conn., and London, 1978), no. 765.

10 In conversation with Baldwin and Ramsden, 1981, as reported to the author.

11 For a more extensive argument along these lines see Art & Language, 'Abstract Expression', *Art–Language*, vol. 5, no. 1 (October 1982), repr. in C. Harrison and F. Orton (eds), *Modernism, Criticism, Realism* (London and New York, 1984).

12 The others are *Raped and Strangled by the Man who Forced her into Prostitution: A Dead Woman: Drawn and Painted by Mouth* and *A Man Battering his Daughter to Death as she Sleeps: Drawn and Painted by*

Mouth. All three were shown for the first time in the exhibition 'Aspects of British Art Today', Tokyo Metropolitan Museum, February 1982.

13 Walter Benjamin, 'The Author as Producer' (1934), tr. Anna Bostock in *Understanding Brecht* (London, 1970), p. 101.

14 'Painting by Mouth', *Art–Language*, vol. 5, no. 1 (October 1982), p. 53.

15 T. J. Clark, 'Preliminaries to a Possible Treatment of *Olympia* in 1865', *Screen*, vol. 21, no. 1 (Spring 1980), edited reprint in F. Frascina and C. Harrison (eds), *Modern Art and Modernism: A Critical Anthology* (London and New York, 1982), pp. 260 and 271. See also P. Wollen, 'Manet, Modernism and Avant Garde', *Screen* vol. 21, no. 2 (Summer 1980); T. J. Clark, 'Reply to Wollen', *Screen*, vol. 21, no. 3 (Autumn 1980); and Michael Baldwin, Charles Harrison and Mel Ramsden, 'Manet's *Olympia* and Contradiction: apropos T. J. Clark's and Peter Wollen's Recent Articles', *Block*, no. 5 (September 1981).

16 On what is meant here by the relative orders of discourse, see essay 5, note 12.

17 See essay 8.

18 Liechtenstein Collection, alternatively numbered *Studio (Atelier) III*. The painting had recently been exhibited in Cologne in the large survey exhibition 'Westkunst: zeitgenössische Kunst seit 1939'.

19 Magritte's *Key of Dreams*, in the collection of Jasper Johns, was reproduced on the cover of Berger's book. A 'revised' version of this painting was produced as art-work for the cover of the corresponding Art & Language publication.

20 The double-page spread referred to is from *Studio International*, vol. 180, no. 924 (July–August 1970). The principal editorial pages of this issue were given over to an international avant-garde 'exhibition' curated by Seth Siegelaub, with selection delegated to an international panel of six avant-garde critics.

21 6 May 1936, Musée Picasso, Paris. The hands appear reversed in Art & Language's painting.

22 *c.* 1826–7, Tate Gallery, T G 3340.

23 Reproduced on p. 274 of the catalogue of the exhibition cited in note 2.

24 Published as Charles Harrison and Fred Orton, *A Provisional History of Art & Language* (Eric Fabre, Paris, April 1982).

25 In the catalogue to 'Documenta 7', Kassel, 1982; in *Art–Language*, vol. 5, no. 1 (October 1982); and elsewhere.

26 See Walter Benjamin, 'Allegory and Trauerspiel', in *The Origins of German Tragic Drama*; and Paul de Man, 'The Rhetoric of Temporality', in *Blindness and Insight: Essays in the Rhetoric of Contemporary Criticism* (London, 1983).

27 See, for instance, Clement Greenberg: ' Towards a Newer Laocoon', *Partisan Review* (New York), vol. VII, no. 4 (July–August 1940, edited repr. in C. Harrison and P. Wood, *Art in Theory 1900–1990* (Oxford, 1982 and Cambridge, Mass., 1983); and 'Modernist Painting' 1960, repr. in Harrison and Wood.

28 For a discussion along these lines, see Thomas Crow, 'Modernism and Mass Culture in the Visual Arts', in B. Buchloh, S. Gilbaut and D. Solkin (eds), *Modernism and Modernity: The Vancouver Conference Papers* (Halifax, NS, 1983).

29 That is to say, at the time of writing his essay 'Avant-Garde and Kitsch', first published in *Partisan Review*, vol. VI, no. 6 (Fall 1939).

30 'Index: The Studio at 3 Wesley Place Painted by Mouth', De Vleeshal, Middelburg.

31 'Painting with your head very close to the surface, a brush-stroke away, you couldn't navigate across the surface very easily. You have to go ahead by dead reckoning rather than in a more sophisticated way. As you move across the surface you tend to get lost. What we came to rely on were the unforeseen consequences of PBM [painting by mouth] . . .' – Michael Baldwin, in 'A Cultural Drama: The Artist's Studio', in *Art & Language* (exhibition catalogue, Los Angeles Institute of Contemporary Art, September 1983).

32 *Index: The Studio at 3 Wesley Place in the Dark (III)*, in acrylic on canvas, was executed in the autumn of 1982 and was first shown at Gewad, Ghent, in March 1983, together with *I* and *II* and a version of *Index: The Studio at 3 Wesley Place Illuminated by an Explosion nearby*, which occupied the fourth place in the series but was subsequently destroyed. A list of the 'embarrassments' represented in *Index: The Studio at 3 Wesley Place in the Dark (III)* was printed in *Art & Language* (exhibition catalogue, Ikon Gallery, Birmingham, May 1983).

33 'Art & Language Paints a Picture – a Fragment', *Gewad Informatief* (Ghent, March 1983), repr. in *Art & Language* (Birmingham exhibition catalogue).

34 *Index: The Studio at 3 Wesley Place illuminated by an Explosion nearby V* and *VI* were completed at the end of 1982 as photographs on canvas and were shown at the Lisson Gallery, London, in the spring of 1983. The first of these was subsequently cut up into sections and incorporated as a form of collage in the painting *Index: Incident in a Museum XXI* (1987) (see plate X). *Index: The Studio at 3 Wesley Place illuminated by an Explosion nearby VII* and *VIII* were painted in oil on canvas early in 1983 and were first shown at Galerie Grita Insam, Vienna, in the summer of that year. Two further exhibitions of selected paintings and studies from the series were held during 1983, at the Ikon Gallery, Birmingham, in May–June and at the Los Angeles Institute of Contemporary Art in September–October. I contributed a text on 'The Orders of Discourse: The Artists' Studio' to the Birmingham catalogue. 'A Cultural Drama: the Artist's Studio' (the transcript of a seminar held at the Ikon Gallery) was published in the Los Angeles catalogue. Apart from more informal working drawings and technical samples, the 'Studio' project generated a series of seven large studies on paper, of which five – including the original maquette – are now in the collection of the Tate Gallery, London.

35 To see in such a prospect a form of reduction to the aesthetic is not necessarily to deny the causal or genetic conditions of this or any artistic work. On the contrary. It is to replace a relatively mechanical and graspable sense of causality with a more complex and richer sense of rootedness, for which procedure of replacement I see the gradual development of the 'Studio' series as a kind of allegory. The recognition of the work of art as significantly other – which is what I take the attribution of aesthetic significance to mean – is no more (and no less) than an acknowledgement of the experience of unexplained and unarticulated effects, and thus an acknowledgement of the limits on causal and other forms of explanation. It is (of the form of) an acknowledgement that to know how a race was won is not necessarily to know how it was to win it. If a change of emphasis is detectable at this point in this book – a lessening of interest in

the conditions of recovery of genetic material – it betokens no more than is involved in the making of this acknowledgement.

Essay 7 On the Surface of Painting

1 Most cogently by Clement Greenberg and Michael Fried. See, in particular, Greenberg's 'Modernist Painting' (1961), repr. in C. Harrison and P. Wood, *Art in Theory 1900–1990* (Oxford, 1982, and Cambridge, Mass., 1983); and Fried's *Three American Painters* (1965), edited reprint in Harrison and Wood, and 'The Achievement of Morris Louis', *Artforum*, vol. V, no. 6 (February 1967).

2 For a relevant review of the problems of reading meaning from painting, and for a substantial contribution to thought on the subject, see Richard Wollheim, *Painting as an Art* (London and Princeton, NJ, 1987). For a review pertinent to the subject of this essay, see Art & Language (Michael Baldwin, Charles Harrison, Mel Ramsden), 'Informed Spectators', *Artscribe* no. 68 (March–April 1988).

3 Wollheim (*Painting as an Art*, p. 21) uses the term 'twofoldness' for 'this strange duality – of seeing the marked surface, and of seeing something in the surface'. In his account this experience leads to a thematizing of the image, which 'ushers in representation'. Translated into his terminology, my suggestion would be that the *Winter Landscape* can be seen as catering to a Modernistic taste for the thematizing of 'twofoldness' itself.

4 On the matter of intention, see Wollheim, *Painting as an Art, passim.* My thesis commits me to the view that meaning can enter a painting irrespective of – or even despite – what I understand as capable of being included under the artist's intention. Wollheim sees the recovery of intention – and not historical situation – as the key to meaning in painting. For him, it is the artist's recoverable intention which establishes the correctness or incorrectness of any acount of a painting's meaning. His notion of intention is a large one, however, partly because he is able to moderate the force of 'irrespective' and 'despite' by recourse to a Freudian theory of the unconscious.

5 Though the phrase is Wollheim's (ibid., p. 22 and *passim*), the person conjured has served in many antecedent accounts to represent the minimum condition for the successful recovery of polite meaning from painting.

6 See the articles cited in essay 6, note 15.

7 This was apparently the destiny imagined for Cézanne by Emile Zola, who had been a close friend in their youth and a firm supporter at least in practical terms during the 1870s. In Zola's novel *L'Œuvre* the central figure of Claude Lantier is clearly modelled on Cézanne. He is portrayed as an unfulfilled genius whose frustrations lead to madness and suicide.

8 Unless underpinned by stronger connections, similarity not only is a weak form of relation between one painting and another, but also may be positively distracting from other forms of relation – including relations of incompatibility. On this question see Nelson Goodman, 'Seven Strictures on Similarity', in *Problems and Projects* (Indianapolis, 1972), repr. in C.

Harrison and F. Orton (eds), *Modernism, Criticism, Realism* (London and New York, 1984).

9 Undated note found in Pollock's files after his death, quoted in Francis O'Connor and Eugene Thaw, *Jackson Pollock: A Catalogue Raisonné of Paintings, Drawings and Other Works* (New Haven, Conn., and London, 1978), vol. IV, p. 253.

10 See, in particular, Clive Bell, *Art* (London, 1914; repr. Oxford, 1987), and *Since Cézanne* (London, 1922); and Roger Fry, *Vision and Design* (London, 1920; repr. Oxford, 1981). For a discussion of the wide sphere of influence of their ideas see my *English Art and Modernism 1900–1939* (London and Indianapolis, 1981; revised, New Haven and London, 1994).

11 Bell, *Art* (1914), p. 8.

12 For two strong examples of such a view (there is a numberless host of weak ones), see Clement Greenberg, 'Complaints of an Art Critic', *Artforum*, vol. VI, no. 2 (October 1967), repr. in Harrison and Orton, *Modernism, Criticism, Realism*, p. 4, where it is claimed that 'Esthetic judgements are given and contained in the immediate experience of art [and] are not arrived at afterwards through reflection or thought'; and Wollheim, *Painting as an Art*, according to whom what is relevant is what the 'adequately sensitive, adequately informed, spectator' may psychologically recover of the artist's intention.

13 Clement Greenberg, in 'Greenberg on Criticism', *A315: Modern Art and Modernism: Manet to Pollock* (Open University, Milton Keynes, 1983), TV 31.

14 Greenberg, 'Complaints of an Art Critic', in Harrison and Orton, *Modernism, Criticism, Realism*, p. 8.

15 'Because esthetic judgements are immediate, intuitive, undeliberate, and involuntary, they leave no room for the conscious application of standards, criteria, rules, or precepts' (ibid. p. 4).

16 Greenberg, 'Modernist Painting', in Harrison and Wood, pp. 755–6.

17 I have tried to fill out the grounds of this assertion, with specific reference to American art of the 1960s, in 'Expression and Exhaustion: Art and Criticism in the Sixties' (two parts), *Artscribe*, nos 56 (February–March 1986) and 57 (April–May 1986).

18 See *Renoir*, catalogue by John House and Anne Distel, with essays by J. House, A. Distel and Lawrence Gowing (Arts Council of Great Britain, Hayward Gallery, London, 1985).

19 For a review of Renoir literature from a perspective informed by feminism, see Kathleen Adler, 'Reappraising Renoir', in *Art History*, vol. 8, no. 3 (September 1985). Adler quotes Gowing on Renoir: 'Verbal commentary and critical debate do not bring us closer to him and he did not welcome them.' She also refers to 'a speaker at a recent Renoir symposium in London [who] equated discussion of Renoir within the frameworks of feminist or Marxist discourse as akin to "playing the violin with a spanner"' (p. 375). I am indebted to Kathleen Adler and Tamar Garb for thought-provoking discussion on this and other issues.

20 This is hardly a novel question. It is one which beset the arch-aesthete Friedrich Nietzsche, for whom, 'Since Kant, all talk of art, beauty, knowledge and wisdom is sullied and made messy by the concept of disinterestedness' – *Gesammelte Werke* (Munich, 1920–9), vol. XVII, p. 304, as quoted in J.P. Stern, *Nietzsche* (London, 1978).

21 See Walter Benjamin, 'The Author as Producer' (1934), tr. Anna Bostock in *Understanding Brecht* (London, 1977). See also Art & Language, 'Author and Producer Revisited', *Art–Language*, vol. 5, no. 1 (October 1982), repr. in Harrison and Orton, *Modernism, Criticism, Realism*.

22 On the relationship between these two (caricatures of) forms of art-historical explanation, see Michael Baldwin, Charles Harrison and Mel Ramsden, 'Art History, Art Criticism and Explanation', *Art History*, vol. 4, no. 4 (December 1981); and Art & Language, 'Author and Producer Revisited', in Harrison and Orton, *Modernism, Criticism, Realism*.

23 Greenberg, 'Modernist Painting', in Harrison and Wood, p. 756.

24 See, for instance, Greenberg's assertion that 'Iconography is brilliantly practiced by people largely blind to the non-literary aspects of art' ('Complaints of an Art Critic', in Harrison and Orton, *Modernism, Criticism, Realism*, p. 8). Note, however, his reservation that 'The thing imaged does, somehow, impregnate the effect no matter how indifferent you may be to it', and his challenging suggestion that 'The problem is to show something of how this happens' – and to do so 'with relevance to the quality of effect'.

25 Taking his cue from John Barrell (*The Political Theory of Painting from Reynolds to Hazlitt: The Body of the Public*, New Haven and London, 1986), Thomas Crow persuasively traces this particular fiction back to the late-eighteenth-century notion of the 'republic of taste' as articulated in Reynolds' *Discourses*, in which 'Vision . . . meant to see beyond particular, local contingencies and merely individual interests.' For those qualified for inclusion in the republic of taste, 'The abstract unity of the pictorial composition was to be an inducement to and metaphor for a transcendent unity of mind'. Crow continues, 'Painting, as much as any other art form, was made to stand for this [separate aesthetic] sphere, for its possession of distinct criteria of value, and any subsequent attempt to reassert the autonomy or "purity" of painting would not easily escape being marked by the origins of those concepts. Such was the case in the linked arguments for the autonomous values of painting offered by Clement Greenberg and Michael Fried.' See Crow, 'The Birth and Death of the Viewer: On the Public Function of Art', in H. Foster (ed.), *Discussions in Contemporary Culture No. 1* (Seattle, 1987), p. 3.

26 This sense of what is meant by what a painting is 'of' is derived from the analysis of the question offered by Art & Language in 'Portrait of V. I. Lenin', *Art–Language*, vol. 4, no. 4 (June 1980), repr. in Harrison and Orton, *Modernism, Criticism, Realism*.

27 G. Debord, 'The Situationists and the New Forms of Action in Politics and Art' (June 1963), in K. Knabb (ed.), *Situationist International Anthology* (Berkeley, Calif., 1981), pp. 317–18.

28 It could be conjectured that the irresolvable aspect of Art & Language's 'snow' project, which occupied a hiatus between representations of the artists' studio and representations of the museum, was realistic in the following sense: that it expressed in a form unamenable to consumption that incompatibility between private and public worlds which Modernist culture generally thematizes into aesthetic capital.

29 This point is well made by W. J. T. Mitchell in his *Iconology: Image, Text, Ideology* (Chicago, 1986), pp. 160–208.

30 I don't mean to denigrate Wright of Derby for not having anticipated those various (and generally much less interesting) artists of the twentieth cen-

tury who have indeed set fire to their paintings. More to the point is the observation that Lawrence Sterne's *Tristram Shandy* was published in 1760–2, that Wright of Derby was among those English artists who used episodes from Sterne's works as subjects for paintings, and that the transfer of some version of formal paradox from literature into painting was neither wholly unprecedented nor inconceivable in later eighteenth-century England. It should be said in Wright's defence that maintenance of a kind of pictorial decorum was a condition of the very considerable success of his most assiduous paintings.

31 As with many of his more successful (saleable) compositions, Wright painted several versions of the *Cottage on Fire*. He refers to the scene of a cottage on fire in Needwood Forest in a letter of 1791. The version referred to here is the one now in the Derby Museum and Art Gallery and is dated 1793. A version in an oval format, currently in an English private collection, is datable to the same year. A third version, in the Minneapolis Institute of Arts, has been conjecturally dated 1787. If accurate, such a dating would make the composition probably prior to the *Cottage in Needwood Forest*, ascribed to the period *c.*1790, and would thus tend to undercut my suggestion about the relations between the two. Given the relative uncertainty about the dating both of the Minneapolis painting and of the *Cottage in Needwood Forest*, however, I am inclined to hold on to the notion that the latter was painted first. It is certainly true, though, that the Minneapolis painting is a more careful work than the Derby *Cottage on Fire* and that it is thus likely to be the earlier of the two versions. That the latter has more the quality of an alienated later repetition than of a studied preliminary is consistent with my view that the contingencies of its production are relatively uninteresting.

32 See T. J. Clark, 'Clement Greenberg's Theory of Art', *Critical Inquiry*, vol. 9, no. 1 (September 1982). In face of misunderstandings to which it had given rise, Clark expanded on his use of the phrase in an extended footnote to the reprint of this article in F. Frascina (ed.), *Pollock and After: The Critical Debate* (London and New York, 1985), p. 55. See essay 1, note 32.

33 The 'moment' of the painting is set by astrological and chronometrical instruments on the table between the two men. De Dinteville's age is inscribed on the hilt of his sword and de Selve's on the book under his arm. The globe charts Magellan's recent voyage of discovery and names de Dinteville's domain of Polisy in France. Other items signify the quadrivium of the liberal arts, and the arts of discourse which constitute the trivium. A book of arithmetic for merchants by Apianus evokes the world of the Hanseatic League. Beside it a book of German canticles is open at a chorale by Luther. (De Selve was a bishop of the French Catholic Church, but one interested in Reformation ideas.) And so on.

34 *The Ambassadors* is a much studied painting. The pioneer work was Mary Helvey, *Holbein's 'Ambassadors', the Picture and the Men* (London, 1900). See also Michael Levey, *National Gallery Catalogues: The German School* (London, 1959), pp. 47–54; Jurgis Balthrusaitis, *Anamorphoses ou magie artificielle des effets merveilleux* (Paris, 1955); Edgar R. Samuel, 'Death in Glass. A New View of Holbein's *Ambassadors*', *Burlington Magazine* (London), no. 105 (October 1963); Michel Butor, 'Un tableau vu en détail', *Répertoire III* (Paris, 1968).

35 For two assiduous studies of this painting, each offering a different interpretation of the enigma it presents, see Marilyn Aronberg Lavin, *Piero*

della Francesca: The Flagellation (London and New York, 1972); and Carlo Ginzburg, *The Enigma of Piero: The Baptism, The Arezzo Cycle, The Flagellation* (London, 1985).

36 My account of this painting owes a great deal to the fertile view of Pissarro presented by T. J. Clark in a television programme on the artist made for the Open University (*A315 Modern Art and Modernism*, TV 04, 1983). He, however, reads *Hoarfrost* as a painting in which 'man and nature still [stand] in intelligible relation to one another', the peasant still serving, as it were, as 'the sign of why these brilliant ephemeral things [shadow, light, hoarfrost and early morning colour] are here at all as something worth painting and capable of being painted'. Clark locates the moment at which 'The figures ... come out of the landscape' a decade later, and explains Pissarro's problems with his peasant subjects in terms of 'a general change which took place in France in the 1880s, an intensification of political, economic and ideological struggle', and in terms of 'Pissarro's response to it, his adopting of left-wing political views'. I would want to say – and it seems to me that the 1873 painting demonstrates the point – that neither the adoption of anarchist views by Pissarro nor an overt intensification of ideological struggle was a necessary condition of his painting's expressing the kind of divergence of trajectories which I take it to express. Indeed, it might be said of his work of the 1880s that the very overtness of his anxiety about the representation of peasants impeded its penetration – as painting – by the meanings of an actual history. If artists turn out at some point to have achieved less than we wanted them to have achieved (and I join Clark in esteem for Pissarro), we may be better occupied in understanding the grounds of that relative failure than in establishing the worthiness of their projects. Clark is concerned to reclaim Pissarro's work as usable – in the sense of capable of being learned from – according to a measure by which 'Monet's later work, say, or Matisse's will seem deserving of benign neglect'. He sees a distinction between the useful and the useless as one needed in art history 'to supplement those it invents and dwells on between great and less great'. This may be to bow too far to the power of a prevailing taste. Would it not be a stronger action in face of such paintings as *Hoarfrost* to *collapse together* the attribution of aesthetic merit and the claim that they can be learned from – even though what they have to offer may not be a simple lesson in political morality? Nor should we rule out the possibility that there are ways we have yet to discover in which Monet's later work or Matisse's can be reclaimed from their admirers and put to use.

37 I deliberated at some length over whether or not the terms 'realist' and 'realism' should be capitalized in the instance of this argument, and thus confronted head-on an issue which these essays have generally sought to skirt round: the issue of the relationship between 'Realism' as an art-historical term (the application or applications of which are open to some considerable dispute), realism as a philosophical concept (the interpretation of which is also open to dispute), and realism as an aspiration or commitment in the production of culture (which may be understood variously by reference to some form of one or other or both of the previous usages). The distinction I have attempted to maintain is as follows. I have generally used a capitalized 'Realism' as a relatively weak valuation, to signify artistically and stylistically soi-disant forms of realism, but with no intention either to support or to deny their representational claims. And I

have generally used a lower-case 'realism' as a stronger valuation, in intended recognition that the enterprises referred to are conducted with an eye to some philosophically significant problem-field. I cannot claim, however, that this distinction is entirely sufficient for all cases, nor that its operations are immune to the effects of irony.

38 In this connection consider the significance of Michael Fried's claim in *Three American Painters* (in Harrison and Wood, *Art in Theory 1900–1990*, p. 770) that 'Roughly speaking, the history of painting from Manet through Synthetic Cubism and Matisse may be characterized in terms of the gradual withdrawal of painting from the task of representing reality – or of reality from the power of painting to represent it – in favour of an increasing preoccupation with problems intrinsic to painting itself.' In Fried's original text, the parenthetical phrase supports a long and interesting footnote.

39 *The Deep* appears to have been the outcome of two phases of work – or of two different notions about what kind of painting it could be. Pollock seems first to have painted a largely white and yellow surface with a deep black centre showing through and setting up a somewhat conventional and 'European' *profondeur*. Possibly having recognized what he had done, he seems to have commenced repainting the entire surface – cancelling the picture – with white paint of a different, and less evidently 'artistic', consistency. At a certain point he stopped. Conceivably it appeared to him that the relationship which was now narrated between cliché and cancellation of cliché had produced a marginally plausible painting. If so, it was the kind of plausibility which found a rightful place for *The Deep* in the *French* national collection of modern art.

Essay 8 Reading the Museum

1 In Sheldon Sacks (ed.), *On Metaphor* (Chicago and London, 1979), p. 45.

2 The series comprises a total of twenty-three extant paintings. The first six completed works from the series were exhibited together with related studies at the Lisson Gallery, London, in April–May 1986. Five paintings and fifteen studies are illustrated in the catalogue *Art & Language – Confessions: Incidents in a Museum*. The works exhibited were numbered *III–VIII*. (*Incident I* was an experimental work which was subsequently cannibalized. *Incident II* was revised and completed late in 1986. *Incident IV* was dismantled after the Lisson Gallery exhibition and its separate components were incorporated in *Incidents XIX* and *XX*.) Eighteen 'Incidents' together with related studies were shown at the Palais des Beaux-Arts, Brussels, in May–June the following year. See *Art & Language: Les Peintures/De Schilderijen/The Paintings* (Société des Expositions du Palais des Beaux-Arts, Brussels, 1987), in which seventeen paintings and six studies are illustrated. A further selection from the series was shown at the Marian Goodman Gallery, New York, in December 1987, including *Incident XXV*.

3 *Index: The Studio at 3 Wesley Place Illuminated by an Explosion nearby V*, photograph on canvas, 1982. The destiny of Art & Language work in store is often to be incorporated and re-represented in work which supersedes it. See essay 3, note 14.

4 Though some forms of reduction and enlargement simply admit larger or smaller swatches of the same stuff.

5 The new Whitney was designed by Marcel Breuer, whose Modern Movement credentials include a period as director of the furniture-design department at the Bauhaus. *Art in America*, vol. 54, no. 5 (September–October 1966) was largely devoted to celebration of the museum. In his article 'The Museum and the City' August Heckscher (then director of the Twentieth Century Fund) pointed unknowingly to the character of the relevant paradigm. Such a museum could only exist, he claimed 'where an intense and highly developed urban existence has created variety and contradiction and driven men constantly towards a search for the new'. He continued, ' "Madison Avenue" [on which the new Whitney is sited] is a term that has heretofore had its share of overtones, not all of them agreeable. Henceforth "Madison Avenue" will mean art in all its ebullience and variety; henceforth it will mean the Whitney.' It could be argued that precisely the converse has happened: that in New York, at least, 'art' has come to signify 'Madison Avenue'.

6 'New York . . . may not be much from certain points of view . . .; but for those who rejoice in the intellectual life, it is everything. And everything, *or nearly everything*, enters inevitably into the city's museum' (ibid.; emphasis added). Under conditions in which 'art' signifies 'Madison Avenue', it may be in the small remainder left by that 'nearly everything' that the aesthetic will have to be discovered or wrought.

7 On 'seeing-in', see the publications cited in essay 5, note 11.

8 See W. J. T. Mitchell, *Iconology: Image, Text, Ideology* (Chicago, 1986), pp. 43–4: 'The dialectic of word and image seems to be a constant in the fabric of signs that a culture weaves around itself. What varies is the precise nature of the weave, the relation of warp and woof. The history of culture is in part the story of a protracted struggle for dominance between pictorial and linguistic signs, each claiming for itself certain proprietary rights on a "nature" to which only it has access. . . . What are we to make of this contest between the interests of verbal and pictorial representation? I propose that we historicize it, and treat it, not as a matter for peaceful settlement under the terms of some all-embracing theory of signs, but as a struggle that carries the fundamental contradictions of our culture into the heart of theoretical discourse itself. The point, then, is not to heal the split between words and images, but to see what interests and powers it serves.'

9 See Richard Wollheim, *Painting as an Art* (London and Princeton, NJ, 1987), pp. 101–85. The suggestion is that a distinct category can be formed from those paintings which contain an imaginary spectator, though Wollheim acknowledges (p. 103) that the grounds of that formation are matters of substantial controversy. (The present essay might be read as a tentative contribution to that controversy.) In the elaboration of his thesis Wollheim accords particular attention to certain landscapes by Caspar David Friedrich and to a group of single-figure subjects by Manet. The tendency of his analyses is to uncover psychological meanings. In his account, the world of Friedrich's landscapes is the world as viewed by the early-nineteenth-century pietist, for whom the purpose of the contemplation of nature was to discover the secrets of its maker. In adopting the point of view presupposed by a typical Friedrich painting, we do not ourselves discover the secrets of creation. Rather, we experience in imagination what it is like to view the world as the pietist viewed it. In the

analysis of Manet's figure paintings what is disclosed is a pattern of aliena-
tion. The spectator in the picture confronts another person in a moment of
abstraction. What is experienced is not relationship but the absence of
relationship, and this experience of absence is taken into the content of the
painting. In glossing the concept of the spectator in the picture by reference
to the work of Wollheim, I do not forget either that the world of nature
and of 'relationships' – present or absent – is the propitious territory of a
traditional and patrician culture, or that, in the world defined by Mitchell's
'dialectic of word and image', the Wollheimian spectator in the picture is a
seer of images, not a reader of texts.

10 In the Kunstmuseum, Basel.

11 The libretto was written in 1982–3 for a prospective collaboration with
Mayo Thompson.

12 This is to stick with the tried and true reading of *Olympia* – which
achieves its most troubled and sophisticated form in T. J. Clark's essay
'Preliminaries to a Possible Treatment of *Olympia* in 1865', *Screen*, vol.
21, no. 1 (Spring 1980) – as a painting which is somehow expressive of the
ambiguous condition of the client, which establishes a form of frankness in
its technical character, which imposes frankness upon the spectator as a
condition of response to that technical character, and which is thus poten-
tially shaming and actually opaque to the would-be respectable bourgeois,
caught as he thus is in the trap between (an unreflective or 'readerly')
response to the represented and (a more sophisticated or 'writerly')
response to the means of representation. It is, however, possible to sustain
another and less polite vision of the painting, for which I am indebted to
Paul Smith. This is to see *Olympia* as the Baudelairean celebration of a
kind of unabashed compact – a mutual abandonment to the effects of
alienation in sexual transactions, symbolized at the level of the technical by
an absorption in artifice. This reading would not banish the spectator in
the picture, but it would accord him – and thus the content of the painting
– a quite different moral character.

13 See, for example, Roger Fry, 'An Essay in Aesthetics' (1909), in *Vision and
Design* (Harmondsworth, 1961), p. 32: 'We must therefore give up the
attempt to judge the work of art by its reaction on life, and consider it as an
expression of emotions regarded as ends in themselves.' See also Clive Bell,
Art (London, 1914), pp. 25 and 28: 'to appreciate a work of art we need
bring with us nothing from life, no knowledge of its ideas and affairs, no
familiarity with its emotions . . . if in the artist an inclination to play upon
the emotions of life is often the sign of a flickering inspiration, in the
spectator a tendency to seek, behind form, the emotions of life is a sign of
defective sensibility always.' See also the more subtle position represented
by Clement Greenberg, 'Complaints of an Art Critic', in C. Harrison and
F. Orton (eds), *Modernism, Criticism, Realism* (London and New York,
1984), p. 8. 'It does seem that literary meaning [i.e. "the meaning of an
illustrated subject"] as such seldom decides the qualitative difference
between one painting or sculpture or another. Yet I say "seem" advisedly.
For at the same time the illustrated subject can no more be thought away,
or "seen away", from a picture than anything else in it can. The thing
imagined does, somehow, impregnate the effect *no matter how indifferent
you may be to it.* The problem is to show something of how this happens,
and that is what I cannot remember having seen any art writer do with real
relevance – with relevance to the quality of the effect. . . . Ruskin, murmur-

ing at a picture he otherwise liked, because it showed children drinking wine, would not sound half so silly were it a piece of fiction he was talking about . . .' (emphasis added).

14 On loan to the Art Institute of Chicago in 1988.

15 For a strong example of a 'formalist' reading, see Clement Greenberg, 'Collage', in *Art and Culture* (Boston, Mass., 1961). For a study of the printed materials used in Cubist collages, see Patricia Leighton, 'Picasso's Collages and the Threat of War', *Art Bulletin*, vol. LXVII, no 4 (December 1985).

16 Like all the larger paintings in the series, *Incident XVI* is also physically divisible into three horizontal sections. These are adjusted to the format of the separate canvases but are otherwise independent of the figurative scheme and its logic. All the works in the series are painted on wood and plywood armatures, not on dismountable stretchers. The lateral divisions were necessary so that the larger paintings could be disassembled for removal from the studio and for transport.

17 Nelson Goodman, *Languages of Art* (Indianapolis, 1968), excerpt in Harrison and Orton, *Modernism, Criticism, Realism*, p. 175.

18 'Abstract Expression', *Art–Language*, vol. 5, no. 1 (October 1982), repr. in Harrison and Orton, p. 204.

19 During the First World War, Claude Monet worked at Giverny, painting ponds full of waterlilies from his garden studio. One of the resulting canvases hangs in the National Gallery in London. At the far end of the room in which it was until recently installed a viewing platform encouraged the visitor to take a distant regard. The painting was clearly organized, however, to be seen from that point at which it entirely fills the visual field – a point which corresponds, unsurprisingly, to that relatively short distance from the surface which might be measured by an arm holding a long paintbrush. Viewed from this position, the painting represents a remarkable technical achievement: the illusion of an oblique and continuous surface extending from bottom to top and from edge to edge of the canvas, marked by the floating *nymphéas*, by shadows and reflections and by the half-discernible evidence of its own figurative transparency; but also a surface of worked and crusted paint, evidently tuned and retuned until its illusory content was adequately contained within just that shape which is the literal shape of the painting. Without that tuning and that containment the atmospheric aspects of the illusion would be overpowering and the integrity and actuality of the painting would be impaired.

Between Monet's house at Giverny and his studio there was a railway line. At times during the war this line was used to convey troops and munitions to the front – which was close enough for the guns to be heard in Monet's water-garden. To one equipped with this information and with a vulgar and moralizing disposition, the painting in the National Gallery might appear to exemplify an escapist – and thus anti-realist – tendency in Modernist art. It might further be said that the value normally accorded to the achieved autonomy of the painting is revealed as the form in which those in flight from history find consolation and reassurance. It could also be argued, however, that the requirement that the war and the railway line be excluded from the surfaces of his paintings was a *significant* condition of realism in Monet's practice and a *relevant* condition of its virtue. Cf. Mitchell, *Iconology*, p. 39: 'We can never understand a picture unless we grasp the ways in which it shows what cannot be seen.'

20 From 'Art & Language Paints a Picture – a Fragment' in *Art & Language* (exhibition catalogue, Ikon Gallery, Birmingham, May 1983), p. 54. It should be noted that the passage quoted is written *as if* it were an item of dialogue in a scenario.

21 Wollheim, *Painting as an Art*, p. 102–3. The function of the spectator in the picture, as Wollheim represents him, is that he should 'do for the spectator of the picture what is expected of him'.

22 Nelson Goodman, 'Seven Strictures on Similarity', in *Problems and Projects* (Indianapolis, 1972), repr. in Harrison and Orton, *Modernism, Criticism, Realism*, p. 86.

23 For a discussion of the type of mechanism which may ground the representational status of an image, see Mitchell, *Iconology*, p. 35: 'The confusion between likeness and picture could also be useful for a priesthood concerned with the education of an illiterate laity. The priest would know that the "true image" is not in any material object, but is encoded in the spiritual – that is, the verbal and textual – understanding, while the people could be given an outward image to gratify their senses and encourage devotion. The distinction between the spiritual and material, inner and outer image, was never a matter of theological doctrine, but was always a question of politics, from the power of priestly castes, to the struggle between conservative and reform movements (the iconophiles and iconoclasts), to the preservation of national identity (the Israelites' struggle to purge themselves of idolatry).'

Essay 10 On Pictures and Paintings

1 The conditions of production of this text are reflected in the awkwardness of its tenses. The lecture on which it is based was written in the autumn of 1988 at a time when the work which is its principal subject was hanging in the Art & Language studio in an unfinished state – or more precisely in a state which had just been *deemed* unfinished. My aim was to explore, to historicize and to represent the grounds upon which that judgement had been made. Before the lecture was delivered the painting had already been changed – though not finished. The final text of the lecture was intended to reflect this change. Subsequently, and before this text was revised for the present publication, the painting was again substantially altered – and finally adjudged finished. But this is an essay about an unfinished painting.

2 Clement Greenberg, 'Modernist Painting' (1961), repr. in Harrison and Wood, *Art in Theory 1900–1990* (Oxford, 1982, and Cambridge, Mass., (1983).

3 See, for example, the discussion of Manet's *Bar at the Folies Bergère* in T. J. Clark, *The Painting of Modern Life: Paris in the Art of Manet and his Followers* (London and New York, 1985), pp. 239–58.

4 See essay 1, note 32.

5 From notes of a lecture given by Rothko at the Pratt Institute, New York, as transcribed by Dore Ashton and published in the *New York Times*, 31 October 1958.

6 '*No Sketches* / acceptance of / *what I do* – . / Experience of our age in terms / [of] painting – not an illustration of – (but *the equivalent*) . . .' From a handwritten note found in Pollock's files after his death, cited in Francis

O'Connor and Eugene Thaw, *Jackson Pollock: A Catalogue Raisonné of Paintings, Drawings and Other Works* (New Haven, Conn., and London, 1978), vol. IV, p. 253.

7 Barnett Newman, 'The Sublime is Now', *Tiger's Eye* (New York), no. 6 (15 December 1948), p. 53.

8 Consider, for instance, the account of Partridge at the performance of *Hamlet* in Fielding's *Tom Jones* (book XVI, ch. 5). His criticisms 'unadulterated by art', Partridge disparages the actor of the leading role: 'He the best player! . . . Why I could act as well as he myself. I am sure if I had seen a ghost, I should have looked in the very same manner, and done just as he did. . . .'

9 The need technically to divert scepticism is common to pseudo-traditional painting, to earnestly literal forms of Realism and to pornography.

10 '. . . the littérateur, who is really nothing, but "represents" almost everything: he plays and "represents" the expert' – Friedrich Nietzsche, *The Joyful Wisdom*, tr. Thomas Common (New York, 1964), pp. 326–7. See also 'The Learned' from 'Three Poems after Friedrich Nietzsche', in *Art–Language*, vol. 5, no. 1 (October 1982), pp. 37–9, which aims to improve on the translation of the relevant passage.

11 For a critique of the significance of likeness, see Nelson Goodman, 'Seven Strictures on Similarity', in *Problems and Projects* (Indianapolis, 1972), repr. in C. Harrison and F. Orton (eds), *Modernism, Criticism, Realism* (London and New York, 1984).

12 Sol LeWitt, 'Paragraphs on Conceptual Art', *Artforum*, vol. V, no. 10 (June 1967), p. 80.

13 The injunction 'Live in your head' was published on the title page of the catalogue for 'When Attitudes Become Form' in 1969. (See essay 2, note 1.)

14 See Joseph Kosuth, 'Art after Philosophy', *Studio International*, vol. 178, no. 915 (October 1969), p. 136.

15 Clement Greenberg, in 'Greenberg on Criticism', *A315: Modern Art and Modernism: Manet to Pollock* (Open University, Milton Keynes, 1983), TV 29.

16 The phrase is Greenberg's. See, for instance, 'Complaints of an Art Critic', in Harrison and Orton, *Modernism, Criticism, Realism*, p. 6: 'Most art-lovers do not believe there actually is such a thing as ungovernable taste. It is taken for granted that esthetic judgements are voluntary. This is why disagreements about art, music, literature so "naturally" become personal and rancorous. This is why positions and lines and programs are brought in. But it is one thing to have an esthetic judgement or reaction, another thing to report it. The dishonest reporting of esthetic experience is what does most to accustom us to the notion that esthetic judgements are voluntary.'

17 These admonitions are not intended as arguments against theory. Quite the contrary. The forms of resistance to theory diagnosed by Paul de Man in his survey of literary scholarship are also endemic to the study of art. Consider the title essay in his *Resistance to Theory* (Manchester, 1982), replacing the terminology of literature with the terminology of art where the replacement can sensibly be effected: 'It turns out that the resistance to theory is in fact a resistance to reading, a resistance that is perhaps at its most effective, in contemporary studies, in the methodologies that call themselves theories of reading but nevertheless avoid the function they

claim as their object. . . . To stress the by no means self-evident necessity of reading implies two things. First of all, it implies that literature is not a transparent message in which it can be taken for granted that the distinction between the message and the means of communication is clearly established. Second, and more problematically, it implies that the grammatical decoding of a text leaves a residue of indetermination that has to be, but cannot be, resolved by grammatical means, however extensively conceived' (p. 15).

18 Rothko, as reported by John Fischer, in Tate Gallery, *Illustrated Catalogue of Acquisitions 1968–70* (London 1970), p. 102. See John Fischer, 'The Easy Chair', *Harpers Magazine* CCXL (July 1970) pp. 16–23. Fischer refers to notes of a conversation with Rothko held in June 1959.

Essay 11 'Hostages' 1: Painting as Cure

1 *Hostage I–X* were completed in the first half of 1988 and were exhibited at the Lisson Gallery, London, from July to September. *Hostage XI* and *XII* were completed during the period of the exhibition.

2 J. Hillis Miller, 'Stevens' Rock and Criticism as Cure', in M. Philipson and P. J. Gudel (eds), *Aesthetics Today*, rev. edn (New York, 1980), p. 509. Discussing Stevens' poem 'The Rock', the author suggests that 'the reader can make sense of the poem by assuming any one of the scenes to be the literal ground on the basis of which the others are defined as analogical, figurative, iconic. By that definition, however, the base, when examined, must be defined as itself analogical.' My title acknowledges the aptness of Hillis Miller's analysis.

Essay 12 'Hostages' 2: Some Other Sense

1 Exhibited at the Cultureel Informatief Centrum, Ghent, October 1978, and Lisson Gallery, London, November 1978. Each work in the series was composed of an actual flag, showing the circular motif on a differently coloured ground, and a wall-mounted text stating a series of beliefs. The flag was proposed as a flag for an organization for which that specific series of beliefs was axiomatic.

2 Michael Fried, 'Shape as Form: Frank Stella's New Paintings', *Artforum*, vol. 5, no. 3 (November 1966). This essay marked a high point of rigour in Abstractionist criticism. One of Fried's clearest statements on the ethical character of Modernist painting was concealed in a footnote (p. 27): 'What the modernist painter can be said to discover in his work – what can be said to be revealed to him in it – is not the irreducible essence of *all* painting, but rather that which, at the present moment in painting's history, is capable of convincing him that it can stand comparison with the painting of both the modernist and pre-modernist past whose quality seems to him beyond question. (In this sense one might say that modernist painting discovers the essence of all painting to be *quality*.) The object of his enterprise is therefore *both* knowledge and conviction – knowledge

through, or better still, *in*, conviction. And this knowledge is simultaneously knowledge of *painting* (i.e., what it must be in order to elicit conviction) and of *himself* (i.e., what he finds himself convinced by) – apprehended not as two distinct entities, but in a single, inextricable fruition.'

Index

Page numbers in bold indicate the location of plates